Sweden

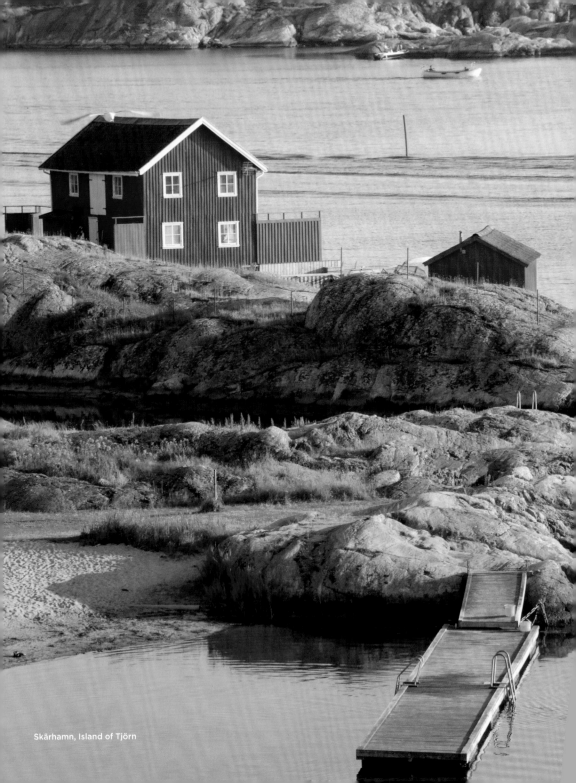

Skärhamn, Island of Tjörn

Sweden

Suède
Suecia
Suécia
Zweden

Udo Bernhart
Sabine von Kienlin

ÉDITIONS
PLACE DES
VICTOIRES

KÖNEMANN

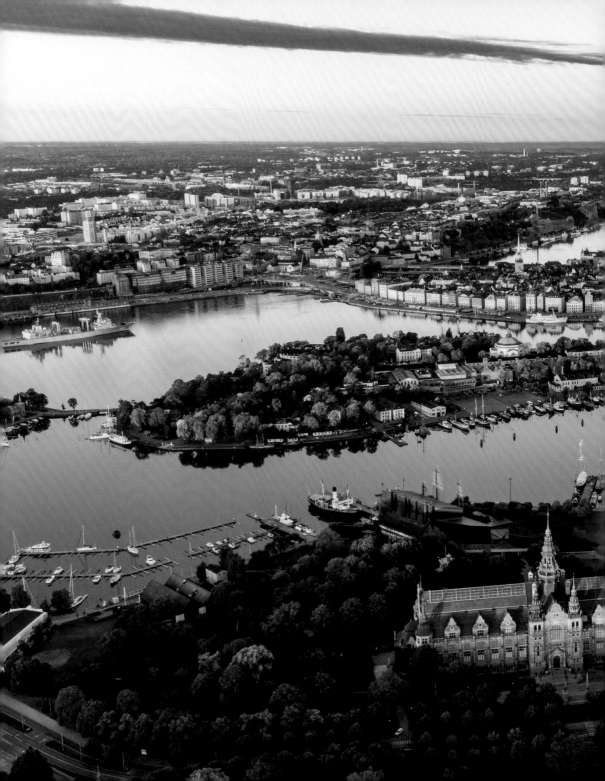

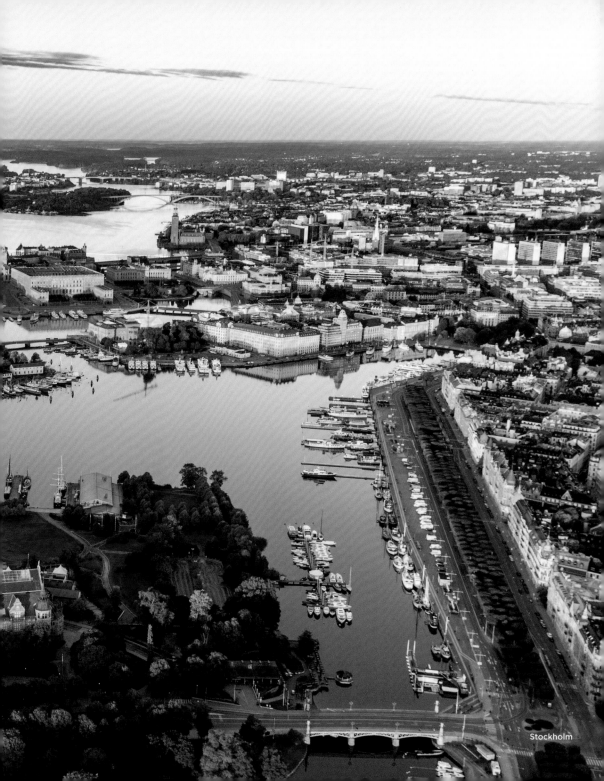

Stockholm

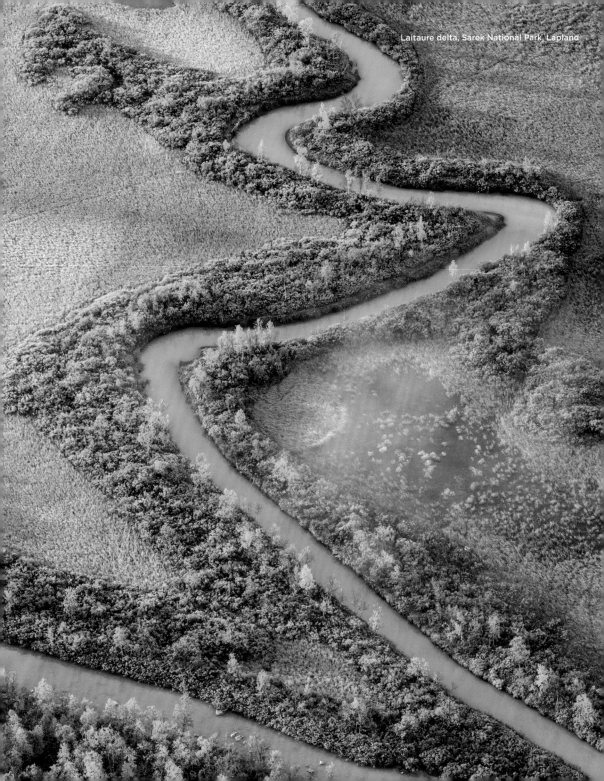
Laitaure delta, Sarek National Park, Lapland

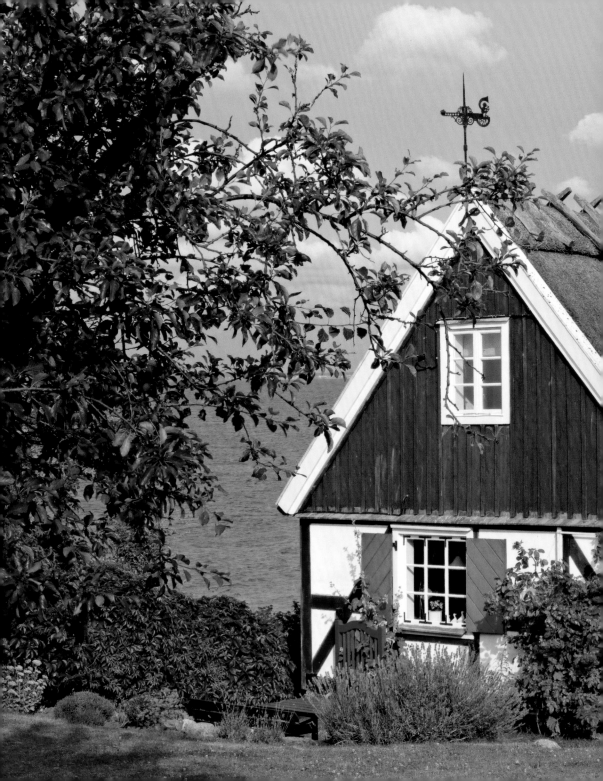

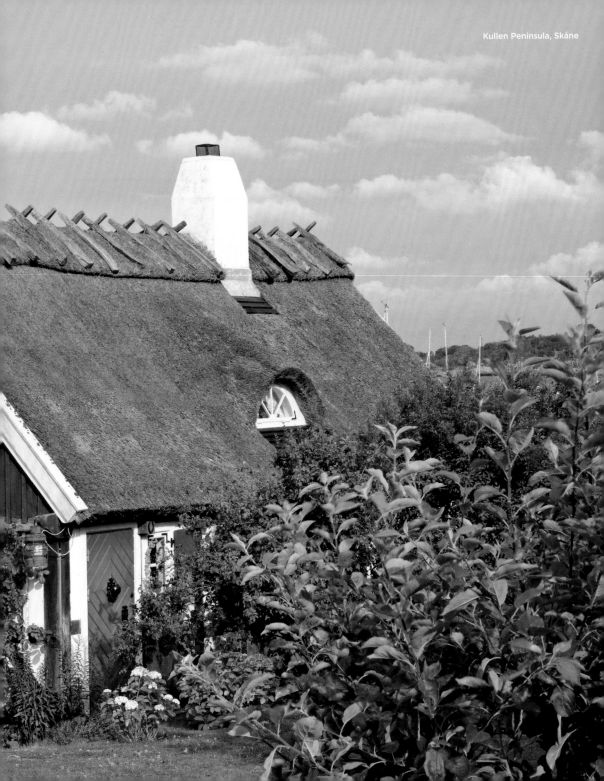

Innaren Lake, Småland

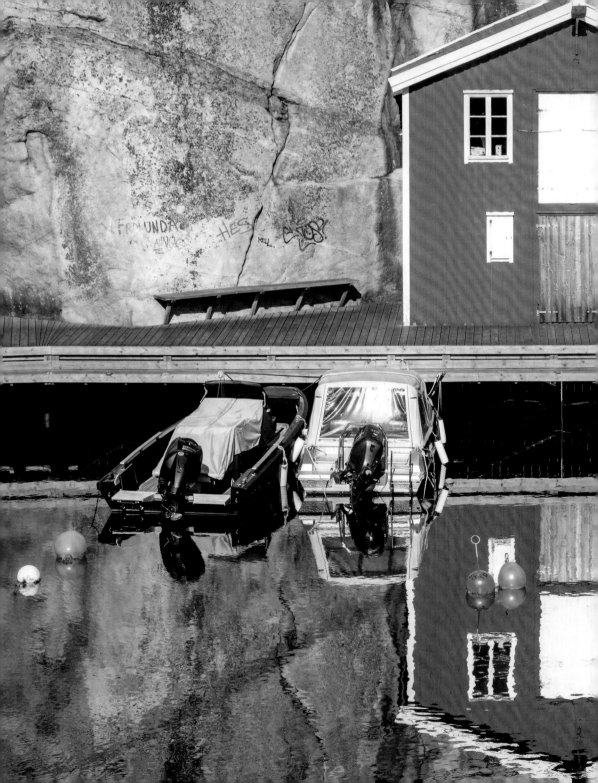

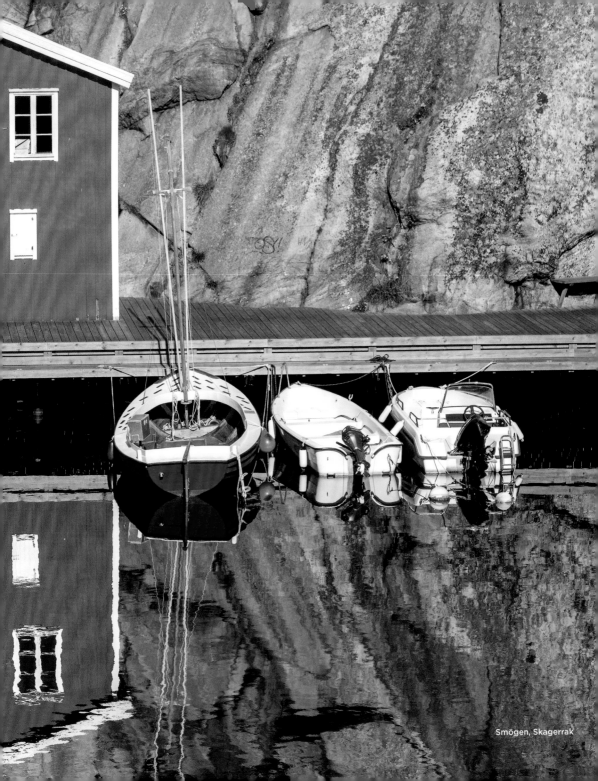

Smögen, Skagerrak

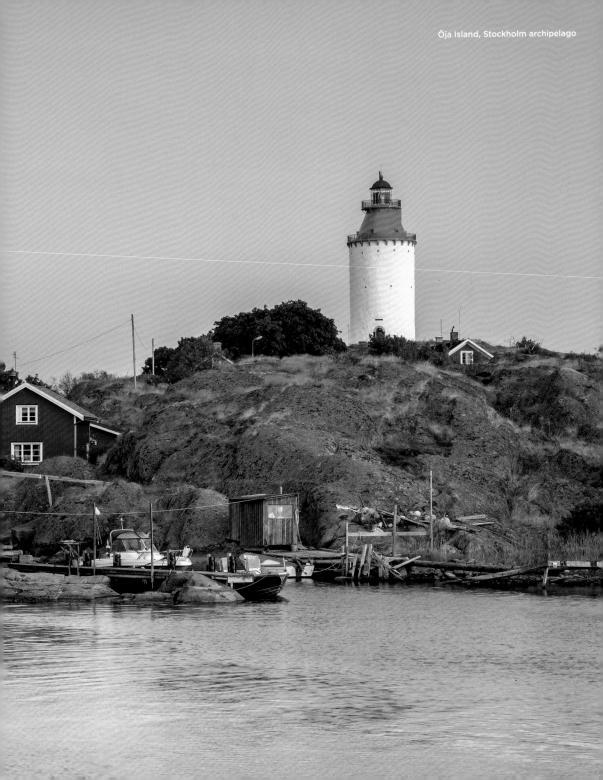

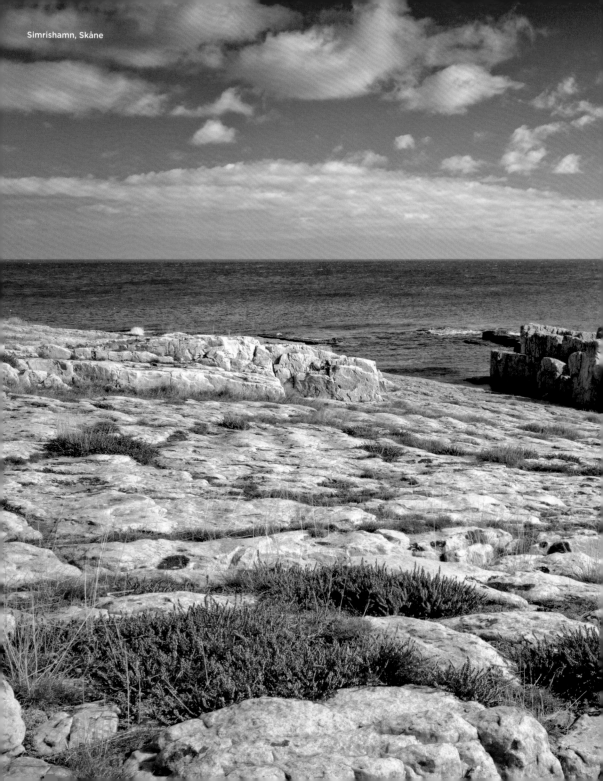
Simrishamn, Skåne

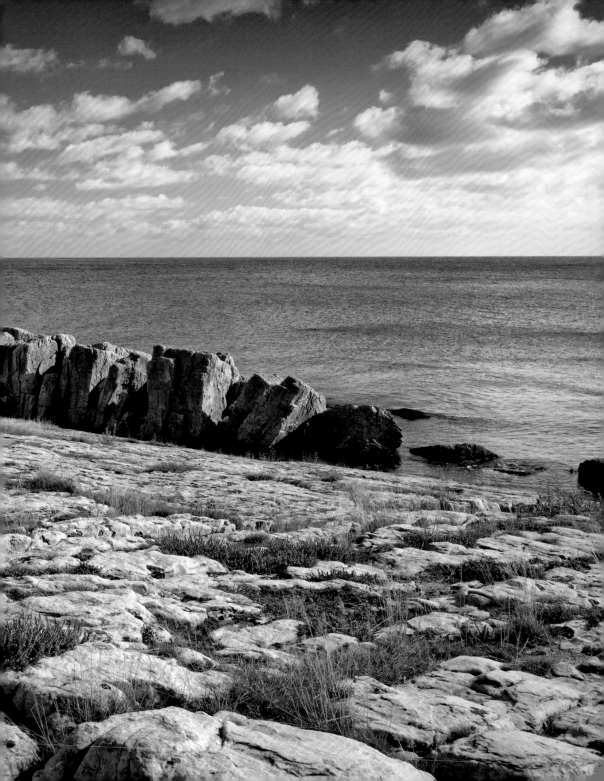

Tjörnekalv Island, Bohuslän

Contents · Sommaire · Inhalt · Índice · Inhoud

Sweden

Sweden, a symbol of Scandinavian idyll, inspires with its falun-red wooden houses in the middle of enchanted gardens surrounded by dense forests, with its quiet bays, long sandy beaches and lonely huts on barren granite rocks, lighthouses and windmills, colorful boathouses, the glittering sea between archipelagos, the infinite number of lakes, the lonely and wide snow landscapes, dog sleds, reindeer and moose. It really does exist—the place of yearning that made Astrid Lindgren so world-famous with her stories of Bullerbü and Ronja the Robber's Daughter. This illustrated book illustrates the fascinating diversity and beauty of Sweden—a country where the Vikings were at home and where early Christian artifacts, medieval churches, castles and palaces tell of the important history of this Nordic kingdom. A country that is considered the kingdom of the midnight sun and northern lights, where summers are hot and winters wonderfully white, where people are unconventional and cosmopolitan, and cities such as Stockholm, Gothenburg and Malmö are friendly and vibrant—and where the love of nature is celebrated in the national anthem. The tension between solitude and the hustle and bustle of big cities, between wilderness and coastal idyll, coupled with friendliness and cultural life make this Scandinavian pearl as extraordinary and endearing as its unofficial national animal, the moose.

Suède

Ambassadrice de l'art de vivre à la scandinave, la Suède remporte tous les suffrages avec ses maisons rouges plantées dans des jardins enchantés aux abords de forêts profondes, avec ses baies tranquilles, ses longues plages de sable et ses cabanes solitaires sur des falaises de granit, ses phares et ses moulins à vent, ses bateaux-maisons bigarrés, ses mers étincelantes et leurs myriades d'îles, ses innombrables lacs, ses paysages enneigés aussi vastes que déserts, ses traîneaux à chiens, ses rennes et ses élans. Ces lieux de rêve sont bien tels qu'Astrid Lindgren les a fait découvrir au monde entier à travers les aventures de Fifi Brindacier et de Ronya, fille de brigand. Ce livre révèle la beauté et la diversité incroyables d'un des pays des Vikings où les vestiges des premiers chrétiens, les églises médiévales, les châteaux forts et les palais rappellent l'importance historique de ces royaumes nordiques. Un pays où l'on peut contempler le soleil de minuit et les aurores boréales, aux étés chauds et aux hivers merveilleusement blancs. Un pays où les habitants se distinguent par leur anticonformisme et leur ouverture d'esprit, où les villes sont accueillantes et vibrantes, à l'image de Stockholm, Göteborg et Malmö. Un pays enfin qui célèbre son amour de la nature dans son hymne national. Ce contraste entre les étendues désertiques et l'animation des métropoles, entre les dernières contrées sauvages et le charme du littoral, associé à un bon accueil et à la vie culturelle, rend la perle scandinave aussi unique et attachante que son fétiche officieux, l'élan.

Schweden

Schweden, ein Sinnbild skandinavischer Idylle, begeistert mit seinen falunroten Holzhäusern inmitten verwunschener Gärten und umringt von dichten Wäldern, mit seinen ruhigen Buchten, langen Sandstränden und einsamen Hütten auf kargen Granitfelsen, den Leuchttürmen und Windmühlen, bunten Bootshäusern, dem glitzernden Meer zwischen Schärengärten, den unendlich vielen Seen, den einsamen und weiten Schneelandschaften, Hundeschlitten, Rentieren und Elchen. Es gibt sie wirklich – diese Sehnsuchtsorte, die Astrid Lindgren mit ihren Geschichten von Bullerbü und Ronja Räubertochter so weltberühmt machte. Dieser Bildband zeigt die faszinierend große Vielfalt und Schönheit Schwedens – ein Land, in dem die Wikinger zu Hause waren und frühchristliche Funde, mittelalterliche Kirchen, Burgen und Schlösser von der bedeutenden Geschichte des nordischen Königreiches berichten. Ein Land, das als Reich der Mitternachtssonne und Polarlichter gilt, in dem die Sommer heiß und die Winter wunderbar weiß sind, in dem die Menschen unkonventionell und weltoffen, und die Städte wie Stockholm, Göteborg und Malmö freundlich und pulsierend sind – und: in dem die Liebe zur Natur bereits in der Nationalhymne besungen wird. Diese Spannung zwischen Einsamkeit und Großstadtgetümmel, zwischen letzter Wildnis und Küstenidylle, gepaart mit Freundlichkeit und kulturellem Leben machen die skandinavische Perle so außergewöhnlich und liebenswert wie ihr inoffizielles Wappentier, den Elch.

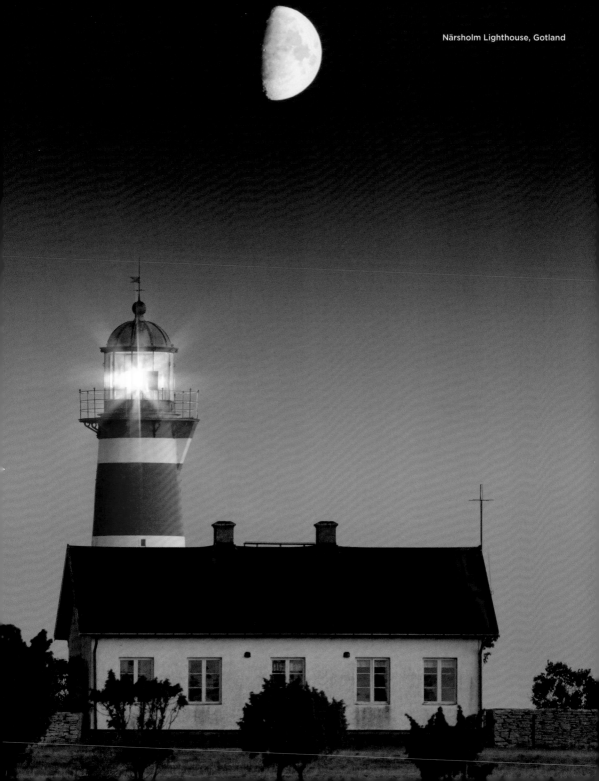

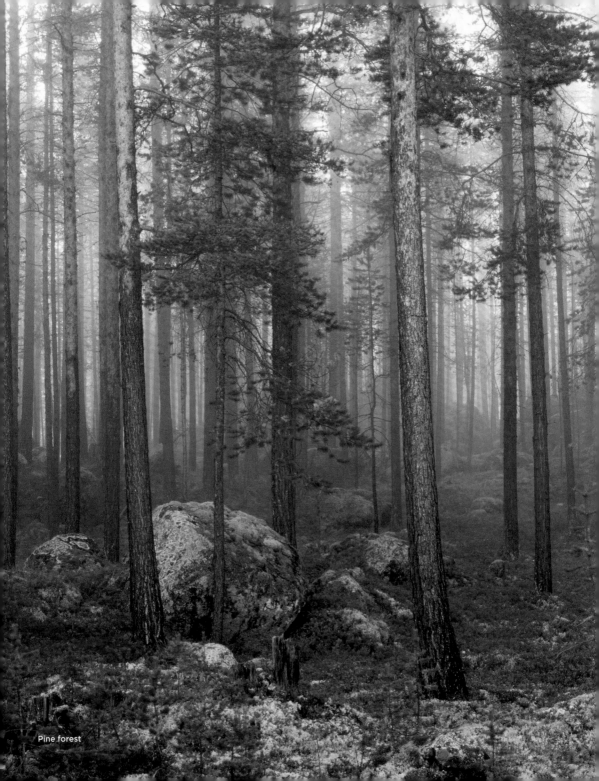

Pine forest

Suecia

Suecia, símbolo del idilio escandinavo, apasiona a los visitantes con sus casas de madera de color rojo Falun en medio de jardines encantados y rodeadas de densos bosques, con sus tranquilas bahías, sus largas playas de arena y sus solitarias cabañas sobre áridas rocas de granito, sus faros y molinos de viento, sus coloridos cobertizos para botes, su mar resplandeciente entre archipiélagos, su infinito número de lagos, sus solitarios y anchos paisajes nevados, sus trineos de perros, sus renos y sus alces. Realmente existen: estos lugares anhelados que hizo a Astrid Lindgren tan famosa en todo el mundo con sus historias de Bullerbyn y Ronja, la hija del bandolero. Este libro ilustrado muestra la fascinante diversidad y belleza de Suecia, un hogar para los vikingos y donde los primeros hallazgos cristianos, las iglesias medievales, los castillos y los palacios cuentan la importante historia del reino nórdico. Un país considerado el reino del sol de medianoche y de la aurora boreal, donde los veranos son calurosos y los inviernos maravillosamente blancos, donde la gente es poco convencional y cosmopolita, y ciudades como Estocolmo, Gotemburgo y Malmö son amistosas y vibrantes, y donde el amor por la naturaleza ya se canta en el himno nacional. Esta tensión entre la soledad y el ajetreo de las grandes ciudades, entre el último desierto y el idilio costero, junto con la amabilidad y la vida cultural, hacen que la perla escandinava sea tan extraordinaria y entrañable como su animal heráldico no oficial: el alce.

Suécia

A Suécia, um símbolo do idílio escandinavo, fascina com suas casas de madeira pintadas com tinta vermelha de Falu em meio de jardins encantados e rodeadas de densas florestas, com as suas baías tranquilas, longas praias de areia e cabanas solitárias sobre rochas de granito estéreis, os faróis e moinhos de vento, as coloridas casas de barcos, o mar cintilante entre arquipélagos, o número infinito de lagos, as paisagens de neve solitárias e vastas, os trenós puxados por cães, renas e alces. Eles realmente existem – estes lugares de anseio que tornou Astrid Lindgren tão famosa mundialmente com suas histórias de Bullerbü e Ronja, a filha do ladrão. Este livro ilustrado mostra a fascinante diversidade e beleza da Suécia – um país onde os Vikings estavam em casa e onde os primeiros achados cristãos, igrejas medievais, castelos e palácios que contam a história importante do reino nórdico. Um país que é considerado como o reino do sol da meia-noite e das luzes do norte, onde os verões são quentes e os invernos maravilhosamente brancos, onde as pessoas não são convencionais e cosmopolitas, e as cidades como Estocolmo, Gotemburgo e Malmö são amigáveis e vibrantes – e: onde o amor pela natureza já é cantado no hino nacional. Este suspense entre a solidão e a azáfama das grandes cidades, entre a última natureza selvagem e o idílio costeiro, aliada à simpatia e à vida cultural, tornam a pérola escandinava tão extraordinária e cativante como o seu animal heráldico não oficial, o alce.

Zweden

Zweden, een zinnebeeld van idyllisch Scandinavië, inspireert met zijn falurode houten huizen midden in lieftallige tuinen en omgeven door dichte bossen, met zijn rustige baaien, lange zandstranden en eenzame hutten op kale granieten rotsen, zijn vuurtorens en molens, kleurrijke boothuizen, de glinsterende zee aan de scherenkust, de oneindige hoeveelheid meren, de eenzame en weidse sneeuwlandschappen, hondensleeën, rendieren en elanden. Ze bestaan echt, deze droomoorden, die Astrid Lindgren wereldberoemd maakte met haar verhalen over Bolderburen (Bullerbü) en Ronja de roversdochter. Dit fotoboek toont de fascinerende diversiteit en schoonheid van Zweden - een land waar de Vikingen vandaan kwamen en waar vroegchristelijke vondsten, middeleeuwse kerken, kastelen en paleizen vertellen over de belangrijke geschiedenis van het noordse koninkrijk. Een land dat wordt beschouwd als het rijk van de middernachtzon en het noorderlicht, waar de zomers warm zijn en de winters wonderbaarlijk wit, waar de mensen onconventioneel zijn en internationaal ingesteld, waar steden als Stockholm, Göteborg en Malmö vriendelijk en levendig zijn - en: waar de liefde voor de natuur al in het volkslied wordt bezongen. Deze spanning tussen eenzaamheid en grootstedelijke drukte, tussen de laatste wildernis en idyllische kust maakt, gekoppeld aan vriendelijkheid en een cultureel leven, de Scandinavische parel even buitengewoon en beminnelijk als zijn onofficiële wapendier, de eland.

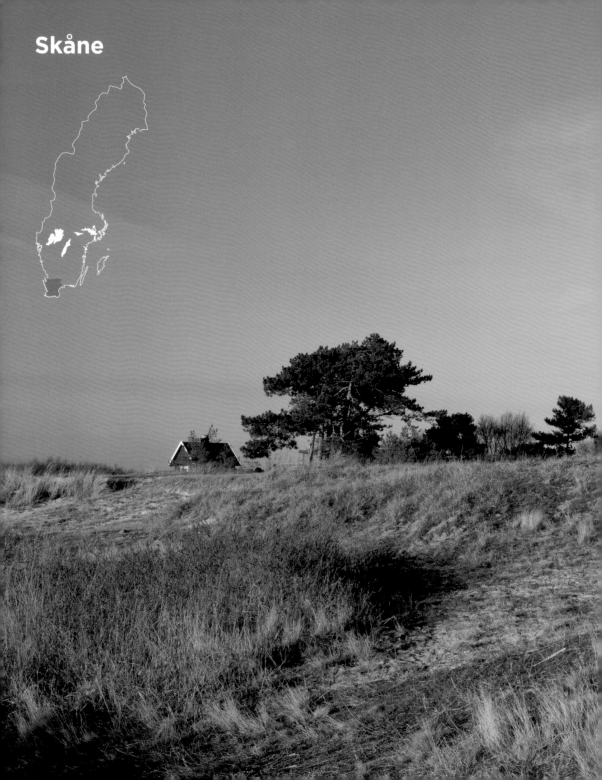

Skåne

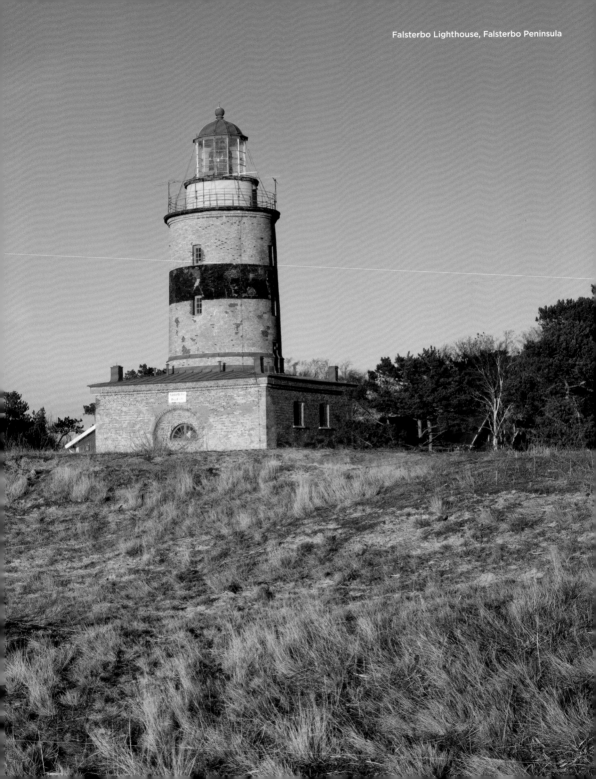
Falsterbo Lighthouse, Falsterbo Peninsula

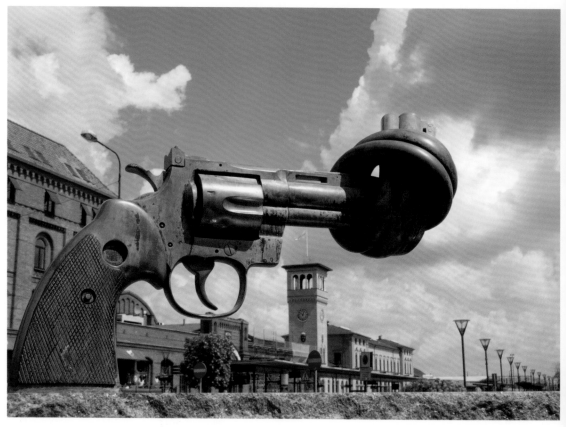

Non-Violence sculpture, Malmö

Skåne

In Skåne, towns such as Malmö, Lund and Kristianstad attract visitors with their impressive buildings and varied cultural life. Numerous castles, idyllic lakes, dense deciduous forests, wide plains, gentle hills and rough cliffs coupled with friendliness and cultural life belong to Scandinavia's southern tip. Skåne, also known as Scania, is a region full of contrasts: surrounded by the sea in three directions and pampered with light and warmth all year round. Skåne was given the title "the granary of Sweden" for its intensive agriculture. The landscape of this former Viking stronghold is also characterized by Renaissance villages and mystical rock formations.

La Scanie

En Scanie, les édifices remarquables et la richesse de la vie culturelle font tout l'intérêt des villes de Malmö, Lund et Kristianstad. La pointe méridionale de la Scandinavie se distingue aussi par ses nombreux châteaux, ses lacs idylliques, d'épaisses forêts de feuillus, d'immenses plaines, de douces collines et des falaises abruptes. La Scanie est une terre de contrastes, entourée sur trois faces par la mer et bénéficiant toute l'année de la lumière du soleil et de températures agréables. Son agriculture intensive lui a valu le surnom de « grenier à blé de la Suède ». Des villages de pur style Renaissance et des mégalithes parachèvent les paysages de cette ancienne patrie des ikings.

Skåne

In Skåne locken Städte wie Malmö, Lund und Kristianstad mit beeindruckenden Bauten und abwechslungsreichem Kulturleben. Aber auch zahlreiche Schlösser, idyllische Seen, dichte Laubwälder, weite Ebenen, sanfte Hügel und raue Klippen gehören zu Skandinaviens südlicher Spitze. Skåne, auch Schonen genannt, ist eine Region voller Kontraste: in drei Himmelsrichtungen umgeben von Meer und das ganze Jahr mit Licht und Wärme verwöhnt. Aufgrund intensiven Ackerbaus erhielt Skåne den Beinamen „Kornkammer Schwedens". Das Landschaftsbild der einstigen Wikingerhochburg ist auch geprägt von Renaissance-Dörfern und mystischen Steinformationen.

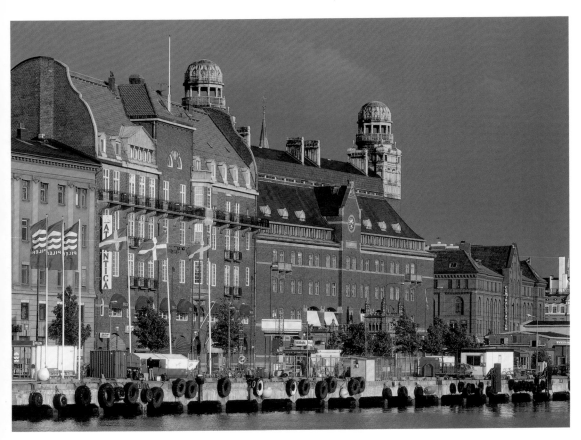

Malmö

Skåne

En Skåne, ciudades como Malmö, Lund y Kristianstad atraen a los visitantes con sus impresionantes edificios y su variada vida cultural. Pero también numerosos castillos, lagos idílicos, densos bosques caducifolios, amplias llanuras, suaves colinas y escarpados acantilados forman parte del extremo sur de Escandinavia. Skåne, también conocida como Escania, es una región llena de contrastes: rodeada por el mar en tres direcciones y llena de luz y calor durante todo el año. A Skåne se le dio el apodo de "el granero de Suecia" por su agricultura intensiva. El paisaje de la antigua fortaleza vikinga también se caracteriza por sus pueblos renacentistas y sus místicas formaciones rocosas.

Skåne

Em Skåne, cidades como Malmö, Lund e Kristianstad atraem visitantes com seus edifícios impressionantes e uma vida cultural variada. Mas também numerosos castelos, lagos idílicos, densas florestas caducifólias, vastas planícies, colinas suaves e penhascos escarpados pertencem ao extremo sul da Escandinávia. Skåne, também conhecida como Escânia, é uma região cheia de contrastes: rodeada pelo mar em três direções e usufrui de luz e calor durante todo o ano. Skåne recebeu o apelido de "celeiro da Suécia" pela sua agricultura intensiva. A paisagem da antiga fortaleza Viking também é caracterizada por aldeias renascentistas e formações rochosas místicas.

Skåne

In Skåne trekken steden als Malmö, Lund en Kristianstad bezoekers met hun indrukwekkende gebouwen en gevarieerde culturele leven. Maar ook talrijke kastelen, idyllische meren, dichte loofbossen, weidse vlakten, glooiende heuvels en ruige klippen horen bij de zuidpunt van Scandinavië. Skåne, vroeger bij ons ook bekend als Schonen, is een regio vol contrasten: aan drie kanten omgeven door de zee en het hele jaar door verwend met licht en warmte. Skåne kreeg vanwege de intensieve landbouw de bijnaam 'graanschuur van Zweden'. Het landschap van dit voormalige Vikingbolwerk wordt ook gekenmerkt door renaissancedorpen en mysterieuze steenformaties.

Arild, Kullen Peninsula

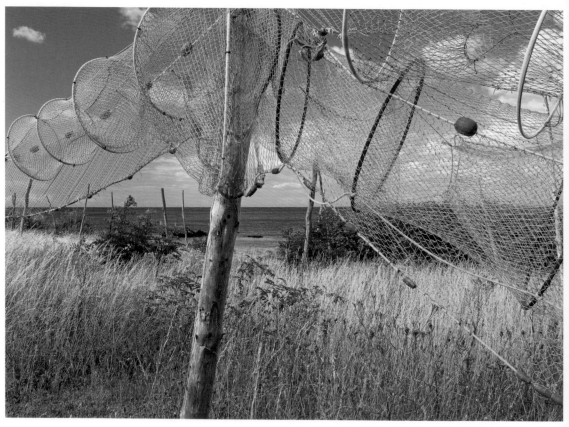

Fish traps, Skälderviken Bay, Kullen Peninsula

Kullen Peninsula

Fish traps are not an unusual sight on the Kullen peninsula. The picturesque fishing and bathing villages of Arild, Mölle and Viken radiate coziness and tranquility, and picturesque thatched cottages can be found amidst winding lanes and remote fields. Kullen rises into the Kattegat and therefore offers cliffs of up to 70 m (230 ft) high with caves, grottos and gorges, as well as impressive vegetation. The region is one of the most beautiful in southern Sweden, and provides hikers, recreation seekers and adventurers with much variety. The area around the 188 m (617 ft) high Kullaberg is one of the most visited nature reserves in Sweden.

La péninsule de Kullen

Les nasses de pêcheurs sont un accessoire familier sur la péninsule de Kullen. Les villages pittoresques de pêcheurs d'Arild, Mölle et Viken, désormais des stations balnéaires, sont aussi accueillants que tranquilles. Dans les ruelles tortueuses ou au milieu des champs, le passant tombe en arrêt devant d'adorables chaumières. Le relief de Kullen, dans le Cattégat, se manifeste par des falaises culminant à 70 m, des grottes et des gorges, ainsi qu'une végétation intéressante. La région, l'une des plus belles du sud de la Suède, se présente sous de multiples facettes aux randonneurs et aux touristes avides de calme ou d'aventure. La réserve naturelle aménagée autour du Kullaberg (188 m) est l'une de plus fréquentées de Suède.

Halbinsel Kullen

Fischreusen sind kein ungewöhnlicher Anblick auf der Halbinsel Kullen. Die pittoresken Fischer- und mittlerweile auch Badedörfchen Arild, Mölle und Viken strahlen Gemütlichkeit und Ruhe aus. Malerisch liegen teils reetgedeckte Häuschen in verwinkelten Gassen und auf abgelegenen Feldern. Kullen ragt in den Kattegat und bietet deswegen neben bis zu 70 m hohen Klippen mit Höhlen, Grotten und Schluchten auch eine interessante Vegetation. Die Region gehört zu den schönsten Südschwedens und bietet Wanderern, Erholungssuchenden und Abenteurern viel Abwechslung. Das Gebiet um den 188 m hohen Kullaberg zählt zu den meistbesuchten Naturreservaten Schwedens.

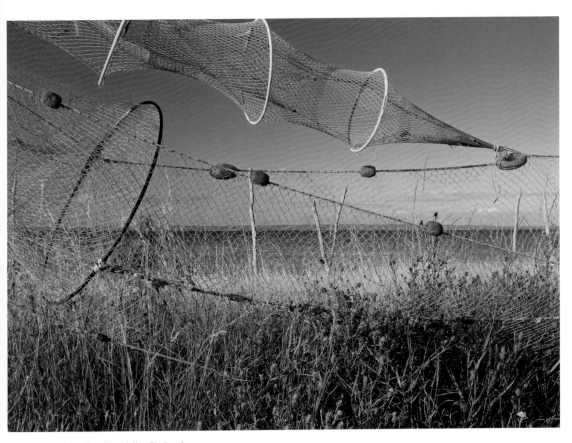

Fish traps, Skälderviken Bay, Kullen Peninsula

Península de Kullen

Las nasas (trampas para peces) no son algo inusual en la península de Kullen. Los pintorescos pueblos pesqueros y balnearios de Arild, Mölle y Viken irradian calidez y tranquilidad. Las pintorescas cabañas de paja se encuentran en serpenteantes callejones y campos remotos. Kullen se eleva en el Kattegat y, por lo tanto, también ofrece una vegetación interesante, junto a acantilados de hasta 70 m de altura con cuevas, grutas y barrancos. La región es una de las más bellas del sur de Suecia y ofrece una gran variedad a los excursionistas, las personas que buscan actividades recreativas y los aventureros. El área alrededor de los 188 m de altura de Kullaberg es una de las reservas naturales más visitadas de Suecia.

Península de Kullen

As armadilhas para peixes não são uma visão incomum na península de Kullen. As pitorescas aldeias de pescadores e banhistas de Arild, Mölle e Viken irradiam aconchego e tranquilidade. Pitorescas cabanas, parcialmente de colmo, encontram-se em ruas sinuosas e campos isolados. Kullen avança para o Kattegat e oferece, portanto, juntamente com as falésias de até 70 m de altura cavernas, grutas e desfiladeiros também uma vegetação interessante. A região é uma das mais belas do sul da Suécia e oferece uma grande variedade de caminhadas, aos aventureiros e aos que procuram recreação e. A área em torno dos 188 m de altura de Kullaberg é uma das reservas naturais mais visitadas da Suécia.

Schiereiland Kullen

Visfuiken bieden geen ongewone aanblik op het schiereiland Kullen. De pittoreske vissers- en intussen ook badplaatsen Arild, Mölle en Viken stralen gezelligheid en rust uit. Schilderachtige, deels met riet gedekte huisjes staan in kronkelende straatjes en op afgelegen velden. Kullen rijst op uit het Kattegat en biedt daarom naast 70 meter hoge klippen met holen, grotten en inhammen ook een interessante vegetatie. De regio behoort tot de mooiste van Zuid-Zweden en biedt wandelaars, recreanten en avonturiers veel afwisseling. Het gebied rond de 188 meter hoge Kullaberg is een van de meest bezochte natuurreservaten van Zweden.

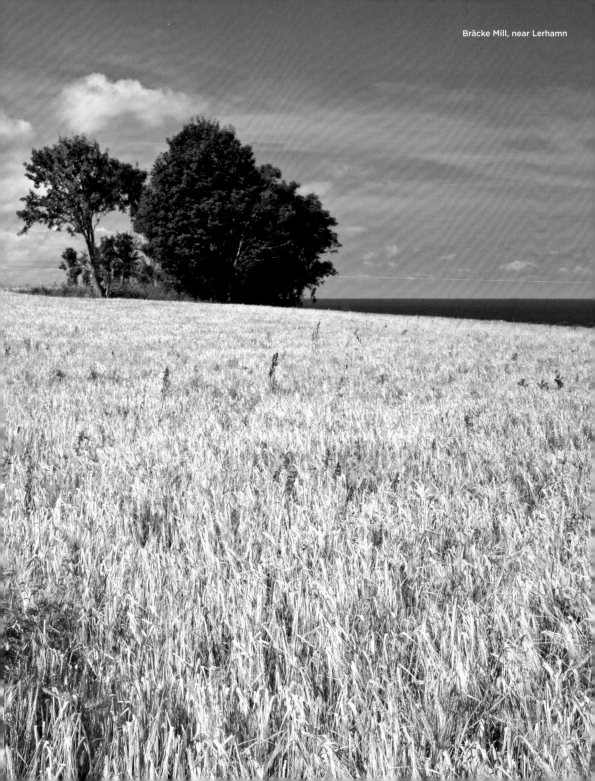

Ellinge Castle, Eslöv

Varied architecture

Whether castles, windmills, towers or churches, Skåne is known for its wealth of sights and the varied architecture which typify the landscape of the region and make it so attractive. Some 150 castles and fortresses built by the Danish aristocracy are still preserved today. Some of them, such as Ellinge Castle near Eslöv, are also used as hotels or are available for sightseeing. The beautiful 18 m (59 ft) high cap windmill "Bräcke Mölla" near the village of Lerhamn can also be visited. Under ideal wind conditions, this mill grinds up to 600 kg (1322 lb) flour per hour.

Une architecture très variée

En Scanie, région célèbre pour ses centres d'intérêt touristiques et son architecture variée, châteaux, moulins à vent, tours et églises rehaussent le paysage et contribuent au charme de l'endroit. Environ 150 châteaux et forts construits autrefois par les nobles danois sont toujours debout. Certains ont été transformés en hôtels, comme le château d'Ellinge près d'Eslöv ; d'autres se visitent. Le Bräcke Mölla, magnifique moulin sur pivot haut de 18 m, près du village de Lerhamn, vaut également le détour. Par vent favorable, il moud jusqu'à 600 kg de farine à l'heure.

Abwechslungsreiche Architektur

Ob Schlösser, Windmühlen, Türme oder Gotteshäuser – Skåne ist bekannt für den Reichtum an Sehenswürdigkeiten und abwechslungsreicher Architektur, die das Landschaftsbild der Region prägen und es so reizvoll machen. Etwa 150 Schlösser und Festungen, einst vom dänischen Adel erbaut, sind heute noch erhalten. Zum Teil werden sie, so wie Ellinge Castle nahe Eslöv, auch als Hotel genutzt oder stehen für Besichtigungen zur Verfügung. Die wunderschöne 18 m hohe Kappenwindmühle „Bräcke Mölla" nahe der Ortschaft Lerhamn kann ebenfalls besucht werden. Bei idealen Windbedingungen mahlt sie bis zu 600 kg Mehl pro Stunde.

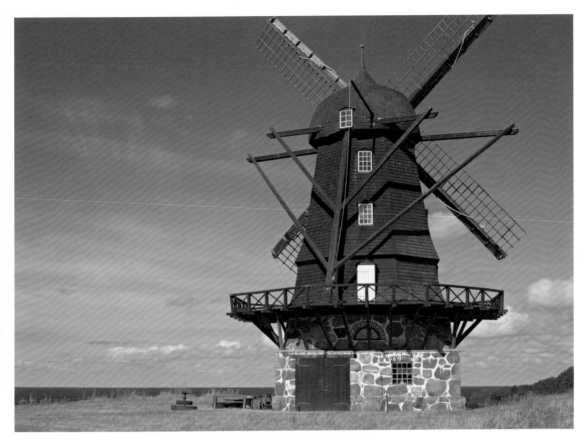

Bräcke Mill, near Lerhamn

Arquitectura variada

Ya se trate de castillos, molinos de viento, torres o iglesias, Skåne es conocida por su riqueza paisajística y su variedad arquitectónica, que caracterizan el paisaje de la región y la hace tan atractiva. Hoy en día aún se conservan unos 150 castillos y fortalezas, construidos en su día por la aristocracia danesa. Algunos de ellos, como el Castillo Ellinge cerca de Eslöv, también se utilizan como hoteles o están disponibles para hacer turismo. También se puede visitar el hermoso molino de viento holandés "Bräcke Mölla" de 18 m de altura, cerca del pueblo de Lerhamn. En condiciones ideales de viento, muele hasta 600 kg de harina por hora.

Arquitetura variada

Quer sejam castelos, moinhos de vento, torres ou igrejas – Skåne é conhecida pela sua riqueza de pontos turísticos e arquitetura variada, que caracterizam a paisagem da região e a tornam tão atraente. Cerca de 150 castelos e fortalezas, uma vez construídos pela aristocracia dinamarquesa, ainda hoje são preservados. Alguns deles, como o Castelo de Ellinge, perto de Eslöv, também são usados como hotéis ou estão disponíveis para passeios turísticos. O belo moinho de vento "Bräcke Mölla", de 18 m de altura, perto da aldeia de Lerhamn, também pode ser visitado. Sob condições ideais de vento, moe até 600 kg de farinha por hora.

Afwisselende architectuur

Of het nu gaat om kastelen, molens, torens of kerken, Skåne staat bekend om zijn rijkdom aan bezienswaardigheden en afwisselende architectuur, die het landschap in de regio kenmerken en zo aantrekkelijk maken. Ongeveer 150 kastelen en vestingen, die ooit door de Deense edelen werden gebouwd, zijn tot op heden bewaard gebleven. Sommige ervan, zoals Ellinge Slott bij Eslöv, worden ook gebruikt als hotel of zijn open voor bezichtiging. De prachtige 18 meter hoge molen Bräcke Mölla bij het dorpje Lerhamn kan eveneens worden bezocht. Bij ideale windstandigheden maalt de molen wel 600 kilo meel per uur.

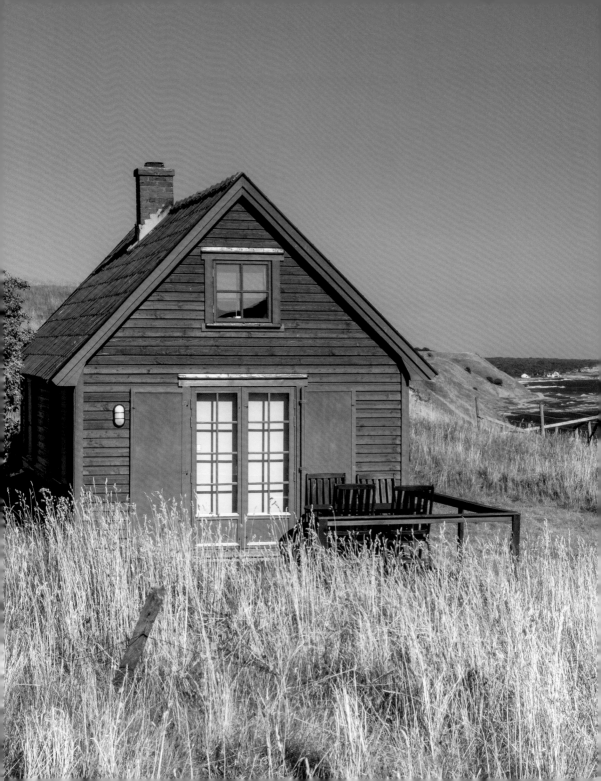

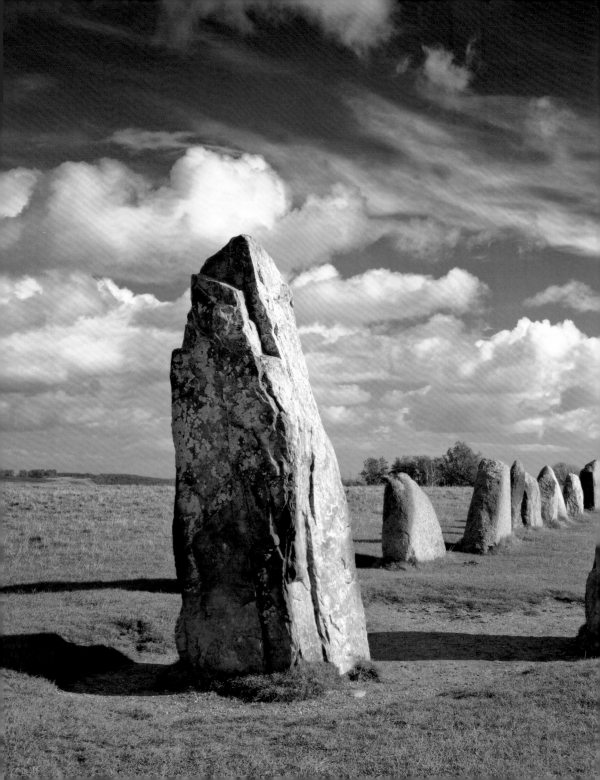

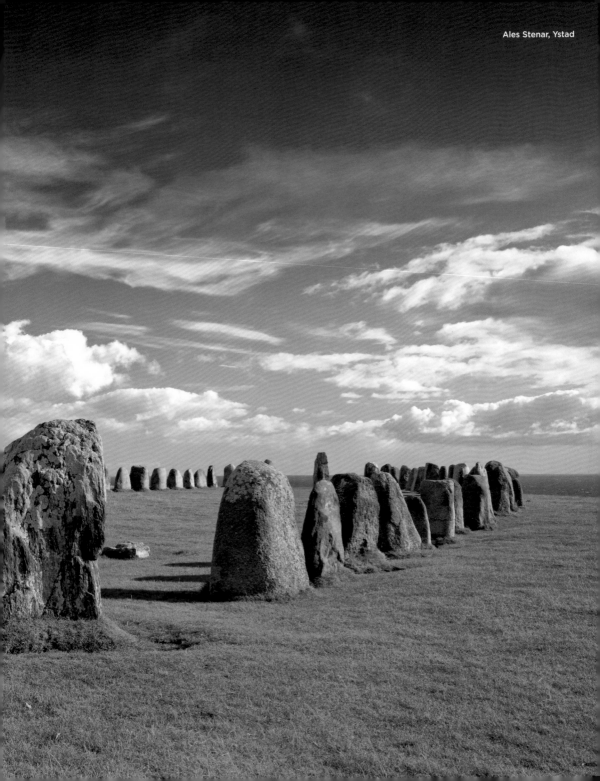

Ales Stenar, Ystad

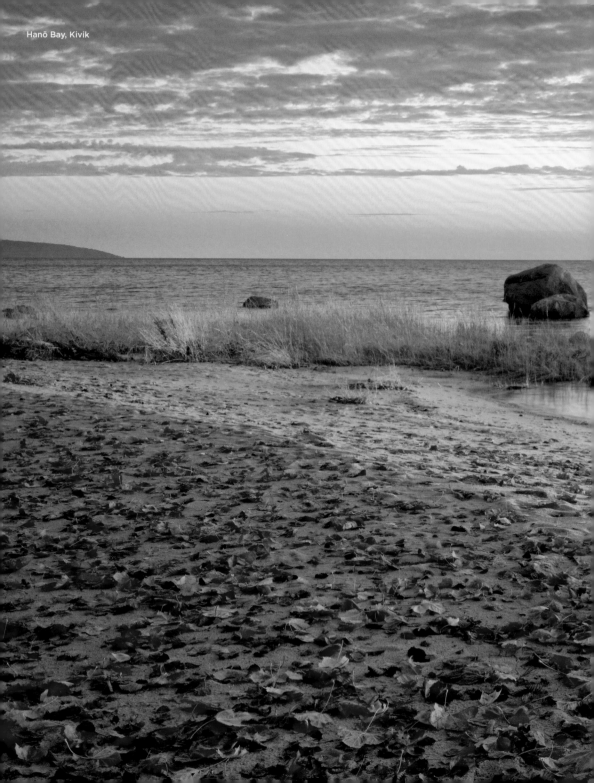
Hanö Bay, Kivik

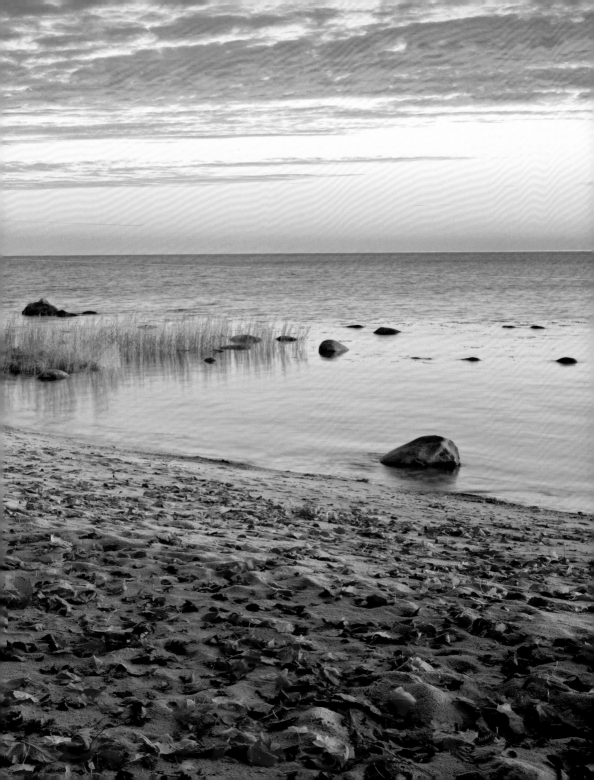

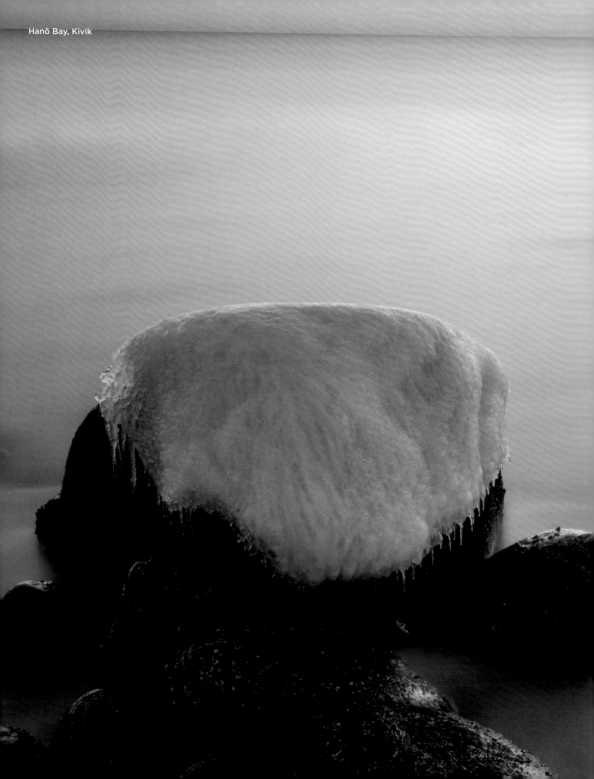

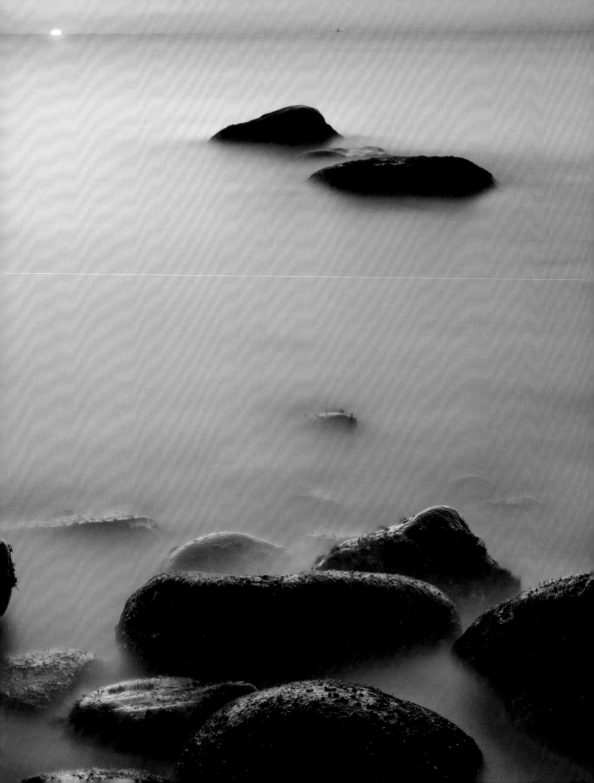

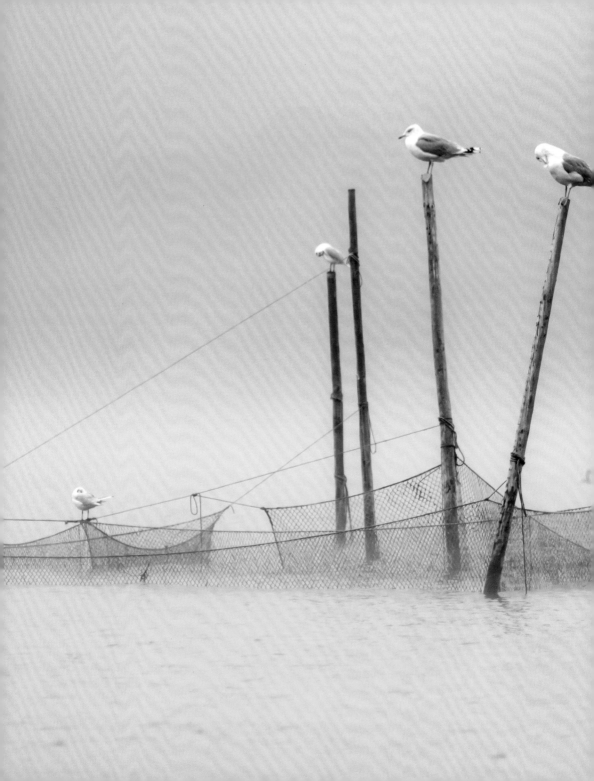

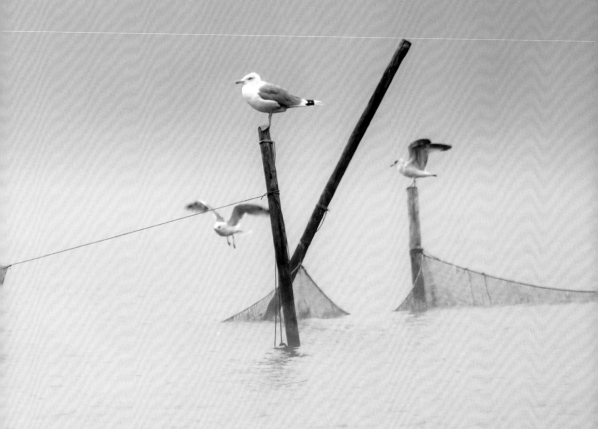

Glimmebodagården Farm near Brösarp

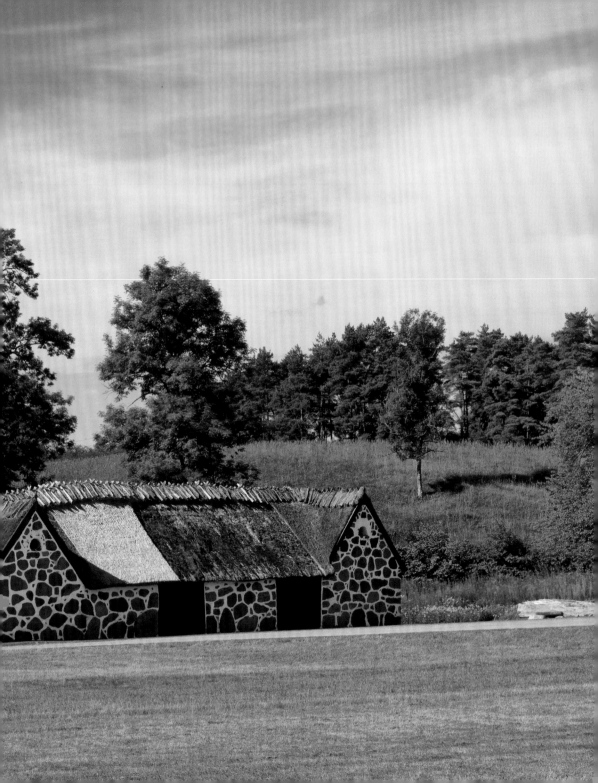

Cuisine

1 Cranberries, Airelles, Arándanos rojos, Cranberry's

2 Donut, Beignets, Krapfen, Berlinesa, Berlinerbollen

3 Lucia roll, Petits pains de la Sainte-Lucie, Luciabrötchen, Bollo de Santa Lucía, O pãozinho de Santa Lucia, Lussekatter (Luciabroodjes)

4 Salmon, Saumon, Lachs, Salmón, Salmão, Zalm

5 Crispbread, Pain croquant, Knäckebrot, Pão crocante, Knäckebröd

6 Surströmming (Sour herring, Hareng saur, Saurer Hering, Arenque fermentado, Zure haring)

7 Blueberries and cloudberries, Myrtilles et plaquebières, Blaubeeren und Moltebeeren, Arándanos azules y camemoros, Os mirtilos e as amoras silvestres, Bosbessen en kruipbramen

8 Princess cake, Gâteau princesse, Prinzessinentorte, Tarta castillo de las hadas, O bolo de princesa, Prinsessentaart

9 Semla

10 Crispbread, Pain croquant, Knäckebrot, Pão crocante, Knäckebröd

11 Smörgåstårta (Sandwich cake, Gâteau sandwich, Butterbrottorte, Tarta de sándwich, Bolo de sanduíche, Boterhamtaart)

12 Cheese, Fromages, Käse, Queso, Queijo, Kaas

13 Kötbullar (Meatballs, Boulettes à la viande, Fleischbällchen, Almôndegas suecas)

14 Mushrooms, Champignons, Pilze, Setas, Cogumelos, Paddenstoelen

15 Cinnamon roll, Viennoiseries à la cannelle, Zimtschnecken, Rollos de canela, Bolo de canela, Kaneelbroodjes

16 Böckling (Smoked herring, Harengs fumés, Geräucherter Hering, Arenque ahumado, Arenque defumado, Gerookte haring)

17 Reindeer sausage, Saucisse de renne, Rentierwurst, Salchicha de reno, Linguiça de rena, Rendierworst

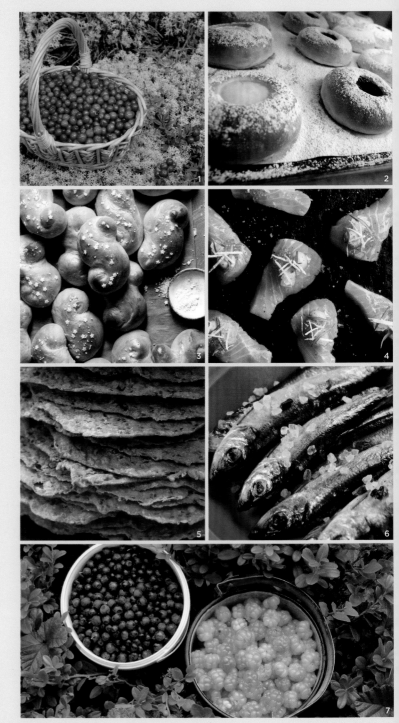

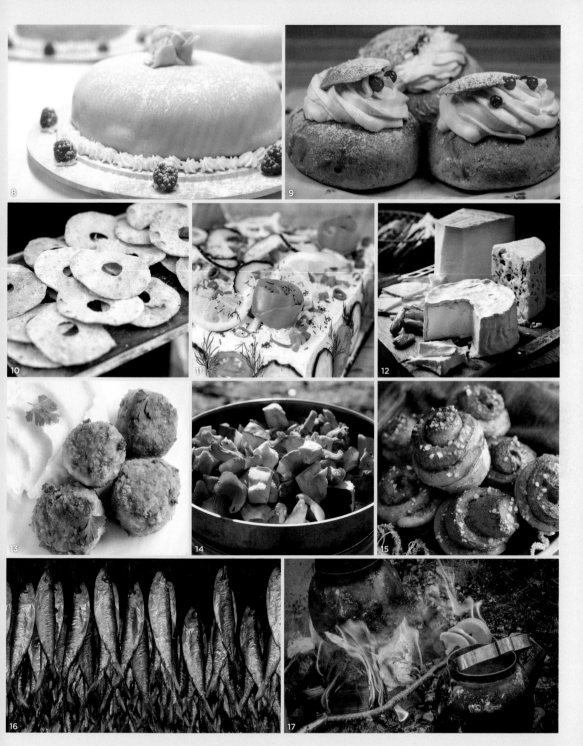

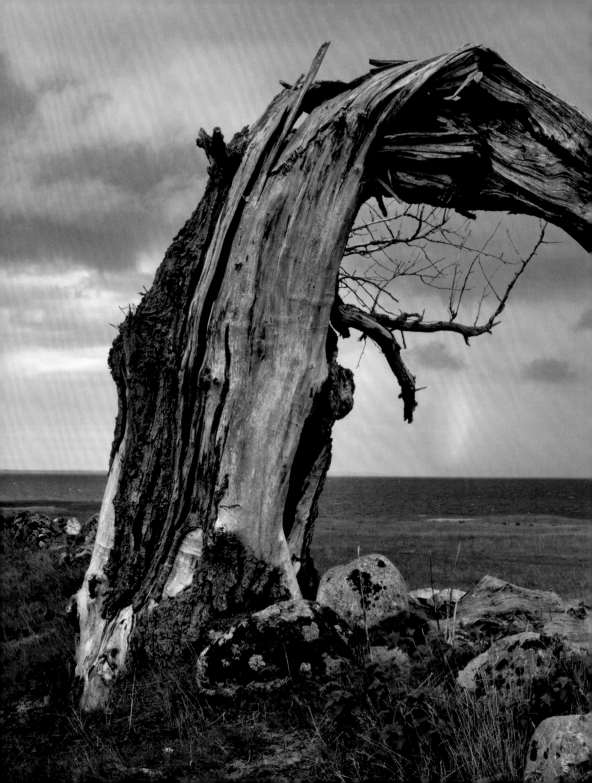

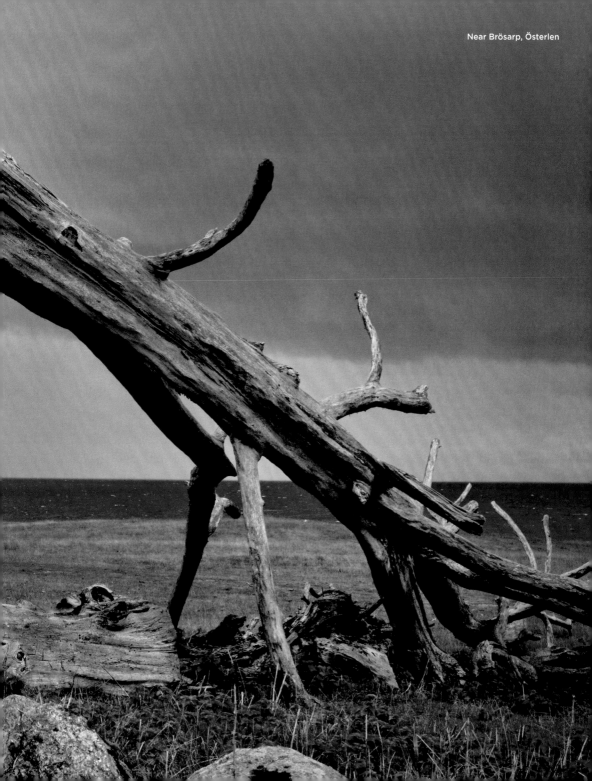

Söderåsen National Park

National Parks

Skåne has several national parks and protected areas with a huge variety of flora and fauna. Söderåsen National Park is a 150 million year old wilderness with cliffs, gorges and untouched forests. The park is home to the largest contiguous protected forest area in Northern Europe, and the so-called "Grand Canyon of Skåne", Skäralid. Stenshuvud National Park on the east coast is characterized by white beaches, and moorland with hornbeams, wild orchids and deciduous forests—a true paradise for birds. By the way: according to legend, giants and trolls live in Stenshuvud.

Les parcs nationaux

Les parcs nationaux et les réserves naturelles de Scanie étonnent par la richesse de leur flore et de leur faune. Dans le parc national de Söderåsen, au milieu d'un paysage façonné il y a 150 millions d'années, les falaises alternent avec les gorges et les forêts primaires. Les randonneurs y découvriront, outre la plus vaste forêt protégée d'Europe du Nord, le « Grand Canyon de Scanie », le Skäralid. Sur la côte est, le parc national de Stenshuvud offre un visage tout autre avec ses plages de sable blanc, ses landes et ses charmes, ses orchidées sauvages et ses forêts de feuillus – bref, le paradis des oiseaux. Il est bon de savoir que, selon la légende, des géants et des trolls vivent à Stenshuvud...

Nationalparks

In Skåne gibt es mehrere Nationalparks und Schutzgebiete mit großer Vielfalt an Flora und Fauna. Im Söderåsen Nationalpark findet man eine 150 Millionen Jahre alte Wildnis mit Klippen, Schluchten und unberührten Wäldern. Zum Nationalpark gehört neben dem größten zusammenhängenden naturgeschützten Waldgebiet Nordeuropas auch der so genannte „Grand Canyon von Skåne", Skäralid. Der an der Ostküste liegende Nationalpark Stenshuvud hingegen ist geprägt von weißen Stränden, einer Heidelandschaft mit Hainbuchen, wilden Orchideen und Laubwäldern – für Vögel ein wahres Paradies. Übrigens: In Stenshuvud sollen der Sage nach Riesen und Trolle wohnen.

Stenshuvud National Park

Parques nacionales

Skåne tiene varios parques nacionales y áreas protegidas con una gran variedad de flora y fauna. El Parque Nacional de Söderåsen tiene 150 millones de años de antigüedad y está rodeado de acantilados, barrancos y bosques vírgenes. El parque nacional alberga la mayor área forestal protegida unida del norte de Europa y el llamado "Gran Cañón de Skåne", Skäralid. En cambio, el Parque Nacional de Stenshuvud, en la costa este, se caracteriza por sus playas de arena blanca, un brezal con carpes, orquídeas salvajes y bosques de hoja caduca: un verdadero paraíso para las aves. A propósito: según la leyenda, en Stenshuvud viven gigantes y trolls.

Parques nacionais

Em Skåne existem vários parques nacionais e áreas protegidas com uma grande variedade de flora e fauna. O Parque Nacional de Söderåsen é uma região selvagem com 150 milhões de anos, com falésias, desfiladeiros e florestas intocadas. Além da maior área florestal protegida contígua do norte da Europa, o parque nacional também inclui o chamado "Grand Canyon of Skåne", Skäralid. O National Park Stenshuvud, na costa leste, é caracterizado por praias de areais brancas, uma paisagem de urzes com carpinos , orquídeas selvagens eflorestas caducifólias – um verdadeiro paraíso para pássaros. A propósito: segundo a lenda, gigantes e trols vivem em Stenshuvud.

Nationale parken

Skåne heeft meerdere nationale parken en beschermde natuurgebieden met een grote biodiversiteit. Nationaal park Söderåsen is een 150 miljoen jaar oude wildernis met klippen, ravijnen en ongerepte bossen. Tot het nationale park behoort niet alleen het grootste aaneengesloten beschermde bosgebied van Noord-Europa, maar ook de zogenaamde 'Grand Canyon van Skåne', Skäralid. Het nationale park Stenshuvud aan de oostkust wordt daarentegen gekenmerkt door witte stranden, heidelandschap met haagbeuken, wilde orchideeën en loofbossen – een paradijs voor vogels. Trouwens: naar verluidt wonen er in Stenshuvud reuzen en trollen.

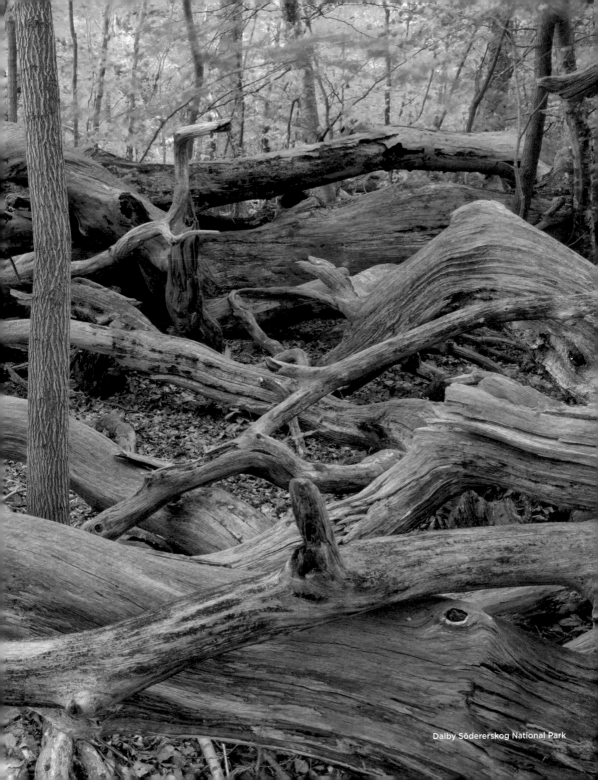

Dalby Södererskog National Park

Söderåsen National Park

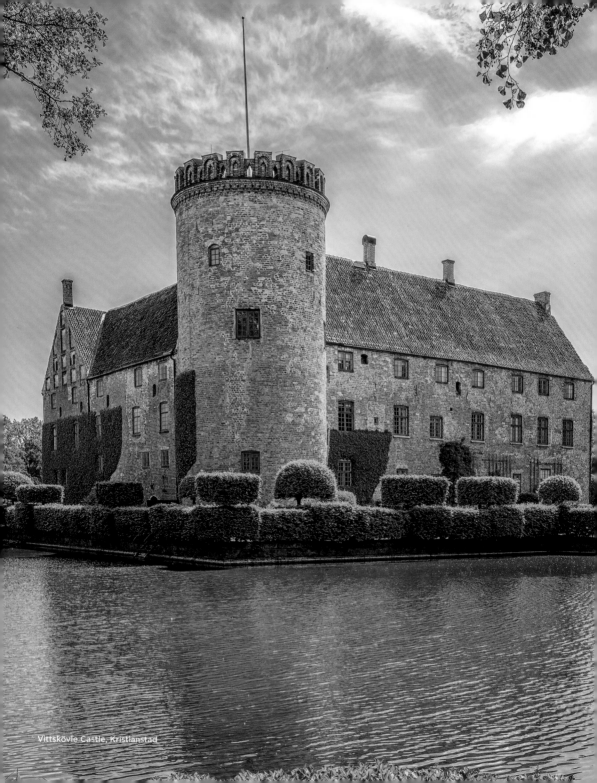

Vittskövle Castle, Kristianstad

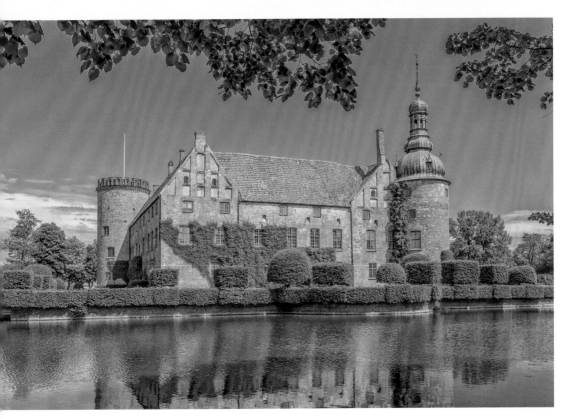

Vittskövle Castle, Kristianstad

Vittskövle Castle

One of Sweden's best preserved Renaissance castles can be found south of Kristianstad. The castle, surrounded by a moat, was built around 1550. The thick walls of the castle evoke tales of war and peace, and inspire us to create fantastic fairy tales. The beautiful castle gardens around Vittskövle were laid out during the 18th century.

Castillo de Vittskövle

Al sur de Kristianstad se encuentra uno de los castillos renacentistas mejor conservados de Suecia. El castillo, rodeado de un foso, fue construido alrededor de 1550. Los gruesos muros del castillo nos dan una idea de las historias de guerra y la paz, y nos inspiran para crear fantásticos cuentos de hadas. Los hermosos jardines del castillo alrededor de Vittskövle no se construyeron hasta el siglo XVIII.

Le château de Vittskövle

Au sud de Kristianstad se dresse l'un des châteaux Renaissance les mieux conservés de Suède. Construit vers 1550, il est entouré de douves. Ses murailles épaisses, révélatrices d'une histoire faite de guerres et de paix, ont inspiré des contes fantastiques. Les jardins magnifiques qui entourent Vittskövle ont été aménagés au XVIIIᵉ siècle.

Castelo de Vittskövle

A sul de Kristianstad encontra-se um dos castelos renascentistas mais bem preservados da Suécia. O castelo, cercado por um fosso, foi construído por volta de 1550. As paredes espessas do castelo dão-nos um vislumbre de guerra e paz e inspiram-nos a criar fantásticos contos de fadas. Os belos jardins do castelo em torno de Vittskövle só foram criados no século XVIII.

Schloss Vittskövle

Südlich von Kristianstad liegt eines der besterhaltenen Renaissanceschlösser Schwedens. Die von einem Wassergraben umgebene Burg wurde um 1550 erbaut. Ihre dicken Mauern lassen Geschichten von Krieg und Frieden erahnen und regen zu fantastischen Märchen an. Die wunderschönen Schlossgärten um Vittskövle wurden erst im 18. Jahrhundert angelegt.

Kasteel Vittskövle

Ten zuiden van Kristianstad ligt een van de best bewaarde renaissancekastelen van Zweden. Het door een slotgracht omgeven kasteel werd rond 1550 gebouwd. De dikke muren roepen gedachten op aan oorlog en vrede en inspireren tot fantastische sprookjes. De prachtige kasteeltuinen rond Vittskövle werden pas in de 18e eeuw aangelegd.

Beech wood, Kristianstad

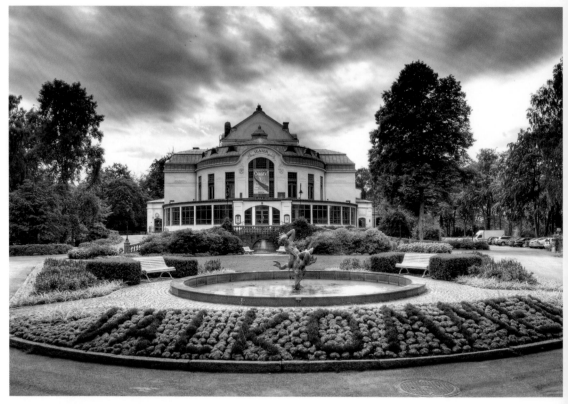

Theatre, Kristianstad

Theatre of Kristianstad

This theatre, built in Art Nouveau style, is one of the oldest still used in the country. It is situated in the middle of Tivoli Park, and was opened in 1906. It was designed by the Swedish architect Axel Anderberg, who also designed the National Opera and the Oscars Theatre in Stockholm. Also worth seeing inside is the ceiling fresco by the painter Nils Asplund.

Teatro de Kristianstad

El teatro, construido en estilo Art Nouveau, es uno de los más antiguos que aún se utilizan en el país. Está situado en el centro del Parque Tivoli y fue inaugurado en 1906. Fue diseñado por el arquitecto sueco Axel Anderberg, que también diseñó la Ópera Nacional y el Teatro de los Oscar de Estocolmo. Algo que también vale la pena ver en el interior es la pintura del techo por el pintor Nils Asplund.

Le théâtre de Kristianstad

Ce théâtre de style Art nouveau est l'un des plus anciens de Suède encore en activité. Situé au milieu du parc de Tivoli, il a été inauguré en 1906. Il est l'œuvre de l'architecte suédois Axel Anderberg, à qui l'on doit également l'Opéra national et le théâtre Oscars à Stockholm. Le plafond peint par Nils Asplund est à ne pas manquer.

Teatro de Kristianstad

O teatro, construído em estilo Art Nouveau, é um dos mais antigos ainda utilizados no país. Ele está situado no meio do Parque Tivoli e foi inaugurado em 1906. Foi projetado pelo arquiteto sueco Axel Anderberg, que também projetou a Ópera Nacional e o Teatro Oscar em Estocolmo. Vale a pena ver também a pintura do teto no interior do pintor Nils Asplund.

Theater von Kristianstad

Das im Jugendstil erbaute Theater ist eines der ältesten noch genutzten des Landes. Es liegt inmitten des Tivoli-Parks und wurde 1906 eingeweiht. Entworfen hat es der schwedische Architekt Axel Anderberg, der auch die Nationaloper und das Oscars-Theater in Stockholm konzipiert hat. Sehenswert im Inneren ist auch das Deckengemälde des Malers Nils Asplund.

Theater van Kristianstad

Het in art-nouveaustijl gebouwde theater is een van de oudste nog gebruikte theaters van het land. Het staat midden in het Tivolipark en werd in 1906 ingewijd. Het werd ontworpen door de Zweedse architect Axel Anderberg, die ook de Nationale Opera en het Oscarsteatern in Stockholm ontwierp. Binnen is de plafondschildering van de schilder Nils Asplund ook de moeite van het bekijken waard.

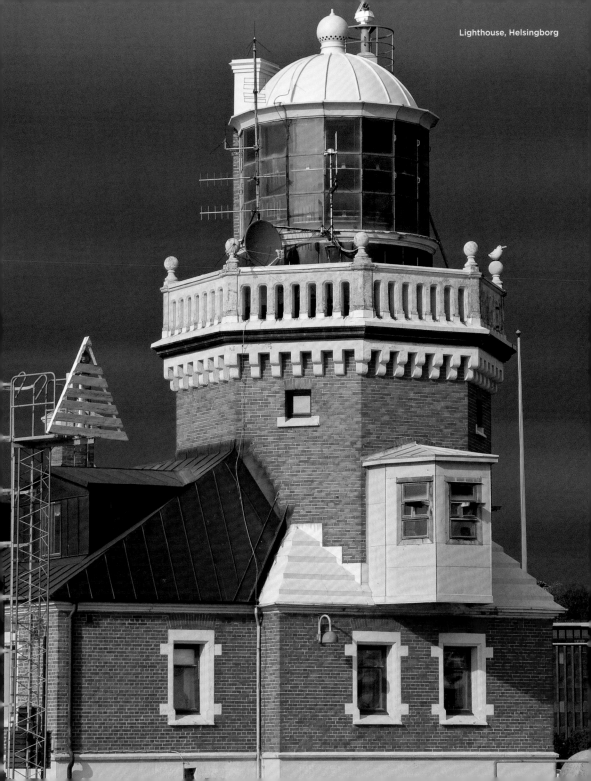
Lighthouse, Helsingborg

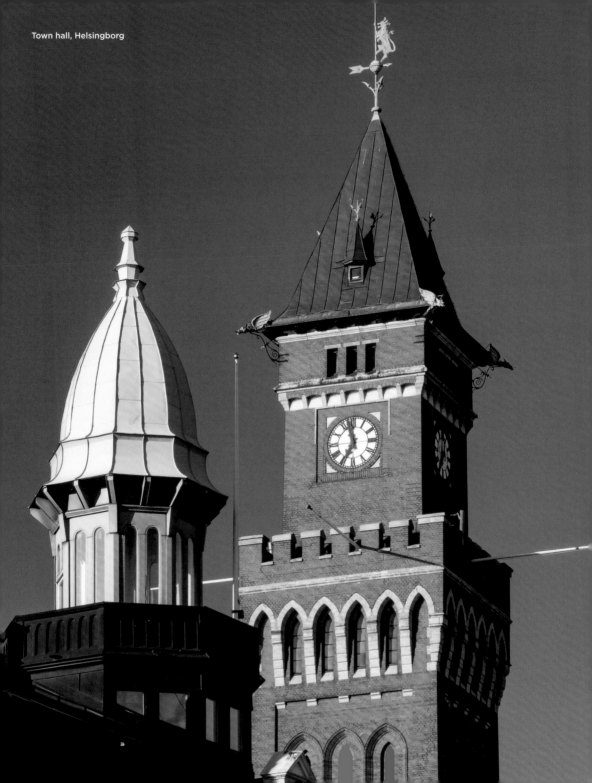

Town hall, Helsingborg

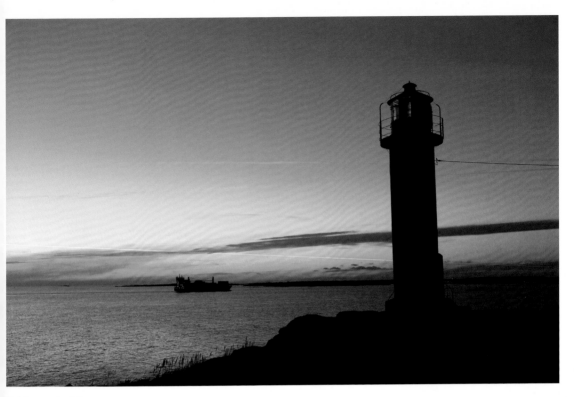

Lighthouse, Apelviken

Helsingborg

Due to its location, this port city is regarded as the "gateway to Sweden". Less than 5 km of sea separate Helsingborg from the Danish mainland, so for locals it is the "gateway to continental Europe". The city's landmark, the Town Hall, represents an up-and-coming and growing Helsingborg. Its soaring tower dominates the skyline, and is the first image of Sweden for many travelers.

Helsingborg

Debido a su ubicación, la ciudad portuaria es considerada como la "puerta de entrada a Suecia". Menos de 5 km de mar separan Helsingborg del continente danés. Para los nativos es, por lo tanto, la "puerta de entrada a la Europa continental". El lugar emblemático de la ciudad, el ayuntamiento, es sinónimo de un Helsingborg prometedor y en crecimiento. Su imponente torre domina el horizonte y es la primera imagen de Suecia para muchos viajeros.

Helsingborg

Sa situation a valu à cette ville portuaire le surnom de « porte de la Suède ». Moins de cinq kilomètres de mer séparent Helsingborg du Danemark et du continent. Ses habitants la considèrent donc comme la « porte de l'Europe continentale ». Son édifice le plus marquant, l'hôtel de ville, symbolise son ambition et sa prospérité. Sa tour élevée, qui domine la silhouette générale de la ville, est souvent la première image que les voyageurs ont de la Suède.

Helsingborg

Devido à sua localização, a cidade portuária é considerada a "porta de entrada para a Suécia". Menos de 5 km de mar separam Helsingborg do continente dinamarquês. Para os habitantes locais é, portanto, a "porta de entrada para a Europa continental". O ponto de referência da cidade, a prefeitura, representa um Helsingborg em ascensão e em crescimento. Sua torre imponente domina o horizonte e é a primeira imagem da Suécia para muitos viajantes.

Helsingborg

Die Hafenstadt gilt aufgrund ihrer Lage als „Tor nach Schweden". Weniger als 5 km Meer trennen Helsingborg vom dänischen Festland. Für Einheimische ist sie deswegen das „Tor zu Kontinentaleuropa". Das Wahrzeichen der Stadt, das Rathaus, steht für ein aufstrebendes und wachsendes Helsingborg. Sein hoch aufragender Turm prägt die Skyline und ist für manche Reisende das erste Bild von Schweden.

Helsingborg

Vanwege de ligging wordt de havenstad beschouwd als de 'poort naar Zweden'. Minder dan 5 km zee scheidt Helsingborg van het Deense vasteland. Voor de autochtone bevolking is het dus de 'poort naar het Europese vasteland'. Het herkenningsteken van de stad, het stadhuis, staat voor een opkomend en groeiend Helsingborg. De toren torent boven de skyline uit en is voor veel reizigers het eerste wat ze van Zweden zien.

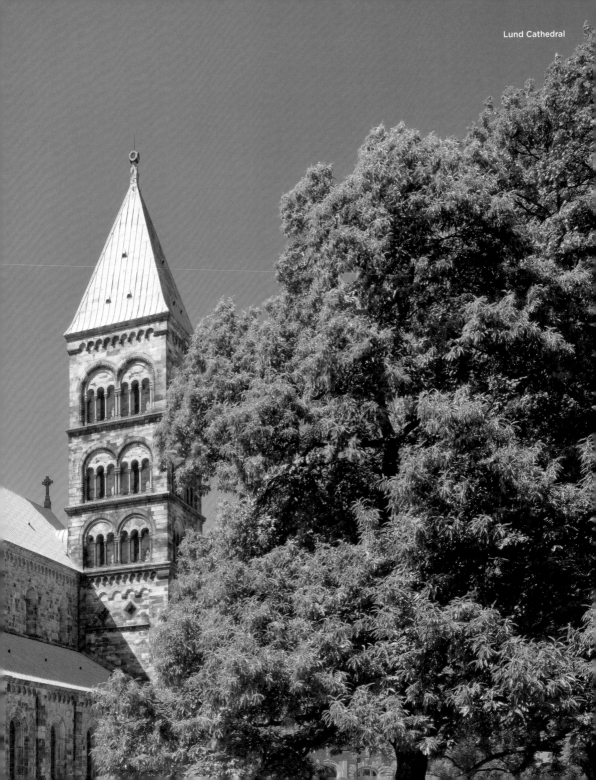
Lund Cathedral

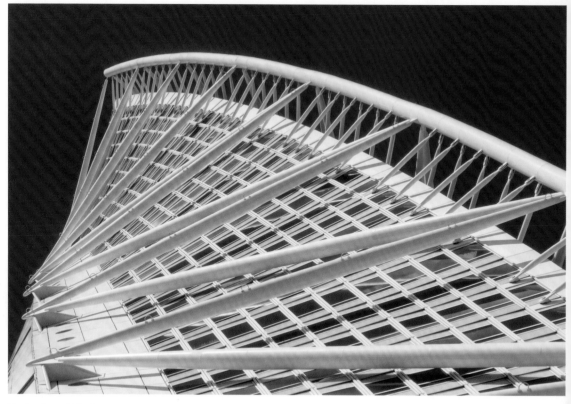

Turning Torso, Malmö

Turning Torso

With a height of 190 m (623 ft) and 54 floors, this landmark of Malmö's Västra Hamnen district is the highest building in Scandinavia. Inspired by deconstructivism, the Spanish artist and architect Santiago Calatrava Valls designed the skyscraper. The concrete-steel construction consists of cube-shaped building parts that move slightly in the wind.

Turning Torso

Con una altura de 190 m y 54 pisos, este símbolo del distrito Västra Hamnen de Malmö es el edificio más alto de Escandinavia. El artista y arquitecto español Santiago Calatrava Valls diseñó el rascacielos inspirado en el deconstructivismo. La construcción de hormigón-acero consiste en piezas de construcción en forma de cubo que se mueven muy poco, incluso con el viento.

Turning Torso

Cette tour de 190 m de hauteur et de 54 étages est le phare du quartier de Västra Hamnen, à Malmö, et l'édifice le plus élevé de Scandinavie. L'artiste et architecte espagnol Santiago Calatrava Valls a signé ce gratte-ciel d'inspiration déconstructiviste. Sa structure, fondée sur des cubes de béton et acier lui donnant une forme torsadée, est conçue pour résister aux vents.

Torso giratório

Com uma altura de 190 m e 54 andares, o marco do distrito de Västra Hamnen em Malmö é o edifício mais alto da Escandinávia. O artista e arquiteto espanhol Santiago Calatrava Valls projetou o arranha-céu inspirado no desconstrutivismo. A construção em aço-concreto é constituída por elementos de construção em forma de cubo que se movimentam um pouco de acordo com as condições do vento.

Turning Torso

Mit 190 m Höhe und 54 Etagen ist das Wahrzeichen von Malmös Stadtteil Västra Hamnen das höchste Gebäude Skandinaviens. Der spanische Künstler und Architekt Santiago Calatrava Valls entwarf den vom Dekonstruktivismus inspirierten Wolkenkratzer. Die Beton-Stahl-Konstruktion besteht aus würfelförmigen Gebäudeteilen, die sich auch bei Wind nur wenig bewegen.

Turning Torso

Met een hoogte van 190 meter en 54 verdiepingen is het herkenningspunt van de wijk Västra Hamnen in Malmö het hoogste gebouw van Scandinavië. De Spaanse kunstenaar en architect Santiago Calatrava Valls ontwierp deze deconstructivistische wolkenkrabber. De constructie van beton en staal bestaat uit kubusvormige bouwdelen die zelfs in de wind nauwelijks bewegen.

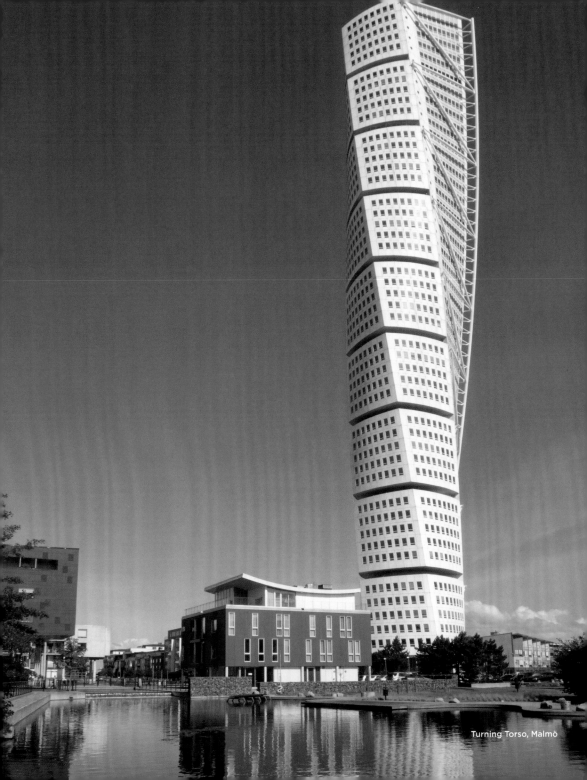

Turning Torso, Malmö

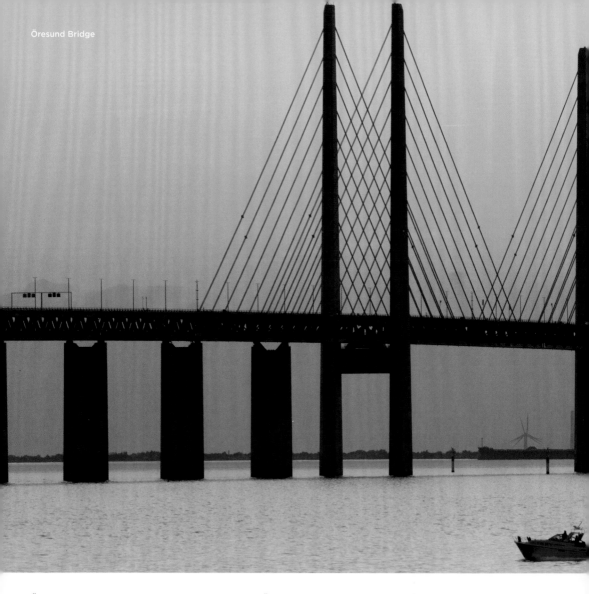

Öresund Bridge

Since 2000 the 7.8 km (4,8 mi) "Öresundsbron" has connected Sweden with Denmark. With its four 206 m (676 ft) high pylons of reinforced concrete, it is the world's largest cable-stayed bridge for road and rail traffic. This impressive construction is of great economic and cultural importance for the entire Öresund region. The construction of the bridge took four and a half years.

Le pont d'Öresund

Depuis 2000, l'Öresundsbron relie la Suède au Danemark sur une longueur de 7,8 km. Avec ses pylônes en béton armé hauts de 206 m, c'est le plus grand pont à haubans du monde où circulent aussi bien des trains que des automobiles. Cet ouvrage d'art hors normes revêt une importance considérable, tant économique que culturelle, pour toute la région de l'Öresund. Sa construction a duré quatre ans et demi.

Öresundbrücke

Seit 2000 verbindet die insgesamt 7,8 km lange „Öresundsbron" Schweden mit Dänemark. Mit ihren vier 206 m hohen Pylonen aus Stahlbeton ist sie die weltgrößte Schrägseilbrücke für Straßen- und Eisenbahnverkehr. Die beeindruckende Konstruktion ist sowohl wirtschaftlich als auch kulturell für die gesamte Öresundregion von großer Bedeutung. Der Bau der Brücke dauerte viereinhalb Jahre.

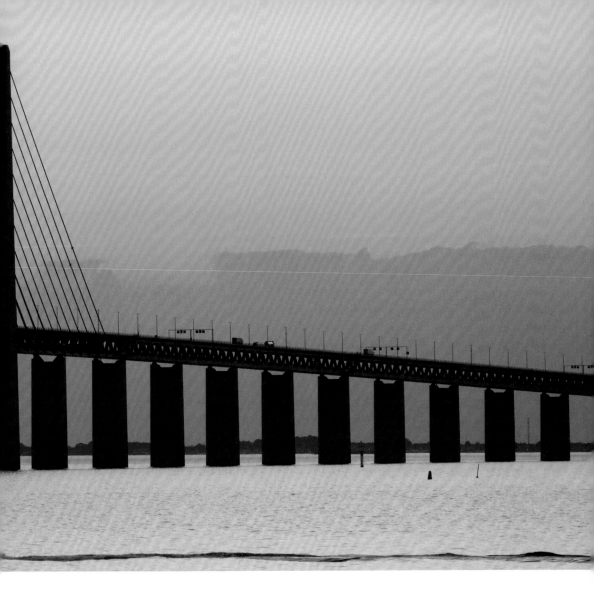

Puente de Öresund

Desde el año 2000, los 7,8 km de "Öresundsbron" conectan Suecia con Dinamarca. Con sus cuatro pilones de hormigón armado de 206 m de altura, es el puente atirantado más grande del mundo para el tráfico por carretera y ferrocarril. La impresionante construcción tiene una gran importancia económica y cultural para toda la región de Öresund. La construcción del puente duró cuatro años y medio.

Ponte Öresund

Desde 2000, o "Öresundsbron" de 7,8 km liga a Suécia à Dinamarca. Com seus quatro pilares de concreto armado de 206 m de altura, é a maior ponte suspensa por cabos do mundo para tráfego rodoviário e ferroviário. A construção impressionante é de grande importância económica e cultural para toda a região de Öresund. A construção da ponte levou quatro anos e meio.

Öresundbrug

Sinds 2000 verbindt de 7,8 km lange 'Öresundsbron' Zweden met Denemarken. Met zijn vier pylonen van 206 meter hoog, gemaakt van gewapend beton, is hij de grootste kabelbrug voor weg- en spoorverkeer ter wereld. De indrukwekkende constructie is van groot economisch en cultureel belang voor de hele Öresundregio. De bouw van de brug duurde vierenhalf jaar.

Småland

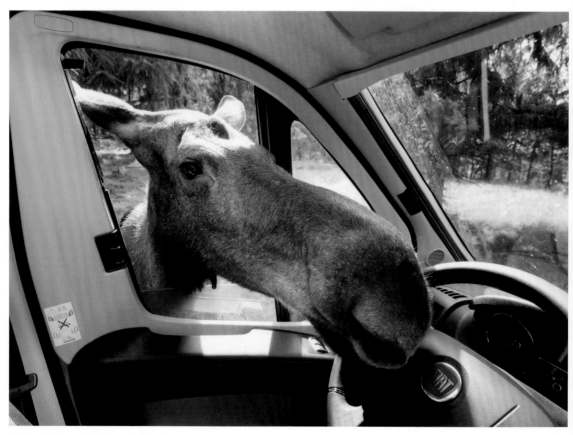

Smålandet Moose Safari, near Markaryd

Småland

Free-range moose are as much a part of the landscape as moss-covered forests, extensive landscapes, idyllic villages, blue lakes, flower meadows, fields and heaths, waterfalls, and last but not least red wooden houses – Småland embodies the typical image of Sweden, and is also considered to be the "most rustic" of the southern regions. There are many national parks, and arts and crafts and design thrive here—Småland is the cradle of the furniture manufacturer IKEA and also the "Kingdom of Crystal" with its impressive glassworks—and the province is the home of Astrid Lindgren and is the scene of most of her enchanting stories.

Le Småland

Les élans en liberté et les forêts tapissées de mousse, les paysages sans fin, les villages de contes de fées, les lacs azur, les champs et les landes, les cascades et bien sûr les maisonnettes rouges en bois font du Småland une région typiquement suédoise et, dans le Sud, celle qui se révèle être la plus authentique. Les parcs nationaux sont légion, l'artisanat et le design prospèrent. Le Småland possède des verreries très réputées, mais est également le berceau d'Ikea – et cette province est aussi bien le pays natal d'Astrid Lindgren que le lieu de la plupart de ses histoires captivantes.

Småland

Freilaufende Elche gehören ebenso zum Landschaftsbild wie moosbewachsene Wälder, weitläufige Landschaften, idyllische Dörfer, blaue Seen, Blumenwiesen, Felder und Heiden, Wasserfälle und nicht zuletzt rote Holzhäuschen – Småland vereint das typische Bild Schwedens und gilt zudem als die „urigste" der südlichen Regionen. Hier gibt es viele Nationalparks, Kunsthandwerk und Design gedeihen – neben dem Glasreich mit beeindruckenden Glashütten ist Småland auch die Wiege des Möbelherstellers IKEA – und die Provinz ist sowohl die Heimat Astrid Lindgrens als auch meist Schauplatz ihrer bezaubernden Geschichten.

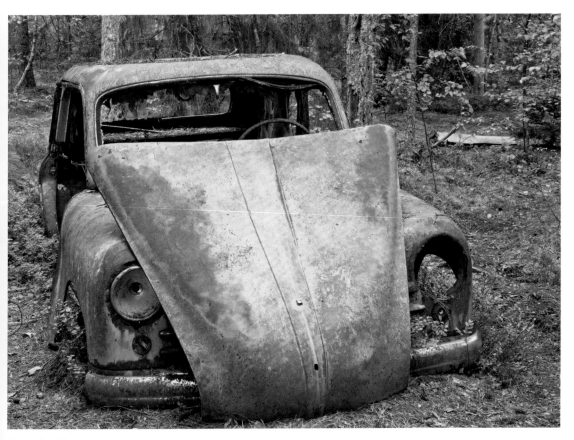

Carwreck, Kyrkö Mosse

Småland

El alce común forma parte del paisaje tanto como los bosques cubiertos de musgo, los extensos paisajes, los pueblos idílicos, los lagos azules, los prados de flores, los campos y brezales, las cascadas y, por último, pero no por ello menos importante, las casas de madera de color rojo. Hay muchos parques nacionales, artesanías y diseño que prosperan aquí; Småland es la cuna del fabricante de muebles IKEA, además del reino del vidrio con sus impresionantes cristalerías, y la provincia es a la vez el hogar de Astrid Lindgren y la escena de sus encantadoras historias.

Småland

Os alces, que vivem ao ar livre, fazem parte tanto da paisagem como das florestas cobertas de musgo, as paisagens extensas, as aldeias idílicas, os lagos azuis, os prados florais, os campos e charnecas, as cascatas e, por último, as casas de madeira vermelhas – Småland unifica a imagem típica da Suécia e é também considerada a "mais rústica" das regiões meridionais. Há muitos parques nacionais, artes e o artesanato e o design prosperam aqui – Småland é o berço do fabricante de mobiliário IKEA, para além do reino do vidro com as suas impressionantes vidrarias – e a província é a casa de Astrid Lindgren e sobretudo o cenário da maioria das suas encantadoras histórias.

Småland

Vrij rondlopende elanden maken evenzeer deel uit van het landschapsbeeld als met mos bedekte bossen, uitgestrekte landschappen, idyllische dorpjes, blauwe meren, bloemenweiden, akkers en heidevelden, watervallen en, niet in de laatste plaats, rode houten huizen. Småland verenigt het typische beeld van Zweden en wordt ook beschouwd als de meest authentieke van de zuidelijke regio's. Hier zijn veel nationale parken en bloeien kunstnijverheid en design. Småland is naast 'glasrijk' (glasriket) met indrukwekkende glasblazerijen de bakermat van de meubelgigant IKEA. De provincie is zowel de geboortegrond van Astrid Lindgren als ook vaak het toneel van haar betoverende verhalen.

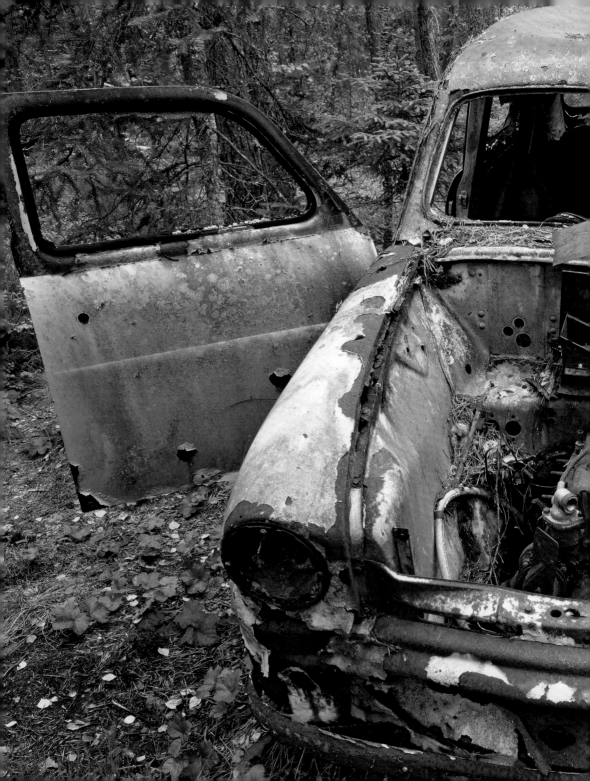

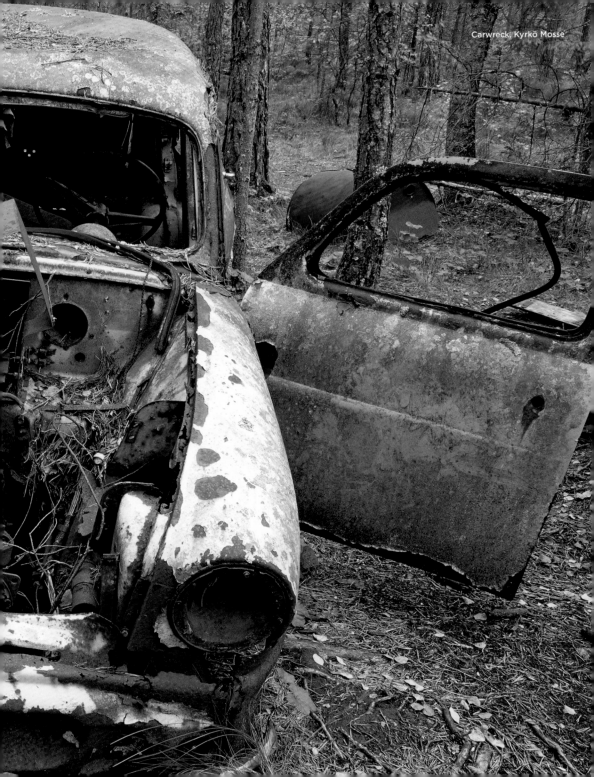

Markaryd forest

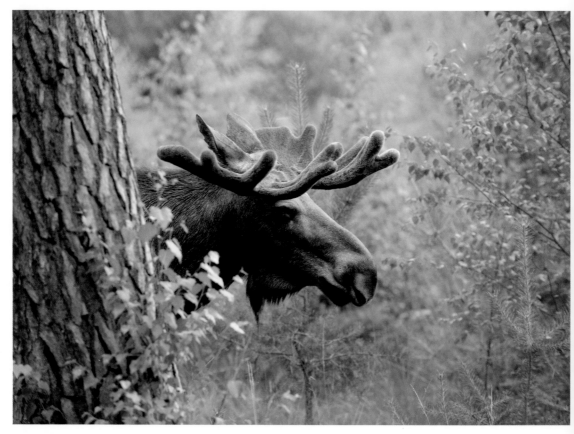

European moose

Moose

In the dark and damp forests of Småland lives the so-called "king of the forests". This shy creature with thin legs and a long head is regarded as Sweden's unofficial emblem. In the wild, this creature that can weigh up to 800 kg (1764 lb) is rarely seen—during the day, moose hide in the undergrowth and only become active at dusk. Nevertheless, the many specially created moose parks make it possible to view them in close proximity. In most parks the moose live in enclosures or in fenced forest areas—on "moose safaris" you can feed and sometimes stroke the animals.

L'élan

Le « roi des forêts » hante les bois sombres et humides du Småland. Cette créature farouche aux pattes fines et à la tête allongée est l'emblème officieux de la Suède. Dans la nature, cet animal pouvant peser jusqu'à 800 kg se laisse rarement voir de jour, il se cache dans les sous-bois et ne s'active qu'à la tombée de la nuit. On peut tout de même s'en approcher dans l'un des nombreux parcs dédiés à cet effet. Là, ils vivent dans des enclos ou des forêts clôturées et des visites sont organisées de temps à autre, offrant aux visiteurs l'occasion de les nourrir et de les caresser.

Der Elch

In den dunklen und feuchten Wäldern Smålands lebt der sogenannte „König der Wälder". Das scheue Wesen mit den dünnen Beinen und dem langen Kopf gilt als inoffizielles Wappentier Schwedens. In freier Wildbahn ist das bis zu 800 kg schwere Geschöpf nur selten zu sehen – tagsüber versteckt sich der Elch im Unterholz und wird erst mit der Dämmerung aktiv. Dennoch machen es die vielen eigens angelegten Elchparks möglich, ihm ganz nah zu sein. In den meisten Parks leben die Elche in angelegten Gehegen oder in eingezäunten Waldgebieten – auf „Elchsafaris" kann man die Tiere füttern und manchmal auch streicheln.

Snail

El alce

En los bosques oscuros y húmedos de Småland vive el llamado "rey de los bosques". La tímida criatura de piernas delgadas y cabeza larga se considera el animal heráldico no oficial de Suecia. En la naturaleza, la criatura de hasta 800 kg de peso se ve con muy poca frecuencia (durante el día, el alce se esconde en el sotobosque y solo se vuelve activo al atardecer). Sin embargo, los numerosos parques de alces especialmente creados permiten estar muy cerca de ellos. En la mayoría de los parques, los alces viven en recintos o en áreas de bosque cercadas; en los "safaris de alces" se puede alimentar y a veces acariciar a los animales.

O alce

Nas florestas escuras e húmidas de Småland vive o chamado "rei das florestas". A criatura tímida com pernas finas e cabeça longa é considerada o animal heráldico não oficial da Suécia. Na natureza, a criatura que pode pesar até 800 kg é raramente vista – durante o dia, o alce esconde-se na vegetação rasteira e só se torna ativo ao anoitecer. No entanto, os muitos parques de alces especialmente criados tornam possível estar próximo deles. Na maioria dos parques, os alces vivem em recintos ou em áreas florestais vedadas – nos "safáris dos alces" você pode alimentar e, por vezes, acariciar os animais.

De eland

In de donkere en vochtige bossen van Småland leeft de zogenaamde koning van de bossen. Het schuwe wezen met zijn dunne poten en lange kop wordt gezien als het onofficiële wapendier van Zweden. In het wild zal je het 800 kilo zware dier zelden tegenkomen – overdag verstopt de eland zich in het kreupelhout en pas bij het vallen van de avond wordt hij actief. Toch maken de vele speciaal aangelegde elandparken het mogelijk ze van heel dichtbij te zien. In de meeste parken leven de elanden in omheiningen of omheinde bosgebieden. Op elandsafari's kun je de dieren voeren en soms ook aaien.

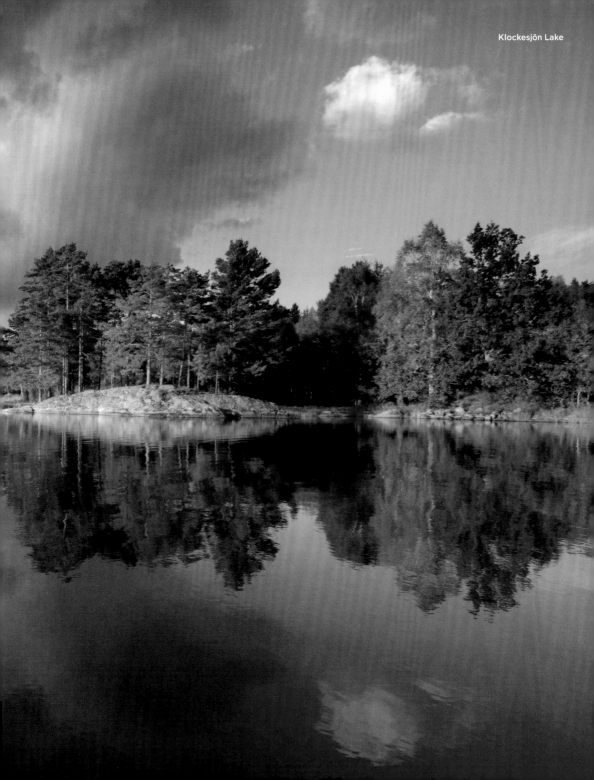
Klockesjön Lake

Farmhouse, Sävsjö

Swedish Houses

These attractive small houses with their colorfully painted wooden facades are characteristic of Sweden. They are mostly painted in Falun red, which provides particularly good weather protection, but light yellow, blue and green are also popular. The white windows, roofed entrance, lovingly painted shutters, colorful flowers and the Swedish flag contribute to the characteristic picturesque charm.

Les maisons suédoises

Les jolies maisons aux façades en bois peintes de couleurs vives sont on ne peut plus suédoises. Quasi omniprésent, le rouge de Falun protège particulièrement bien contre les intempéries. Le jaune clair, le bleu et le vert ont aussi leurs amateurs. Le charme et le pittoresque du pays tiennent aux fenêtres blanches, aux entrées surmontées d'un auvent, aux volets peints avec amour, aux fleurs multicolores et au drapeau suédois.

Schwedenhäuser

Typisch schwedisch sind die attraktiven Häuschen mit ihren bunt angestrichenen Holzfassaden – meist in Falunrot, das besonders gut vor Witterung schützt. Aber auch helles Gelb, Blau und Grün sind beliebt. Die weißen Fenster, ein überdachter Hauseingang, liebevoll bemalte Fensterläden, bunte Blumen und die Schwedenflagge tragen zum charakteristisch malerischen Charme des Landes bei.

Casas suecas

Las atractivas casas de campo con sus fachadas de madera pintadas de colores son típicamente suecas, en su mayoría de color rojo Falun, que ofrece una protección especialmente buena contra la intemperie. Pero el amarillo claro, el azul y el verde también son populares. Las ventanas blancas, la entrada a la casa techada, las persianas pintadas con mucho cariño, las flores de colores y la bandera sueca contribuyen al pintoresco encanto característico del país.

Casas suecas

As atraentes casas de campo com as suas fachadas de madeira pintadas com tinta colorida são tipicamente suecas – principalmente em pigmento vermelho, recuperado na mina de cobre de Falun, o que proporciona uma proteção climática particularmente boa. Mas amarelo claro, azul e verde também são populares. As janelas brancas, a entrada coberta, as venezianas pintadas com amor, as flores coloridas e a bandeira sueca contribuem para o charme pitoresco característico do país.

Zweedse huizen

De aantrekkelijke huizen met hun kleurig geschilderde houten gevels – meestal in falurood – zijn typisch Zweeds. Rood beschermt extra goed bij onweer. Maar ook lichtgeel, lichtblauw en lichtgroen zijn populair. De witte kozijnen, een overdekte ingang, liefdevol geschilderde luiken, kleurige bloemen en de Zweedse vlag dragen bij aan de karakteristieke schilderachtige charme van het land.

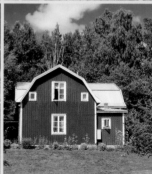
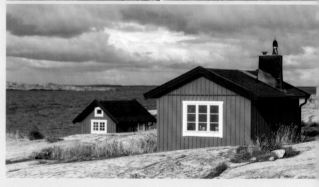

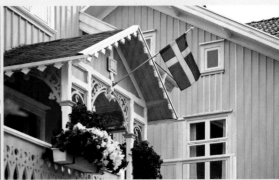

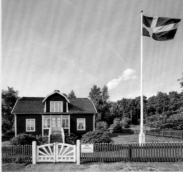
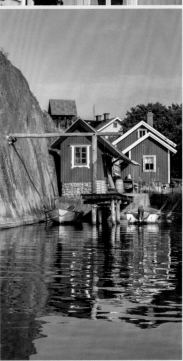

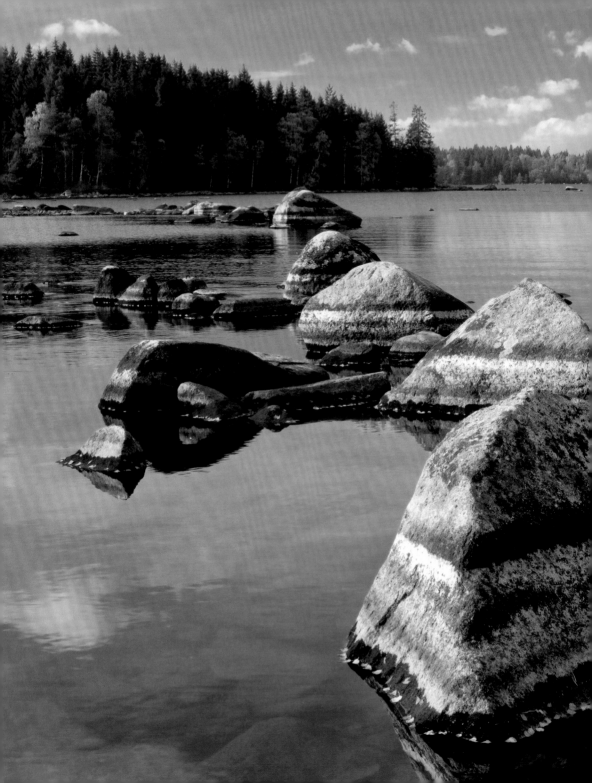

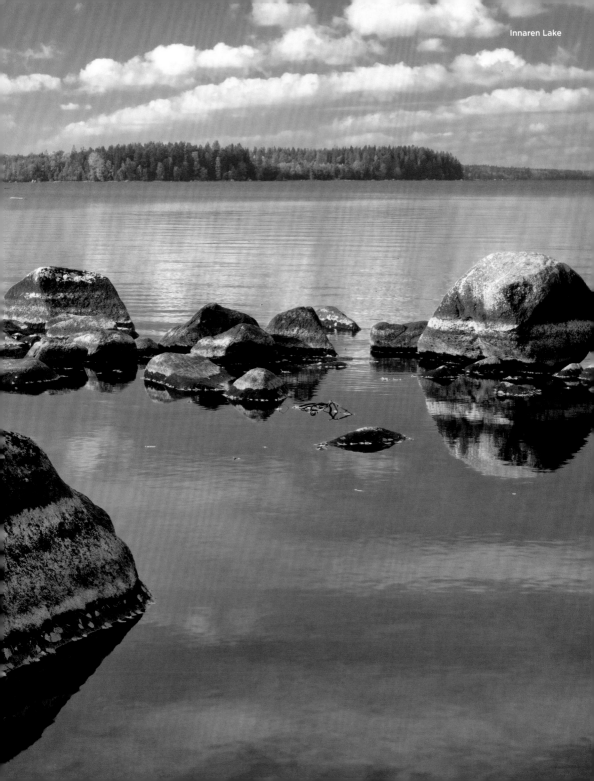
Innaren Lake

Växjö

Växjö

This attractive university city is one of the most important metropolises in southern Sweden, and is the capital both of the province of Kronobergs län and of the "Kingdom of Crystal". Växjö is one of the greenest cities in Europe due to its initiative to become free of fossil fuels, and in 2018 it received the European Green Leaf Award from the European Commission. In addition to the hustle and bustle of culture, shops and restaurants, Växjö offers plenty of balance with idyllic lakes and green spaces such as the beautiful Linné Park. This city park, named after the Swedish biologist Carl von Linné, is located close to the cathedral, which is well worth seeing.

Växjö

Cette très belle ville universitaire est l'une des principales métropoles du sud de la Suède et la capitale, aussi bien du comté de Kronoberg que du « royaume du verre ». Växjö, qui a décidé de renoncer aux carburants fossiles, est l'une des villes les plus vertes d'Europe et s'est vu décerner par la Commission européenne le prix de la Feuille verte en 2018. À côté de l'animation des lieux de culture, des magasins et des restaurants, elle possède d'agréables et abondants lacs et espaces verts, comme le magnifique parc Linné. Ce parc municipal nommé en l'honneur du biologiste suédois Carl von Linné a pour voisine la cathédrale, qui mérite une visite.

Växjö

Die attraktive Universitätsstadt gehört zu den bedeutendsten Metropolen Südschwedens und ist Hauptstadt sowohl der Provinz Kronobergs län als auch des „Glasreiches". Aufgrund der Initiative, frei von fossilen Brennstoffen zu werden, zählt Växjö zu den grünsten Städten Europas und erhielt von der Europäischen Kommission den European Green Leaf Award 2018. Neben dem Trubel von Kultur, Geschäften und Restaurants bietet sie genügend Ausgleich mit idyllischen Seen und Grünanlagen wie dem schönen Linné-Park. Der nach dem schwedischen Biologen Carl von Linné benannte Stadtpark befindet sich direkt im Umfeld der sehenswerten Domkirche.

Växjö Cathedral

Växjö

La atractiva ciudad universitaria es una de las metrópolis más importantes del sur de Suecia y es la capital tanto de la provincia de Kronobergs län como del "reino del vidrio". Växjö es una de las ciudades más verdes de Europa gracias a su iniciativa de liberarse de los combustibles fósiles y ha recibido el premio European Green Leaf Award 2018 de la Comisión Europea. Además del bullicio de la cultura, las tiendas y los restaurantes, ofrece un gran equilibrio con lagos idílicos y espacios verdes como el bello Linné Park. El parque de la ciudad, que lleva el nombre del biólogo sueco Carl von Linné, se encuentra en las inmediaciones de la iglesia catedral, que merece la pena visitar.

Växjö

A atraente cidade universitária é uma das metrópoles mais importantes do sul da Suécia e é a capital tanto da província de Kronobergs län como do "reino do vidro". Växjö é uma das cidades mais verdes da Europa, devido à sua iniciativa de se tornar livre de combustíveis fósseis, e recebeu o Prémio Europeu da Folha Verde 2018 da Comissão Europeia. Para além da agitação da cultura, lojas e restaurantes, Växjö oferece muito equilíbrio com lagos idílicos e espaços verdes como o belo Parque Linné. O parque da cidade, com o nome do biólogo sueco Carl von Linné, está localizado nas imediações da igreja catedral, que vale a pena ser visitada.

Växjö

De aantrekkelijke universiteitsstad is een van de belangrijkste metropolen van Zuid-Zweden en is de hoofdstad van zowel de provincie Kronobergs län als van het 'glasrijk'. Door het initiatief om Växjö vrij te maken van fossiele brandstoffen is het een van de groenste steden van Europa en ontving het in 2018 de Europese Green Leaf Award van de Europese Commissie. Naast de drukte van cultuur, winkels en restaurants biedt Växjö voldoende evenwicht met idyllische meren en groenvoorzieningen, zoals het prachtige Linnéparken. Dit stadspark, vernoemd naar de Zweedse bioloog Carl Linnaeus, ligt in de directe omgeving van de bezienswaardige domkerk.

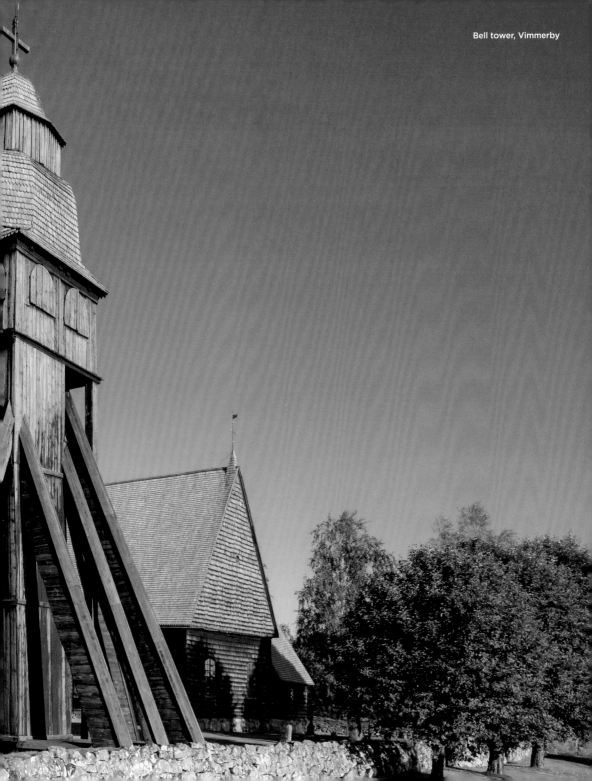

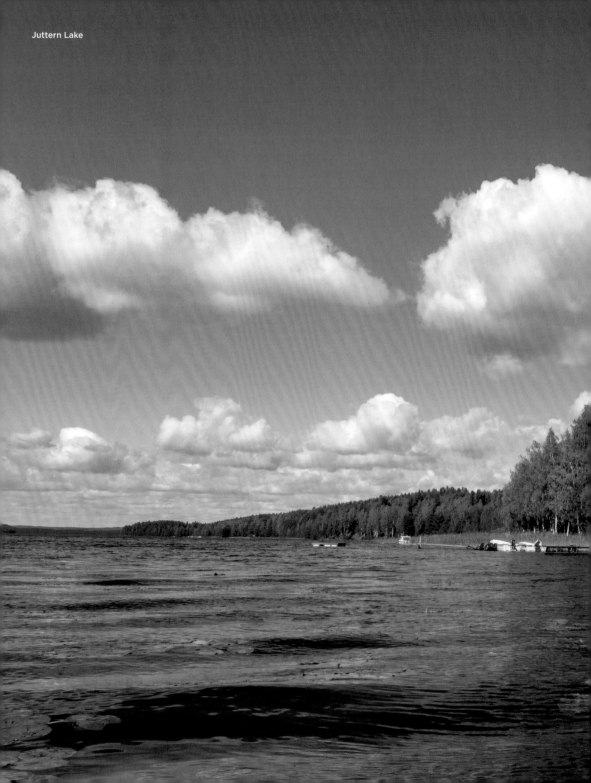

Juttern Lake

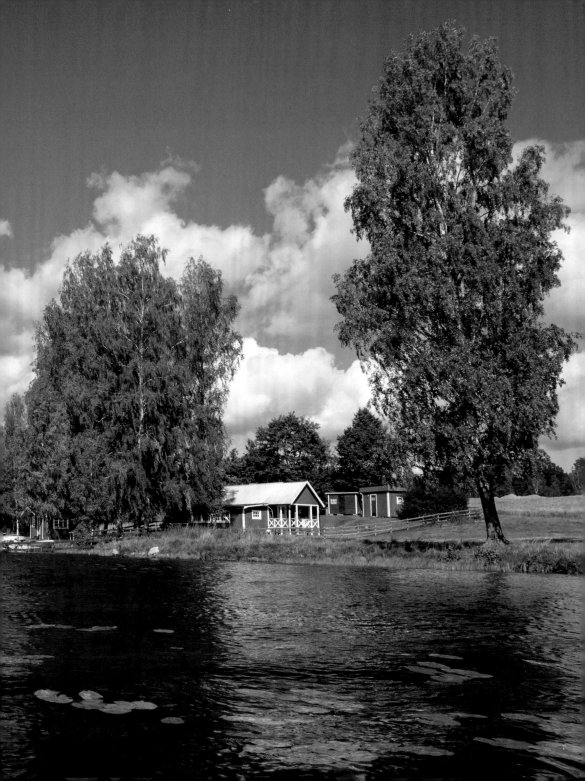

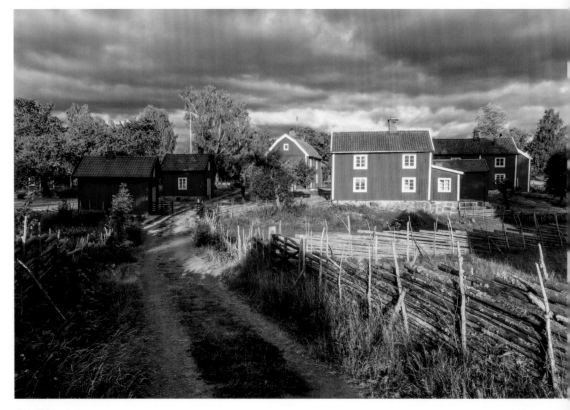

Stensjö by

Stensjö by

Red farmhouses, fields, wooden fences, gravel paths, rare cows and sheep—in the historic town of Stensjö the world seems to have paused in the 19th century: it is a living cultural monument. This idyll also served as a backdrop for the film adaptations of Astrid Lindgren's *The Children of Bullerbü* and *Michel from Lönneberga.*

Stensjö by

Masías rojas, campos, vallas de madera, caminos de grava, vacas y ovejas raras... En la histórica ciudad de Stensjö by, parece que el mundo se hubiese detenido en el siglo XIX porque es un monumento cultural vivo. Este idilio también sirvió de telón de fondo para las adaptaciones cinematográficas de *Los hijos de Bullerbü* y *Michel de Lönneberga* de Astrid Lindgren.

Stensjö by

Des fermes peintes en rouge, des champs, des clôtures en bois, des chemins caillouteux, des vaches et moutons rares : à Stensjö by, village et patrimoine historique vivant, le temps semble s'être arrêté au xixᵉ siècle. Ce cadre de rêve a servi de décor à deux films tirés d'histoires d'Astrid Lindgren, *Les Enfants de Bullerbü* et *Michel de Lönneberga.*

Stensjö by

Casas de fazenda vermelhas, campos, cercas de madeira, caminhos de cascalho, vacas e ovelhas raras – na cidade histórica de Stensjö, o mundo parece ter parado no século 19, porque é um monumento cultural vivo. Este idílio também serviu de cenário para as adaptações cinematográficas para os films *Os filhos de Bullerbü* e *Michel de Lönneberga,* de Astrid Lindgren.

Stensjö by

Rote Bauernhäuser, Äcker, Holzzäune, Schotterwege, seltene Kühe und Schafe – im historischen Ort Stensjö by scheint die Welt im 19. Jahrhundert stehengeblieben, denn er ist ein lebendiges Kulturdenkmal. Diese Idylle diente auch den Verfilmungen von Astrid Lindgrens *Die Kinder von Bullerbü* und *Michel aus Lönneberga* als Kulisse.

Stensjö by

Rode boerderijen, akkers, houten hekken, straten van steenslag, zeldzame koeien en schapen – in de historische plaats Stensjö by lijkt de wereld stil te zijn gebleven staan in de 19e eeuw, want het is een levend cultureel monument. Deze idylle diende ook als decor bij de verfilming van Astrid Lindgrens *De kinderen van Bolderburen* en *Michiel van de Hazelhoeve.*

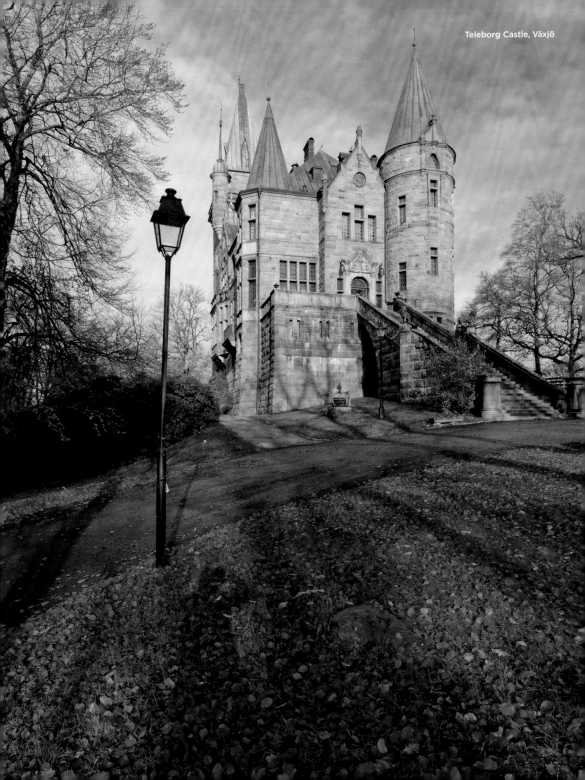

Teleborg Castle, Växjö

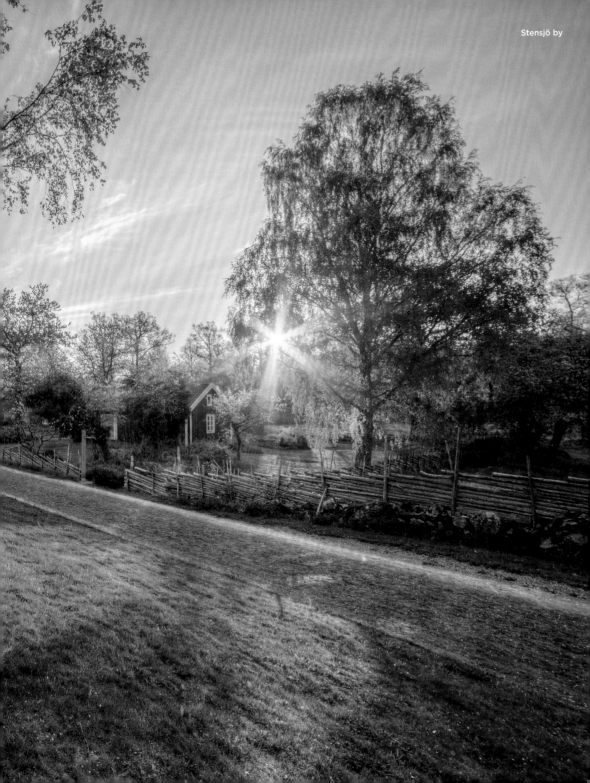

Stensjö by

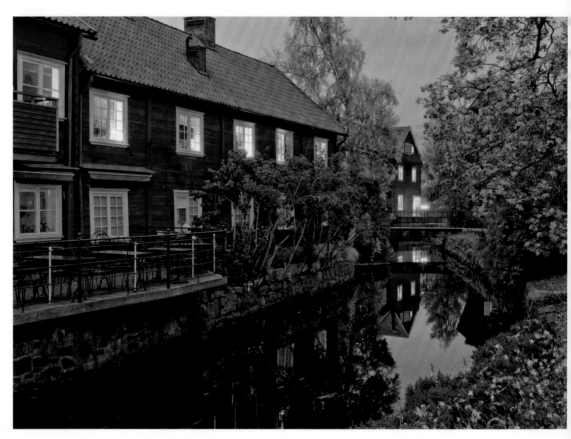

Eksjö

Eksjö

The well-preserved wooden town Eksjö is a pearl of Småland, and with its location directly on the river "Eksjöån" it is very cosy. In summer the old town full of blossoms of many colors, and in several corners you can drink coffee or enjoy a typical Swedish *dagens* (dish of the day). Around 60 of the centuries-old houses and magnificent courtyards in the old town are protected monuments. Besides Nora in Bergslagen and Hjo in Västergötland, Eksjö is one of the three most beautiful wooden towns in the country *(tre trästäder),* which retain their historic townscape. In recognition of this, the town have been awarded the Europa Nostra Prize.

Eksjö

Eksjö, avec ses maisons de bois très bien conservées, est la perle du Småland. Sa situation sur les berges de l'Eksjöån la rend particulièrement agréable. En été, la vieille ville croule sous les fleurs de toutes les couleurs et, à presque tous les coins de rue, on peut boire un café ou consommer un Dagens (« plat du jour ») typiquement suédois. Environ 60 % des maisons et des fermes centenaires centrales sont préservées au titre de monuments historiques. Avec Nora dans le Bergslagen et Hjo dans le Västergötland, Eksjö est l'une des trois plus jolies villes en bois (tre trästäder) du pays à avoir conservé son aspect d'autrefois. Ce qui lui a valu de recevoir le prix Europa Nostra.

Eksjö

Die gut erhaltene Holzstadt Eksjö ist eine Perle Smålands und mit ihrer Lage direkt am Fluss „Eksjöån" besonders gemütlich. Im Sommer erblüht die Altstadt in zahlreichen Farben und an vielen Ecken kann man Kaffee trinken oder ein typisch schwedisches *dagens* (Tagesgericht) zu sich nehmen. Rund 60 der jahrhundertealten Häuser und prächtigen Höfe in der Altstadt stehen unter Denkmalschutz. Neben Nora in Bergslagen und Hjo in Västergötland gehört Eksjö zu den drei schönsten Holzstädten des Landes *(tre trästäder),* die ihr historisches Stadtbild bewahren. Dafür wurden sie mit dem Europa-Nostra-Preis ausgezeichnet.

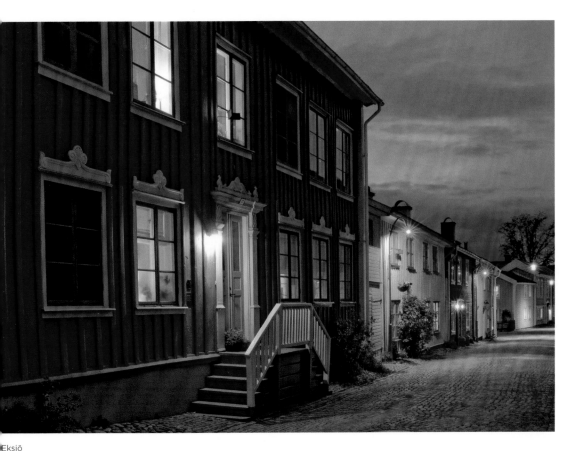

Eksjö

Eksjö

La bien conservada ciudad de madera de Eksjö es una perla de Småland y con su ubicación directamente en el río Eksjöån es muy acogedora. En verano el casco antiguo florece en muchos colores y en muchos rincones se puede tomar café o un típico *dagens* (plato del día) sueco. Alrededor de 60 de las casas centenarias y los magníficos patios del casco antiguo se consideran conservaciones históricas. Junto con Nora en Bergslagen y Hjo en Västergötland, Eksjö es una de las tres ciudades de madera más bellas del país *(tre trästäder)*, que conservan su paisaje histórico. Por ello se les concedió el Premio Europa Nostra.

Eksjö

A cidade de madeira bem preservada Eksjö é uma pérola de Småland e com sua localização diretamente no rio Eksjöån é muito aconchegante. No verão a cidade velha floresce em muitas cores e em muitos cantos você pode beber café ou comer um típico *dagens* sueco (prato do dia). Cerca de 60 das casas centenárias e magníficos pátios da cidade velha são tombados como monumentos históricos. Além de Nora em Bergslagen e Hjo em Västergötland, Eksjö é uma das três mais belas cidades de madeira do país *(tre trästäder)*, que preservam sua paisagem histórica. Devido a isso, honrados como Prémio Europa Nostra.

Eksjö

De goed geconserveerde houten stad Eksjö is een parel van Småland en ziet er met zijn ligging aan de rivier de Eksjöån erg gezellig uit. In de zomer bloeit het oude centrum in tal van kleuren en op allerlei hoeken kun je koffiedrinken of een typisch Zweedse *dagens* (dagschotel) nuttigen. Zo'n zestig van de eeuwenoude huizen en prachtige binnenplaatsen in het oude centrum vallen onder monumentenzorg. Naast Nora in Bergslagen en Hjo in Västergötland is Eksjö een van de drie mooiste houten steden van het land *(tre trästäder)*, die hun historische stadsbeeld hebben behouden. Hiervoor ontvingen zij de Europa Nostra Award.

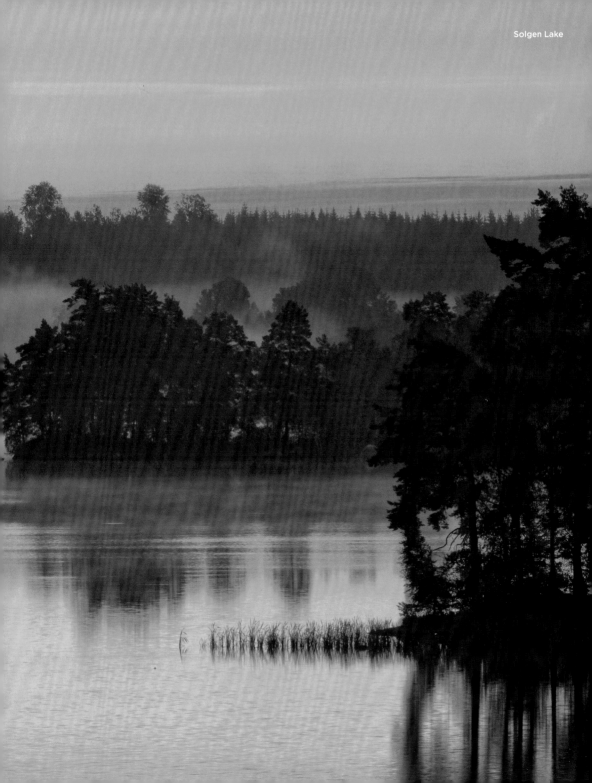

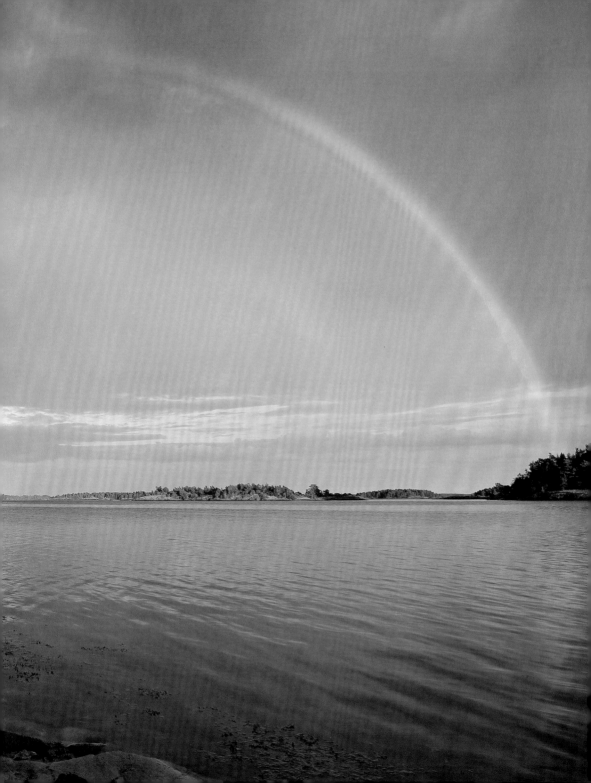

Hultsfred

Nature Conservation

Thanks to abundant rainfall, Småland's
nature is dotted with untouched upland
moors, idyllic lakes and deep forests. To
preserve these treasures, four national
parks have been established in Småland
alone: Store Mosse, Sweden's largest
contiguous moorland area; Åsnen, an
exceptional freshwater lake archipelago;
Blå Jungfrun, a granite island with Stone
Age traces; and Norra Kvill, a primeval
forest landscape with huge boulders.
Nonetheless, the extensive coniferous
forests provide enough timber for the
furniture industry and match factories, as
well as the kilns of the famous glassworks.

La protection de la nature

Grâce aux pluies généreuses, le Småland
s'enorgueillit de landes verdoyantes, de
lacs de rêve et de forêts touffues. Pour
protéger ces trésors, la région a ouvert
quatre parcs nationaux, celui de Store
Mosse où se trouvent les plus vastes
landes de Suède, Åsnen, caractérisé
par les îles qui parsèment son lac, Blå
Jungfrun, une île granitique qui recèle
des traces de l'âge de pierre, et Norra
Kvill, une forêt très ancienne hérissée
d'énormes rochers. Ce qui n'empêche pas
les immenses forêts de résineux de livrer
assez de bois pour l'industrie du meuble,
les usines d'allumettes et les fourneaux des
célèbres verreries.

Naturschutz

Smålands Natur ist dank reichlich
Niederschlags mit unberührten
Hochmooren, idyllischen Seen und tiefen
Wäldern bestückt. Um diese Schätze
zu bewahren, wurden allein in Småland
vier Nationalparks gegründet: so
schützt Store Mosse Schwedens größtes
zusammenhängendes Moorgebiet, Åsnen
eine außergewöhnliche Süßwassersee-
Schärenlandschaft, Blå Jungfrun eine
Granitinsel mit Steinzeitspuren und Norra
Kvill eine urwaldartige Waldlandschaft
mit riesigen Felsblöcken. Und dennoch
liefern die ausgedehnten Nadelwälder
genügend Nutzholz für die Möbelindustrie,
Streichholzfabriken und die Brennöfen der
berühmten Glashütten.

Timber

Conservación natural

Gracias a las abundantes lluvias, la naturaleza de Småland está salpicada de turberas vírgenes, lagos idílicos y bosques profundos. Para preservar estos tesoros, solo en Småland se han creado cuatro parques nacionales: Store Mosse (la mayor zona de páramos contiguos de Suecia), Åsnen (un excepcional archipiélago lacustre de agua dulce), Blå Jungfrun (una isla de granito con vestigios de la Edad de Piedra) y Norra Kvill (un paisaje forestal primigenio con enormes rocas). Sin embargo, los extensos bosques de coníferas proporcionan suficiente madera para la industria del mueble, las fábricas de fósforos y los hornos de las famosas fábricas de vidrio.

Conservação da natureza

Graças às chuvas abundantes, a natureza de Småland é repleta de turfeiras altas virgens, lagos idílicos e florestas profundas. A fim de preservar estes tesouros, foram criados quatro parques nacionais apenas em Småland: Store Mosse protege a maior área pantanosa contígua da Suécia; Åsnen, um excepcional arquipélago de lagos de água doce; Blå Jungfrun, uma ilha de granito com vestígios da Idade da Pedra; e Norra Kvill, uma paisagem florestal primitiva com enormes rochas. E, no entanto, as extensas florestas de coníferas fornecem madeira suficiente para a indústria moveleira, as fábricas de fósforos e os fornos das famosas vidrarias.

Natuurbescherming

Dankzij de overvloedige regenval is de natuur van Småland bezaaid met ongerepte hoogvenen, idyllische meren en diepe bossen. Om deze schatten te behouden zijn alleen al in Småland vier nationale parken opgericht: de Store Mosse, het grootste aaneengesloten heidegebied van Zweden, Åsnen, een uitzonderlijk zoetwater-scherengebied, Blå Jungfrun, een granieteiland met sporen uit de steentijd, en Norra Kvill, een oerwoudachtig landschap met enorme rotsblokken. En toch leveren de uitgestrekte naaldbossen voldoende hout voor de meubelindustrie, luciferfabrieken en ovens van de beroemde glasfabrieken.

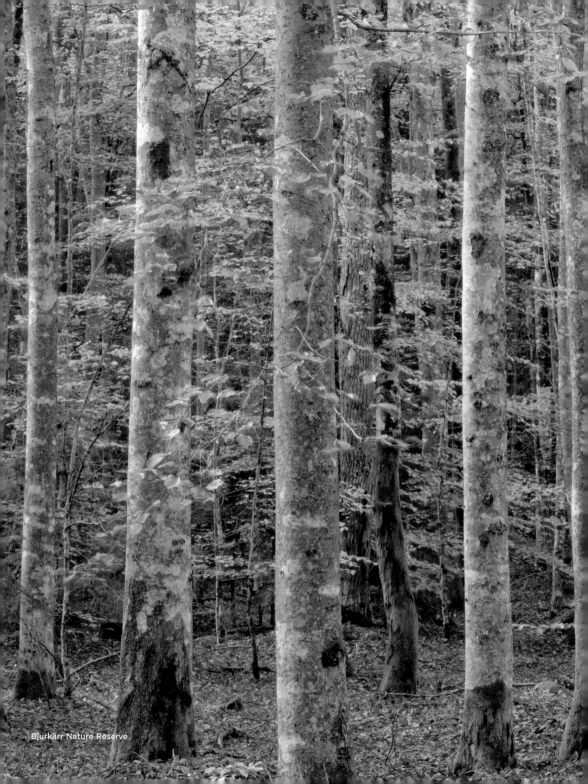

Bjurkärr Nature Reserve

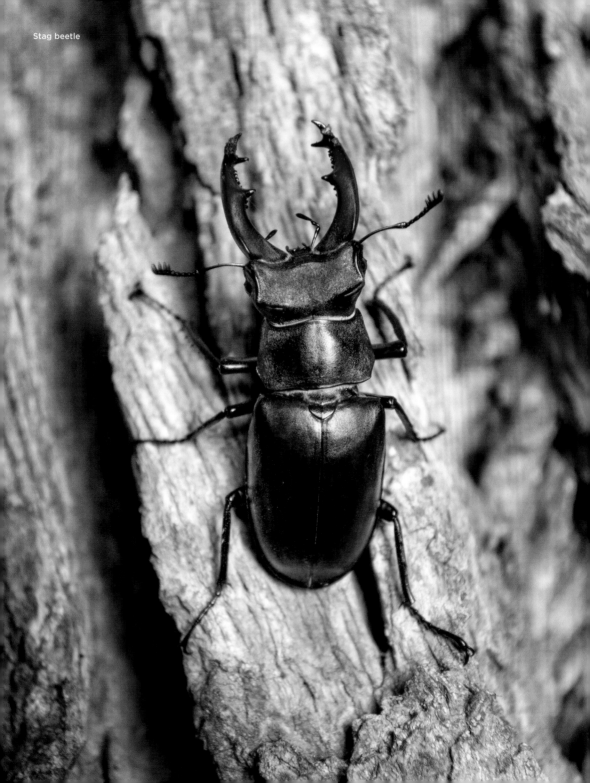

Stag beetle

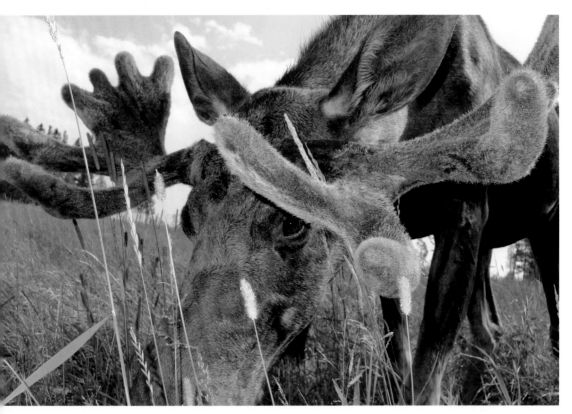

European moose

Antlers

Moose and stag beetles – they seem as different as day and night, and yet they have more in common than just their habitat. Both have antlers, and only the males adorn themselves with these. The bulls of this largest species of deer carry a shovel-like antler of up to 20 kg (44 lb). Every year in January they cast it off, then it grows back bigger and more beautiful.

Cuernos

El alce y el ciervo volante: parecen diferentes como el día y la noche y todavía tienen más en común que solo el hábitat. Ambos tienen cuernos y en ambos casos solo los machos los llevan. Los machos más imponentes de las especies de ciervos más grandes llevan una cornamenta de hasta 20 kg. Cada año se deshacen de ella en enero, y entonces crece más grande y más bella.

Les bois de l'élan

L'élan et un coléoptère, le cerf-volant ou grande biche, si on ne peut imaginer animaux plus différents, ne font pas que partager le même habitat. En effet, les mâles des deux espèces possèdent des « bois », qui peuvent peser jusqu'à 20 kg chez le plus grand des cervidés. Cette parure tombe chaque année en janvier, pour repousser ensuite, encore plus belle et plus imposante

Galhadas

Escaravelho-veado e alce – eles parecem tão diferentes como o dia e a noite e mesmo assim eles têm muito mais em comum do que apenas o habitat. Ambos têm chifres e ambos têm apenas os machos que são adornados com eles. Os touros das maiores espécies de veados transportam até 20 kg de chifres pesados. Todo ano em janeiro, os chifres caem e depois crescem novamente e fica mais bonito.

Geweihe

Elch und Hirschkäfer – sie scheinen unterschiedlich wie Tag und Nacht und haben dennoch mehr gemeinsam als nur den Lebensraum. Beide tragen Geweih und bei beiden sind es nur die Männchen, die sich damit schmücken. Die Bullen der größten vorkommenden Hirschart tragen ein bis zu 20 kg schweres Schaufelgeweih. Jedes Jahr werfen sie es im Januar ab, dann wächst es größer und schöner nach.

Geweien

Eland en vliegend hert – ze lijken als dag en nacht te verschillen en hebben toch meer met elkaar gemeen dan hun leefomgeving. Beide hebben een gewei en bij beide zijn het alleen de mannetjes die zich daarmee tooien. De stieren van deze grootste hertensoort dragen een schoffelgewei van wel 20 kilo. Elk jaar werpen ze dat in januari af, waarna het nog groter en mooier weer aangroeit.

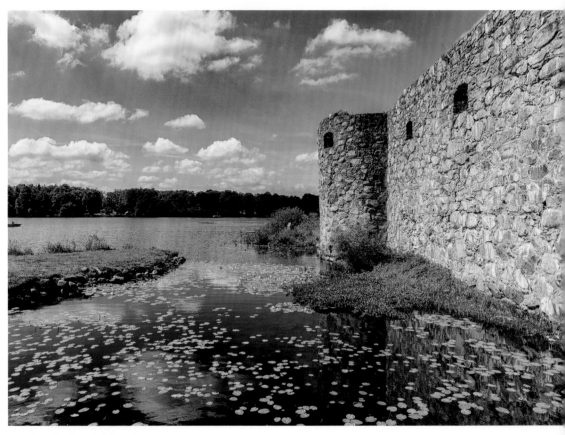

Kronoberg Castle, Helgasjön Lake

Kronoberg

The region around Växjö is famous for its lakes, which were formed during the Ice Age and offer enchanting flora and fauna. In addition to fresh air, impressive nature and many leisure activities, the province also offers sights such as the Kronberg castle complex on Lake Helgasjön, divided into three small islands. It was built in the 14th century as a bishop's seat, and began to fall into disrepair after it lost its military significance with the peace treaty of 1658. Near the ruin there is another attraction: Kosta—Sweden's oldest still existing glassworks.

Kronoberg

Les environs de Växjö doivent leur notoriété à leurs lacs d'origine glaciaire, qui abritent une flore et une faune étonnantes. L'air est pur, la nature impressionnante et l'offre de loisirs généreuse, mais la province ne manque pas de sites touristiques, comme le château de Kronoberg, répartis sur trois petites îles du lac d'Helgasjön. Cette résidence épiscopale construite au XIVᵉ siècle perdit son intérêt militaire après le traité de paix de 1658 et entama alors un long déclin. Non loin de ces ruines, on est tenté de visiter Kosta, la plus ancienne verrerie de Suède.

Kronoberg

Die Region um Växjö ist berühmt für ihre Seen, die im Laufe der Eiszeit entstanden sind und mit bezaubernder Flora und Fauna aufwarten. Neben frischer Luft, beeindruckender Natur und vielen Freizeitmöglichkeiten bietet die Provinz auch Sehenswürdigkeiten wie die auf drei kleine Inseln aufgeteilte Schlossanlage Kronoberg am See Helgasjön. Sie wurde im 14. Jahrhundert als Bischofssitz erbaut und begann zu verfallen, nachdem sie durch das Friedensabkommen von 1658 ihre militärische Bedeutung verlor. In der Nähe der Ruine befindet sich eine weitere Attraktion: Kosta – Schwedens älteste noch bestehende Glashütte.

Kronoberg Castle, Helgasjön Lake

Kronoberg

La región alrededor de Växjö es famosa por sus lagos, que se formaron durante la Edad de Hielo y ofrecen una flora y fauna encantadoras. Además de aire fresco, naturaleza impresionante y muchas actividades de ocio, la provincia también ofrece lugares de interés como el complejo del castillo de Kronoberg en el lago Helgasjön, dividido en tres pequeñas islas. Fue construida en el siglo XIV como sede episcopal y comenzó a deteriorarse después de perder su importancia militar con el tratado de paz de 1658. Cerca de la ruina hay otra atracción: Kosta, la fábrica de vidrio más antigua de Suecia.

Topo da copa

A região ao redor de Växjö é famosa por seus lagos, que foram formados durante a Era Glacial e oferecem flora e fauna encantadoras. Além de ar puro, natureza impressionante e muitas atividades de lazer, a província também oferece vistas como o complexo do castelo de Kronoberg no Lago Helgasjön, dividido em três pequenas ilhas. Foi construído no século XIV como sede de um bispado e começou a cair em ruína depois de ter perdido o seu significado militar com o tratado de paz de 1658. Perto da ruína há outra atração: Kosta – a mais antiga fábrica de vidro da Suécia ainda existente.

Kronoberg

De regio rond Växjö is beroemd om zijn meren, die in de loop van de ijstijd zijn gevormd en een betoverende flora en fauna bieden. Naast frisse lucht, een indrukwekkende natuur en veel recreatiemogelijkheden biedt de provincie verdeeld over drie kleine eilanden bezienswaardigheden zoals de kasteelruïnes van Kronoberg aan het Helgasjönmeer. Het slot werd in de 14e eeuw gebouwd als bisschopszetel en raakte in verval nadat het met het vredesverdrag van 1658 zijn militaire betekenis verloor. Vlak bij de ruïnes bevindt zich nog een andere attractie: Kosta, – de oudste nog bestaande glasfabriek van Zweden.

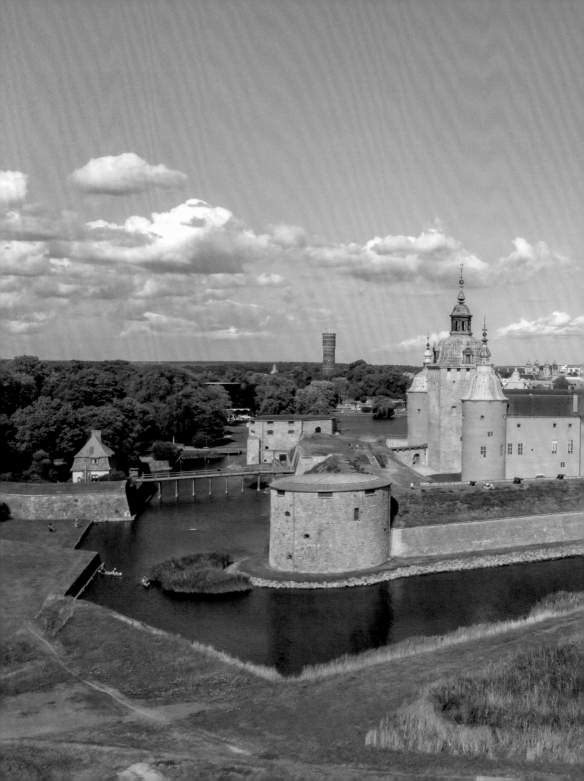

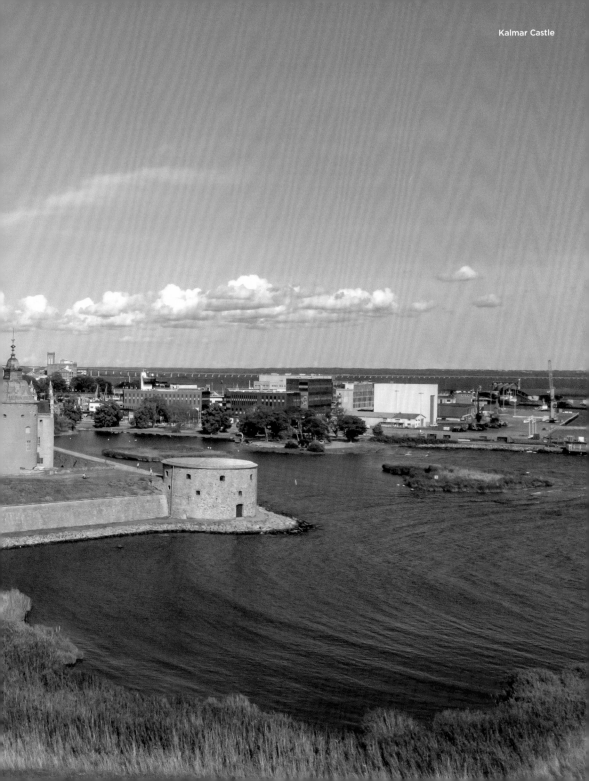

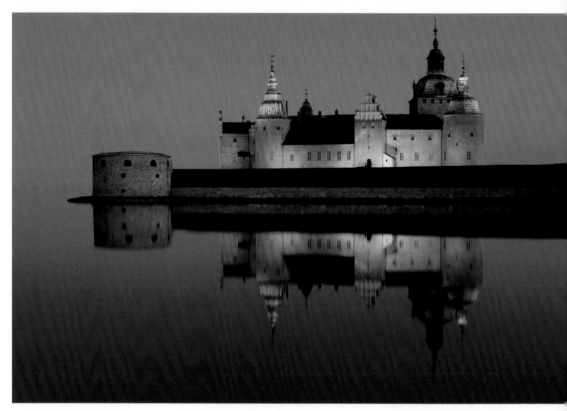

Kalmar Castle

Kalmar Castle
Elegant and venerable, this legendary castle has been enthroned on an artificial island since the 12th century, only accessible from the mainland via a narrow bridge. The Union of Kalmar was signed here in 1397. The once important defensive complex did not become a royal Renaissance castle until the end of the 16th century.

Le château de Kalmar
Ce château légendaire, aussi élégant que vénérable, se dresse depuis le xiie siècle sur une île artificielle, reliée à la terre ferme par un pont étroit. C'est ici que fut signée l'Union de Kalmar, en 1397. Remanié à la Renaissance, ce fort autrefois d'une grande importance est devenu une résidence royale à la fin du xvie siècle.

Schloss Kalmar
Elegant und ehrwürdig thront das sagenumwobene Schloss seit dem 12. Jahrhundert auf einer künstlich angelegten Insel, nur über eine schmale Brücke vom Festland aus erreichbar. 1397 wurde hier die Union von Kalmar unterzeichnet. Zu einem königlichen Renaissanceschloss wurde die einst bedeutende Verteidigungsanlage erst Ende des 16. Jahrhunderts.

Castillo de Kalmar
Elegante y venerable, el legendario castillo ha sido entronizado en una isla artificial desde el siglo XII, a la que solo se puede acceder desde tierra firme a través de un estrecho puente. La Unión de Kalmar se firmó aquí en 1397. El importante complejo defensivo no se convirtió en un castillo real renacentista hasta finales del siglo XVI.

Castelo de Kalmar
Elegante e venerável, o lendário castelo foi entronizado em uma ilha artificial desde o século XII, acessível apenas através de uma ponte estreita a partir do continente. A União de Kalmar foi assinada aqui em 1397. O outrora importante complexo defensivo tornou-se um castelo real renascentista somente no final do século XVI.

Kasteel Kalmar
De legendarische burcht is elegant en eerbiedwaardig en staat sinds de 12e eeuw op een kunstmatig eiland, dat alleen via een smalle brug vanaf het vasteland bereikbaar is. De Unie van Kalmar werd hier in 1397 ondertekend. Het eens zo belangrijke verdedigingscomplex werd pas aan het eind van de 16e eeuw, tijdens de renaissance, een koninklijk kasteel.

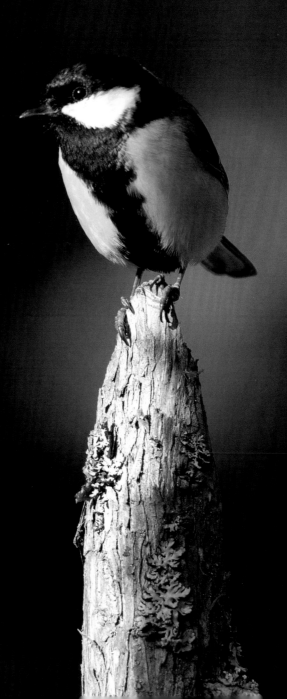

Great tit

Gotland & Öland

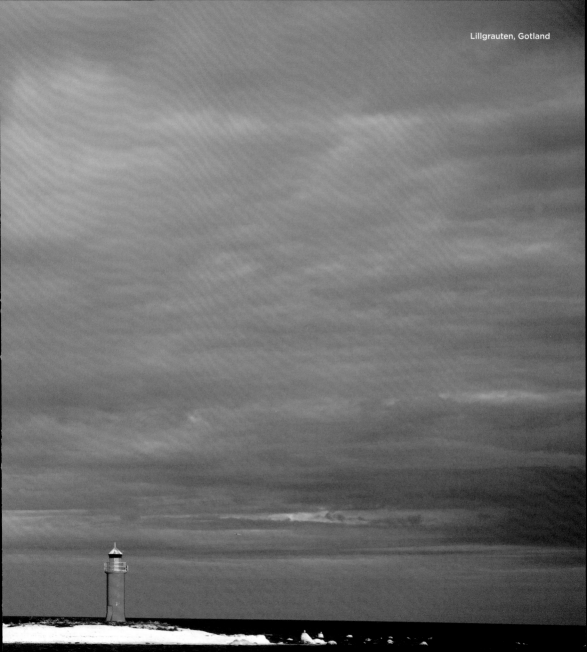

Lillgrauten, Gotland

Kutens Bensin, Farö Island

Gotland and Öland

On Gotland and Öland the clock seems to stop from time to time—slowing down is the order of the day. The Swedes lovingly call these their "sun islands", because during the summer months in particular they are reminiscent of Spanish rather than Scandinavian islands, with high temperatures and unique vegetation growing in calcareous soils. Their landscape is full of contrasts—wide sandy beaches, coastal forests with pines shaped by the sea, sand and wind, and high cliffs. Even orchids thrive in this area where many Swedes like to spend their summer holidays. Windmills, castles, ruins, stone ramparts and idyllic villages complete the picture.

Gotland et Öland

À Gotland et à Öland, prendre son temps est une habitude bien ancrée – ici, on vit au ralenti. Leur surnom d'« îles du soleil » est révélateur de l'affection que leur portent les Suédois. En effet, en été, les températures élevées et la végétation particulière qui se développe sur le sol calcaire évoquent plutôt l'Espagne que la Scandinavie. Les paysages frappent par leurs contrastes, entre les immenses plages de sable, les forêts du littoral aux pins déformés par la mer, le sable, le vent et les falaises élevées. Des orchidées poussent même dans ces îles où les Suédois adorent passer leurs vacances d'été. Les moulins à vents, châteaux forts, ruines, remparts et villages de rêve complètent le panorama.

Gotland und Öland

Auf Gotland und Öland scheint die Uhr ab und an wie stehen geblieben – Entschleunigung ist angesagt. Die Schweden nennen sie liebevoll ihre „Sonneninseln", denn vor allem während der Sommermonate erinnern sie mit hohen Temperaturen und besonderer Vegetation auf kalkhaltigen Böden eher an spanische als an skandinavische Inseln. Ihr Landschaft ist voller Gegensätze – weite Sandstrände, Küstenwälder mit von Meer, Sand und Wind geprägten Kiefern und hohen Kliffen. Selbst Orchideen gedeihen da, wo viele Schweden am liebsten ihren Sommerurlaub verbringen. Windmühlen, Burgen, Ruinen, Steinwälle und idyllische Dörfer runden das Bild ab.

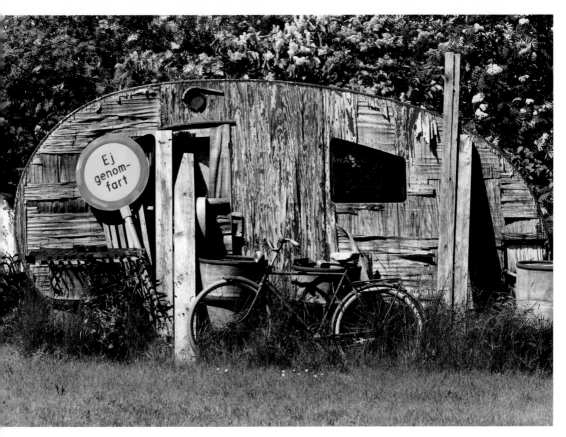

Kutens Bensin, Farö Broskogs, Farö Island

Gotland y Öland

En Gotland y Öland el reloj parece pararse de vez en cuando: la desaceleración está a la orden del día. Los suecos los llaman cariñosamente sus "islas del sol", porque especialmente durante los meses de verano nos recuerdan más a las islas españolas que a las escandinavas, con altas temperaturas y una vegetación especial en suelos calcáreos. Su paisaje está lleno de contrastes: amplias playas de arena, bosques costeros con pinos formados por el mar, la arena y el viento, y altos acantilados. Incluso las orquídeas prosperan en estos lugares en los que a los suecos les encanta pasar sus vacaciones de verano. Molinos de viento, castillos, ruinas, murallas de piedra y pueblos de ensueño completan el cuadro.

Gotland et Öland

Em Gotland e Öland, o relógio parece ter parado de vez em quando – a desaceleração é a ordem do dia. Os suecos carinhosamente as chamam de "ilhas do sol", porque especialmente durante os meses de verão elas nos fazem lembrar das ilhas espanholas e não escandinavas, com altas temperaturas e vegetação especial em solos calcários. A sua paisagem é cheia de contrastes – amplas praias de areia, florestas costeiras com pinheiros e altas falésias caracterizadas por mar, areia e vento. Até mesmo as orquídeas prosperam, onde muitos suecos preferem passar as suas férias de verão. Moinhos de vento, castelos, ruínas, muralhas de pedra e aldeias idílicas completam o cenário.

Gotland en Öland

Op Gotland en Öland lijkt de tijd af en toe stil te staan – onthaasting is hier aan de orde van de dag. De Zweden noemen ze liefdevol hun 'zonne-eilanden', omdat ze vooral in de zomermaanden met hun hoge temperaturen en bijzondere begroeiing op kalkrijke grond eerder doen denken aan Spaanse dan aan Scandinavische eilanden. Hun landschap is erg contrastrijk: brede zandstranden, kustbossen met pijnbomen die door zee, zand en wind gevormd zijn en hoge klippen. Zelfs wilde orchideeën gedijen daar waar veel Zweden hun zomervakantie het liefst doorbrengen. Molens, kastelen, ruïnes, stenen muurtjes en idyllische dorpjes maken het plaatje compleet.

Lighthouse, Gotland

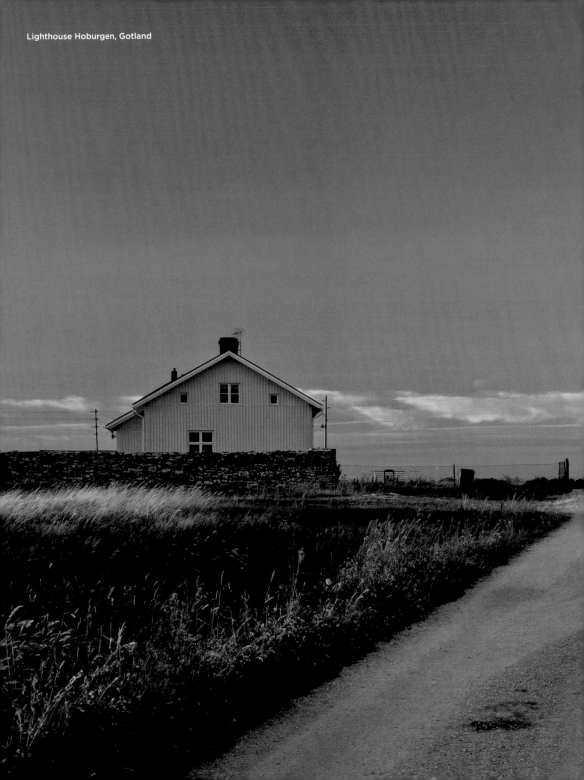

Lighthouse Hoburgen, Gotland

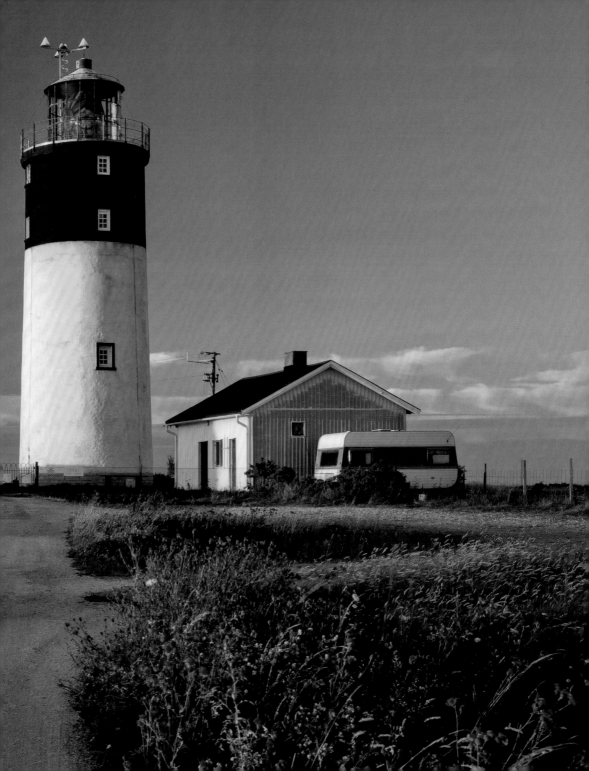

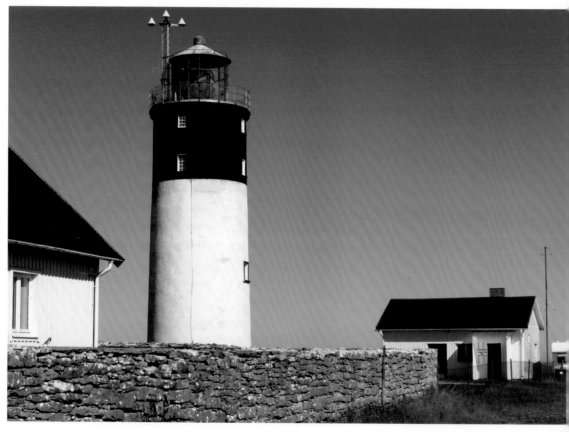

Lighthouse Hoburgen, Gotland

Beacons

A total of 64 lighthouses line the coastline of Gotland, and each seems to carry its own history—like guards they defy wind and weather and show sailors the way. One of the most popular is the När lighthouse. It stands on the southern peninsula of the nature reserve of Närsholmen, and is the last big lighthouse on the east coast of Gotland. Since 1961 its light has operated without a lighthouse keeper. Almost like an African savannah, the barren landscape around the tower with its red and white stripes is a destination for excursions and is a bird sanctuary. Various wading birds, ruffs, hoopoes and pied avocets breed here.

Les phares

Quelque 64 phares bordent le littoral de Gotland et chacun semble auréolé de légendes, à force de défier les éléments et d'indiquer le chemin aux marins. Le phare de När est l'un des plus populaires. Il se dresse à la pointe sud de la réserve de Närsholmen et fut l'un des derniers grands fanaux sur la côte est de Gotland. Depuis 1961, il fonctionne sans gardien. Autour du phare peint en rouge et blanc, le paysage austère, qui ressemble presque à une savane africaine, abrite une réserve d'oiseaux où il fait bon se promener. Plusieurs espèces d'oiseaux aquatiques, dont le combattant varié, la huppe et l'avocette élégante, fréquentent ce site de nidification.

Leuchtfeuer

Insgesamt 64 Leuchttürme säumen die Küstenlinie Gotlands, und jeder scheint seine eigene Geschichte zu tragen – wie Wächter trotzen sie Wind und Wetter und zeigen Seefahrern den Weg. Zu den beliebtesten zählt der Leuchtturm När. Er steht an der Süd-Huk des Naturschutzgebiets von Närsholmen und war das letzte große Leuchtfeuer an der Ostküste Gotlands. Seit 1961 wird sein Licht ohne Leuchtturmwärter betrieben. Die karge, fast wie eine afrikanische Savanne anmutende Landschaft um den Turm mit den rot-weißen Streifen ist Ausflugsziel und Vogelschutzgebiet. Hier brüten verschiedene Watvögel, Kampfläufer, Wiedehopfe und Säbelschnäbler.

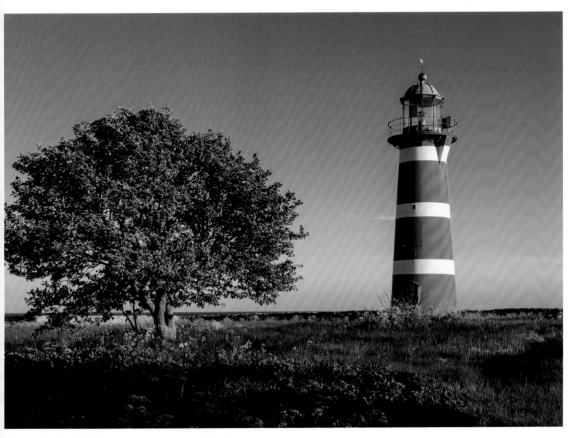

När Lighthouse, Gotland

Faros

Un total de 64 faros bordean la costa de Gotland, y cada uno de ellos parece tener su propia historia: como guardias, desafían el viento y el clima y muestran el camino a los marineros. Uno de los más populares es el faro de När, que se encuentra en el sur de Huk de la reserva natural de Närsholmen y fue el último gran faro de la costa este de Gotland. Desde 1961 su luz ha sido operada sin un farero. El paisaje árido, casi como una sabana africana, alrededor de la torre con sus franjas rojas y blancas, es un destino para excursiones y un santuario de aves. Varios pájaros vadeadores, rufianes, abubillas y avocetas se reproducen aquí.

Faróis

Um total de 64 faróis se estendem pelo litoral de Gotland, e cada umdeles parece ter a sua própria história – como guardas, desafiam o vento e o tempo e mostram o caminho aos marinheiros. Um dos mais populares é o farol de När. Ele fica no Huk sul da reserva natural de Närsholmen e foi o último grande farol na costa leste de Gotland. Desde 1961 a sua luz tem sido operada sem faroleiro. A paisagem estéril, quase como uma savana africana, ao redor da torre com suas listras vermelhas e brancas é um destino para excursões e um santuário de pássaros. Vários pássaros como limícolas, ,combatentes, , poupas e alfaiates se reproduzem aqui.

Vuurtorens

Er staan in totaal 64 vuurtorens langs de kustlijn van Gotland, die elk hun eigen geschiedenis lijken mee te brengen. Als wachters trotseren ze wind en weer en wijzen ze zeelieden de weg. Een van de populairste is de vuurtoren van När. Hij staat aan de zuidkaap van het beschermde natuurgebied Närsholmen en was de laatste grote vuurtoren aan de oostkust van Gotland. Sinds 1961 wordt het licht bediend zonder vuurtorenwachter. Het kale landschap rond de toren met zijn rode en witte strepen oogt haast als een Afrikaanse savanne en is een bestemming voor excursies en een vogelreservaat. Hier broeden verschillende waadvogels, kemphanen, hoppen en kluten.

Ljugarn, Gotland

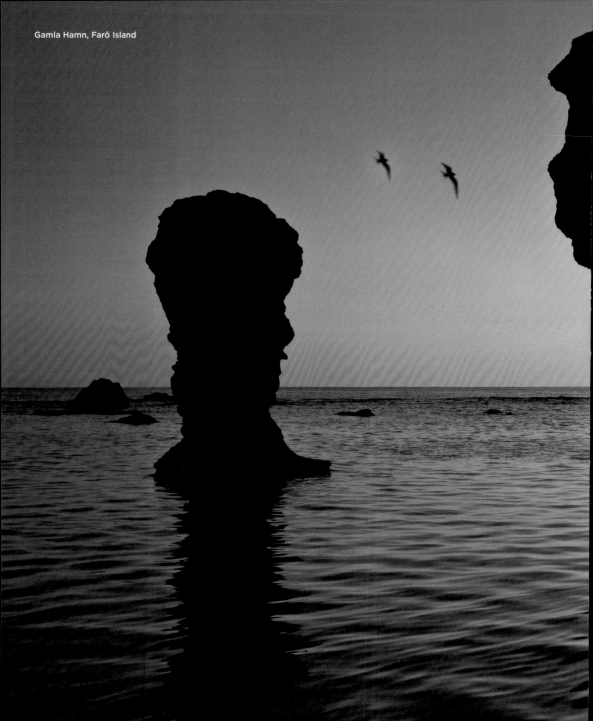
Gamla Hamn, Farö Island

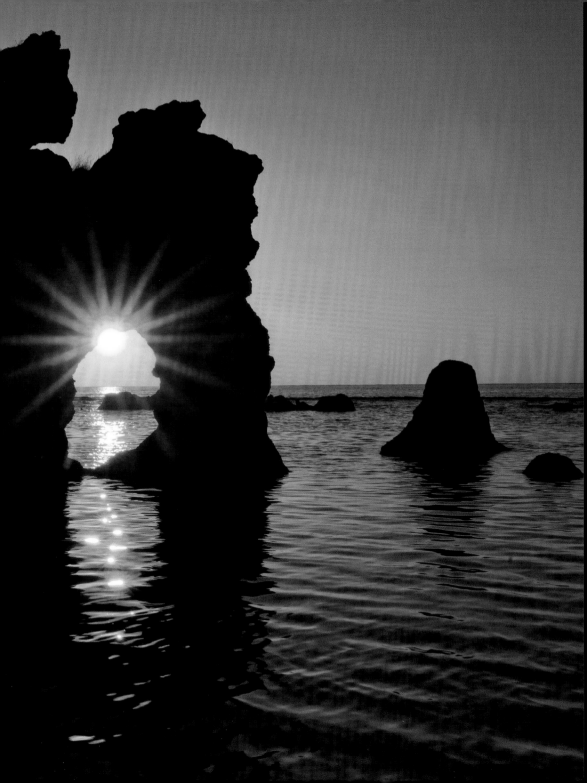

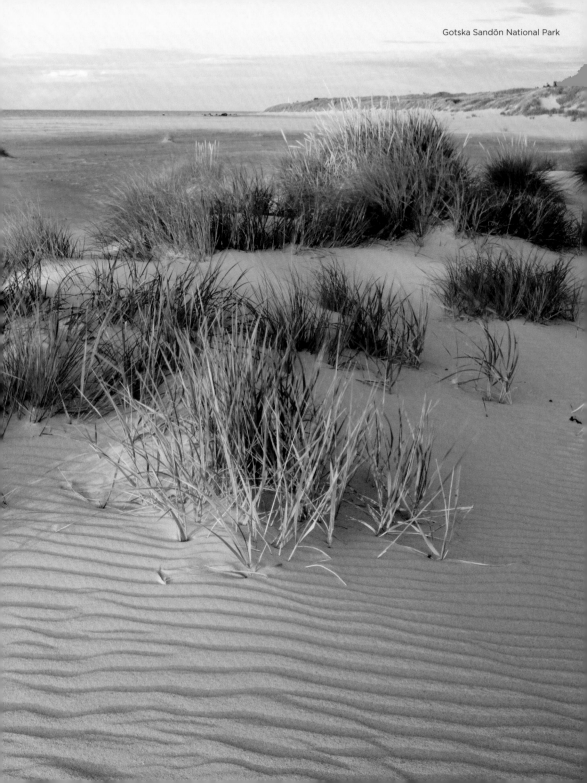

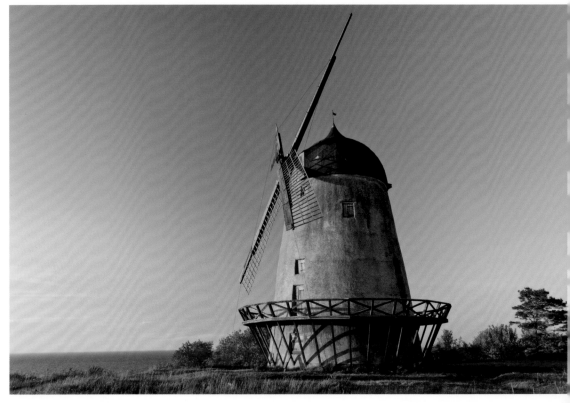

Windmill, Sojvide, Gotland

Windmills

You can often see houses covered with reeds that once served as barns. Even more typical for the landscape are the many windmills made of stone and wood. They testify to the importance of grain cultivation. In the past there were up to 2000 windmills, and today there are about 350 in Öland alone. They are protected monuments and are a symbol of this sunny island.

Molinos de viento

A menudo se pueden ver casas cubiertas de juncos que solían servir como graneros, pero aún más típicos en el paisaje son los numerosos molinos de viento, que están hechos de piedra y madera. Son testimonio de la importancia del cultivo de cereales. En el pasado había hasta 2000 molinos de viento; hoy en día hay alrededor de 350 solo en Öland. Son un patrimonio protegido y el punto de referencia de la soleada isla.

Les moulins à vent

Les maisons à toit de chaume, en fait d'anciennes granges, font partie du paysage. Cependant, les moulins à vent en pierre et en bois sont encore plus typiques. Ils rappellent l'importance des cultures céréalières. Öland en comptait 2000 autrefois, mais il n'en reste plus que 350. Ces emblèmes de l'île du soleil sont désormais protégés.

Moinhos de vento

É comum ver casas cobertas de juncos que serviam de celeiros. Ainda mais típicos para a paisagem são os muitos moinhos de vento – feitos de pedra e madeira. Eles testemunham a importância do cultivo de grãos. No passado existiam até 2000 moinhos de vento, hoje existem cerca de 350 só em Öland. Eles são monumentos tombados e o símbolo da ilha ensolarada.

Windmühlen

Oft sieht man mit Schilf bedeckte Häuser, die früher als Scheunen dienten. Noch typischer für das Landschaftsbild sind jedoch die vielen Windmühlen – aus Stein und Holz. Sie zeugen von der Wichtigkeit des Getreideanbaus. Gab es einst bis zu 2000, stehen allein auf Öland heute noch etwa 350 Windmühlen. Sie sind denkmalgeschützt und das Wahrzeichen der Sonneninsel.

Molens

Er zijn vaak met riet bedekte huizen te zien die vroeger als schuren dienden. Nog typerender voor het landschap zijn de vele molens – gemaakt van steen en hout. Zij getuigen van het belang van de graanteelt. Vroeger waren er wel 2000 molens, en tegenwoordig staan er alleen al in Öland zo'n 350. Ze vallen onder monumentenzorg en zijn de herkenningstekens van het zonnige eiland.

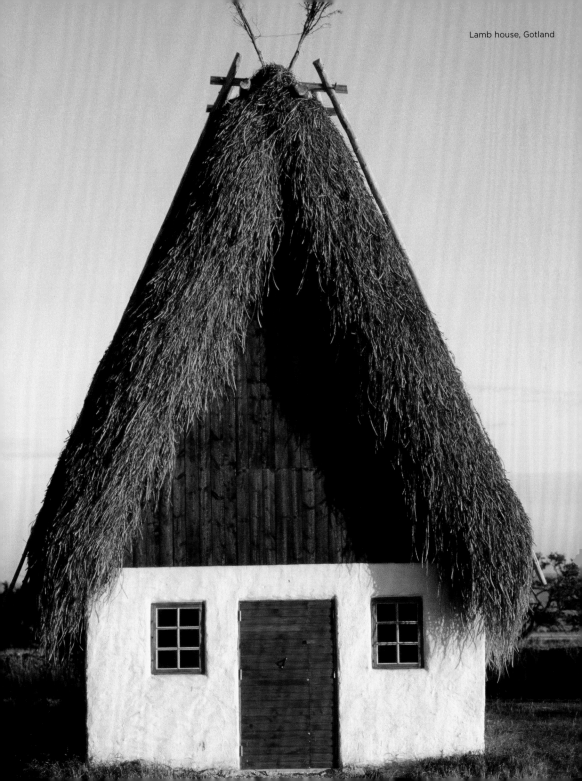

Visby, Gotland

...sby, Gotland

...sby

...ustic cottages that crowd close to
...bbled streets and have romantic gardens
...aracterize the town of Visby. This
...anseatic city is regarded as one of the
...ost beautiful in the north, and enchants
...th its medieval buildings and lively
...ghtlife within its historic city walls. Visby
...s been a UNESCO World Heritage Site
...nce 1995.

...sby

...a ciudad de Visby está caracterizada por
...sas rurales rústicas que se amontonan
...rca de calles empedradas y jardines
...mánticos. La ciudad hanseática está
...nsiderada como una de las más bellas
...el norte y encanta con sus edificios
...edievales y su animada vida nocturna
...entro de la muralla histórica de la ciudad.
... Patrimonio de la Humanidad de la
...NESCO desde 1995.

Visby

Visby est irrésistible, avec ses maisonnettes
anciennes serrées les unes contre les
autres le long des ruelles pavées. Et
derrière se cachent des jardins tout
à fait romantiques. Cette petite ville
hanséatique, l'une des plus ravissantes du
nord, s'épanouit au milieu de ses murailles
médiévales et s'anime la nuit. Elle est
inscrite au Patrimoine mondial de l'Unesco
depuis 1995.

Visby

Casas rústicas pequenas, que
se aglomeram perto de ruas de
paralelepípedos e acomodam jardins
românticos, caracterizam a cidade de
Visby. A cidade hanseática é considerada
uma das mais belas do norte e encanta
com seus edifícios medievais e vida
noturna animada dentro da muralha
histórica da cidade. É Património Mundial
da UNESCO desde 1995.

Visby

Urige Häuschen, die sich dicht an dicht
an Kopfsteinpflastergassen drängen
und romantische Gärten beherbergen,
prägen das Bild des Städtchens
Visby. Die Hansestadt gilt als eine der
schönsten des Nordens und verzaubert
innerhalb der historischen Stadtmauer
mit mittelalterlichen Bauten und regem
Nachtleben. Seit 1995 gehört sie zum
Weltkulturerbe der UNESCO.

Visby

Het stadsbeeld van Visby wordt getekend
door authentieke huisjes die dicht bij de
met kinderhoofdjes geplaveide straten
staan en romantische tuinen bezitten.
De Hanzestad wordt gezien als een van
de mooiste van het noorden en betovert
met zijn middeleeuwse gebouwen en
levendige nachtleven binnen de historische
stadsmuur. Hij staat sinds 1995 op de
werelderfgoedlijst van de Unesco.

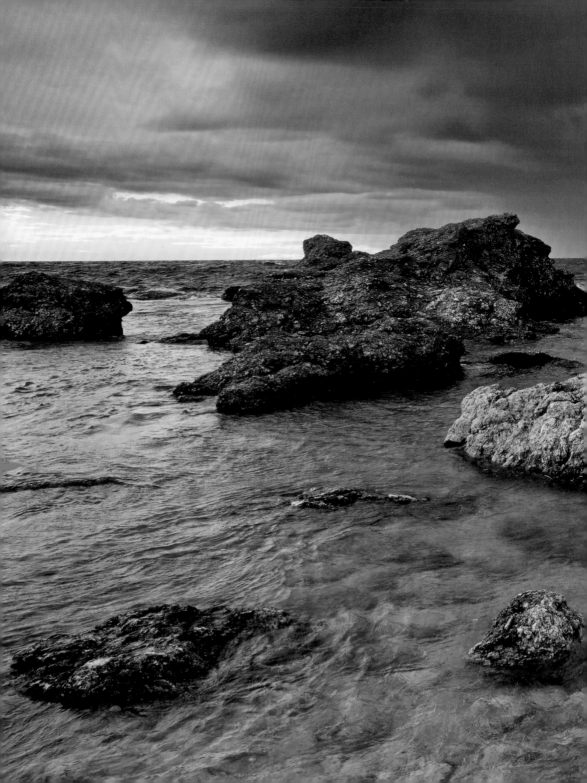

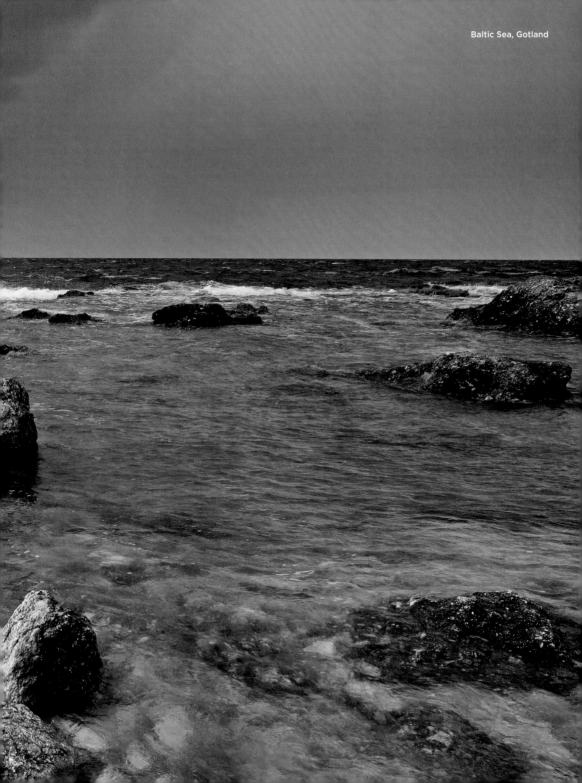

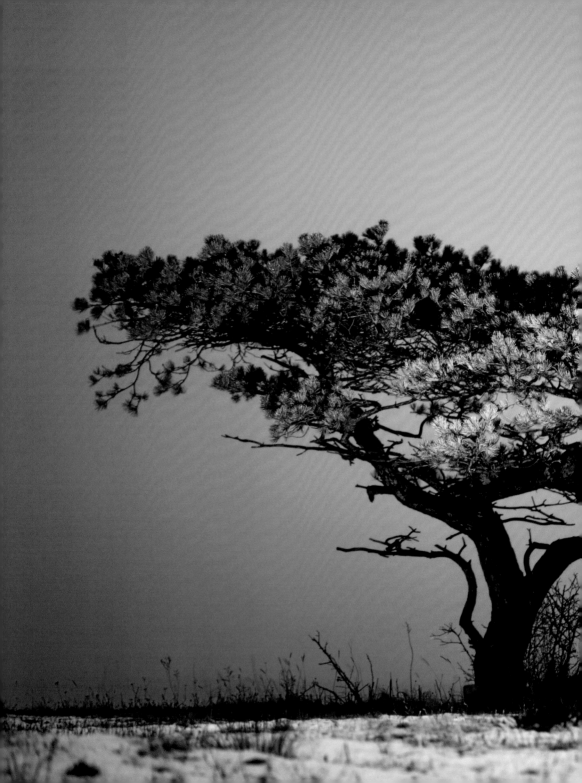

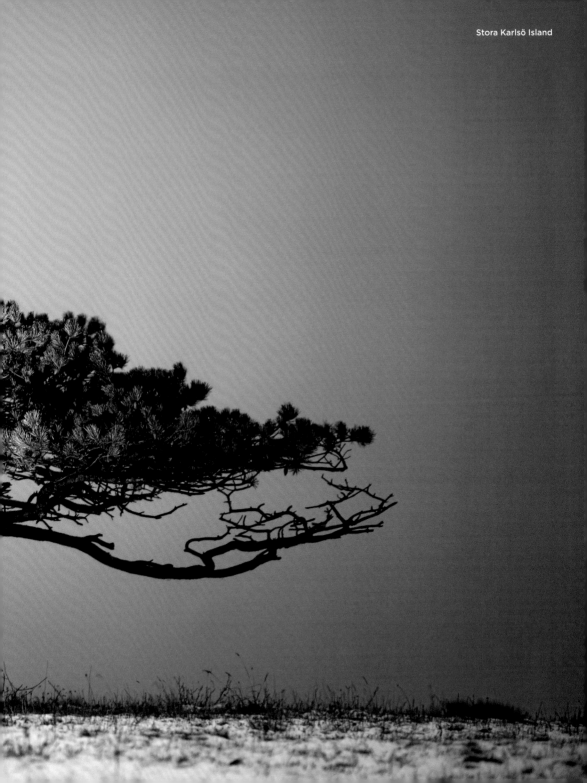

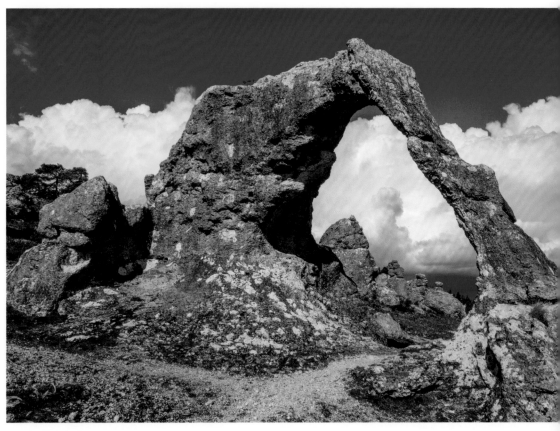

Gamla Hamn, Farö Island

Rocks and Ruins

Mystical and bizarre, these stone giants stand up to 10 m (33 ft) high in the sea, giving free rein to fantasy and superstition. Dog, virgin or gateway are only a few of the names for the limestone columns modeled by wind, water and weather, which rise into the sky on land and along the coast. The stone formations, known as *raukar* in Sweden, have been created over millions of years and give Gotland a unique landscape which is just as impressive as the many ruins on the island. The historical sites, rune stones and early historical settlements are a true paradise for those interested in history.

Raukar et ruines

Les *raukar,* étranges géants de pierre dont certains se dressent au milieu de la mer sur dix mètres de hauteur, ont toujours nourri l'imagination et la superstition. Réparties entre le sable et l'eau, ces colonnes de calcaire sculptées par les intempéries sont affublées de noms tels que « Chien », « Jeune Fille ou « Porte ». Ces formations minérales, fruits d'une érosion qui s'est déroulée sur des millions d'années, contribuent à l'originalité de Gotland et émerveillent les touristes, au même titre que les nombreuses ruines de l'île. Les sites historiques, les pierres runiques et les vestiges de communautés préhistoriques sont un véritable Eldorado pour les passionnés d'histoire.

Rauken und Ruinen

Mystisch und bizarr stehen zum Teil bis zu 10 m hohe steinerne Riesen im Meer und lassen Fantasie und Aberglaube freien Lauf. Hund, Jungfrau oder Pforte sind nur wenige Namen für die durch Wind, Wasser und Witterung modellierten Kalksteinsäulen, die an Land und Küste in den Himmel ragen. Die Steinformationen, im schwedischen *raukar* genannt, entstanden in Millionen von Jahren und bescheren Gotland ein einzigartiges Landschaftsbild – das ebenso bestaunt wird wie die vielen Ruinen der Insel. Die historischen Stätten, Runensteine und frühgeschichtlichen Siedlungen sind ein wahres Dorado für Geschichtsinteressierte.

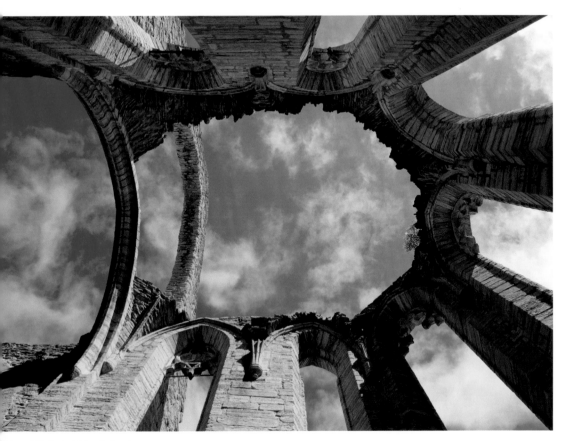

Ruins of St. Karin, Visby, Gotland

Formaciones geológicas y ruinas

Místicos y extraños, algunos gigantes de piedra de hasta 10 m de altura se paran en el mar, dando rienda suelta a la fantasía y a la superstición. Perro, virgen o puerta son solo algunos nombres para las columnas de piedra caliza modeladas por el viento, el agua y el clima, que se elevan hacia el cielo en tierra y costa. Las formaciones de piedra, llamadas *raukar* en sueco, han sido creadas a lo largo de millones de años y dan a Gotland un paisaje único, tan admirable como las numerosas ruinas de la isla. Los sitios históricos, las piedras rúnicas y los primeros asentamientos históricos son un verdadero paraíso para los interesados en la historia.

Falécias e ruínas

Alguns gigantes de pedra no mar, místicos e bizarros de até 10 m de altura, e deixam a fantasia e a superstição correrem soltos. Cão, virgem ou portão são apenas alguns nomes para as colunas de calcário modeladas pelo vento, água e clima, que sobem ao céu na terra e na costa. As formações de pedra, chamadas *raukar* em sueco, foram criadas ao longo de milhões de anos e dão a Gotland uma paisagem única – que é tão admirável quanto as muitas ruínas da ilha. Os locais históricos, as runas e as primeiras povoações históricas são um verdadeiro paraíso para os interessados na história.

Raukar en ruïnes

Mystiek en bizar steken sommige stenen reuzen wel 10 meter hoog op uit zee. Ze geven aanleiding tot fantasie en bijgeloof. Hond, maagd en poort zijn slechts enkele namen voor de door wind, water en weer gemodelleerde kalkstenen zuilen die op het land en aan de kust de lucht in steken. De stenen formaties, in het Zweeds *raukar* genoemd, ontstonden in de loop van miljoenen jaren en geven het landschap van Gotland een uniek aanzien. Ook de vele ruïnes op het eiland worden bewonderd. De historische plaatsen, runenstenen en prehistorische nederzettingen zijn een paradijs voor geschiedenisliefhebbers.

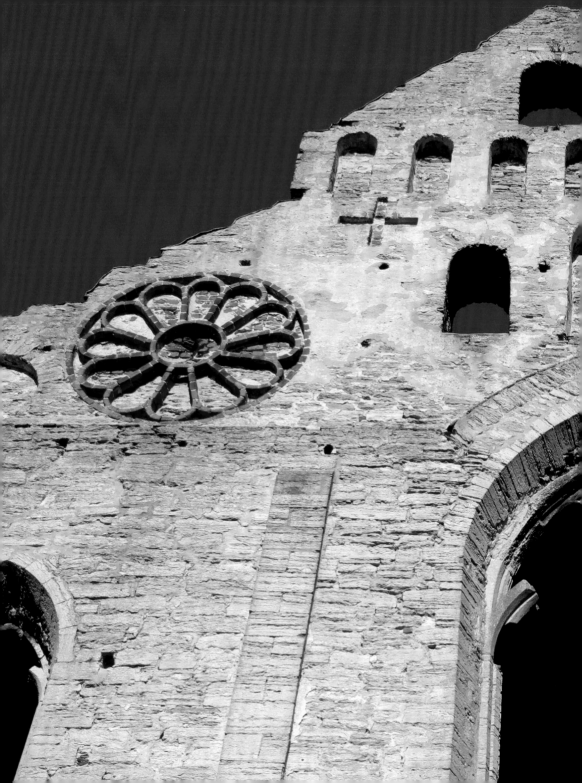

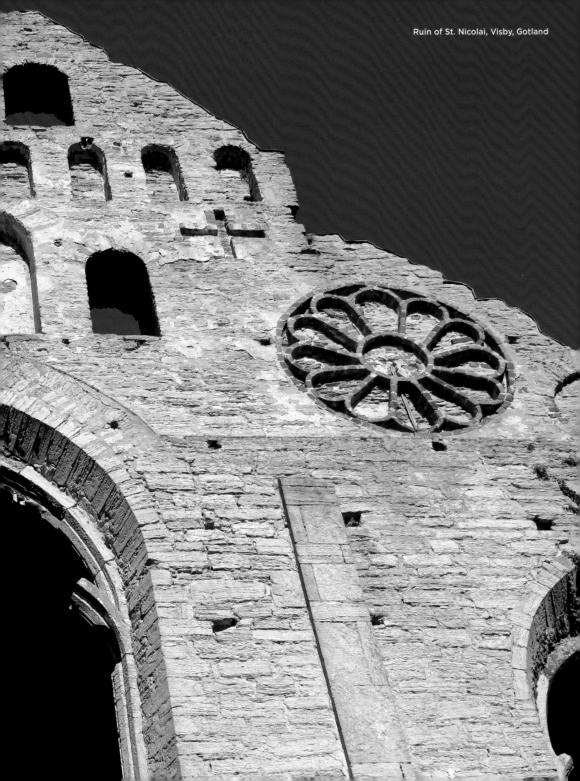

Ruin of St. Nicolai, Visby, Gotland

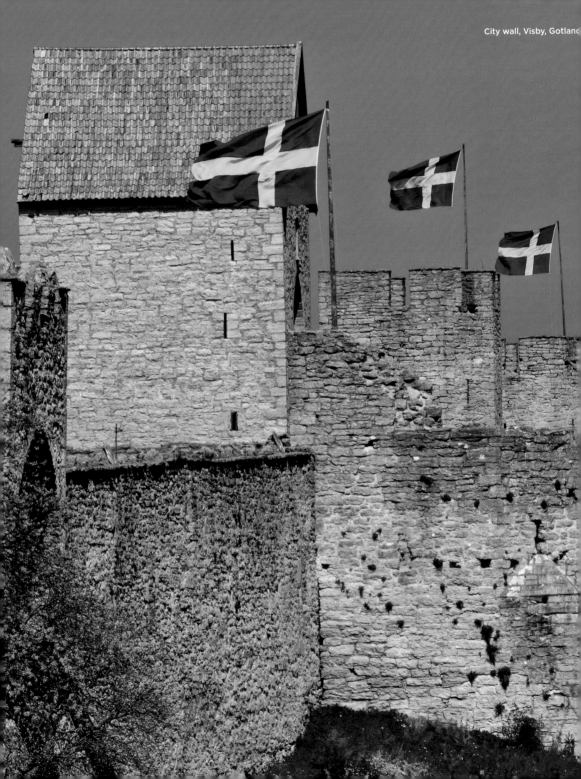

City wall, Visby, Gotland

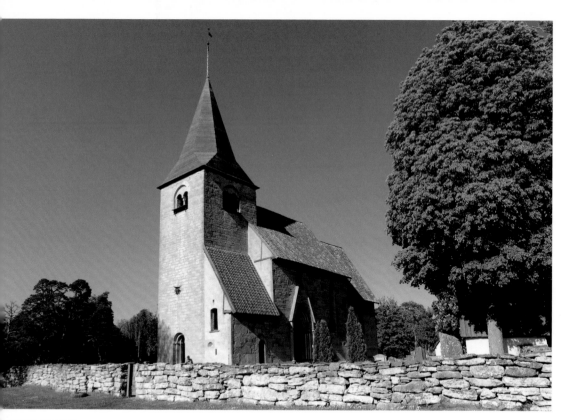

o Church, Gotland

o Church

e Bro Kyrka, about 12 km (7,5 mi)
rtheast of Visby, is one of the sacred
hts of Gotland—it seems that there
s already a sacrificial site here during
e-Christian times. The Votivkirche was
ilt in 1250 as a symbol of thanksgiving
d salvation for seafarers. Stones from a
evious building, which was one hundred
ars older, were also used.

esia de Bro

Bro kyrka, a unos 12 km al noreste de
by, es uno de los lugares sagrados de
erés de Gotland; presumiblemente había
lugar de sacrificio en el mismo lugar ya
tiempos precristianos. La iglesia votiva
otivkirche) fue construida en 1250 como
no de acción de gracias y salvación para
marineros. Para construirla se utilizaron
dras de un edificio anterior cien años
s antiguo.

L'église de Bro

Située à environ 12 km au nord-est de
Visby, cette église (Bro kyrka) est l'un des
édifices religieux les plus intéressants de
Gotland. Elle a sans doute remplacé un
site païen où se déroulaient des sacrifices.
Cette église votive a été édifiée en 1250
par les marins reconnaissants d'avoir eu la
vie sauve. Des pierres d'un sanctuaire déjà
centenaire ont été réemployées à cet effet.

Igreja do Irmão

O Bro kyrka, a cerca de 12 km a nordeste
de Visby, é um dos pontos turísticos mais
sagrados de Gotland – presumivelmente
havia um lugar de sacrifício no mesmo
lugar já nos tempos pré-cristãos. A Igreja
Votiva foi construída em 1250 como
sinal de ação de graças e salvação para
os marinheiros. Pedras de um edifício
antecessor cem anos mais velho também
foram usadas.

Kirche von Bro

Die Bro kyrka, etwa 12 km nordöstlich
von Visby, gehört zu den sakralen
Sehenswürdigkeiten Gotlands – vermutlich
befand sich an gleicher Stelle bereits in
vorchristlicher Zeit eine Opferstätte. Die
Votivkirche wurde 1250 als Zeichen des
Dankes und der Rettung für Seefahrer
erbaut. Verwendet wurden dazu auch
Steine von einem hundert Jahre älteren
Vorgängerbau.

Kerk van Bro

De Bro kyrka, zo'n 12 km ten noordoosten
van Visby, behoort tot de gewijde
bezienswaardigheden van Gotland.
Vermoedelijk stond op dezelfde plek al in
de voorchristelijke tijd een offerplaats. De
votiefkerk werd in 1250 gebouwd als teken
van dank voor de redding van zeelieden.
Er werden daarvoor ook stenen van een
honderd jaar oudere voorganger gebruikt.

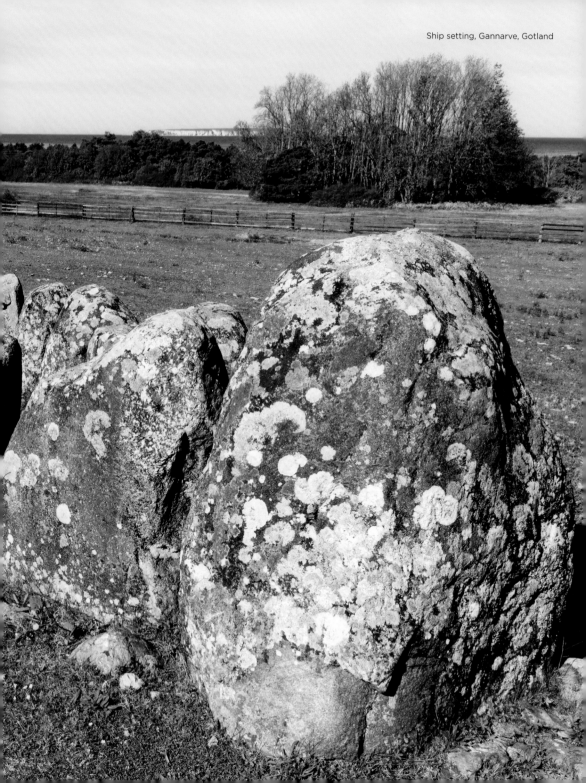

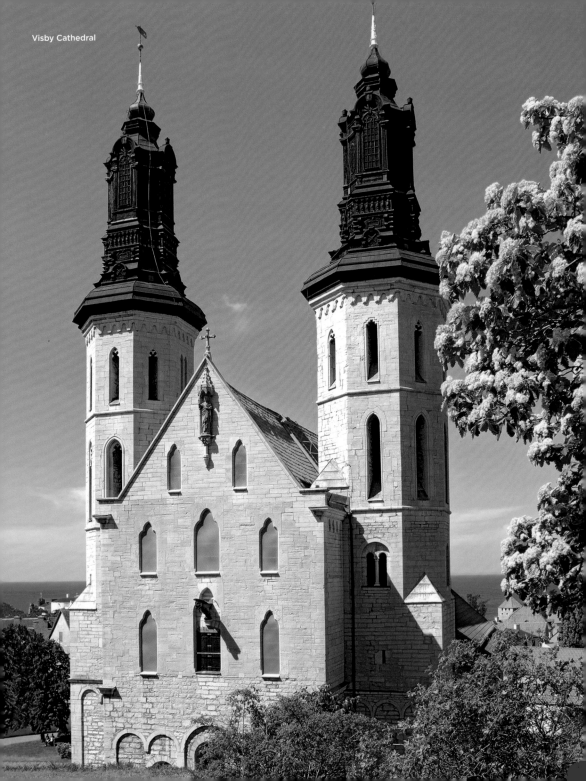

Visby Cathedral

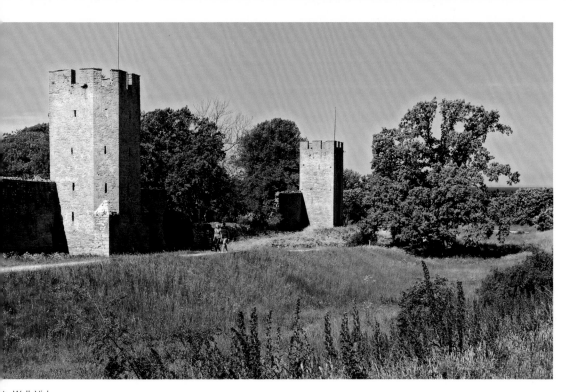

ty Wall, Visby

ortified Wall

sby looks almost like a fairytale with its
ty wall built of pale limestone. The 3.5
n (2 mi) long building with more than
0 watchtowers, imposing city gates and
idges dates back to the 13th century,
d its construction took almost 100 years.
e complex was intended to protect the
anseatic city – including against the rural
opulation – and is today one of the best
eserved medieval city fortifications in
rope.

uro fortificado

sby parece un cuento de hadas con su
uralla de piedra caliza clara. El edificio
3,5 km de largo con más de 40
rres de vigilancia, imponentes puertas
la ciudad y puentes se remonta al
glo XIII; su construcción duró casi 100
os. El complejo estaba destinado a
oteger la ciudad hanseática (también
ntra la población rural) y hoy es una
las fortificaciones medievales mejor
nservadas de Europa.

Des remparts efficaces

Dans sa ceinture de pierres de calcaire
blanc, Visby semble surgir d'un conte
de fées. Cette muraille longue de 3,5 km
est ponctuée de plus de 40 tours de
guet, de portes imposantes et de ponts.
Sa construction, qui a commencé au
xiiie siècle, a duré plus de cent ans.
Ces remparts, qui devaient protéger
la ville hanséatique – y compris contre
les habitants des environs – se classent
aujourd'hui parmi les fortifications
médiévales les mieux conservées d'Europe.

Parede fortificada

Visby parece quase um conto de
fadas com sua muralha construída de
calcário claro. A construção de 3,5 km
de comprimento com mais de 40 torres
de vigia, imponentes portões e pontes
da cidade remonta ao século XIII, a
sua construção levou quase 100 anos.
O complexo destinava-se a proteger a
cidade hanseática – também contra a
população rural – e é hoje uma das mais
bem preservadas fortificações da cidade
medieval na Europa.

Wehrhafte Mauer

Fast märchenhaft wirkt Visby durch
die aus hellem Kalkstein errichtete
Stadtmauer. Der 3,5 km lange Bau mit
mehr als 40 Wachtürmen, imposanten
Stadttoren und Brücken geht auf das
13. Jahrhundert zurück, seine Errichtung
dauerte fast 100 Jahre. Die Anlage sollte
die Hansestadt schützen – auch gegen die
Landbevölkerung – und gehört heute zu
den am besten erhaltenen mittelalterlichen
Stadtbefestigungen Europas.

Versterkte muur

Visby ziet er met zijn stadsmuur van
lichte kalksteen haast sprookjesachtig uit.
Het 3,5 km lange bouwwerk met meer
dan veertig wachttorens, imposante
stadspoorten en bruggen stamt uit de
13e eeuw. De bouw ervan duurde bijna
honderd jaar. De muur was bedoeld om de
Hanzestad te beschermen – ook tegen de
plattelandsbevolking – en is tegenwoordig
een van de best bewaarde middeleeuwse
stadsversterkingen van Europa.

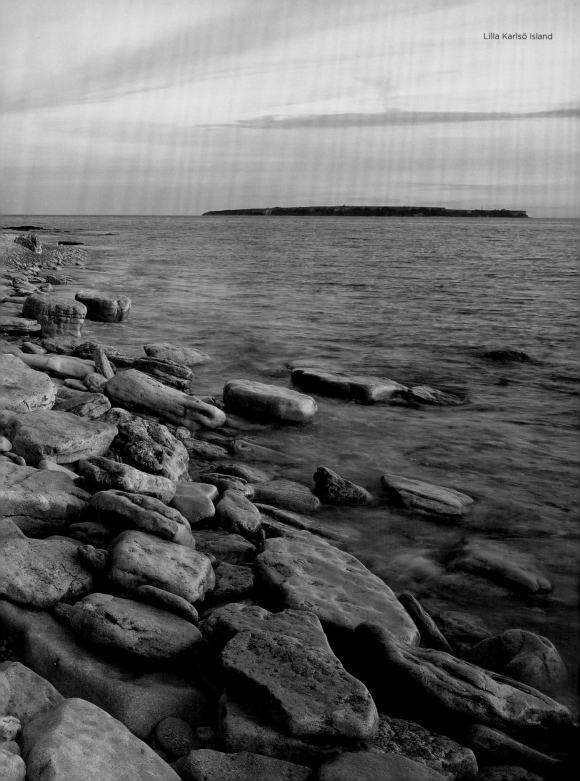
Lilla Karlsö Island

St. Birgitta's chapel, Kapelludden, Öland

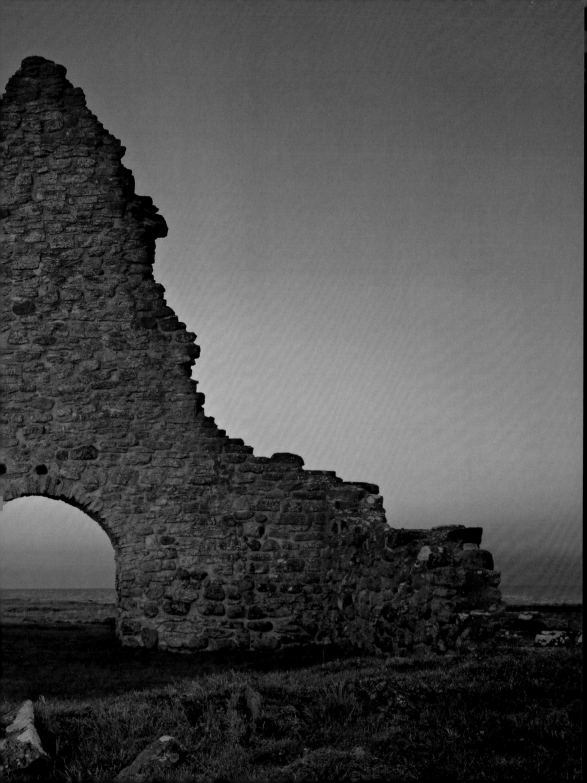

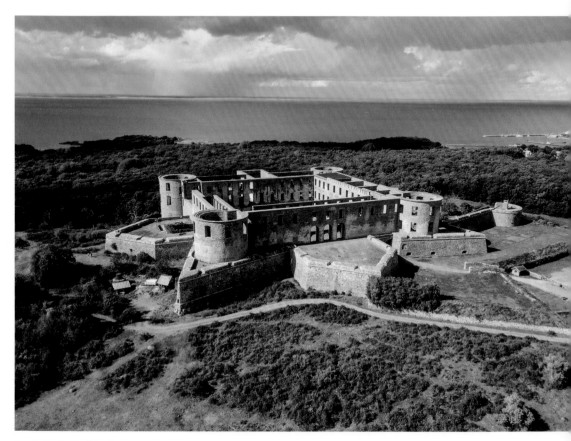

Borgholm Castle, Öland

Öland

In the west of the island, Borgholm Castle, "the most beautiful castle ruin in Scandinavia", towers over Öland and impresses with a size of over 5000 m² (53,820 sqmi). In 1806 a fire destroyed the baroque castle built by King Karl X. Gustav in the 17th century, and the well preserved limestone walls still give an idea of the splendor of earlier times. The island also attracts visitors with its windmills, wide sandy beaches, 75 nature reserves, insights into geological history, nature with southern charm and a unique heath landscape, the "Stora Alvaret", which grows on a limestone plateau and is a UNESCO World Heritage Site.

Öland

À l'ouest de l'île, Borgholm, « le plus beau château en ruine de Scandinavie », domine Öland. Ses plus de 5000 m² ne manquent jamais d'impressionner. En 1806, un incendie détruisit ce château baroque édifié au XVIIᵉ siècle par le roi Charles-Gustave et ses murs encore debout donnent une idée de son ancien éclat. Öland possède d'autres atouts, comme ses moulins à vent, ses vastes plages de sable, ses 75 réserves naturelles, les traces de son histoire géologique, sa nature au charme méridional et les landes exceptionnelles de Stora Alvaret, qui s'étendent sur un plateau calcaire et appartiennent au Patrimoine mondial de l'Unesco.

Öland

Im Westen der Insel thront Schloss Borgholm, „die schönste Burgruine Skandinaviens", über Öland und beeindruckt mit einer Größe von über 5000 m². Ein Feuer zerstörte 1806 das im 17. Jahrhundert von König Karl X. Gustav erbaute Barockschloss, und die erhalten gebliebenen Kalksteinmauern lassen noch heute den Glanz früherer Zeiten erahnen. Die Insel lockt darüber hinaus mit ihren Windmühlen, weiten Sandstränden, 75 Naturreservaten, Einblicken in die geologische Geschichte, einer Natur mit südländischem Charme und einer einzigartigen Heidelandschaft, der „Stora Alvaret", die auf einem Kalkplateau wächst und zum UNESCO-Weltkulturerbe zählt.

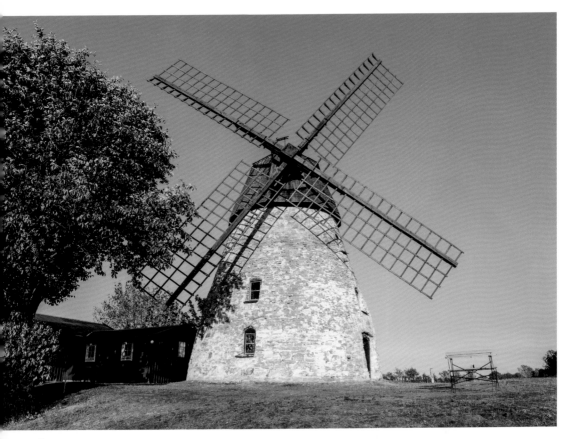

Vindmill, Öland

Öland

n el oeste de la isla, el castillo de
Borgholm, "la ruina más bella de los
castillos escandinavos", se eleva sobre
Öland e impresiona con sus más de
5000 m². En 1806 un incendio destruyó
el castillo barroco construido por el rey
Carlos X Gustavo en el siglo XVII, y las
paredes de piedra caliza que aún se
conservan nos dan una idea del esplendor
de épocas anteriores. La isla también
atrae a los visitantes con sus molinos de
viento, sus amplias playas de arena, sus 75
reservas naturales, su historia geológica,
su naturaleza con encanto sureño y un
paisaje de brezal único, la "Stora Alvaret",
que crece en una meseta de piedra caliza
y es Patrimonio de la Humanidad de
la UNESCO.

Öland

No oeste da ilha, o Castelo de Borgholm,
"a mais bela ruína do castelo na
Escandinávia", se ergue sobre Öland e
impressiona com um tamanho de mais de
5000 m². Em 1806, um incêndio destruiu o
castelo barroco construído pelo rei Carlos
X Gustav no século XVII, e as paredes de
pedra calcária preservadas ainda dão uma
idéia do esplendor dos tempos anteriores.
A ilha também atrai visitantes com os
seus moinhos de vento, amplas praias de
areia, 75 reservas naturais, uma visão da
história geológica, natureza com encanto
do sul e uma paisagem de urze única, a
planície "Stora Alvaret", que cresce num
planalto calcário e é Património Mundial
da UNESCO.

Öland

In het westen van het eiland torent kasteel
Borgholm, 'de mooiste kasteelruïne
van Scandinavië', boven Öland uit en
imponeert met een oppervlak van ruim
5000 m². In 1806 verwoestte een brand
het barokke kasteel, dat in de 17e eeuw
door koning Karel X Gustaaf van Zweden
was gebouwd, maar de bewaard gebleven
kalkstenen muren geven nog een idee van
de vroegere pracht en praal. Het eiland
trekt bovendien bezoekers met zijn molens,
brede zandstranden, 75 natuurreservaten,
inkijkjes in de geologische geschiedenis,
natuur met zuidelijke charme en een uniek
heidelandschap, de Stora Alvaret, die op
een kalksteenplateau groeit en Unesco-
werelderfgoed is.

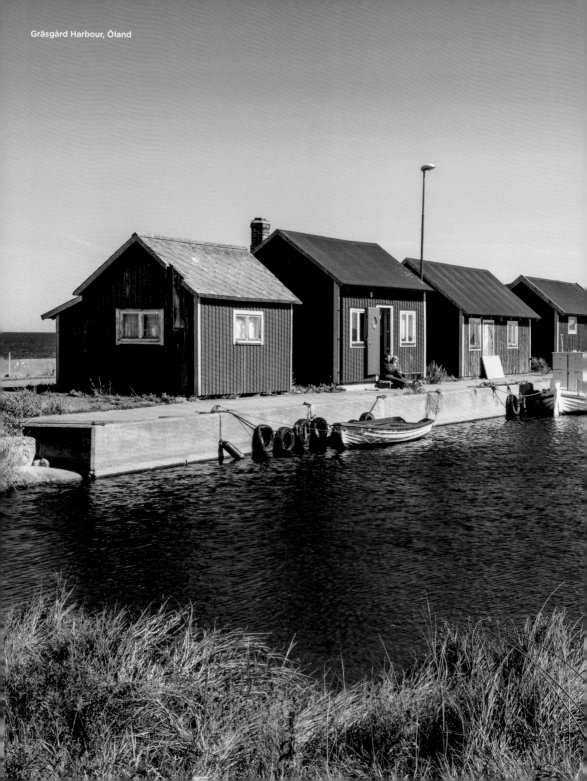

Gräsgård Harbour, Öland

Windmill, Vickleby, Öland

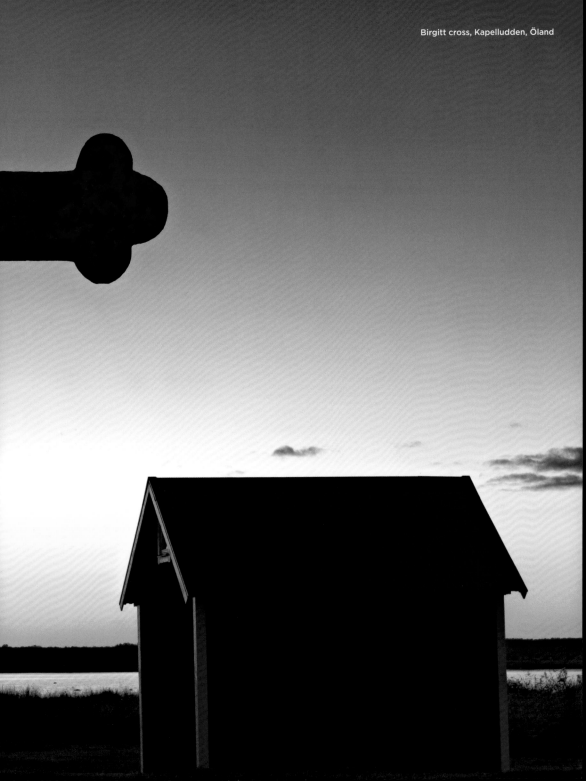

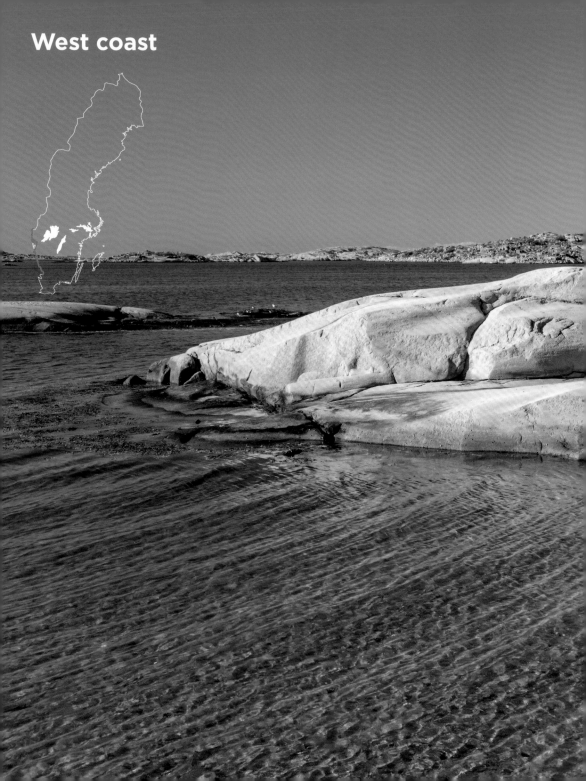

West coast

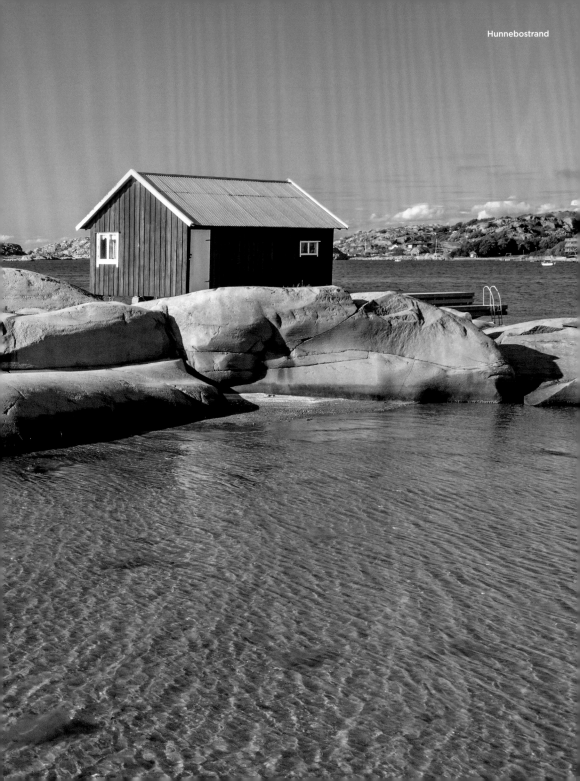

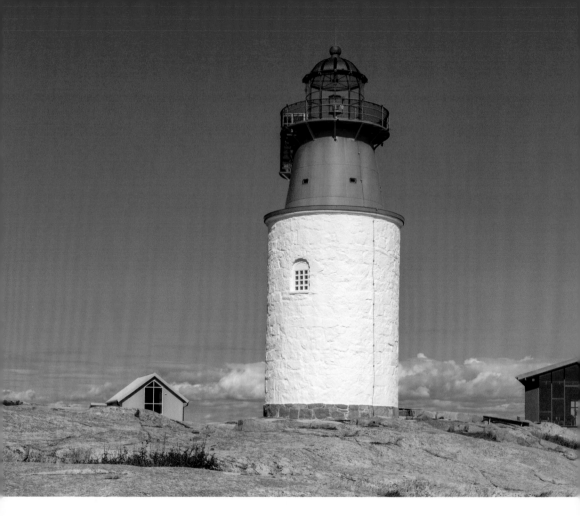

West coast

The region around Bohuslän is characterized by smooth rocks, wide coastal landscapes with lighthouses and picturesque harbors. The west coast runs from Ängelholm through Göteborg to the Norwegian border and is quite varied. Here you can find island after island, many bare and barren – but still full of life. Traditional fishing villages and colorful seaside resorts contrast maritime hustle and bustle with peaceful tranquility. Idyllic and characteristic at the same time, the innumerable boats and fishing vessels swarming with seagulls are idyllic and typical of the area. Prehistoric rock paintings and the first marine national park of Sweden are also part of the wonderful west coast.

La côte ouest

La province de Bohuslän se distingue par ses falaises lisses et ses panoramas d'un littoral sans fin, agrémenté de phares et de ports pittoresques. D'Ängelholm à Göteborg, puis à la frontière avec la Norvège, la côte ouest se révèle d'une grande diversité. Les îles, souvent désolées et pourtant pleines de vie, se succèdent. Les villages traditionnels de pêcheurs et leur activité alternent avec les stations balnéaires bigarrées et leur quiétude contemplative. Les bateaux, dont les cotres des pêcheurs entourés de nuées de mouettes, sont aussi amusants que typiques. En prime, cette merveilleuse côte ouest peut se targuer de posséder des peintures rupestres et le premier parc maritime national de Suède.

Westküste

Glattgeschliffene Felsen, weite Küstenlandschaften mit Leuchttürmen und malerische Häfen prägen die Region um Bohuslän. Die Westküste verläuft von Ängelholm über Göteborg bis zur norwegischen Grenze und zeigt sich wechselhaft. Hier liegt Insel an Insel, viele kahl und karg – und trotzdem voller Leben. Urige Fischerdörfer und farbenfrohe Badeorte wechseln zwischen maritimem Treiben und kontemplativer Ruhe. Idyllisch und charakteristisch zugleich sind unzählige Boote und von Möwen umschwärmte Fischkutter. Aber auch vorzeitliche Felszeichnungen und der erste Meeres-Nationalpark Schwedens gehören zur wundervollen Westküste.

osta oeste

a región alrededor de Bohuslän se
aracteriza por sus rocas lisas, amplios
aisajes costeros con faros y pintorescos
uertos. La costa oeste va desde
ngelholm, a través de Gotemburgo y
asta la frontera noruega, y es cambiante.
qui hay una isla tras otra, muchas
esnudas y estériles, pero todavía llenas de
da. Tradicionales pueblos de pescadores
coloridos balnearios se alternan entre
bullicio marítimo y la tranquilidad
ontemplativa. Los innumerables barcos
embarcaciones de pesca plagadas de
aviotas son idílicos y característicos al
ismo tiempo. Pero también las pinturas
pestres prehistóricas y el primer parque
acional marino de Suecia pertenecen a la
aravillosa costa oeste.

Costa oeste

La región alrededor de Bohuslän se
caracteriza por sus rocas lisas, amplios
paisajes costeros con faros y pintorescos
puertos. La costa oeste va desde
Ängelholm, a través de Gotemburgo y
hasta la frontera noruega, y es cambiante.
Aquí hay una isla tras otra, muchas
desnudas y estériles, pero todavía llenas de
vida. Tradicionales pueblos de pescadores
y coloridos balnearios se alternan entre
el bullicio marítimo y la tranquilidad
contemplativa. Los innumerables barcos
y embarcaciones de pesca plagadas de
gaviotas son idílicos y característicos al
mismo tiempo. Pero también las pinturas
rupestres prehistóricas y el primer parque
nacional marino de Suecia pertenecen a la
maravillosa costa oeste.

Westkust

De regio rond Bohuslän wordt getekend
door gladgeslepen rotsen, weidse
kustlandschappen met vuurtorens en
schilderachtige havens. De westkust
loopt van Ängelholm via Göteborg naar
de Noorse grens en is zeer afwisselend.
Hier ligt eiland na eiland, waarvan vele
kaal en schraal zijn, maar desondanks vol
leven zitten. Authentieke vissersdorpjes
en kleurrijke badplaatsen wisselen de
drukte op zee af met contemplatieve
rust. Idyllisch en karakteristiek tegelijk
zijn de talloze boten en door meeuwen
omzwermde vissersschepen. Maar ook
prehistorische rotstekeningen en het eerste
nationale zeepark van Zweden horen bij de
prachtige westkust.

Kallbadhus, Varberg

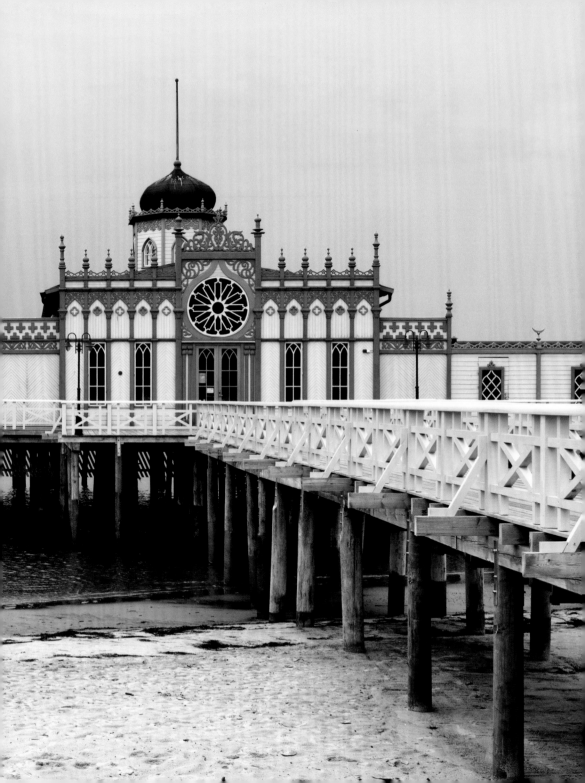

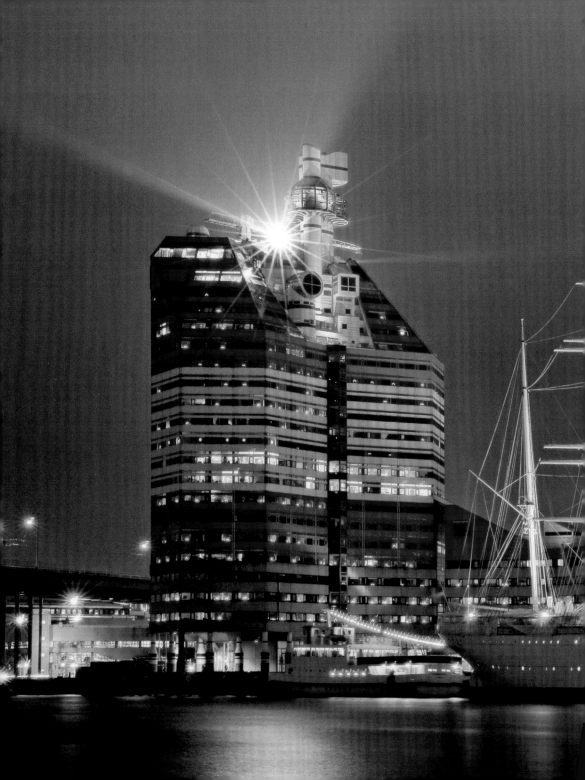

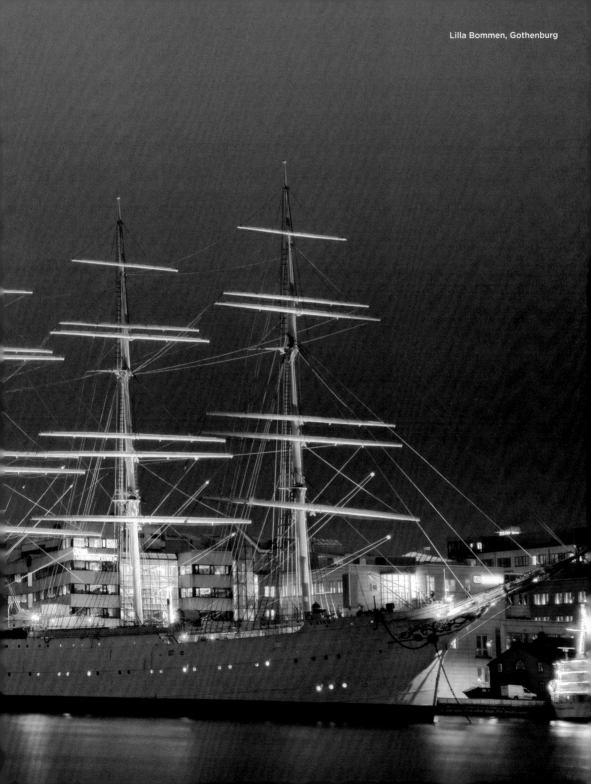

Lilla Bommen, Gothenburg

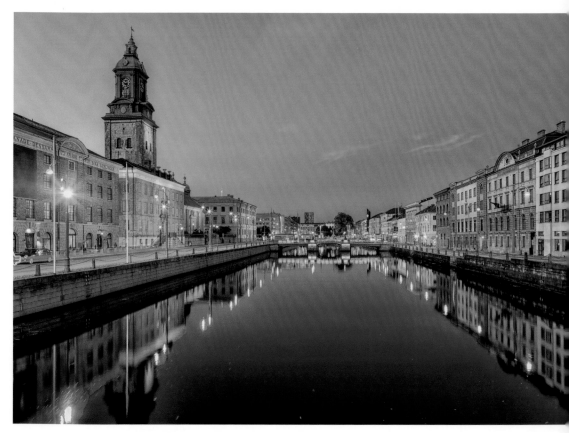

Big Harbor Canal, German Church, Gothenburg

Gothenburg

Gothenburg, the second largest city in Sweden, is both beautiful and cosmopolitan. This port city with its history and relaxed atmosphere has a lot to offer: from sights such as "Feskekôrka", the church-shaped fish market, the Haga district, opera houses, child-friendly museums, art and design to attractive shopping areas, top restaurants and a vibrant nightlife. Canals and bridges are a feature of the northern end of the Kattegat, as are numerous parks and good connections to the green surroundings. Excursions to the fascinating west coast are just as delightful as a day in the Liseberg amusement park.

Göteborg

Göteborg, deuxième ville de Suède, est aussi somptueuse qu'ouverte sur le monde. Ce port plein d'histoire et à l'ambiance décontractée a tout pour plaire : des sites touristiques comme le Feskekôrka, sa grande halle aux poissons en forme d'église, le quartier de Haga, des opéras, des musées destinés aux enfants, de l'art et du design, mais aussi des possibilités intéressantes de shopping, des restaurants de grande classe et enfin tout ce qu'il faut pour les noctambules. Ses canaux et ses ponts caractérisent la métropole à la pointe nord du Cattégat, de même que son chapelet de parcs et l'accès facile à la campagne environnante. Les excursions sur la côte ouest sont tout aussi conseillées qu'une journée dans le parc d'attractions de Liseberg.

Göteborg

Wunderschön und weltoffen ist Göteborg, die zweitgrößte Stadt Schwedens. Die Hafenstadt mit Geschichte und entspannter Atmosphäre hat viel zu bieten: von Sehenswürdigkeiten wie der kirchenförmigen Fischgroßmarkthalle „Feskekôrka", über den Stadtteil Haga, Opernhäuser, kinderfreundliche Museen, Kunst und Design bis hin zu attraktiven Einkaufsmöglichkeiten, Spitzenrestaurants und einem pulsierenden Nachtleben. Kanäle und Brücken prägen die Metropole am Nordende des Kattegat ebenso wie zahlreiche Parks und die gute Anbindung an die grüne Umgebung. Ausflüge an die faszinierende Westküste sind ebenso reizvoll wie ein Tag im Vergnügungspark Liseberg.

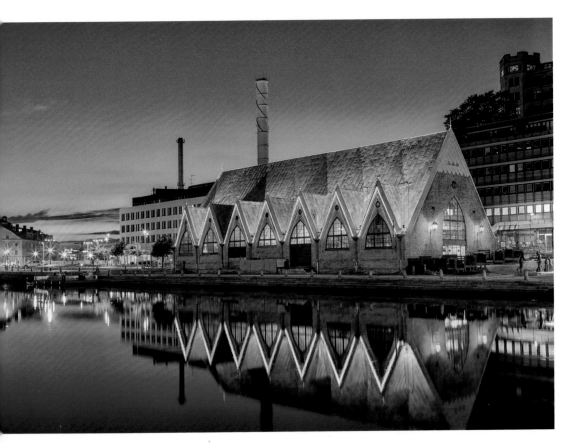

sh Church, Gothenburg

otemburgo

otemburgo, la segunda ciudad
ás grande de Suecia, es hermosa y
osmopolita. La ciudad portuaria, con
u historia y su ambiente relajado, tiene
ucho que ofrecer: desde lugares de
terés como el mercado de pescado en
orma de iglesia "Feskekôrka", el barrio
e Haga, teatros de ópera, museos
cogedores para los niños, arte y diseño
asta atractivas tiendas, los mejores
staurantes y una vibrante vida nocturna.
anales y puentes caracterizan la
etrópoli en el extremo norte del Kattegat,
sí como numerosos parques y buenas
onexiones con los verdes alrededores. Las
xcursiones a la fascinante costa oeste son
n deliciosas como un día en el parque de
racciones de Liseberg.

Gotemburgo

Bonita e cosmopolita é Gotemburgo, a
segunda maior cidade da Suécia. A cidade
portuária com sua história e atmosfera
descontraída tem muito a oferecer: de
pontos turísticos como o mercado de
peixe em forma de igreja "Feskekôrka", o
bairro de Haga, casas de ópera, museus
para crianças, arte e design e também
atraentes lojas, excelentes restaurantes e
uma vibrante vida noturna. Canais e pontes
caracterizam a metrópole no extremo
norte do Kattegat, assim como numerosos
parques e boas conexões com o ambiente
verde. Excursões para a fascinante costa
oeste são tão atraentes quanto um dia no
parque de diversões de Liseberg.

Göteborg

Mooi en internationaal georiënteerd is
Göteborg, de op een na grootste stad
van Zweden. De havenstad met zijn
geschiedenis en ontspannen sfeer heeft
veel te bieden: van bezienswaardigheden
zoals de kerkvormige markthal voor vis,
Feskekôrka, de wijk Haga, operagebouwen,
kindvriendelijke musea, kunst en design
tot aantrekkelijke winkels, toprestaurants
en een bruisend nachtleven. Grachten en
bruggen kenmerken de metropool aan de
noordkant van het Kattegat, evenals talrijke
parken en een goede bereikbaarheid van
de groene omgeving. Excursies naar de
fascinerende westkust zijn even heerlijk als
een dag in het pretpark Liseberg.

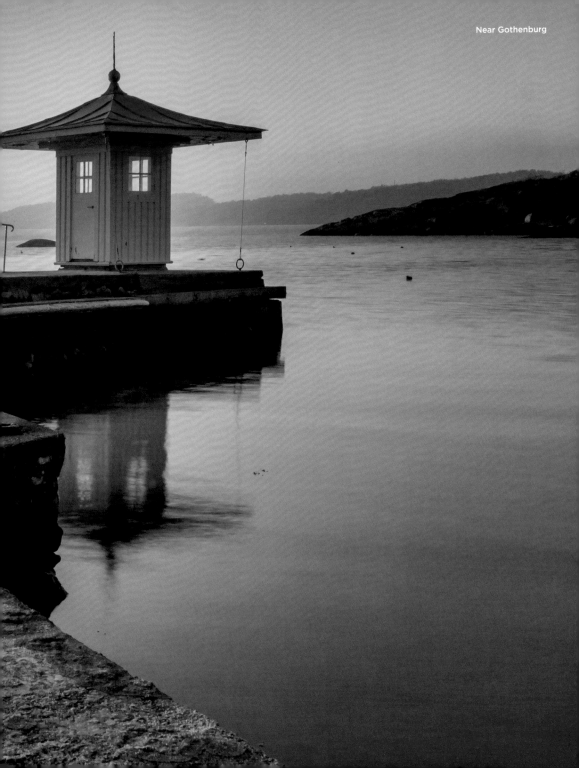

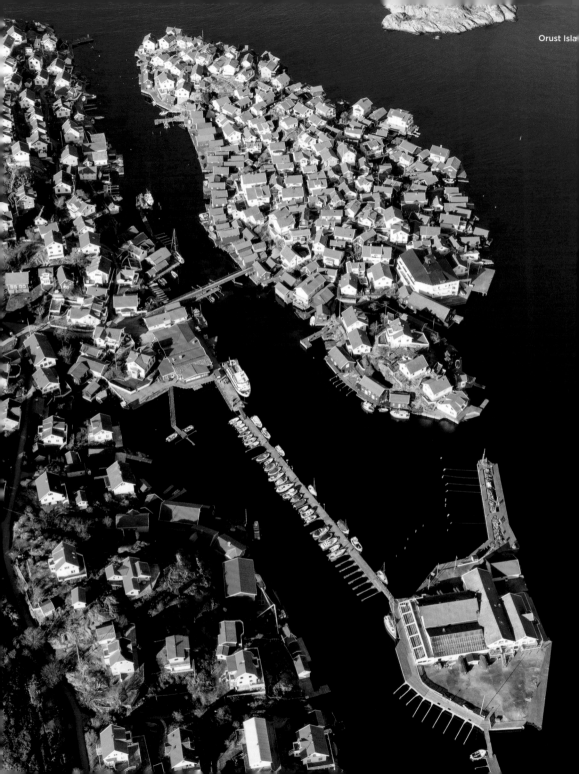

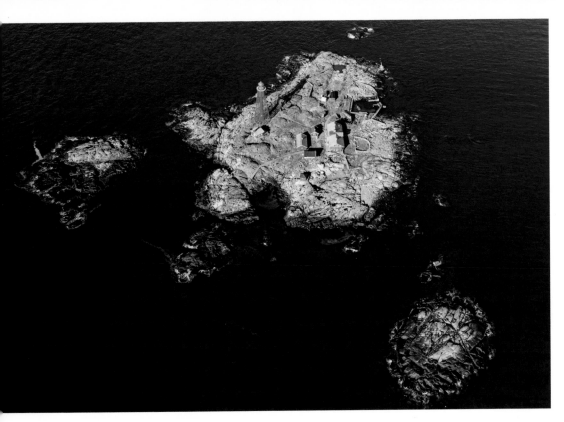

ter Noster Island

Orust

ust, Sweden's third largest island, lies
rth of Gothenburg between countless
ands. It is a popular holiday and weekend
stination, and offers an impressive
ndscape, many beaches and bays as well
historical places of interest. Throughout
e island there are important sites with
onze Age tombs, rock carvings and
ne stones.

rust

rust, la tercera isla más grande de Suecia,
encuentra al norte de Gotemburgo,
stino popular de vacaciones y fines de
mana y ofrece un paisaje impresionante,
uchas playas y bahías, así como lugares
interés histórico. A lo largo de la isla hay
portantes yacimientos con tumbas de
Edad de Bronce, esculturas rupestres y
edras rúnicas.

Orust

Située au nord de Göteborg et au milieu
d'une myriade d'îles, Orust se trouve être la
troisième île de Suède. Les Suédois aiment
y passer un week-end ou leurs vacances
pour profiter de ses paysages inoubliables,
des nombreuses plages et des baies, mais
aussi pour découvrir des témoignages de
leur histoire. En effet, l'île est parsemée de
tombes de l'âge du bronze, de gravures
rupestres et de pierres runiques.

Orust

Orust, a terceira maior ilha da Suécia, fica
ao norte de Gotemburgo, entre inúmeros
arquipélagos. É um destino popular de
férias e fins de semana e oferece uma
paisagem impressionante, muitas praias e
baías, bem como locais históricos. Por toda
a ilha há locais importantes com túmulos
da Idade do Bronze, gravuras rupestres e
pedras rúnicas.

Orust

Nördlich von Göteborg liegt zwischen
unzähligen Schären Schwedens drittgrößte
Insel, Orust. Sie ist beliebtes Urlaubs-
und Wochenendziel und hat neben
einer beeindruckenden Landschaft,
vielen Stränden und Badebuchten auch
historische Sehenswürdigkeiten zu bieten.
So sind auf der ganzen Insel bedeutende
Orte mit Gräbern aus der Bronzezeit,
Felsritzungen oder Runensteine zu finden.

Orust

Orust, het op twee na grootste eiland van
Zweden, ligt ten noorden van Göteborg
tussen talloze scheren. Het is een populaire
vakantie- en weekendbestemming en
biedt een indrukwekkend landschap,
veel stranden en baaien en historische
bezienswaardigheden. Overal op het eiland
zijn belangrijke plaatsen met graven uit de
bronstijd, rotstekeningen en runenstenen
te vinden.

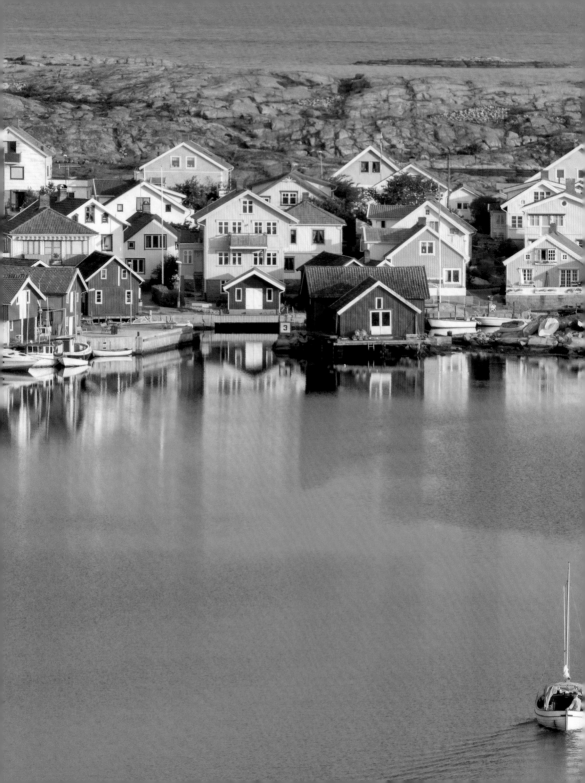

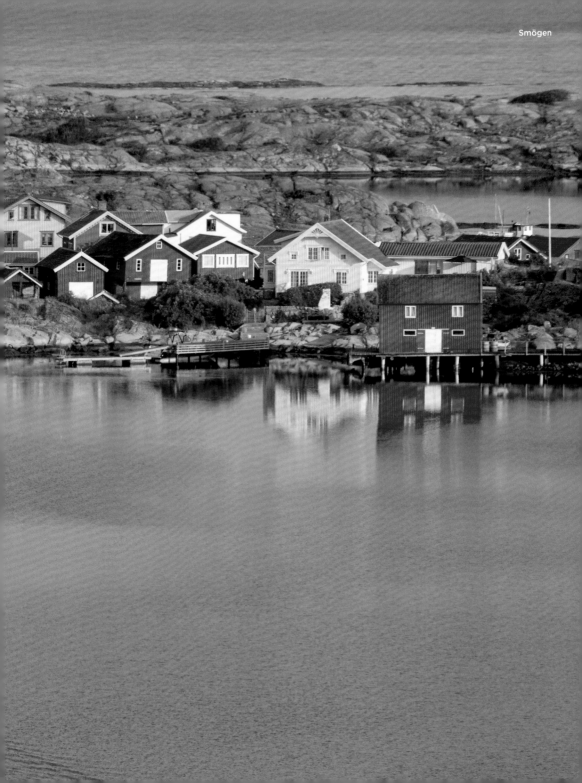

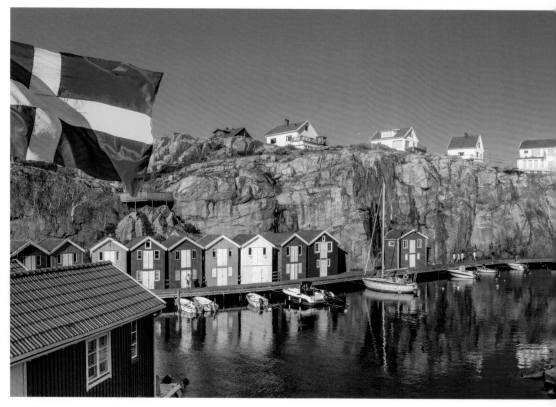
Smögen

Smögen

The small village of Smögen is famous for the "Smögenbryggan", an almost 1 km (3281 ft) long wooden jetty with former boat sheds, which runs along the renowned granite rocks of the western Swedish landscape. This idyllic and colorful fishing village combines original charm with hustle and bustle in summer, tranquility and solitude in winter.

Smögen

El pequeño pueblo de Smögen es famoso por el "Smögenbryggan", un muelle de madera de casi 1 km de largo con antiguos cobertizos de barcos, que discurre a lo largo de las rocas de granito conocidas por su paisaje sueco occidental. El idílico y colorido pueblo de pescadores combina el encanto original con el bullicio en verano y la tranquilidad y la soledad en invierno.

Smögen

Le petit village de Smögen doit sa notoriété à son *Smögenbryggan,* une jetée en bois de près d'un kilomètre, bordée d'anciennes cabanes de pêcheurs, qui longe les rochers de granit emblématiques de l'ouest de la Suède. En été, ce port de pêche aussi charmant que haut en couleur vit à un rythme endiablé, puis retrouve son calme et sa tranquilité en hiver.

Smögen

A pequena vila de Smögen é famosa pelo "Smögenbryggan", um cais de madeira com quase 1 km de extensão e antigos galpões de barcos, que corre ao longo das rochas de granito conhecidas pela sua paisagem ocidental sueca. A idílica e colorida vila de pescadores combina charme original com a agitação no verão e a tranquilidade e a solidão no inverno.

Smögen

Der kleine Ort Smögen ist bekannt für die „Smögenbryggan", einen fast 1 km langen Holzsteg mit ehemaligen Bootsschuppen, der entlang der für das westschwedische Landschaftsbild bekannten Granitfelsen verläuft. Das idyllische und farbenfrohe Fischerdorf vereint im Sommer ursprünglichen Charme mit Trubel, im Winter Ruhe und Einsamkeit.

Smögen

Het dorpje Smögen is bekend om de Smögenbryggan, een bijna 1 km lange houten steiger met voormalige botenhuizen die langs de granieten rotsen loopt die zo bekend zijn in het West-Zweedse landschap. Het idyllische en kleurrijke vissersdorp combineert originele charme met drukte in de zomer en rust en eenzaamheid in de winter.

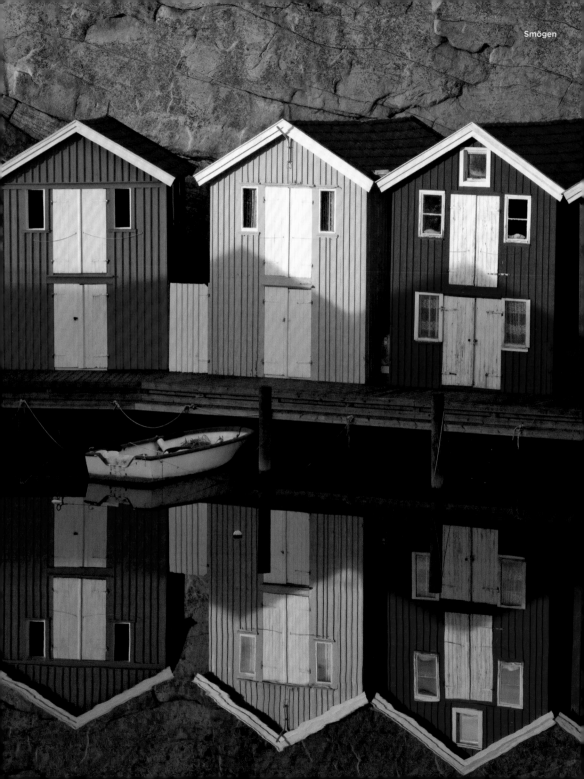

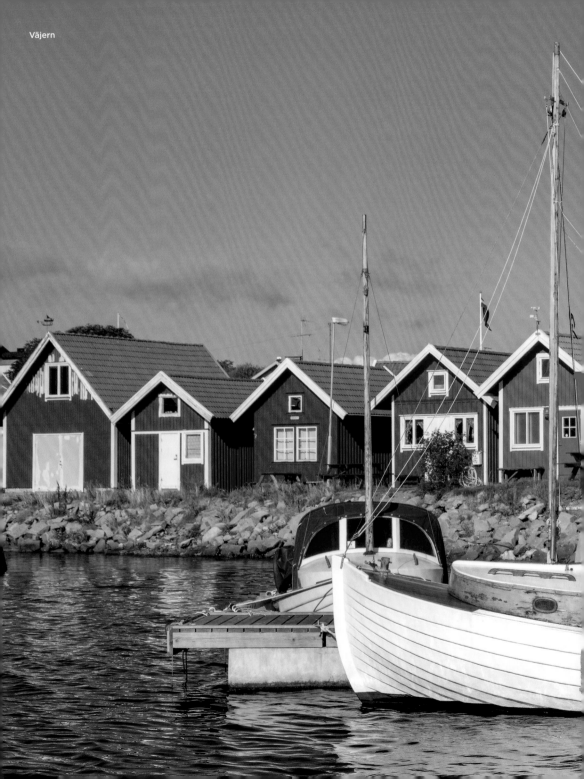

Väjern

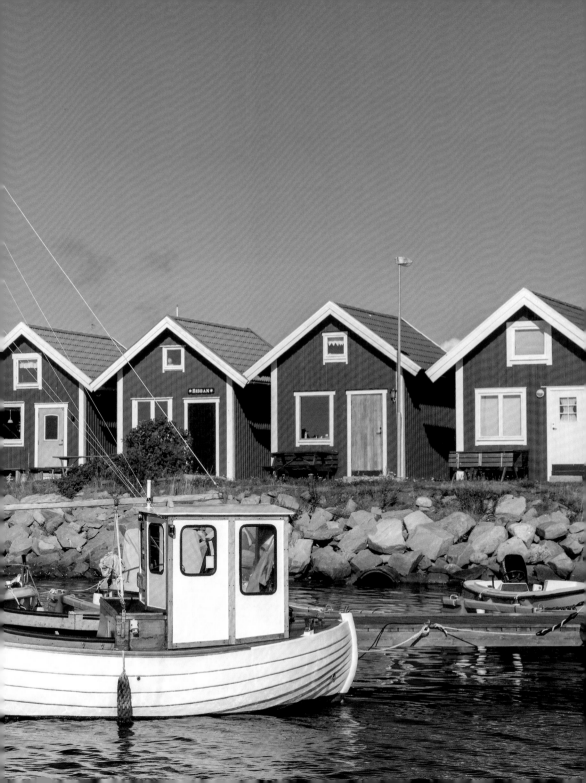

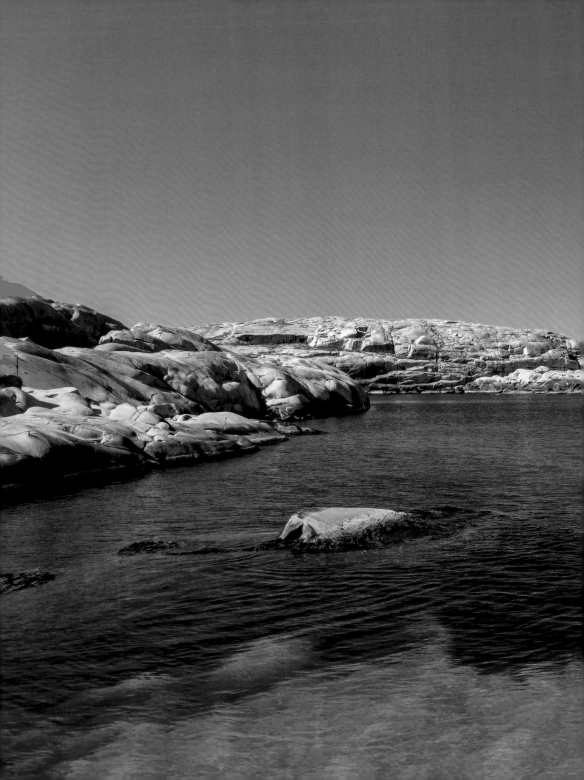

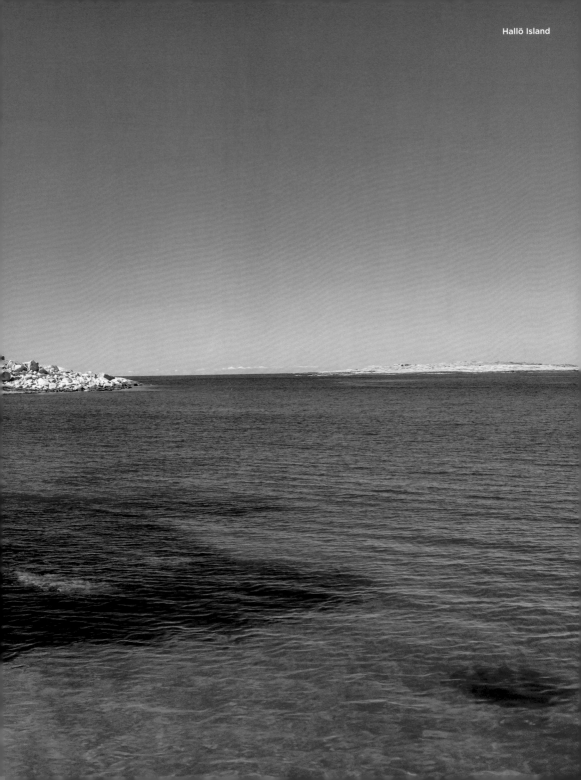

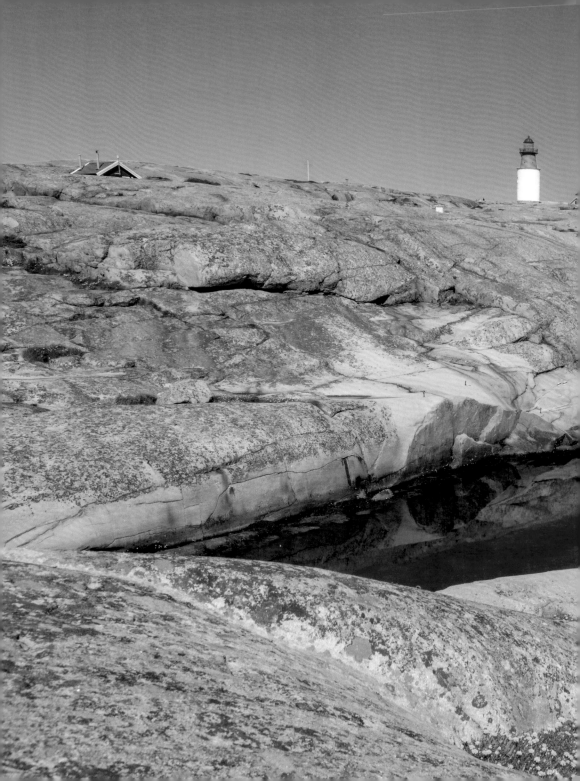

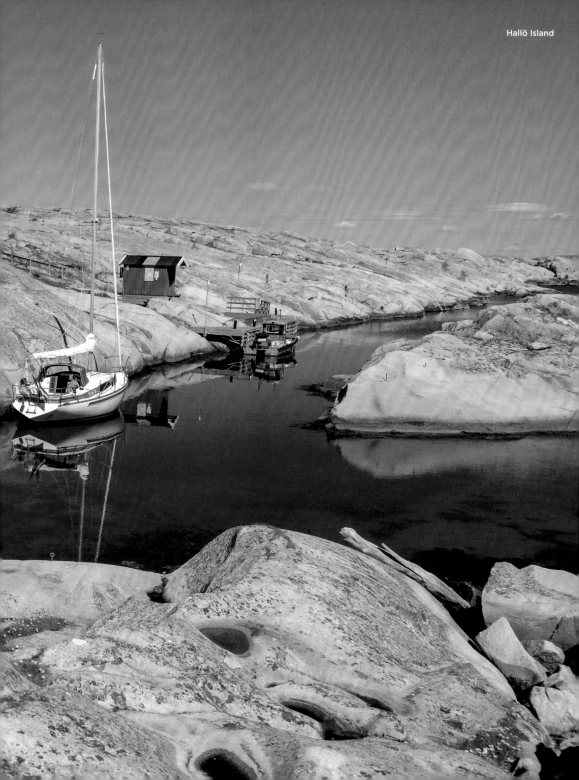

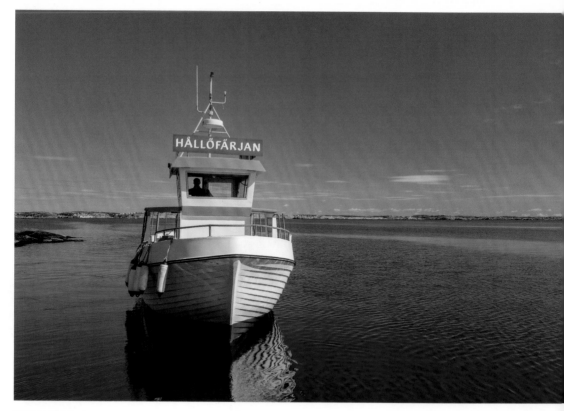

Ferry, Hallö Island

Water Taxi

Life by the sea has its own charm. To reach the partly car-free islands, boats of local shipping companies and ferry lines commute back and forth from the archipelago. Countless larger and smaller islands line the coast, rough and romantic, quaint and unconventional—a contrast that makes this landscape so attractive.

Les bateaux-taxis

La vie au contact de la mer possède un charme particulier. Des bacs et des navires appartenant à des compagnies privées font la navette entre les îles, où les voitures n'ont pas toujours accès. La côte est bordée d'innombrables îles, austères et romantiques, originales et non conformistes. Ce sont ces contrastes qui rendent la région si attachante.

Wassertaxi

Das Leben am und mit dem Meer hat seinen eigenen Charme. Um die zum Teil autofreien Inseln zu erreichen, pendeln Boote lokaler Reedereien und Fährlinien zwischen den Schären hin und her. Unzählige größere und kleinere Inseln tummeln sich entlang der Küste, rau und romantisch, urig und unkonventionell – ein Kontrast, der den Reiz dieser Landschaft ausmacht.

Taxi acuático

La vida junto al mar tiene su propio encanto. Para llegar a las islas parcialmente libres de automóviles, los barcos de las compañías navieras locales y las líneas de transbordadores viajan de un lado a otro del archipiélago. Innumerables islas grandes y pequeñas recorren la costa, ásperas y románticas, pintorescas y poco convencionales; un contraste que hace que este paisaje sea tan atractivo.

Táxi aquático

A vida no e com o mar tem o seu próprio encanto. Para chegar às ilhas parcialmente livres de automóveis, os barcos das companhias de navegação locais e as linhas de balsas circulam de um lado para o outro entre o arquipélago. Inúmeras ilhas maiores e menores encontram-se ao longo da costa, rústicas e românticas, pitorescas e pouco convencionais – um contraste que torna esta paisagem tão atraente.

Watertaxi's

Het leven aan en met de zee heeft zijn eigen bekoring. Om de deels autovrije eilanden te bereiken varen de boten van lokale rederijen en veerdiensten tussen de scheren heen en weer. Talloze grote en kleine eilanden liggen langs de kust, ruig en romantisch, authentiek en onconventioneel – een contrast dat dit landschap zo aantrekkelijk maakt.

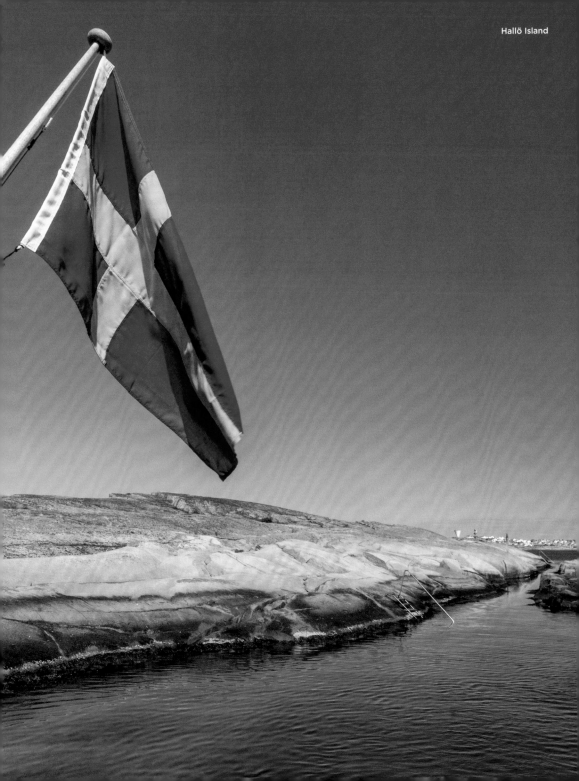

Birds

1 Greylag goose, Oie cendrée, Graugans, Ganso común, Ganzo-bravo, Grauwe ganzen

2 Eider duck, Eider à duvet, Eiderente, Eider común, Eider-edredão, Eidereend

3 Snow owl, Harfang des neiges, Schnee-Eule, Búho nivel, Coruja-das-neves, Sneeuwuil

4 Guillemot, Guillemot de Troïl, Trommellumme, Arao común, Airo, Zeekoeten

5 Black grouse, Tétras-lyre, Birkhuhn, Gallo lira, Galo-lira, Korhoenen

6 Capercaillie, Grand tétras, Auerhahn, Urogallo, Tetraz, Auerhoen

7 White-tailed eagle, Pygargue à queue blanche, Seeadler, Pigargo, Águia-rabalva, Zeearend

8 Goldcrest, Roitelet huppé, Wintergoldhähnchen, Reyezuelo sencillo, Estrelinha-de-poupa, Goudhaan

9 Grey heron, Héron cendré, Graureiher, Garza Real, Garça-real-europeia, Blauwe reiger

10 Ural owl, Chouette de l'Oural, Habichtskauz, Cárabo uralense, Coruja-dos-urais, Oeraluil

11 Siberian jay, Mésangeai imitateur, Unglückshäher, Arrendajo siberiano, Gaio-siberiano, Taigagaai

12 Crane, Grue, Kranich, Grulla común, Grou-comum, Kraanvogels

13 Taiga bean goose, Oie des moissons, Saatgans, Ganso campestre, Ganso-campestre, Taigarietganzen

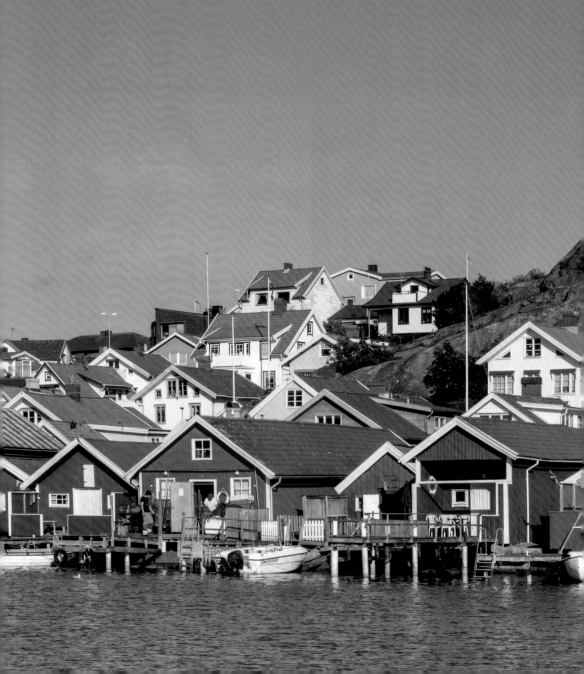

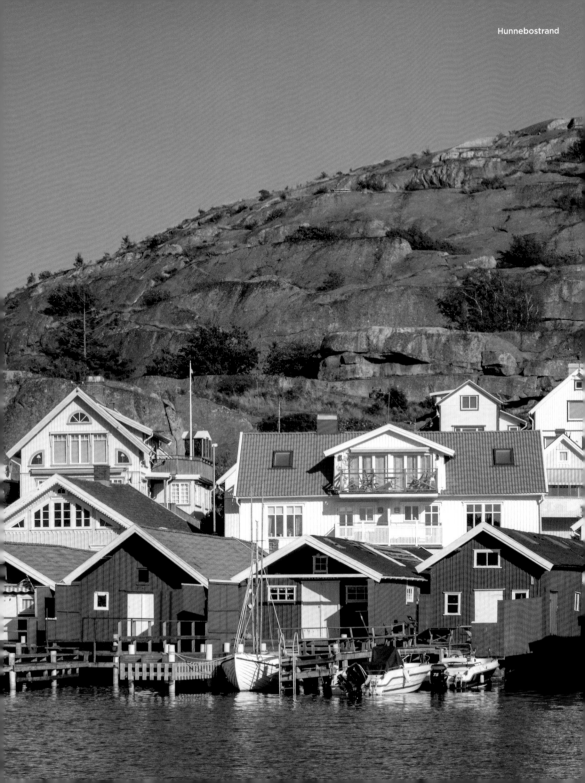

Eel nets, Hunnebostrand

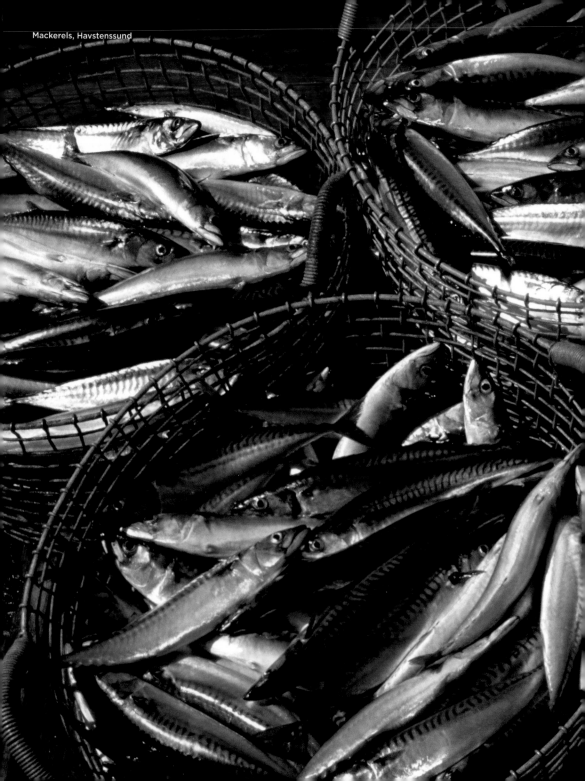

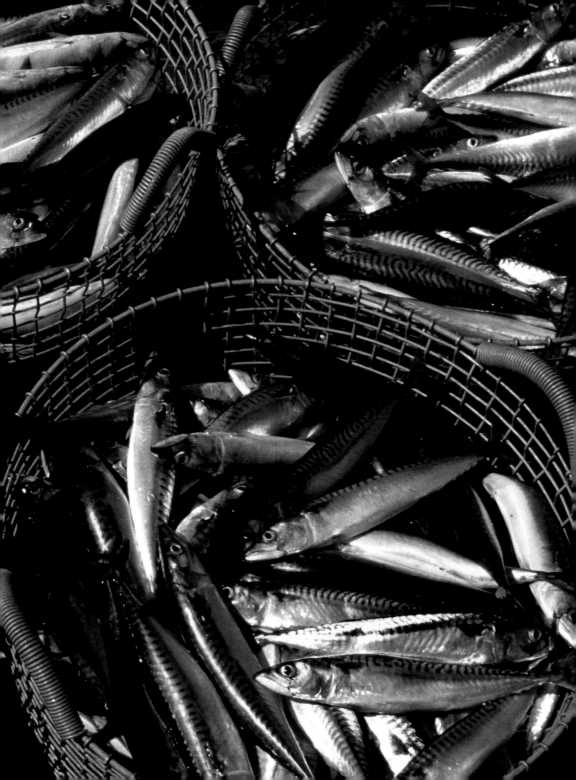

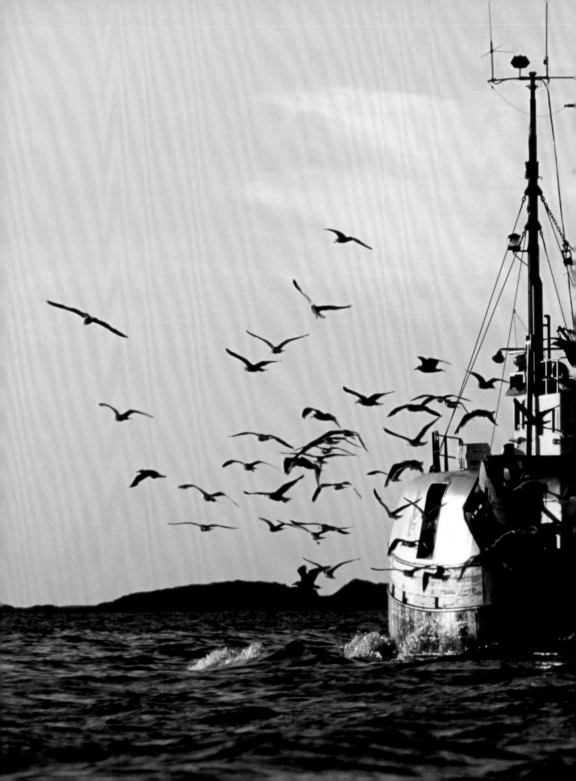

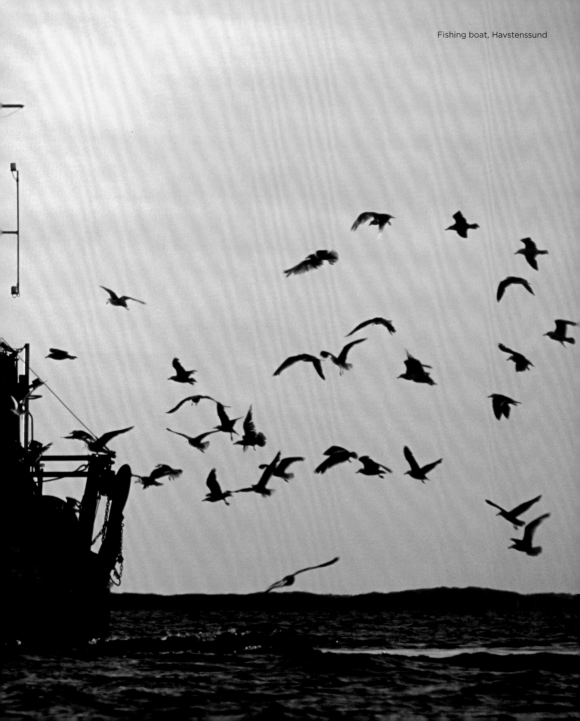

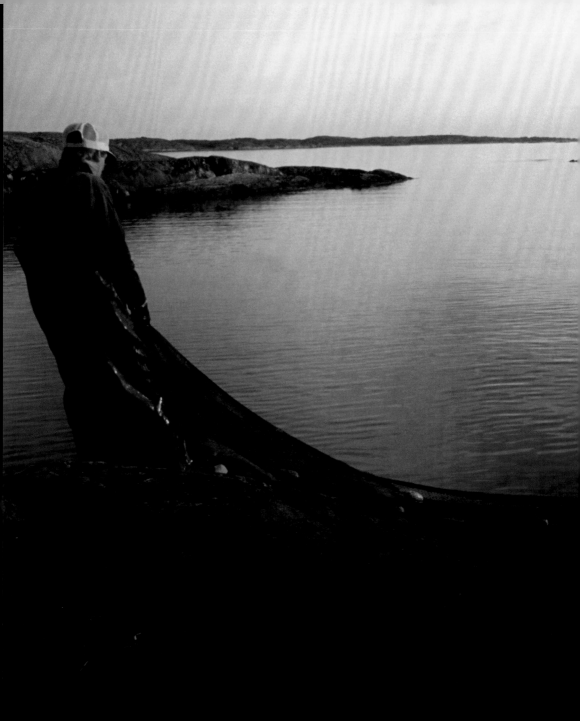

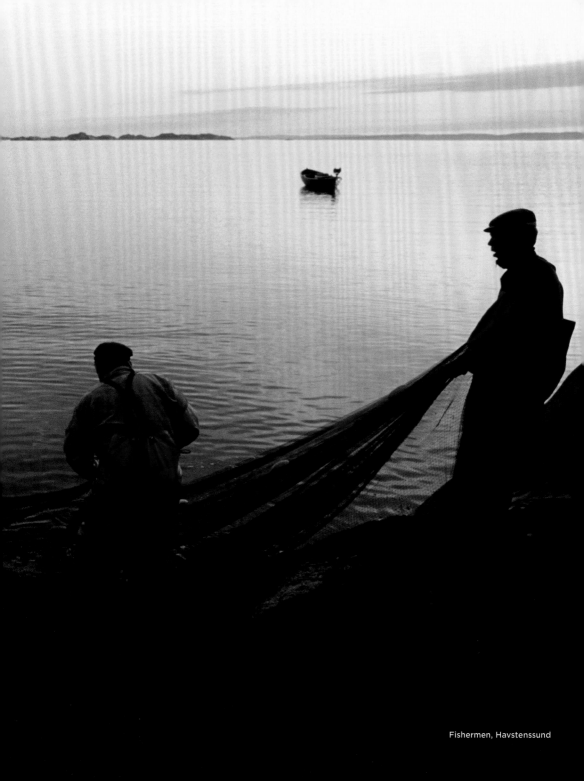

Fishermen, Havstenssund

Jellyfish, Coast of Sotenäs

Kosterhavet National Park

Lion's mane jellyfish and blue jellyfish can be found in the channel off the Koster Islands. Here off the west coast, bordering Norway, is Sweden's most species-rich and first marine reserve—Kosterhavet National Park. More than 6000 different plant and animal species live here, including endemic species and many that are already on the Red List of threatened species. As a result of the direct connection with the Atlantic funnel of the North Sea, underwater currents drive numerous deep-sea species into the Kosterfjord, with salinity and temperatures which resemble the open ocean rather than Swedish coastal waters.

Le parc national de Kosterhavet

La méduse à crinière de lion et la cyanée bleue sont des méduses à ombrelle qui fréquentent le canal situé devant les îles Koster. Le parc national de Kosterhavet, première réserve maritime de Suède et celle où la biodiversité est la plus riche, se trouve au large de la côte ouest et près de la frontière avec la Norvège. Plus de 6 000 espèces animales et végétales y vivent, endémiques pour certaines et inscrites sur la Liste rouge des espèces menacées pour beaucoup. La mer du Nord agissant comme un entonnoir, les courants sous-marins entraînent toutes sortes d'espèces dans le fjord de Koster, dont la teneur en sel et la température se rapprochent davantage de celles de l'océan que des eaux côtières suédoises.

Kosterhavet Nationalpark

Die Gelbe Haar- und die Blaue Nesselqua gehören zu den Fahnenquallen und sind im Kanal vor den Koster-Inseln zu finden Hier vor der Westküste, an Norwegen grenzend, liegt Schwedens artenreichste und erstes Meeresschutzgebiet – der Nationalpark Kosterhavet. Dort leben me als 6000 verschiedene Pflanzen- und Tierarten, darunter endemische und viele die bereits auf der Roten Liste stehen. Infolge der direkten Verbindung mit dem atlantischen Trichter der Nordsee treiben Unterwasserströmungen zahlreiche Tiefseearten in den Kosterfjord, dessen Salzgehalt und Temperatur eher dem offenen Ozean als einem schwedischen Küstengewässer gleichen.

llyfish, Coast of Sotenäs

rque Nacional Kosterhavet

medusa melena de león ártica y la
dusa azul son medusas semeostomas
e pueden encontrar en el canal de las
s Koster. Aquí, frente a la costa oeste,
la frontera con Noruega, se encuentra
eserva marina más rica en especies
a primera reserva marina de Suecia:
Parque Nacional Kosterhavet. Más de
00 especies diferentes de plantas
nimales viven aquí, entre las que se
luyen especies endémicas y muchas ya
luidas en la Lista Roja. Como resultado
la conexión directa con el embudo
ántico del Mar del Norte, las corrientes
omarinas llevan a numerosas especies
aguas profundas al fiordo Koster, cuya
inidad y temperatura se asemejan
s al mar abierto que a las aguas
steras suecas.

Parque Nacional Kosterhavet

A água-viva-juba-de-leão e a água-
viva bluefire pertencem à ordem
Semaeostomeae e podem ser encontradas
no canal ao largo das Ilhas Koster. Aqui, na
costa oeste, na fronteira com a Noruega,
está a primeira reserva marinha mais rica
em espécies da Suécia – o Parque Nacional
Kosterhavet. Aqui vivem mais de 6000
espécies diferentes de plantas e animais,
incluindo espécies endémicas e muitas
já incluídas na Lista Vermelha. Como
resultado da ligação direta com o funil do
Atlântico do Mar do Norte, as correntes
submarinas levam inúmeras espécies de
águas profundas para o Kosterfjord, cuja
salinidade e temperatura se assemelham
mais ao oceano aberto do que às águas
costeiras suecas.

Nationaal park Kosterhavet

De gele en blauwe haarkwallen behoren
tot de grote schijfkwallen en zijn te vinden
in de zee-engte bij de Koster-eilanden.
Hier voor de aan Noorwegen grenzende
westkust ligt het meest soortenrijke en
eerste beschermde zeegebied van Zweden:
het nationale park Kosterhavet. Meer dan
6000 verschillende planten- en diersoorten
leven hier, waaronder endemische en
soorten die al op de rode lijst staan. Als
gevolg van de directe verbinding met de
Atlantische trechter van de Noordzee
drijven stromingen diepzeesoorten de
Kosterfjord binnen, waarvan zoutgehalte
en temperatuur meer overeenkomen met
de open oceaan dan met de Zweedse
kustwateren.

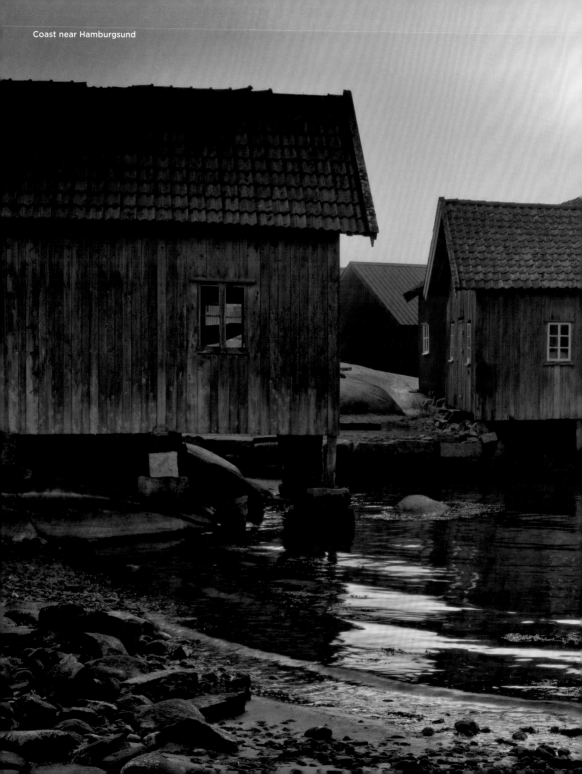

Coast near Hamburgsund

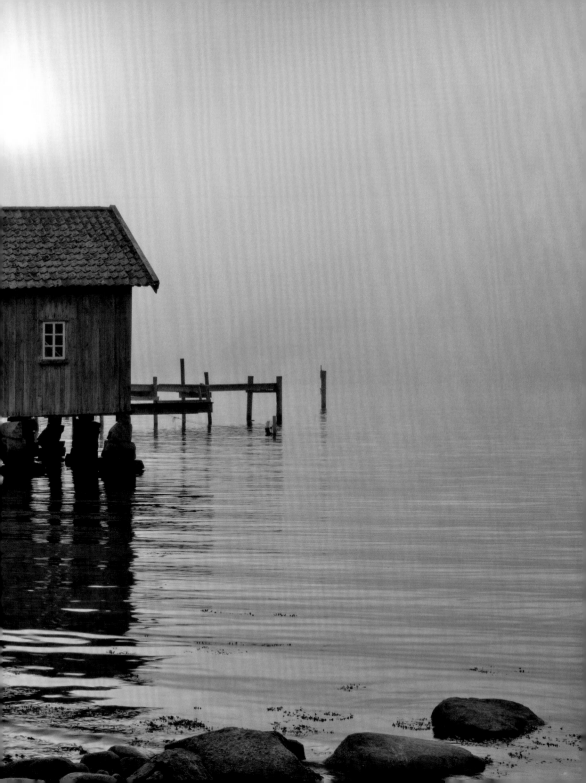

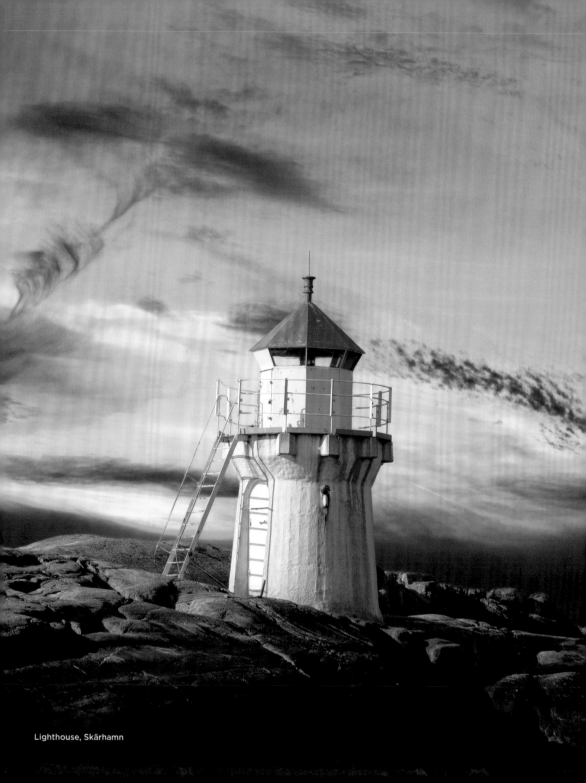

Lighthouse, Skärhamn

...nundön Island

...inter Fairy Tale

...om January to March the early setting
...n often bathes the islands in a strange
...ht, and the west coast seems to sink
...o a kind of winter fairy tale. Only a few
...sitors still take boats that make their way
...rough the increasingly icy water—until
...e waterways are completely frozen over
...d skating is possible.

Un conte d'hiver

De janvier à mars, le soleil qui se couche
tôt plonge les îles dans une lumière
étrange et la côte ouest ressemble alors à
un paysage de conte d'hiver. Les visiteurs
de moins en moins nombreux empruntent
des bateaux qui ont de plus en plus de
mal à se frayer un passage dans l'eau qui
épaissit, puis finit par geler. C'est alors le
moment de sortir les patins à glace.

Wintermärchen

Von Januar bis März taucht die früh
untergehende Sonne die Inseln oft in ein
eigentümliches Licht, dann scheint die
Westküste in eine Art Wintermärchen
zu versinken. Nur noch wenige Besucher
nehmen Boote, die sich ihren Weg durch
das immer dicker werdende Wasser
bahnen – bis die Wasserwege vollends
zugefroren sind und Schlittschuhlaufen
möglich ist.

...uento de hadas invernal

...e enero a marzo, la puesta de sol
...mprana suele bañar a las islas con una
...z extraña, y entonces la costa oeste
...rece hundirse en una especie de cuento
...e hadas de invierno. Solo unos pocos
...sitantes toman botes que se abren paso a
...avés de las aguas cada vez más espesas,
...sta que las vías fluviales se congelan por
...mpleto y es posible patinar sobre hielo.

Conto de fadas de inverno

De janeiro a março, o pôr-do-sol bem
cedo banha as ilhas sob uma luz peculiar
e, em seguida, a costa ocidental parece
afundar-se numa espécie de conto de
fadas do inverno. Apenas alguns poucos
visitantes ainda apanham barcos que
atravessam as águas cada vez mais
espessas – até que os cursos de água
fiquem completamente congelados e a
patinagem seja possível.

Winters sprookje

Van januari tot maart dompelt de vroeg
ondergaande zon de eilanden vaak in
een merkwaardig licht, waardoor de
westkust lijkt weg te zakken in een soort
wintersprookje. Slechts enkele bezoekers
nemen nu nog de boot, die zich een
weg moet banen door het steeds dikker
wordende water – totdat de waterwegen
volledig bevroren zijn en er kan
worden geschaatst.

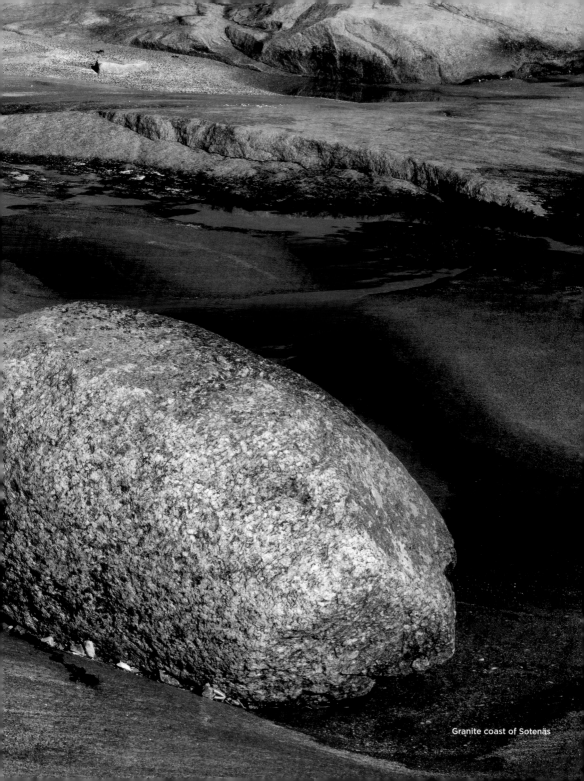
Granite coast of Sotenäs

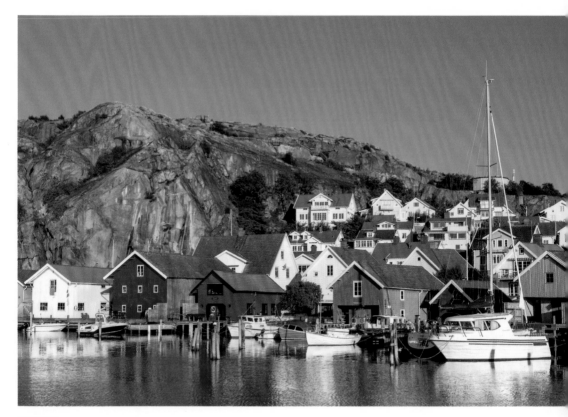

Fjällbacka

Fjällbacka

This fairytale fishing village at the foot of the rugged rock face of the Vetteberg is famous for its charming contrast of colorful wooden houses in front of bare rock. This idyllic place, which used to be famous for herring fishing, has become a popular seaside resort: celebrities such as Ingrid Bergman used to spend their summers here.

Fjällbacka

El pueblo de pescadores que parece sacado de un cuento de hadas y que se encuentra al pie de la escarpada pared rocosa de Vetteberg es conocido por su encantador contraste de coloridas casas de madera frente a la roca desnuda. En la actualidad, este idílico lugar, que solía ser famoso por la pesca del arenque, es un popular balneario: celebridades como Ingrid Bergman pasaban sus veranos aquí.

Fjällbacka

Ce petit village de pêcheurs qui se niche au pied du Vetteberg séduit par le contraste entre ses maisons de bois colorées et cet énorme rocher. Cet endroit merveilleux, qui devait sa prospérité au hareng, est devenu une station balnéaire très courue : des célébrités, telle Ingrid Bergman, y passaient l'été.

Fjällbacka

O vilarejo de pescadores de conto de fadas ao pé da rocha escarpada de Vetteberg é famoso por seu contraste encantador de casas de madeira coloridas em frente à rocha lisa. Entretanto, este lugar idílico, que costumava ser famoso pela pesca do arenque, tornou-se uma estância balnear popular: celebridades como Ingrid Bergman passaram aqui os seus verões.

Fjällbacka

Das märchenhafte Fischerdörfchen am Fuße der schroffen Felswand des Vetteberg ist bekannt für seinen reizvollen Kontrast von bunten Holzhäusern vor kahlem Fels. Mittlerweile ist der idyllische Ort, der früher durch Heringsfischerei bedeutend war, populärer Badeort: Berühmtheiten wie Ingrid Bergman verbrachten hier Ihre Sommer.

Fjällbacka

Het sprookjesachtige vissersdorpje aan de voet van de steile wand van de Vetteberg staat bekend om zijn charmante contrast van kleurige houten huizen voor kale rotsen. Ondertussen is deze idyllische plek, die vroeger belangrijk was voor de haringvisserij, uitgegroeid tot een populaire badplaats: beroemdheden als Ingrid Bergman brachten hier de zomer door.

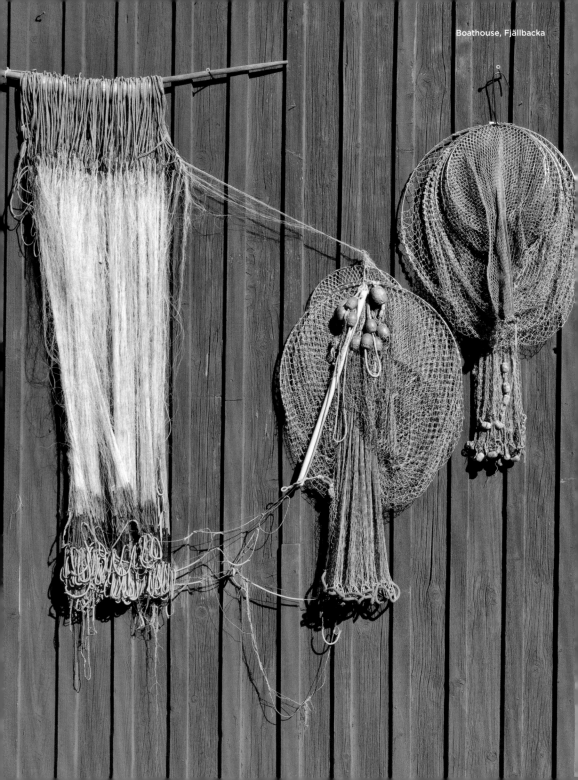

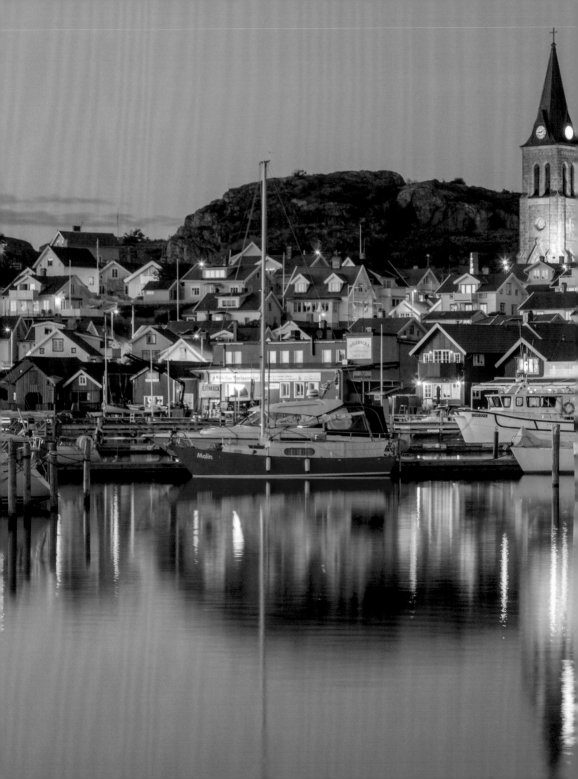

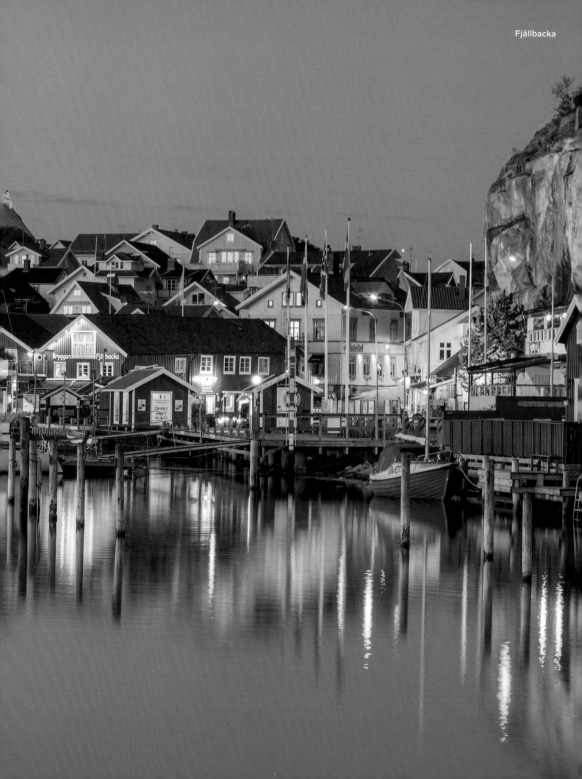

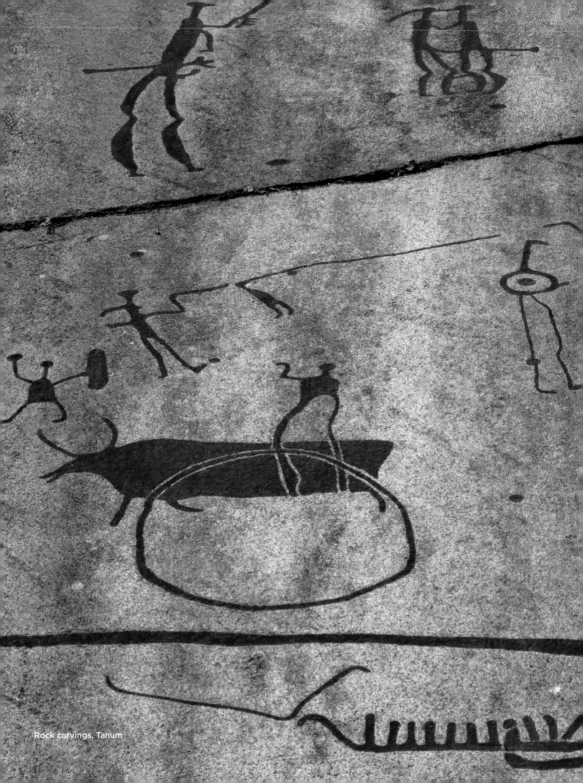

Rock carvings, Tanum

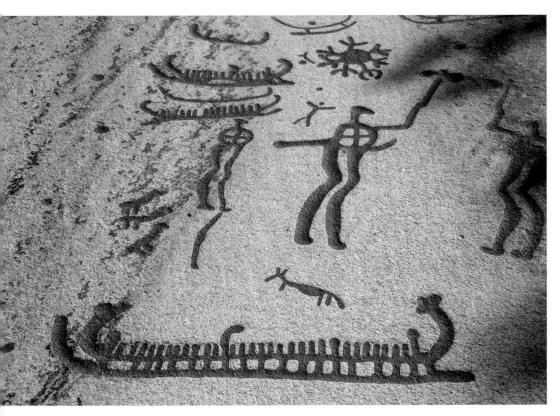

ck carvings, Tanum

ehistoric Drawings

e almost 10,000 rock carvings in Tanum
e part of the UNESCO World Heritage,
d provide information about religious
d social life in Northern Europe during
e Bronze Age. The large number and
ality are remarkable. Covering almost
km² (16 sqmi), there are more than 600
fferent sites with such drawings; these
ere originally at sea level.

soro pictórico prehistórico

s casi 10 000 esculturas en piedra
Tanum pertenecen al Patrimonio
ndial de la UNESCO y proporcionan
formación sobre la vida religiosa y social
el norte de Europa durante la Edad
l Bronce. El gran número y la calidad
n notables: en casi 42 km² hay más de
0 sitios diferentes con tales dibujos,
e originalmente se encontraban al nivel
l mar.

Une galerie d'art préhistorique

Inscrites au Patrimoine mondial de
l'Unesco, les 10 000 gravures rupestres de
Tanum illustrent la vie religieuse et sociale
en Europe du Nord à l'âge du bronze. Elles
sont tout à fait exceptionnelles de par leur
nombre et leur qualité. Sur 42 km², on
ne compte pas moins de 600 sites, qui à
l'origine se trouvaient au niveau de la mer.

Tesouro de imagens pré-históricas

As quase 10 000 esculturas rupestres em
Tanum pertencem ao Patrimônio Mundial
da UNESCO e fornecem informações sobre
a vida religiosa e social no norte da Europa
durante a Idade do Bronze. O grande
número e a qualidade são notáveis –
em quase 42 km² existem mais de 600
locais diferentes com tais imagens, que
originalmente estavam ao nível do mar.

Prähistorischer Bilderschatz

Die knapp 10 000 Felsritzungen in
Tanum gehören zum UNESCO Welterbe
und geben Hinweise auf das religiöse
und soziale Leben in Nordeuropa zur
Bronzezeit. Bemerkenswert ist die große
Anzahl und Qualität – auf knapp 42 km²
gibt es über 600 verschiedene Stätten mit
solchen Zeichnungen, die ursprünglich auf
Höhe des Meeresspiegels lagen.

Prehistorische beeldenschat

De bijna 10 000 rotstekeningen in Tanum
behoren tot het werelderfgoed van de
Unesco en geven aanwijzingen over het
religieuze en sociale leven in Noord-Europa
tijdens de bronstijd. Het grote aantal
en de kwaliteit ervan zijn opmerkelijk.
Op een kleine 42 km² zijn er meer dan
600 plaatsen met dergelijke tekeningen,
die oorspronkelijk ter hoogte van het
wateroppervlak zaten.

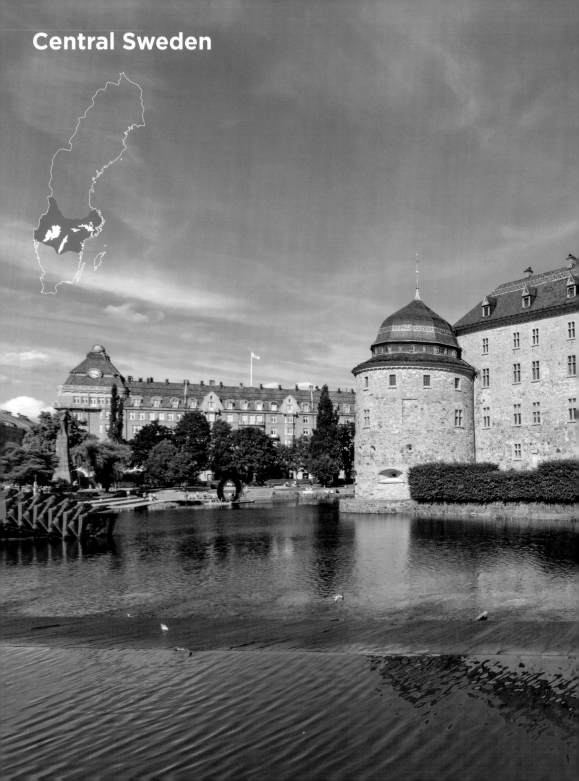

Central Sweden

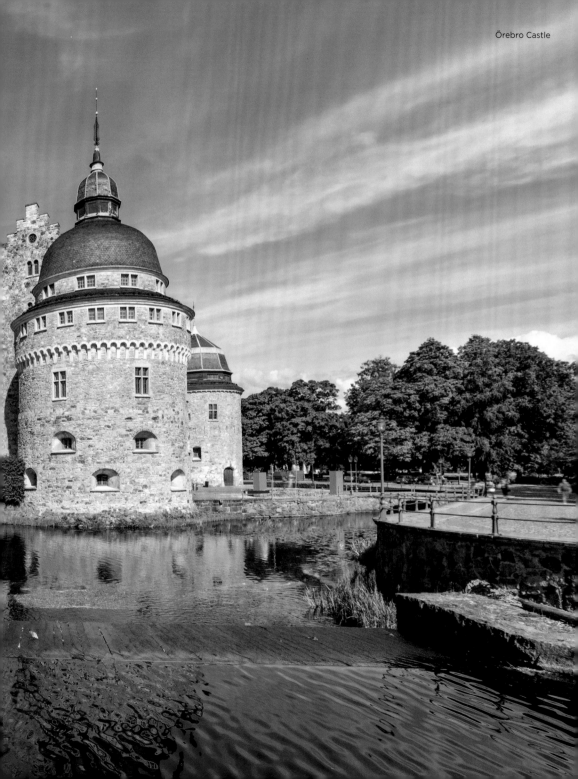

Örebro Castle

Arbogaån River, Arboga

Central Sweden

The heart of the country stretches from the foothills of the Scandinavian mountains to the archipelago of Stockholm. This is a region with deep forests and thousands of lakes, including the two largest in Sweden, Vänern and Vättern, which legend has it were created when in anger a giant tore two clods of earth out of the field and threw them into the Baltic Sea. Central Sweden is crossed by the Trollhätte and Göta Canals and about 100,000 small islands, which are hard to surpass in terms of flora and biodiversity. The region is also characterized by fascinating fairytale castles such as Läckö, picturesque small towns such as Vadstena and the vibrant Örebro.

Le centre de la Suède

Le cœur du pays s'étend des contreforts de la montagne scandinave jusqu'à la côte de Stockholm parsemée d'îles. C'est une région aux forêts profondes et aux mille lacs, dont les deux plus grands du pays, le Vänern et le Vättern. La légende attribue leur création à un géant qui, dans un mouvement de colère, ramassa deux mottes de terre dans un champ pour les jeter dans la mer Baltique. Le centre de la Suède est parcouru par les canaux de Trollhätte et de Göta, mais aussi ponctué par quelque 100 000 petites îles à la biodiversité incomparable. La région se distingue aussi par ses châteaux de rêve, comme celui de Läckö, et par de ravissantes bourgades telles Vadstena ou Örebro, plus trépidant.

Mittelschweden

Das Herz des Landes erstreckt sich von den Ausläufern des skandinavischen Gebirges bis zur Schärenküste vor Stockholm – eine Region mit tiefen Wäldern und tausenden Seen, darunter die zwei größten Schwedens, Vänern und Vättern, die der Sage nach entstanden sind, als ein Riese im Zorn zwei Schollen aus dem Acker gerissen und sie in die Ostsee geschleudert hat. Mittelschweden wird durchzogen von Trollhätte- und Göta-Kanal und etwa 100 000 kleinen Inseln, die an Pflanzenreichtum und Artenvielfalt kaum zu übertreffen sind. Darüber hinaus prägen faszinierende Märchenschlösser wie Läckö, malerische Kleinstädte wie Vadstena und das pulsierende Örebro die Region.

Svartån River, Örebro

Suecia central

En el corazón del país se extiende desde las estribaciones de las montañas escandinavas hasta el archipiélago de Estocolmo, una región con profundos bosques y miles de lagos, entre los que se encuentran los dos más grandes de Suecia, Vänern y Vättern, cuya leyenda cuenta que se originaron cuando un gigante furioso arrancó dos sollas del campo y las arrojó al mar Báltico. La Suecia central está atravesada por los canales de Trollhätte y Göta y por unas 100 000 islas pequeñas, pero que son difíciles de superar en términos de flora y biodiversidad. La región también se caracteriza por fascinantes castillos que parecen sacados de cuentos de hadas, como Läckö; pintorescas ciudades pequeñas, como Vadstena; y el vibrante Örebro.

Suécia Central

O coração do país estende-se desde os contrafortes das montanhas escandinavas até ao arquipélago de Estocolmo – uma região com florestas profundas e milhares de lagos, incluindo os dois maiores da Suécia, Vänern e Vättern, cuja lenda diz que tiveram origem quando um gigante em fúria arrancou dois torrões do campo e os atirou para o Mar Báltico. O centro da Suécia é atravessado pelos canais Trollhätte e Göta e por cerca de 100 000 pequenas ilhas, que são difíceis de superar em termos de flora e biodiversidade. A região também é caracterizada por fascinantes castelos de contos de fadas como Läckö, pequenas cidades pitorescas como Vadstena e o vibrante Örebro.

Midden-Zweden

Het hart van het land strekt zich uit van de uitlopers van de Scandinavische bergen tot de scherenkust van Stockholm. Het is een gebied met diepe bossen en duizenden meren, waaronder de twee grootste van Zweden, het Väner- en Vättermeer, die volgens een legende zijn ontstaan toen een reus in woede twee aardkluiten uit de akker trok en in de Oostzee slingerde. De kanalen Trollhätte en Göta lopen, net als zo'n 100 000 kleine eilandjes, die qua planten- en dierenrijkdom moeilijk te overtreffen zijn, door centraal Zweden. De regio wordt ook gekenmerkt door fascinerende sprookjeskastelen zoals Läckö, pittoreske stadjes als Vadstena en het levendige Örebro.

233

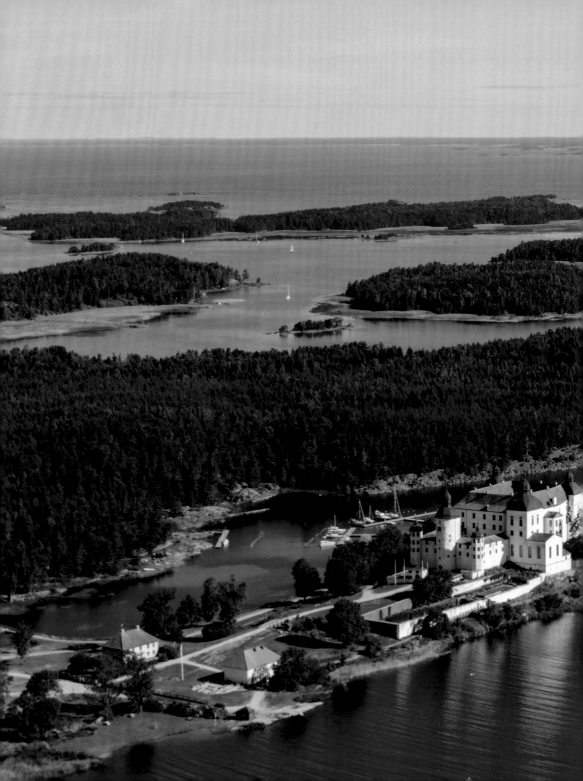

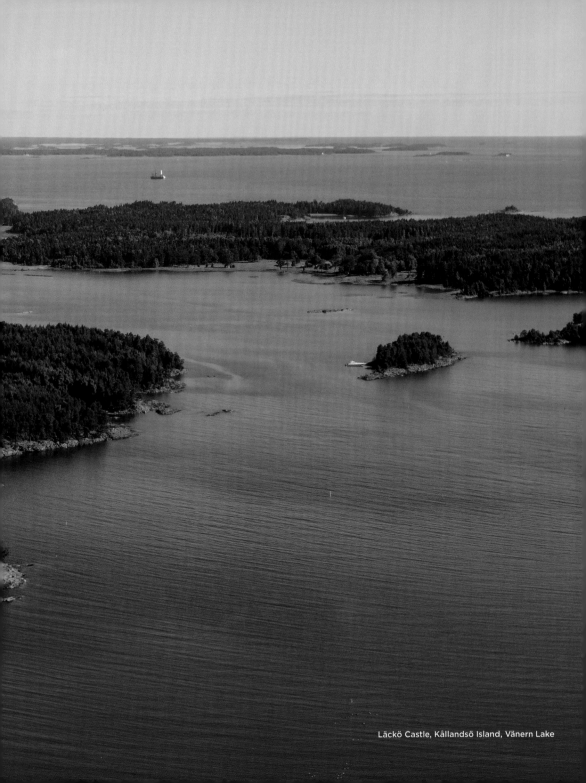

Läckö Castle, Kållandsö Island, Vänern Lake

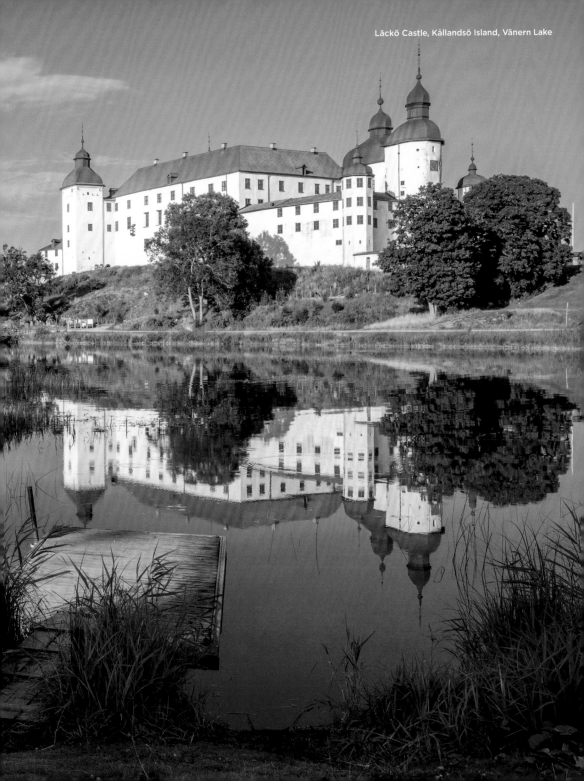
Läckö Castle, Kållandsö Island, Vänern Lake

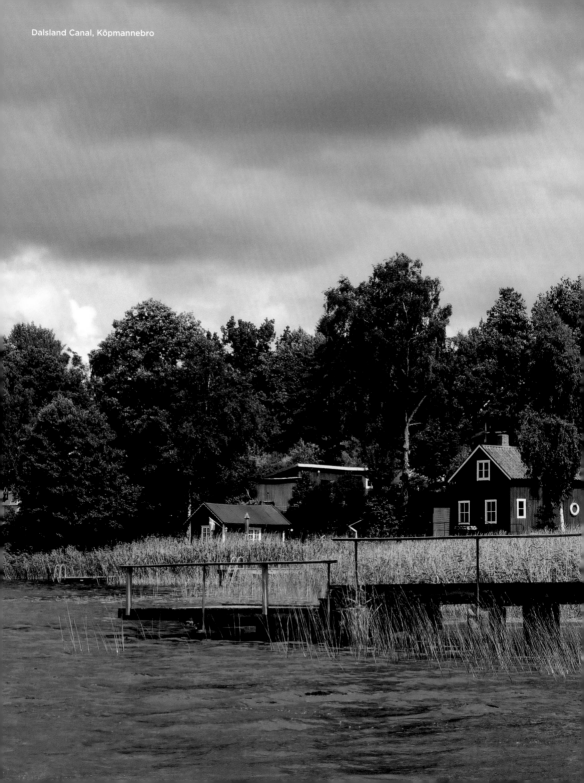

Dalsland Canal, Köpmannebro

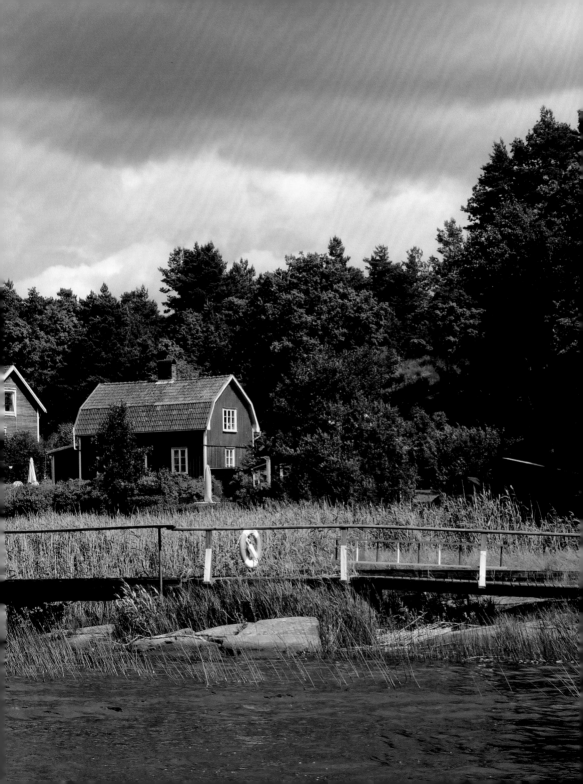

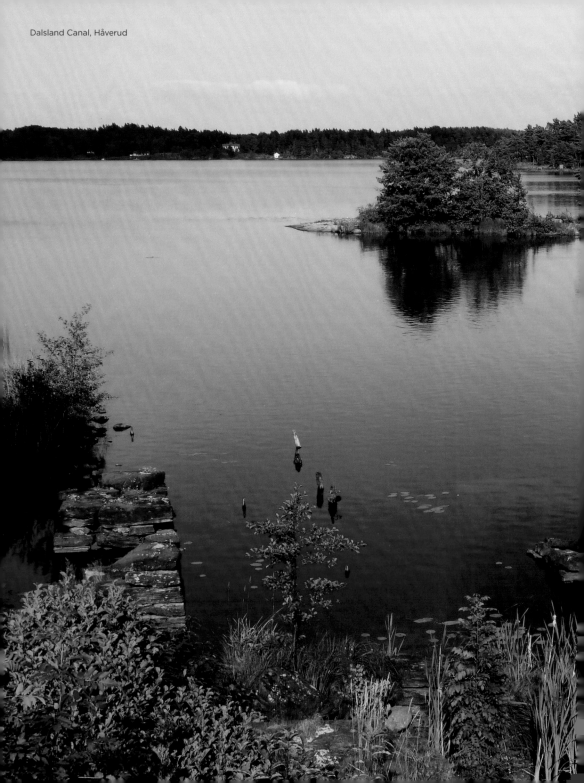
Dalsland Canal, Håverud

Aqueduct, Håverud

Vänern Lake

Idyll by the Lake

Countless small bays where you can swim, camp and relax unobserved can be found around the lakes of the region. During the summer months, it is a special pleasure to explore a lake by canoe or to enjoy the romantic sunset. In the crystal clear waters of Lake Vätter or Lake Väner, you can swim as if in the sea. With a depth of up to 120 m (394 ft) and an extraordinary variety of species, the two waters are a small paradise for divers and snorkelers. Anglers usually don't have to wait long for their first catch—regardless of the season.

Des lacs de rêve

Les lacs de la région sont festonnés de petites anses où l'on peut nager, camper et se détendre en toute tranquillité. En été, rien de tel qu'une promenade en canot sur un lac ou la contemplation d'un coucher de soleil romantique. On se baigne dans les eaux cristallines du Vänern et du Vättern presque comme dans la mer. Ces deux lacs, d'une profondeur maximale de 120 m, se distinguent par leur biodiversité extraordinaire, ce qui en fait un paradis pour les plongeurs. Quant aux pêcheurs, ils n'attendent jamais très longtemps la première prise, et cela en toute saison.

Idylle am See

Unzählige kleine Buchten, in denen man unbeobachtet schwimmen, zelten und sich entspannen kann, findet man rund um die Seen der Region. Ein besonderes Vergnügen ist es, in den Sommermonaten mit dem Kanu einen See zu erkunden oder den romantischen Sonnenuntergang zu genießen. Im kristallklaren Wasser von Vätter- oder Vänersee badet man fast wie im Meer. Mit einer Tiefe von bis zu 120 m und einer außergewöhnlichen Artenvielfalt sind die beiden Gewässer ein kleines Paradies für Taucher und Schnorchler. Aber auch Angler lässt der erste Fang meist nicht lange auf sich warten – egal zu welcher Jahreszeit.

änern Lake near Mariestad

Idilio en el lago

lrededor de los lagos de la región
e puede encontrar un sinnúmero de
equeñas bahías, donde se puede nadar,
campar y relajarse sin ser observado.
urante los meses de verano es un placer
special explorar un lago en canoa o
sfrutar de la romántica puesta de sol. En
s aguas cristalinas del lago Vätter o del
go Väner se puede nadar casi como en el
ar. Con una profundidad de hasta 120 m
una extraordinaria variedad de especies,
s dos aguas son un pequeño paraíso para
uceadores y aficionados al esnórquel.
ero incluso los pescadores no suelen
ner que esperar mucho tiempo para su
rimera pesca, independientemente de
temporada.

Idílio junto ao lago

Inúmeras pequenas baías, onde você
pode nadar, acampar e relaxar sem ser
observado, podem ser encontradas ao
redor dos lagos da região. Durante os
meses de verão é um prazer especial
explorar um lago de canoa ou desfrutar do
pôr-do-sol romântico. Nas águas cristalinas
do Lago Vätter ou do Lago Väner você
pode nadar quase como no mar. Com
uma profundidade de até 120 m e uma
extraordinária variedade de espécies, as
duas águas são um pequeno paraíso para
mergulhadores e praticantes de snorkel.
Mas mesmo os pescadores normalmente
não têm de esperar muito tempo pela sua
primeira captura- independenteda estação
do ano.

Idylle aan het meer

Rond de meren in het gebied zijn talloze
baaitjes te vinden, waar je onopgemerkt
kunt zwemmen, kamperen en ontspannen.
Tijdens de zomermaanden is het een
bijzonder genoegen om per kano een
meer te verkennen of een romantische
zonsondergang te bewonderen. In het
kristalheldere water van de Vätter- en
Vänermeren kun je bijna zwemmen als in
de zee. Met een diepte tot 120 meter en
een buitengewone biodiversiteit zijn de
twee wateren een paradijs voor duikers en
snorkelaars. Maar ook hengelaars hoeven
meestal niet lang te wachten op hun eerste
vangst – ongeacht het seizoen.

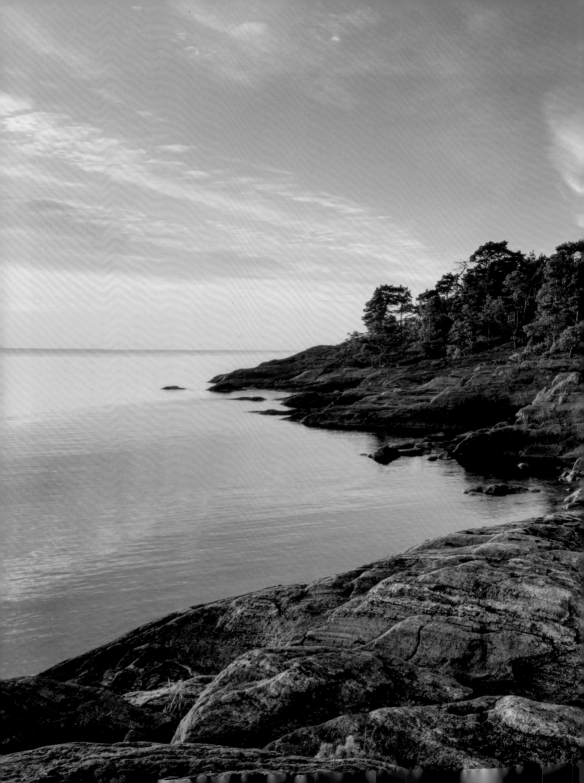

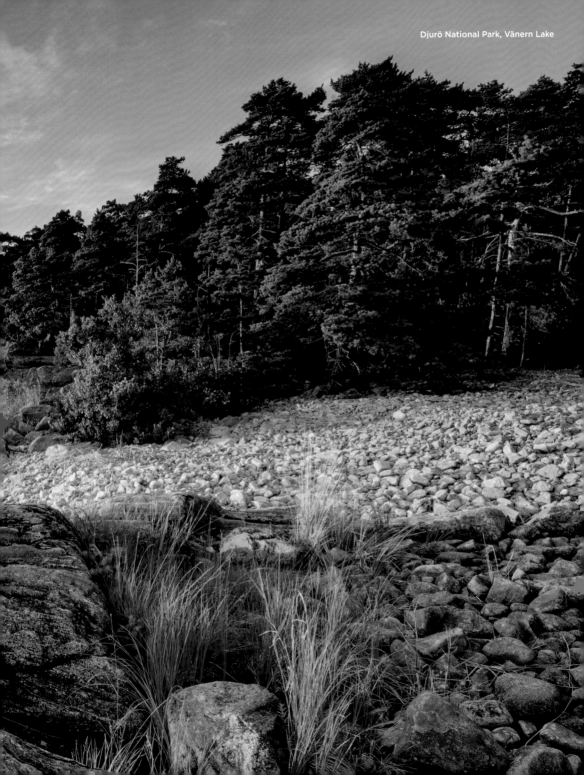
Djurö National Park, Vänern Lake

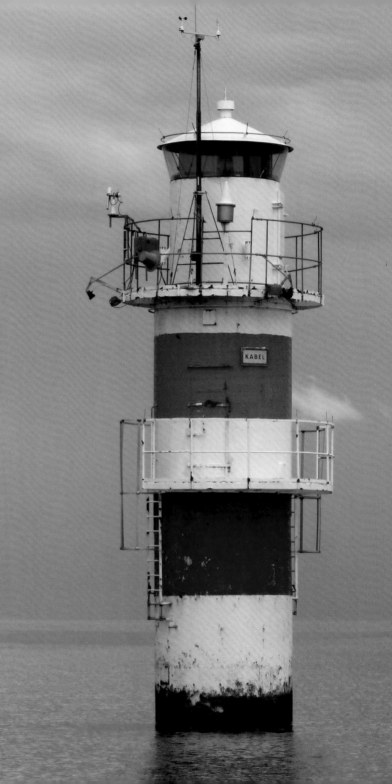

Lighthouse, Vänern Lake

Sedum

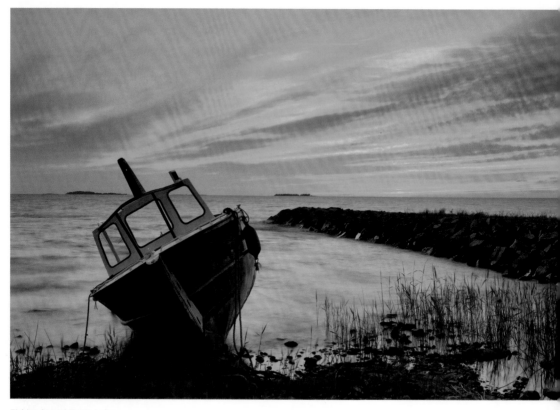

Fishing boat, Vänern Lake

Inland Sea Vänern

Sweden's largest lake is often referred to as an inland sea because of its appearance—rightly so, because it preserves marine life forms from a time when it was still part of the sea. The lake was formed by the land uplift at the end of the last ice age, when the last glacier pushed a wall of debris before it and melted.

Mar epicontinental Vänern

El lago más grande de Suecia a menudo se conoce como un mar interior por su apariencia, y con razón, porque preserva formas de vida marina de una época en la que todavía formaba parte del mar. Se formó con el levantamiento de tierra al final de la última era glacial, cuando el último glaciar empujó una pared de escombros ante él y se derritió.

La mer intérieure Vänern

Le plus grand lac de Suède est souvent qualifié de mer intérieure, et à juste titre, car il a gardé des formes de vie marine de l'époque où il faisait partie de la mer. Il a été formé par un soulèvement à la fin de la dernière période glaciaire, lorsque l'ultime glacier a déposé un mur de moraines avant de fondre.

Mar interior Vänern

O maior lago da Suécia é frequentemente referido como um mar interior devido à sua aparência - e com razão, porque preserva formas de vida marinha de uma época em que era, na verdade, parte do mar. Ele foi formado com a elevação da terra no final da última era glacial, quando a última geleira empurrou uma parede de detritos para frente dela e em seguida derreteu.

Binnenmeer Vänern

Oft wird der größte See Schwedens aufgrund seiner Anmutung als Binnenmeer bezeichnet – zurecht, denn er bewahrt marine Lebensformen aus einer Zeit, als er noch tatsächlich ein Teil des Meeres war. Er entstand dann mit der Landeshebung am Ende der letzten Eiszeit, als der letzte Gletscher einen Wall von Schutt vor sich her schob und schmolz.

Binnenzee Vänern

Het grootste meer van Zweden wordt vanwege zijn uiterlijk vaak een binnenzee genoemd. Terecht, want het bewaart zeeleven uit een tijd dat het nog deel uitmaakte van de zee. Het werd gevormd door de verhoging van het land aan het eind van de laatste ijstijd, toen de laatste gletsjer gletsjerpuin voor zich uitschoof en smolt.

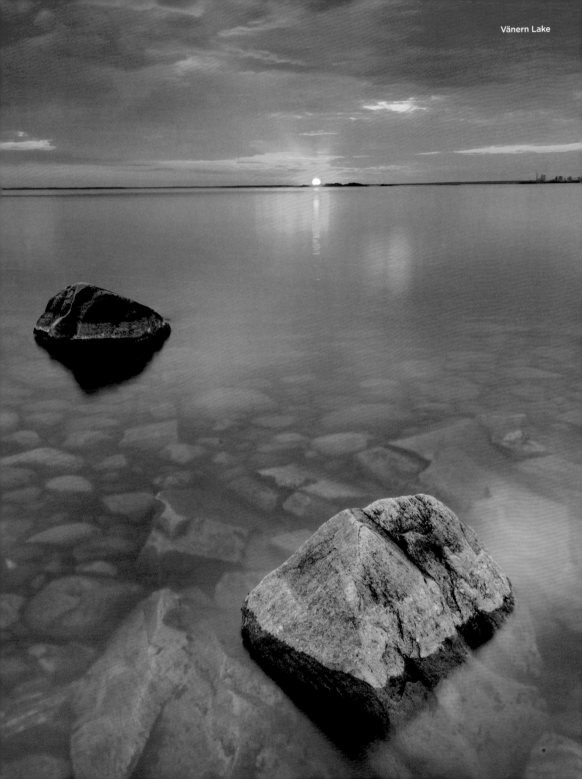

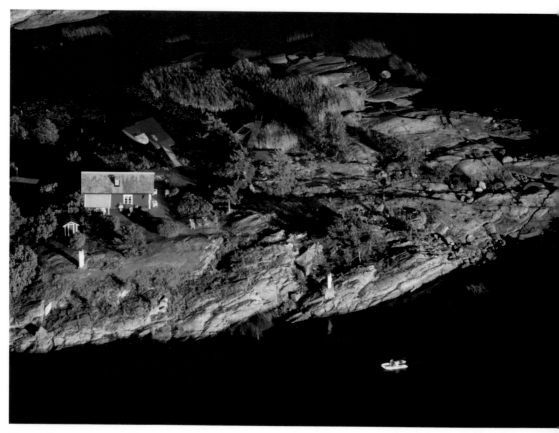

Vänern Lake

Vänern

There are 22,000 islands (and islets) in several archipelagos in Vänern alone, the largest being Torsö, Kållandso and Hammerö. Some of the archipelagos are inhabited, some are deserted, green or rocky. Altogether the lake has a varied coastline of 4800 km (2983 mi), with fine sandy beaches, small bays, simple rocks, colorful meadows, dense forests and picturesque villages—a dream for flora, fauna and individualists. This largest freshwater archipelago in Europe was declared a Biosphere Reserve by UNESCO in June 2010.

Le lac Vänern

Le lac Vänern ne compte pas moins de 22 000 îles (et îlots), les plus grandes étant Torsö, Kållandso et Hammerö. Certaines sont habitées, d'autres non, les unes sont vertes, les autres composées de roches dénudées. En tout, les côtes s'étirent sur 4 800 km de plages de sable fin et d'anses rehaussées de rochers, de prés verdoyants, de forêts touffues et de villages pittoresques – un rêve pour la flore, la faune et les voyageurs solitaires. Le plus vaste archipel en eau douce d'Europe a été déclaré Réserve de biosphère par l'Unesco en juin 2010.

Vänern

In mehreren Schärengärten liegen allein im Vänern ansehnliche 22 000 Inseln (und Inselchen), die größten sind Torsö, Kållandso und Hammerö. Manche der Schären sind bewohnt, manche menschenleer, grün oder felsig karg. Zusammen verfügt der See über eine abwechslungsreiche Küstenlänge von 4800 km mit feinen Sandstränden, bunten Wiesen, dichten Wäldern und malerischen Ortschaften – ein Traum für Flora, Fauna und Individualisten. Dieser größte Süßwasser-Archipel Europas wurde von der UNESCO im Juni 2010 zum Biosphärenreservat ernannt.

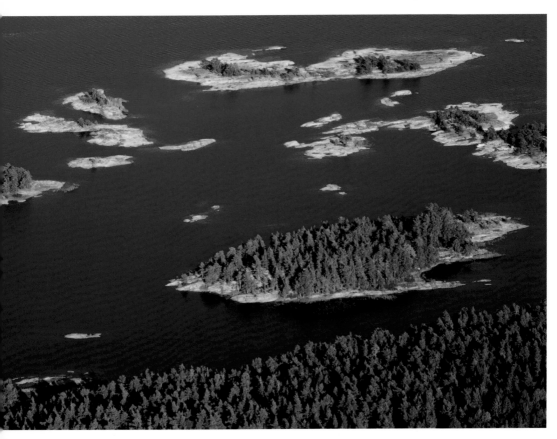

nern Lake

nern

lo en Vänern hay 22000 islas (e islotes)
varios archipiélagos, las más grandes
las cuales son Torsö, Kållandso y
mmerö. Algunos de los archipiélagos
tán habitados; otros están desiertos,
rdes o rocosos. Contándolos a todos, el
jo tiene una costa variada de 4800 km
n playas de arena fina, pequeñas bahías,
:as simples, prados coloridos, bosques
nsos y pueblos pintorescos: un sueño
ra la flora, la fauna y los individualistas.
:e archipiélago de agua dulce, que es
nás grande de Europa, fue declarado
serva de la Biosfera por la UNESCO en
io de 2010.

Vänern

Existem 22000 respeitáveis ilhas (e
ilhotas) em vários arquipélagos só em
Vänern, sendo as maiores Torsö, Kållandso
e Hammerö. Alguns dos arquipélagos são
habitados, outros são desertos, verdes ou
rochosos. Juntos, o lago tem uma costa
variada de 4800 km com praias de areia
fina, pequenas baías, rochas simples,
prados coloridos, florestas densas e aldeias
pitorescas – um sonho para a flora, fauna
e individualistas. Este maior arquipélago
de água doce da Europa foi declarado
Reserva da Biosfera pela UNESCO em
junho de 2010.

Vänern

Alleen al in het Vänermeer liggen aan
meerdere scherenkunsten 22000 eilanden
(en eilandjes), waarvan de grootste Torsö,
Kållandso en Hammerö zijn. Sommige
scheren zijn bewoond, andere verlaten,
groen of rotsachtig en kaal. Al met al heeft
het meer een gevarieerde kustlijn van
4800 km lang, met fijne zandstranden,
kleine baaien, kale rotsen, kleurrijke
weiden, dichte bossen en schilderachtige
dorpjes – een droom voor flora, fauna
en individualisten. Deze grootste
zoetwaterarchipel van Europa werd in
juni 2010 door de Unesco uitgeroepen tot
biosfeerreservaat.

Lighthouse, Vänern Lake

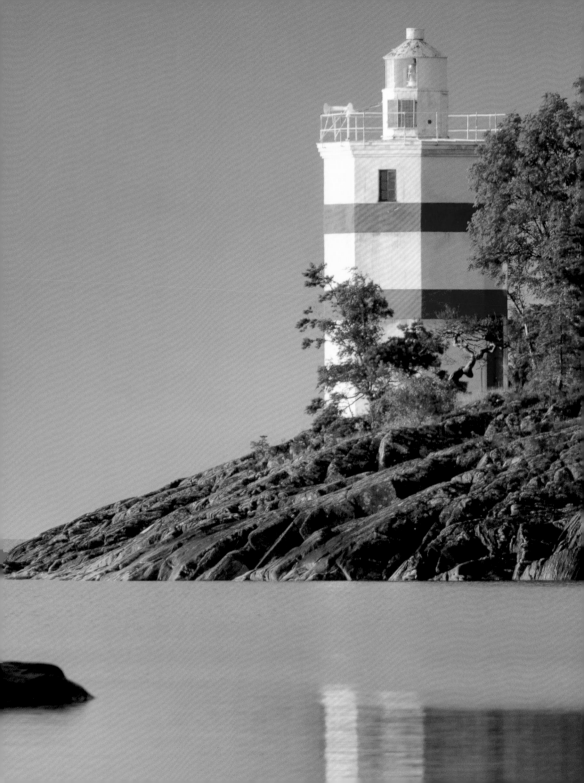

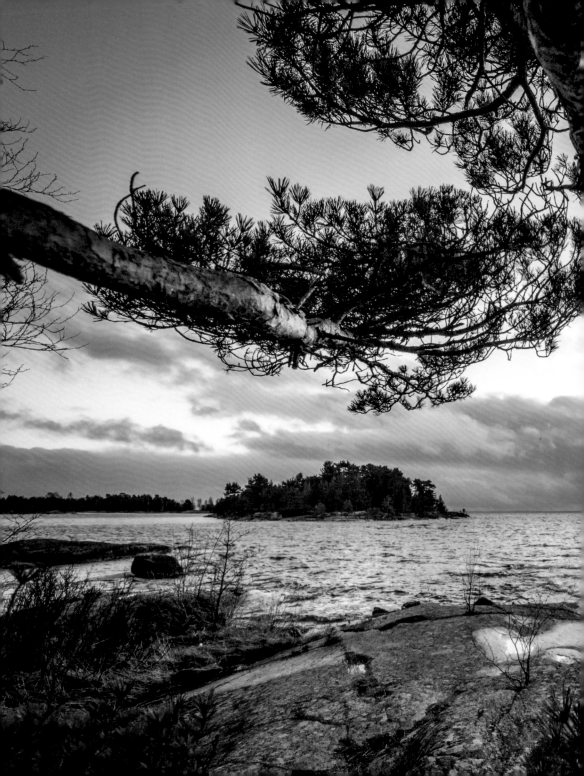

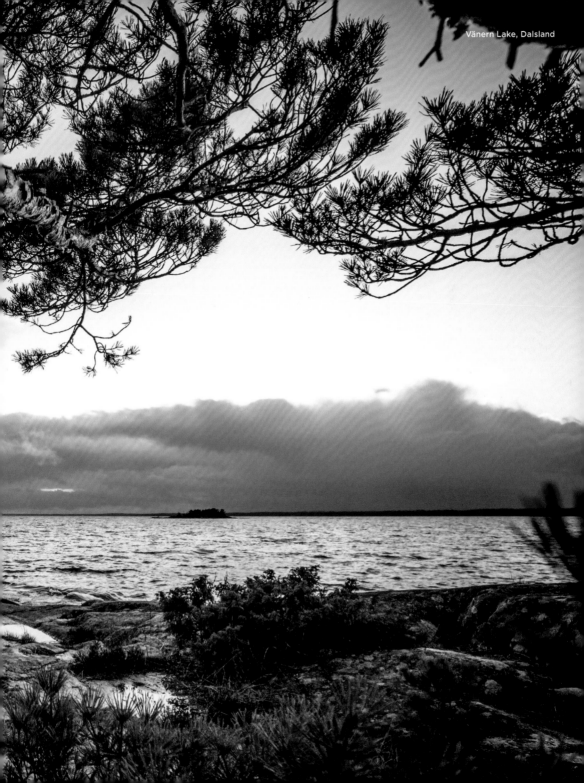
Vänern Lake, Dalsland

Vänern Lake

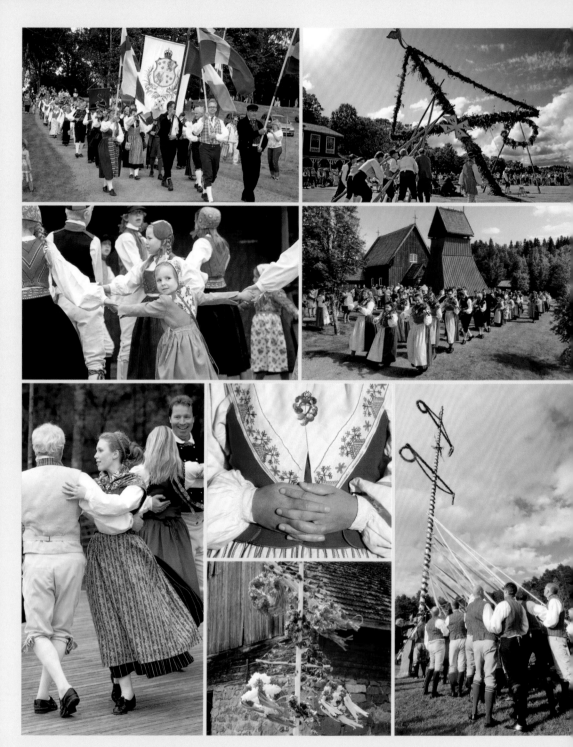

Midsummer

When meadows glow with the most beautiful colors, villages are dressed up and days become longer, Sweden celebrates the summer solstice! The "Midsommar" festival is officially held on Saturdays between 20 and 26 June. Until late in the "white night", families and friends celebrate this "national holiday" with all kinds of rituals.

Midsommar

Lorsque les prés se parent de leurs plus belles couleurs, que les villages sont nettoyés et les jours plus longs, la Suède fête le solstice d'été. La fête « nationale » de Midsommar se déroule toujours un samedi, entre le 20 et le 26 juin. Les célébrations se font en famille et entre amis, avec toutes sortes de rituels.

Mittsommer

Wenn Wiesen in den schönsten Farben erstrahlen, Ortschaften herausgeputzt sind und die Tage länger werden, dann feiert Schweden die Sommersonnenwende! Das „Midsommar"-Fest ist gesetzlich immer am Samstag zwischen 20. und 26. Juni. Familien und Freunde zelebrieren diesen „Nationalfeiertag" mit allerlei Ritualen.

Pleno verano

Cuando las praderas brillan con los colores más bellos, los pueblos se visten bien y los días se alargan, Suecia celebra el solsticio de verano. El festival "Midsommar" se celebra siempre oficialmente el sábado entre el 20 y el 26 de junio. Familias y amigos celebran esta "fiesta nacional" con todo tipo de rituales.

Pleno verão

Quando os prados brilham com as cores mais bonitas, as aldeias são enfeitadas e os dias ficam mais longos, a Suécia celebra o solstício de verão! O festival "Midsommar" é sempre no sábado, entre 20 e 26 de junho. Famílias e amigos celebram este "feriado nacional" com todos os tipos de rituais.

Midzomer

Als de weilanden in de mooiste kleuren stralen, de dorpen versierd zijn en de dagen lengen, viert Zweden de zomerzonnewende! Het 'Midsommarfest' is wettelijk altijd op de zaterdag tussen 20 en 26 juni. Families en vrienden vieren deze nationale feestdag met allerlei rituelen.

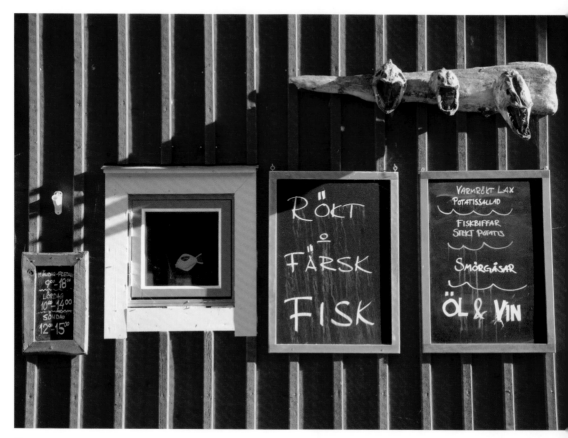

Hjo

Hjo

The wooden town of Hjo is a jewel in Vättern—a former health resort with a history dating back to the Middle Ages and a town charter dating from 1413. In the centre of the small village are picturesque wooden villas with their typical red and white paint—mostly from the 18th and 19th centuries. The idyllic cobblestone market square (Stora Torget) is surrounded by shops, cafés and restaurants. Like Eksjö in Småland, the town was awarded a prize in 1990 for the remarkable preservation of its wooden buildings.

Hjo

Vrai bijou sur les rives du Vättern, Hjo est une ville en bois très bien conservée, fière de son histoire remontant au Moyen Âge et de son droit de cité acquis en 1413. Dans le centre, les demeures charmantes, peintes comme il se doit en rouge et blanc, datent pour la plupart des XVIIIe et XIXe siècles. La belle place du marché (Stora Torget) est pavée et bordée de magasins, de cafés et de restaurants. De même qu'Eksjö dans le Småland, Hjo a reçu un prix en 1990 pour la conservation remarquable de son patrimoine bâti en bois.

Hjo

Ein Juwel am Vättern ist die bis heute sehr gut erhaltene Holzstadt Hjo – ein ehemaliger Kurort mit Geschichte bis zurück ins Mittelalter und Stadtrecht seit 1413. Im Zentrum des kleinen Ortes stehen malerische Holzvillen mit dem typisch rot-weißen Anstrich – meist stammen sie aus dem 18. und 19. Jahrhundert. Um den idyllischen Marktplatz (Stora Torget) aus Kopfsteinpflaster findet man Geschäfte, Cafés und Restaurants. Wie Eksjö in Småland wurde die Stadt im Jahr 1990 preisgekrönt für die beachtenswerte Erhaltung ihrer hölzernen Bebauung.

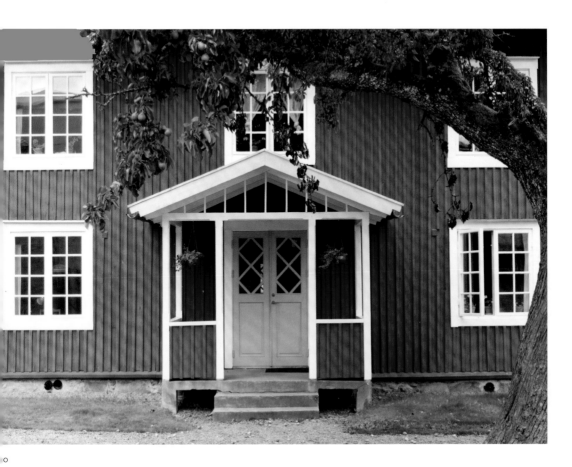

o

Hjo

Una joya de Vättern es la ciudad de
madera de Hjo, un antiguo balneario con
una historia que se remonta a la Edad
Media y que es fuero municipal desde
1413. En el centro del pequeño pueblo se
encuentran pintorescas villas de madera
con la típica pintura roja y blanca, sobre
todo de los siglos XVIII y XIX. La idílica
plaza del mercado de adoquines (Stora
Torget) está rodeada de tiendas, cafeterías
y restaurantes. Al igual que Eksjö en
Småland, la ciudad recibió un premio en
1990 por la notable conservación de sus
edificios de madera.

Hjo

Uma jóia em Vättern é ainda a cidade de
madeira de Hjo – uma antiga estância de
saúde com história que remonta à Idade
Média e com caráter de cidade desde
1413. No centro da pequena aldeia há
pitorescas vilas de madeira com a típica
pintura vermelha e branca – principalmente
dos séculos XVIII e XIX. A idílica praça do
mercado de paralelepípedos (Stora Torget)
está rodeada de lojas, cafés e restaurantes.
Tal como Eksjö em Småland, a cidade
recebeu um prémio em 1990 pela notável
preservação dos seus edifícios de madeira.

Hjo

Een juweel aan het Vättermeer is de
nog altijd goed geconserveerde houten
stad Hjo – een voormalig kuuroord met
een geschiedenis die teruggaat tot de
middeleeuwen en sinds 1413 stadsrechten
heeft. In het centrum van het plaatsje staan
schilderachtige houten villa's die in het
typerende rood en wit zijn geschilderd
– meestal uit de 18e en 19e eeuw. Het
idyllische marktplein (Stora Torget) van
kinderhoofdjes wordt omgeven door
winkels, cafés en restaurants. Net als Eksjö
in Småland kreeg de stad in 1990 een prijs
voor het opmerkelijke behoud van zijn
houten huizen.

Hästholmen, Vättern Lake

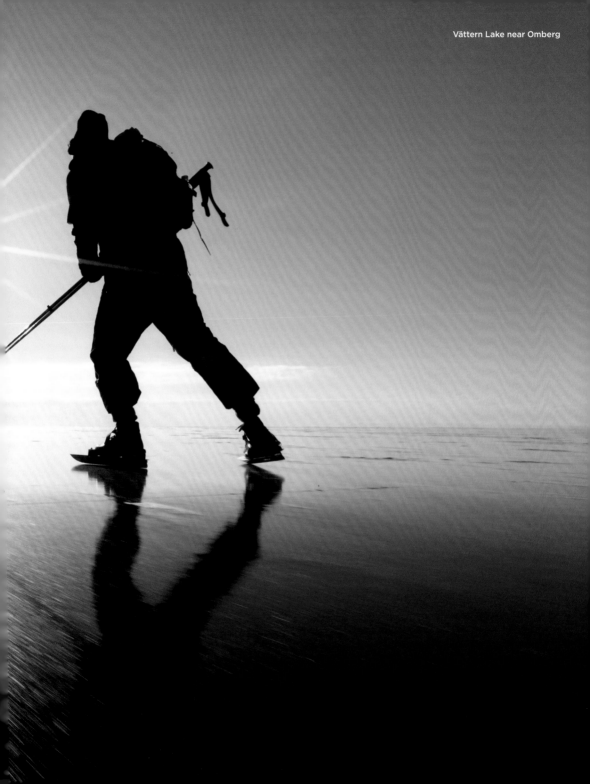

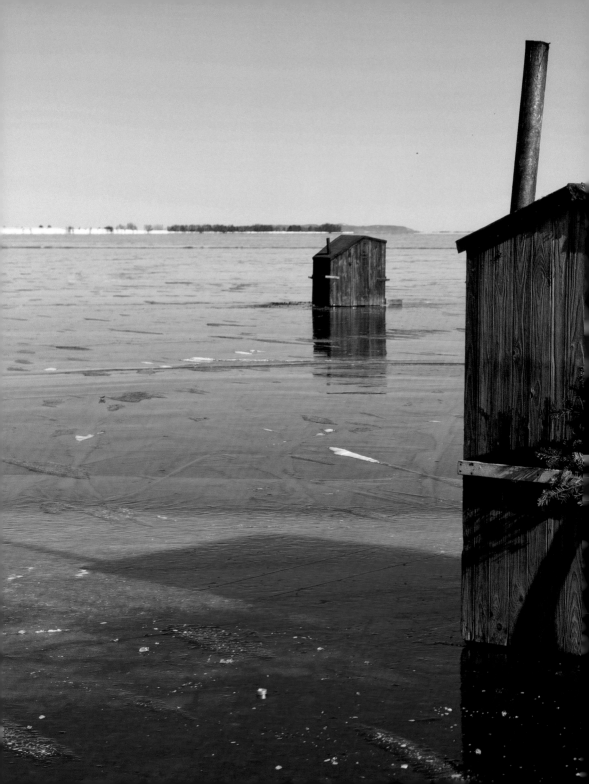

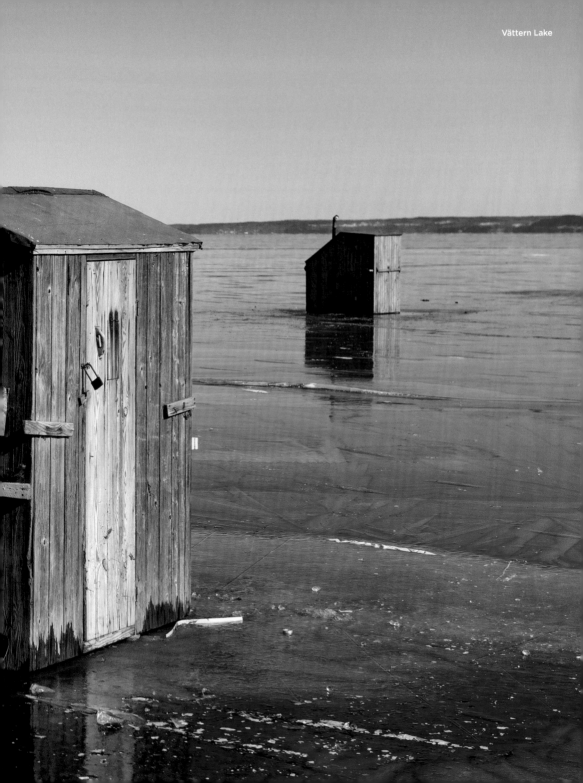

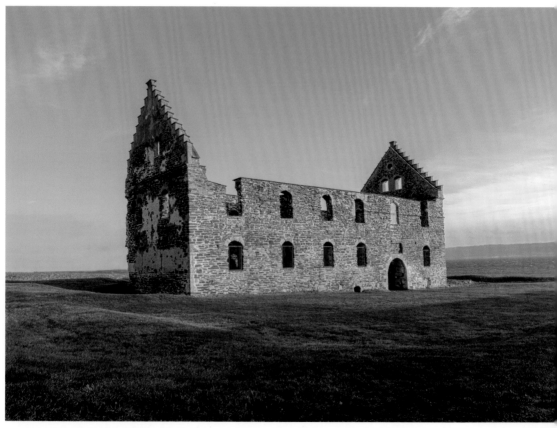

Visingsborg, Visingsö Island, Vättern Lake

Castle Ruins

The thick walls tell of times from the 17th
century when today's Brahehus ruin was
still a magnificent pleasure palace. With
a fantastic view, the ruins tower about 90
m (295 ft) above Vättern—a location that
Count Per Brahe the Younger deliberately
chose in order to demonstrate his power.
It was to be the widow's residence for
his wife Kristina, who died before its
completion. Count Per Brahe himself
resided at his castle in Visingsborg, which
is located directly opposite on the island
of Visingsö. Today, this ruin is one of the
historical sights around Vättern.

Châteaux en ruine

L'épaisseur des murs rappelle que
Brahehus, aujourd'hui une ruine, était
encore un splendide château au xviie siècle.
Installé sur une hauteur à 90 m au-dessus
du Vättern – un emplacement délibérément
choisi par le comte Per Brahe le Jeune pour
démontrer sa puissance –, l'édifice offre
une vue fabuleuse. Il l'avait fait construire
pour que son épouse, Kristina, y réside
une fois veuve, mais celle-ci mourut avant
la fin des travaux. Per Brahe, quant à lui,
habitait dans son château de Visingsborg,
juste en face, sur l'île de Visingsö. De nos
jours, cette ruine est aussi l'un des centres
d'intérêt les plus riches en histoire des rives
du Vättern.

Burgruinen

Die dicken Gemäuer erzählen von Zeiten
aus dem 17. Jahrhundert, als die heutige
Ruine Brahehus noch ein prunkvolles
Lustschloss war. Mit einem traumhaften
Ausblick thront die Ruine etwa 90 m über
dem Vättern – eine Lage, die Bauherr Graf
Per Brahe der Jüngere bewusst wählte, um
seine Macht zu demonstrieren. Es sollte
der Witwensitz für seine Frau Kristina
werden, die jedoch noch vor Fertigstellung
verstarb. Graf Per Brahe selbst residierte
auf seinem Schloss Visingsborg, das gleich
gegenüber auf der Insel Visingsö liegt.
Heute gehört auch diese Ruine zu den
geschichtsträchtigen Sehenswürdigkeiten
um den Vättern.

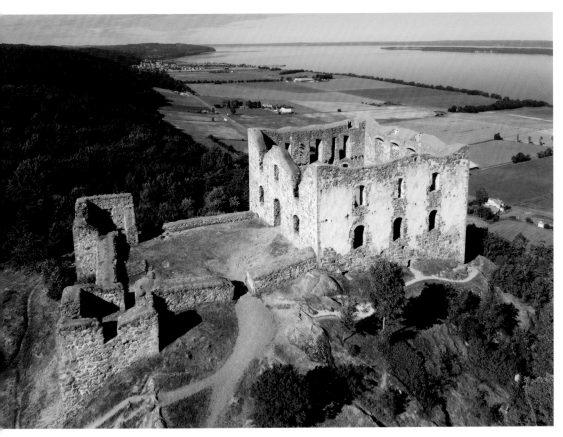

rahehus Castle

uinas de castillos

as gruesas paredes hablan de tiempos
el siglo XVII, cuando las actuales ruinas
e Brahehus eran todavía un magnífico
astillo de placer. Con una vista fantástica,
s ruinas se elevan unos 90 m por encima
e Vättern: una ubicación que el Conde Per
rahe el Joven eligió deliberadamente para
emostrar su poder. Iba a ser la residencia
e la viuda de su esposa Kristina, pero esta
lleció antes de terminarse la construcción
el castillo. El propio conde Per Brahe
esidía en su castillo de Visingsborg,
tuado justo enfrente de la isla de
isingsö. Hoy en día, esta ruina también
ertenece a los monumentos históricos de
s alrededores de Vättern.

Ruínas do castelo

As paredes espessas contam os tempos
do século XVII, quando a ruína Brahehus
de hoje ainda era um magnífico palácio
de prazeres. Com uma vista fantástica, as
torres da ruína se erguem a cerca de 90 m
acima de Vättern – um local que o Conde
Per Brahe, o Jovem, conscientemente
escolheu para demonstrar o seu poder.
Era para ser a residência da viúva para
sua esposa Kristina, que morreu antes da
conclusão. O próprio Conde Per Brahe
residiu em seu castelo em Visingsborg,
localizado em frente à ilha de Visingsö.
Hoje, esta ruína também pertence aos
pontos turísticos históricos em torno
do Vättern.

Kasteelruïnes

De dikke muren vertellen van tijden uit
de 17e eeuw, toen de huidige ruïne van
Brahehus nog een schitterend lustslot was.
Met een fantastisch uitzicht torent de ruïne
ongeveer 90 meter boven het Vättermeer
uit – een standplaats die landdrost Per
Brahe de Jonge bewust had gekozen
om zijn macht te demonstreren. Het zou
de residentie voor zijn weduwe Kristina
worden, die echter voor de voltooiing
van het project overleed. Per Brahe zelf
woonde op zijn kasteel Visingsborg, dat
direct tegenover het eiland Visingsö staat.
Tegenwoordig behoort ook deze ruïne tot
de historische bezienswaardigheden rond
het Vättermeer.

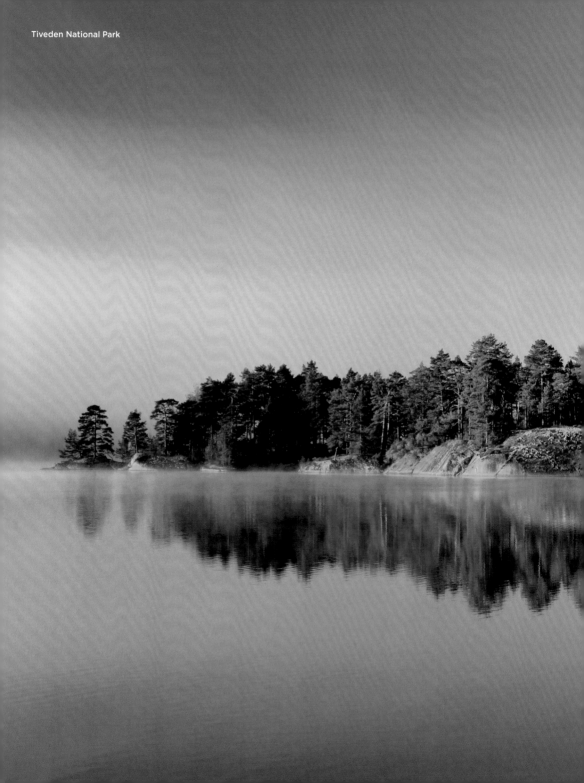
Tiveden National Park

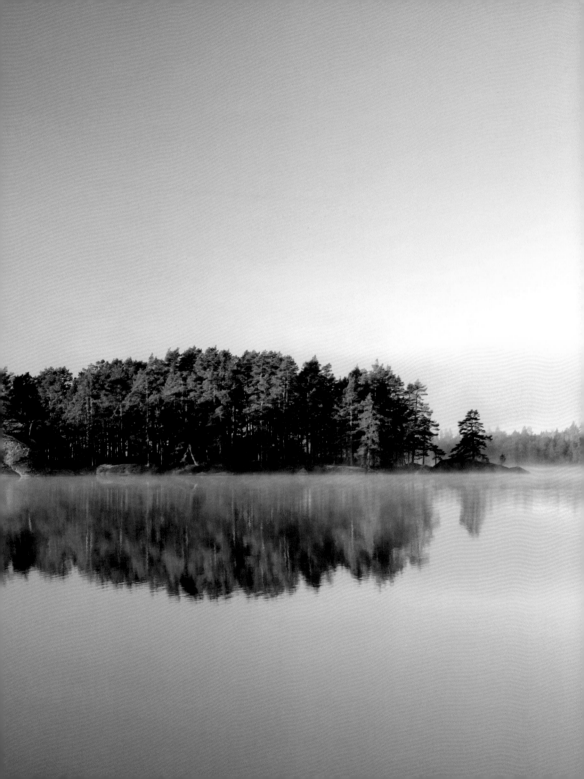

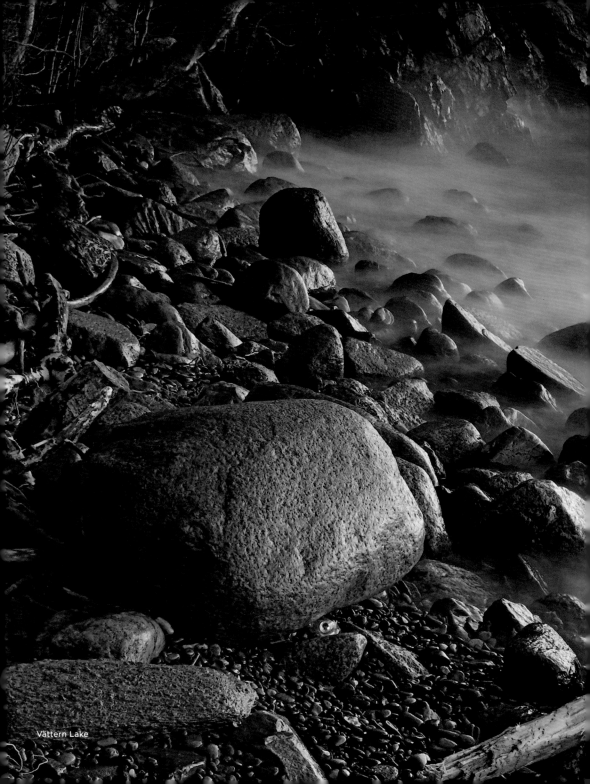
Vättern Lake

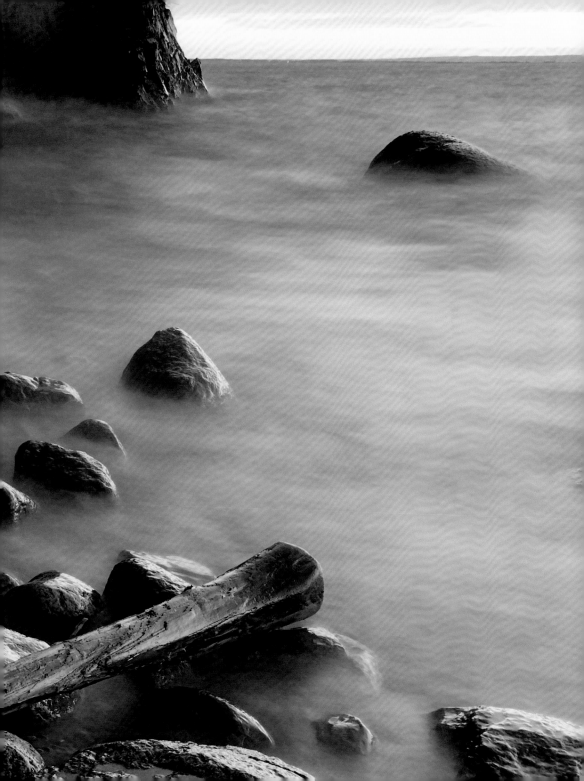

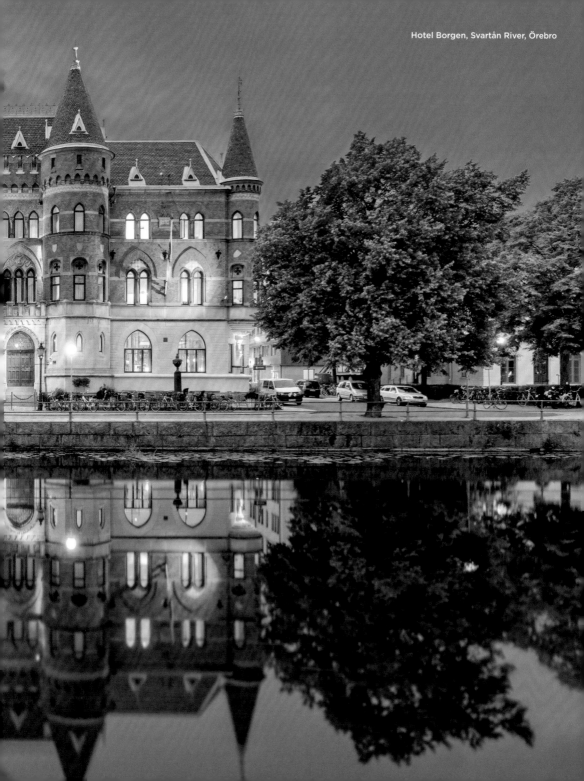

Hotel Borgen, Svartån River, Örebro

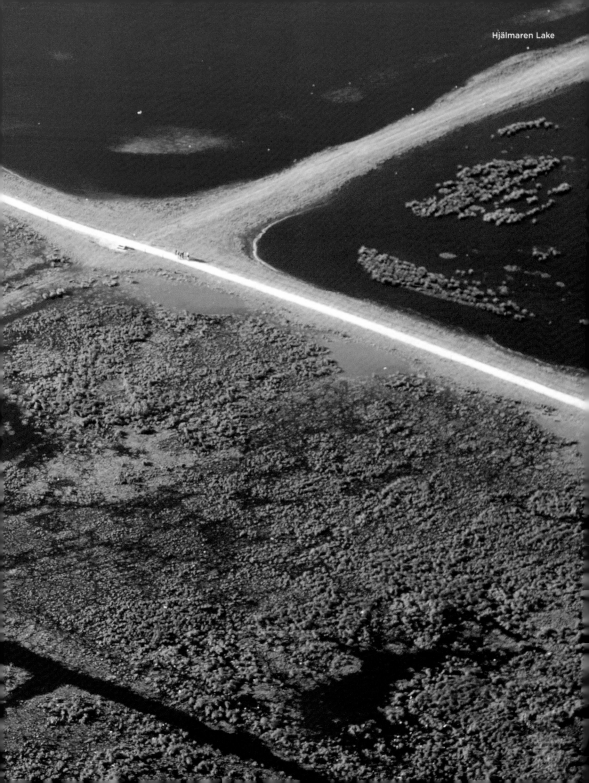

Hjälmaren Lake

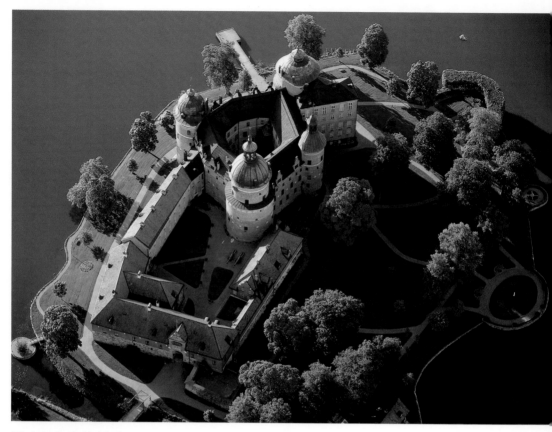

Gripsholm Castle, Mariefred

Södermanland

Just like in Katrineholm, romantic sunsets by the lake are not unusual in the province of Södermanland. The region lies between the Baltic Sea and the waters of Hjälmaren and Mälaren. It is famous for its many watercourses, hundreds of lakes, small wooded hills, and also for castles such as Gripsholm and Tullgarn. The railway network plays an important role: like Mariefred, Gnesta and Vingåker, the Katrineholm railway junction is an important part of this historical province and is resembles a miniature Sweden – something of everything: forest, lakes, bathing places, local recreation areas, parks, hiking trails and lots of fresh air.

Södermanland

Les couchers de soleil romantiques sur un lac n'ont rien d'extraordinaire dans le Södermanland, par exemple à Katrineholm. Cette province se situe entre la mer Baltique et deux lacs, le Hjälmaren et le Mälar. Elle est connue pour ses nombreux cours d'eau, ses centaines de lacs et ses petites collines boisées, mais aussi pour les châteaux de Gripsholm et Tullgarn. Les voies ferrées y jouent un rôle important. Le nœud ferroviaire de Katrineholm appartient comme Mariefred, Gnesta et Vingåker à la province historique et ressemble un peu à une Suède miniature, avec tous les ingrédients : des forêts, des lacs, des baignades, des bases de loisirs, des parcs, des chemins de randonnée et du bon air autant qu'on en veut.

Södermanland

Romantische Sonnenuntergänge am See wie in Katrineholm, sind in der Provinz Södermanland nicht außergewöhnlich. Die Region liegt zwischen Ostsee und den beiden Gewässern Hjälmaren und Mälaren. Sie ist bekannt für ihre vielen Wasserläufe, hunderte von Seen, kleine bewaldete Hügel, aber auch für Schlösse wie Gripsholm und Tullgarn. Eine wichti Rolle spielt das Schienennetz, der Eisenbahnknotenpunkt Katrineholm geh wie Mariefred, Gnesta und Vingåker zur historischen Provinz und ist ein wenig wie ein kleines Schweden auf begrenzte Fläche – von allem etwas: Wald, Seen, Badestellen, Naherholungsgebiete, Parkanlagen, Wanderwege und viel frische Luft.

lösjön Lake, Katrineholm

dermanland
s románticas puestas de sol en el lago,
mo en Katrineholm, no son inusuales en
provincia de Södermanland. La región
encuentra entre el mar Báltico y las
uas de Hjälmaren y Mälaren. Esta región
conocida por sus numerosos cursos de
ua, cientos de lagos, pequeñas colinas
scosas, pero también por castillos como
psholm y Tullgarn. La red ferroviaria
ga un papel importante, el enclave
roviario Katrineholm pertenece, como
riefred, Gnesta y Vingåker, a la provincia
tórica y es un poco como una pequeña
ecia en un área limitada: hay un poco
todo: bosques, lagos, lugares de baño,
as de recreo locales, parques, senderos
senderismo y mucho aire fresco.

Södermanland
O pôr-do-sol romântico no lago, como em
Katrineholm, não é incomum na província
de Södermanland. A região situa-se entre
o mar Báltico e as águas de Hjälmaren e
Mälaren. É famosa por seus muitos cursos
de água, centenas de lagos, pequenas
colinas arborizadas, mas também por
castelos como Gripsholm e Tullgarn. A
rede ferroviária desempenha um papel
importante: o entroncamento ferroviário
Katrineholm pertence à provícia histórica
como Mariefred, Gnesta e Vingåker e é
um pouco como uma pequena Suécia em
uma área limitada – algo de tudo: floresta,
lagos, locais de banho, áreas de recreação
local, parques, trilhas para caminhadas e
muito ar fresco.

Södermanland
Romantische zonsondergangen aan
het meer, zoals in Katrineholm, zijn
niet ongebruikelijk in de provincie
Södermanland. Het gebied ligt tussen de
Oostzee en de wateren van Hjälmaren
en Mälaren. Het is beroemd om zijn vele
waterlopen, honderden meren, kleine
beboste heuvels, maar ook om kastelen als
Gripsholm en Tullgarn. Het spoorwegnet
speelt een belangrijke rol. Het
spoorwegknooppunt Katrineholm hoort
net als Mariefred, Gnesta en Vingåker bij
de historische provincie en lijkt een beetje
op een miniatuur-Zweden. Hier is van alles
wat: bos, meren, zwemgelegenheden, dicht
bij een stad gelegen recreatiegebieden,
parken, wandelpaden en veel frisse lucht.

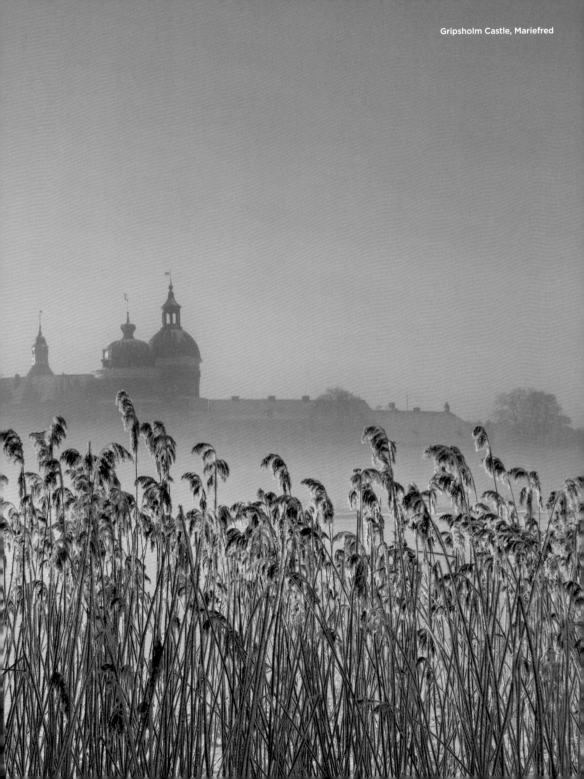

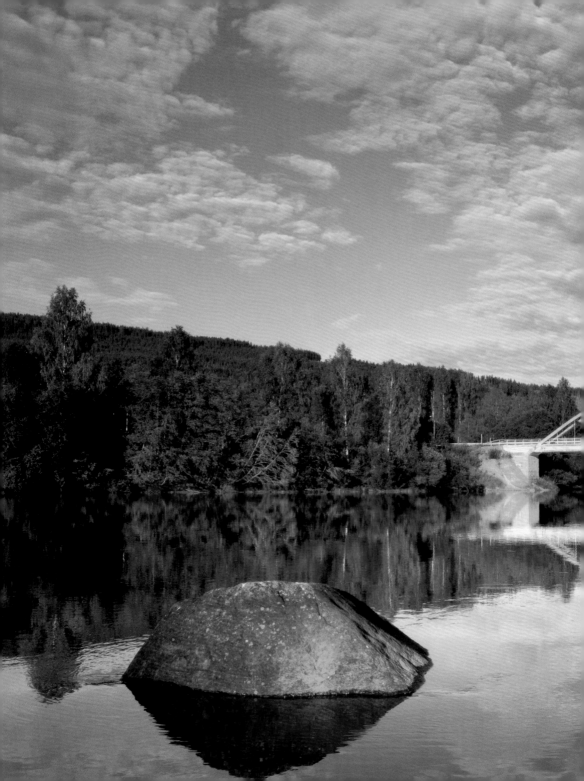

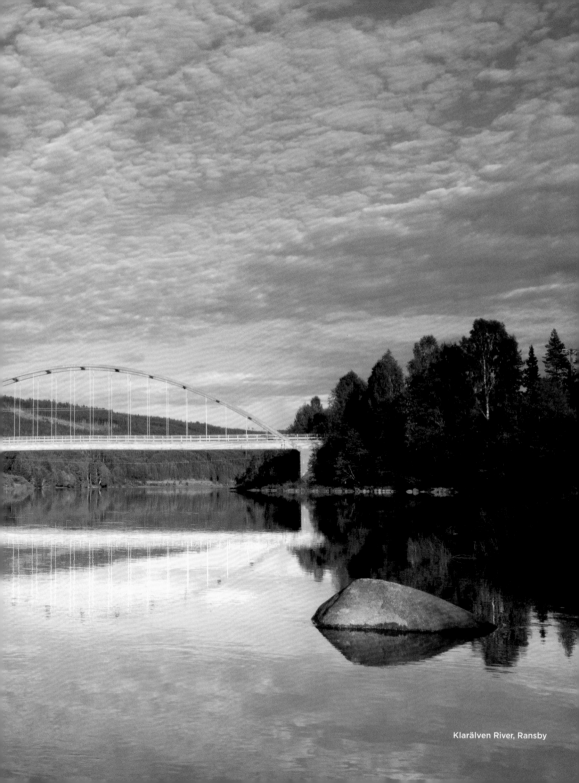

Klarälven River, Ransby

Walpurgis Night, Uppsala

Uppsala

An exciting city history with almost 550 years of scientific tradition, Viking royal tombs, beautiful botanical gardens and cosy cafés make Uppsala an attractive world renowned university city. Cultural highlights such as the Walpurgis Night on 30 April in Swedish "Valborg" turn Uppsala into a festival hotspot hotspot and crowd-puller. Then spring is welcomed with a huge bonfire—songs are sung, speeches are held, student caps are swung, a boat race takes place on the river Fyrisån and everyone dances into the next day.

Uppsala

Son histoire passionnante, dont une université qui compte presque 550 ans, ses tombes de rois vikings, ses superbes jardins botaniques et ses bars agréables expliquent pourquoi les étudiants viennent du monde entier à Uppsala. Lors d'événements culturels comme la nuit de Walpurgis (*Valborg* en suédois), le 30 avril, le public converge pour célébrer une fête qui gagne toute la ville. Ensuite, de grands feux sont allumés pour souhaiter la bienvenue au printemps, au milieu de chansons et de discours scandés par les étudiants qui brandissent leurs casquettes. Des régates ont lieu sur la rivière, le Fyrisån, et tout le monde danse jusqu'au petit matin.

Uppsala

Eine spannende Stadtgeschichte mit fast 550 Jahre alter Tradition der Wissenschaft, Wikinger-Königsgrabstätten wunderschönen Botanischen Gärten und gemütlichen Cafés machen Uppsala international zu einer attraktiven Universitätsstadt. Auch kulturelle Highlights wie die Walpurgisnacht am 30. April, auf schwedisch „Valborg", verwandeln Uppsala zu einer Feierhochburg und zum Publikumsmagneten. Dann wird mit einem großen Feuer der Frühling willkommen geheißen – dabei werden Lieder gesungen, Reden gehalten, Studentenmützen geschwungen, auf dem Fluss Fyrisån findet ein Bootsrennen statt und alle tanzen bis in den nächsten Tag hinein.

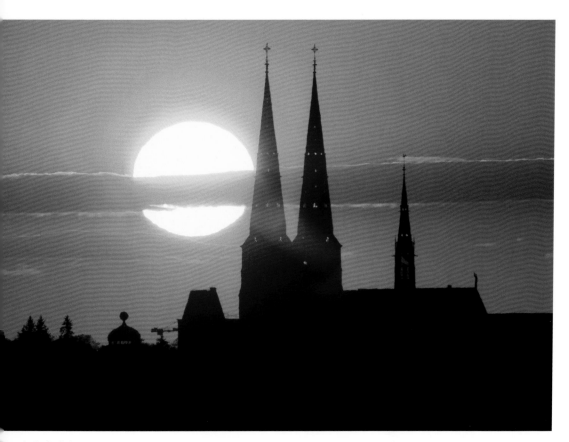

ppsala Cathedral

ppsala

na emocionante historia de la ciudad
on casi 550 años de tradición científica,
umbas reales vikingas, hermosos jardines
otánicos y acogedoras cafeterías hacen de
ppsala una atractiva ciudad universitaria
nivel internacional. Los acontecimientos
ulturales más destacados, como la Noche
e Walpurgis del 30 de abril, en sueco
Valborg", también convierten a Uppsala en
n bastión de celebraciones y en un punto
e atracción para las multitudes. Luego,
e da la bienvenida a la primavera con una
ran hoguera: se cantan canciones, se dan
scursos, se balancean las gorras de los
tudiantes, se celebra una carrera de botes
el río Fyrisån y todo el mundo baila hasta
día siguiente.

Uppsala

Uma história emocionante da cidade com
quase 550 anos de tradição científica,
tumbas reais vikings, belos jardins
botânicos e cafés acolhedores fazem de
Uppsala uma cidade universitária atraente
internacionalmente. Destaques culturais
como a Noite de Walpurgis a 30 de Abril,
em sueco "Valborg", transformam Uppsala
em uma fortaleza de de celebração e
num atrativo de multidões. Em seguida,
a primavera é recebida com um grande
fogo – canções são cantadas, discursos
são proferidos, bonés são balançados, uma
corrida de barco acontece no rio Fyrisån e
todos dançam até o dia seguinte.

Uppsala

Een spannende stadsgeschiedenis met een
bijna 550 jaar oude wetenschapstraditie,
graven van Vikingkoningen, prachtige
botanische tuinen en gezellige cafés
maken Uppsala internationaal tot een
aantrekkelijke universiteitsstad. Ook culturele
hoogtepunten zoals de Walpurgisnacht op
30 april, in het Zweeds Valborg, veranderen
Uppsala in een feestbolwerk en trekpleister.
Dan wordt de lente verwelkomd met een
groot vuur. Er worden liederen gezongen,
toespraken gehouden, er wordt met
studentenpetten gezwaaid, er vindt een
bootrace plaats op de rivier de Fyrisån en
iedereen danst tot diep in de nacht.

Stockholm

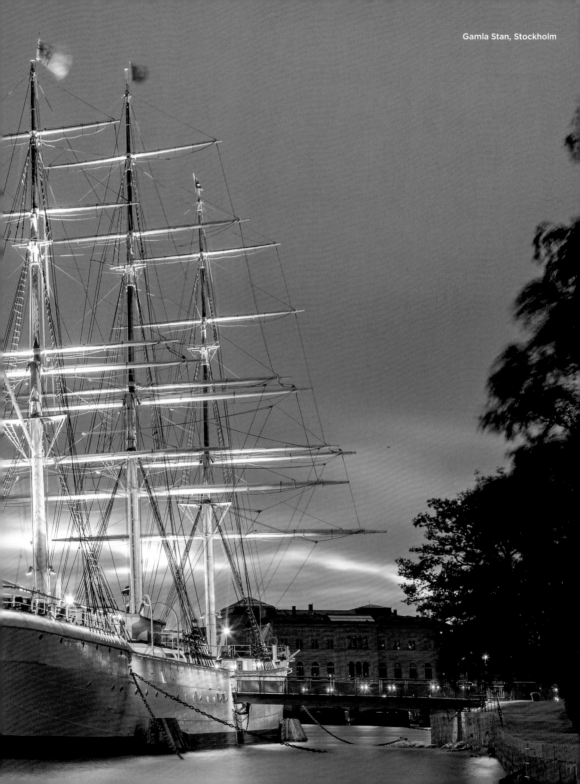

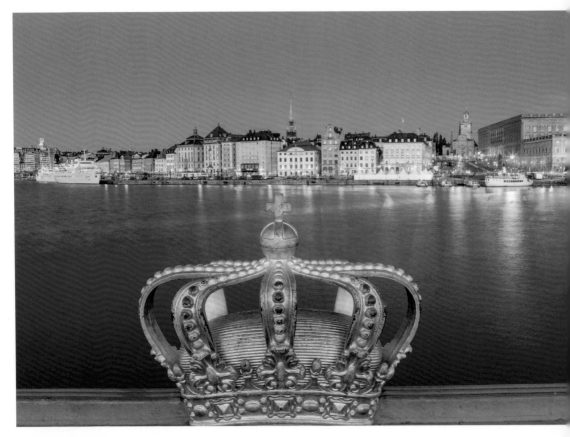

Skeppsholm Bridge, Stockholm

Stockholm

There are names for the Swedish capital such as "Venice of the North" or "City on the Water"—but each name does justice to only one part of this exciting metropolis. The floating city stretches across 14 islands connected by 57 bridges, and owes its special charm above all to its location between Lake Mälaren and the Baltic Sea. The royal palace, seat of government, many impressive buildings and numerous museums tell the story of a long city history and, together with forests and green spaces as well as beaches and the archipelago islands make up the legendary beauty of Stockholm.

Stockholm

La capitale suédoise a été surnommée « Venise du Nord » ou « Ville sur l'eau », mais ces noms sont loin de rendre justice à cette métropole ensorcelante. La ville flottante s'étend sur plus de 14 îles, reliées par 57 ponts, et doit son attrait incomparable avant tout à sa situation entre le lac Mälar et la mer Baltique. Le palais royal, les ministères, tout un chapelet d'édifices imposants et de musées racontent sa longue histoire et s'associent aux forêts et aux espaces verts, mais aussi aux plages et aux îles, pour conférer à Stockholm sa beauté légendaire.

Stockholm

Für die schwedische Hauptstadt gibt es Namen wie „Venedig des Nordens" oder „Stadt auf dem Wasser" – doch jede Bezeichnung wird nur einem Teil der aufregenden Metropole gerecht. Die schwimmende Stadt erstreckt sich über 14 Inseln, ist durch 57 Brücken verbunden und verdankt vor allem der Lage zwischen dem See Mälaren und der Ostsee ihren besonderen Charme. Königspalast, Regierungssitz, viele imposante Gebäude und zahlreiche Museen erzählen von einer langen Stadtgeschichte und machen im Zusammenspiel mit Wäldern und Grünflächen sowie Stränden und den Schäreninseln die legendäre Schönheit Stockholms aus.

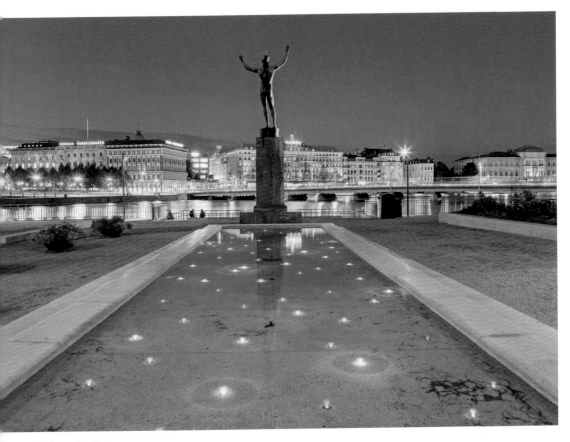

Helgeandsholmen, Stockholm

Estocolmo

Para la capital sueca hay nombres como "Venecia del Norte" o "Ciudad en el Agua", pero cada nombre hace justicia solo a una parte de la excitante metrópoli. La ciudad flotante se extiende a través de 14 islas, está conectada por 57 puentes y debe su encanto especial, sobre todo, a su ubicación entre el lago Mälaren y el mar Báltico. El palacio real, la sede del gobierno, muchos edificios impresionantes y numerosos museos cuentan la historia de una larga ciudad y, junto con los bosques y las zonas verdes, así como las playas y las islas del archipiélago, conforman la legendaria belleza de Estocolmo.

Estocolmo

Para a capital sueca há nomes como "Veneza do Norte" ou "Cidade na Água" – mas cada nome faz justiça a apenas uma parte da excitante metrópole. A cidade flutuante estende-se por 14 ilhas, está ligada por 57 pontes e deve o seu charme especial sobretudo à sua localização entre o Lago Mälaren e o Mar Báltico. O palácio real, sede do governo, muitos edifícios impressionantes e numerosos museus contam a história de uma longa história da cidade e, juntamente com as florestas e espaços verdes, bem como as praias e as ilhas do arquipélago, compõem a beleza lendária de Estocolmo.

Stockholm

Voor de Zweedse hoofdstad zijn er namen als 'Venetië van het noorden' en 'stad op het water', maar elke benaming doet slechts recht aan één aspect van de opwindende metropool. De drijvende stad strekt zich uit over veertien eilanden, is door 57 bruggen met elkaar verbonden en dankt zijn bijzondere charme vooral aan zijn ligging tussen het Mälarmeer en de Oostzee. Het koninklijk paleis, de regeringszetel, veel imposante gebouwen en talrijke musea vertellen van een lange stadsgeschiedenis en vormen samen met de bossen, groenvoorzieningen, stranden en schereneilanden de legendarische schoonheid van Stockholm.

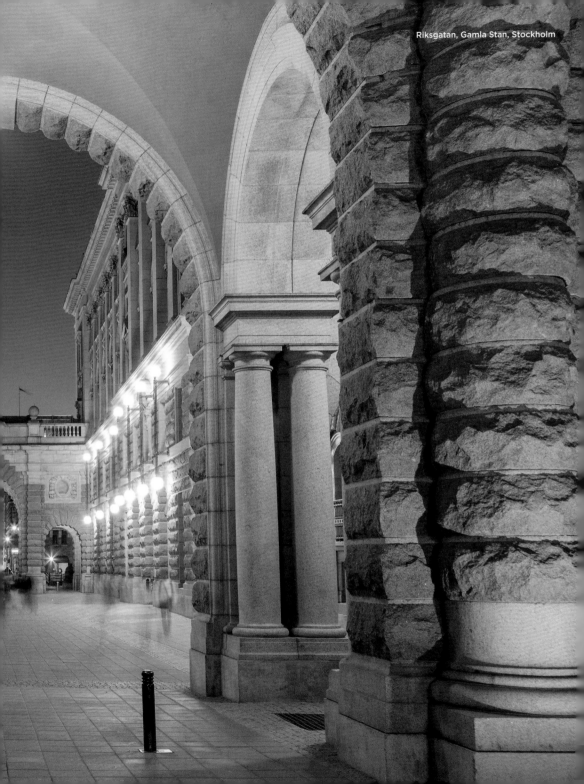

Riksgatan, Gamla Stan, Stockholm

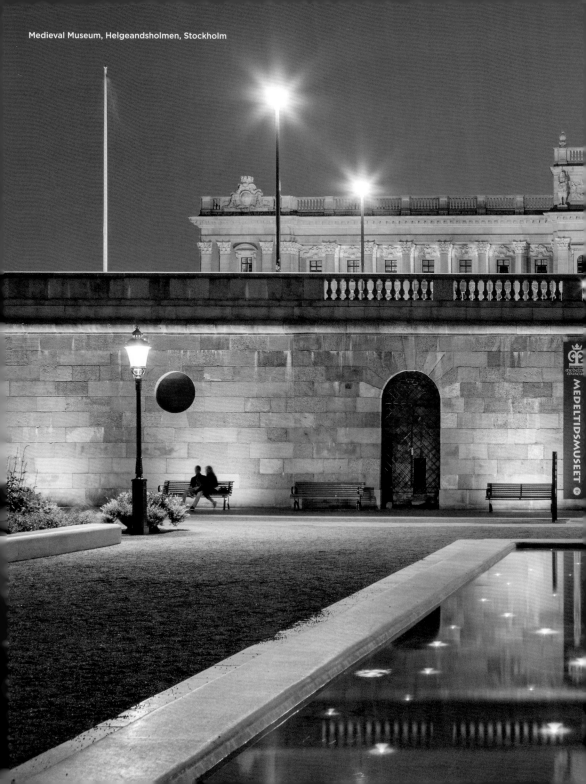

Medieval Museum, Helgeandsholmen, Stockholm

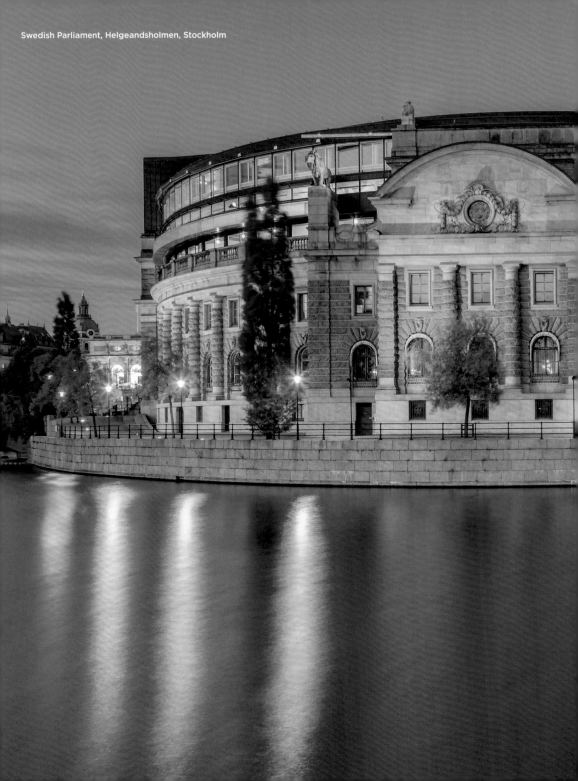

Swedish Parliament, Helgeandsholmen, Stockholm

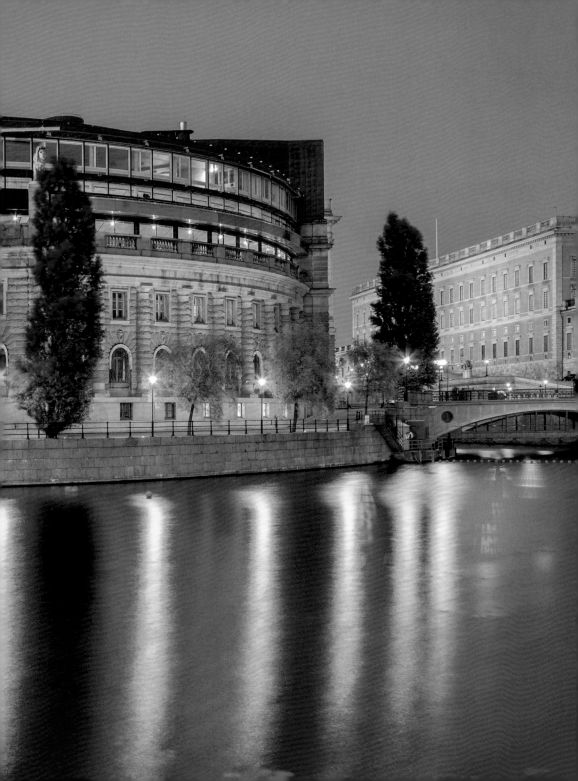

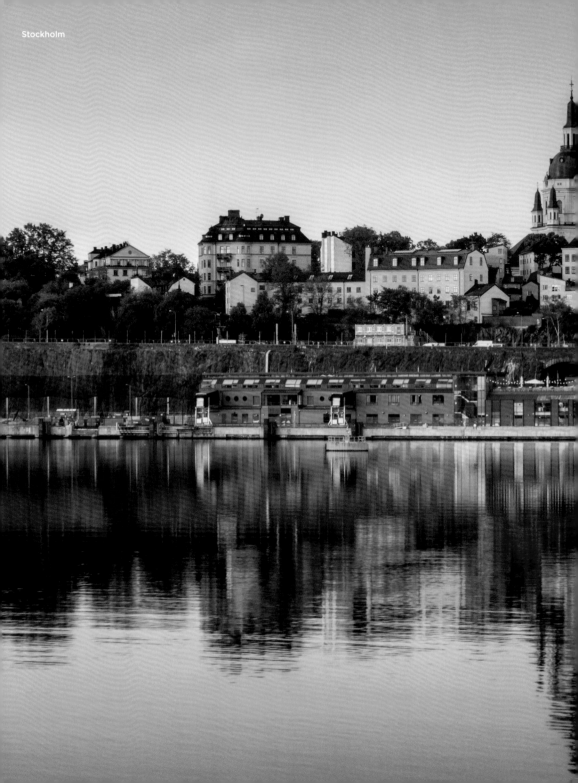

Stockholm

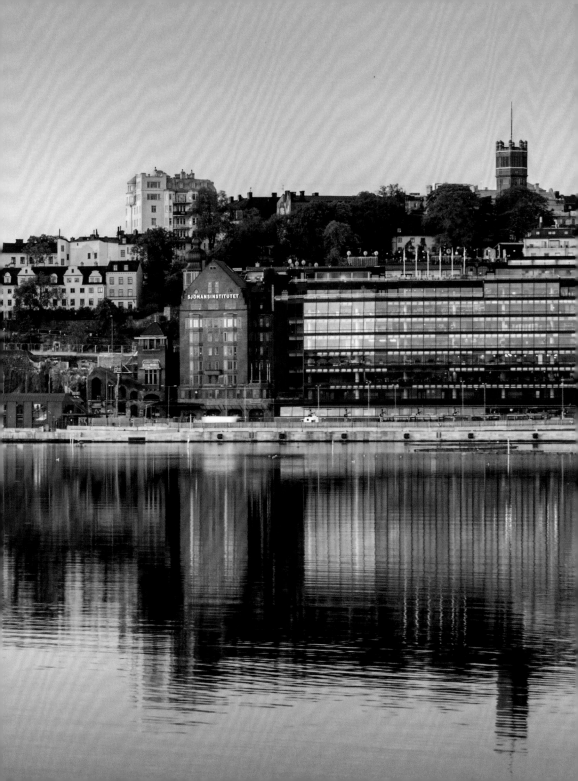

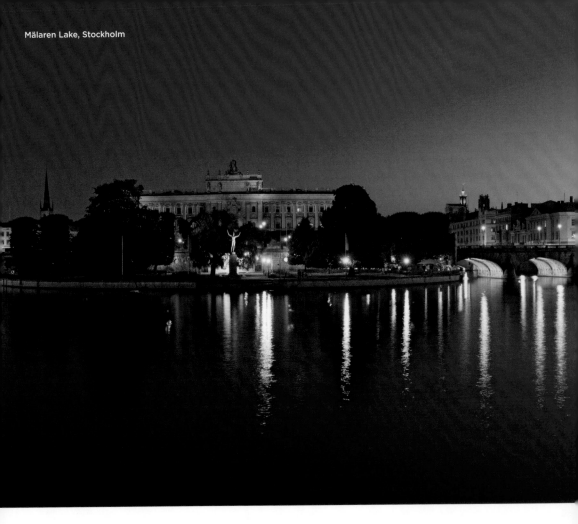
Mälaren Lake, Stockholm

Way of Life

Friendly, modern and culturally open—Stockholm is one of the most exciting and charismatic cities in Europe. At the same time, it is considered to be one of the cleanest cities in Europe and for good reason has been awarded the "European Green Capital Award 2010" by the European Commission. Aspects such as public green spaces, transport, air quality, noise and sustainability were assessed. One third of Stockholm's surface area alone consists of water and another third consists of green areas and parks. In addition, the water quality here is so good that it is safe to swim in the middle of the city.

L'art de vivre

Accueillante, moderne et pétrie de culture, Stockholm est l'une des capitales les plus fascinantes et charismatiques d'Europe. Elle passe également pour être l'une des plus propres et c'est à juste titre que la Commission européenne lui a décerné le prix de la Capitale verte de l'Europe en 2010. Elle a été évaluée selon des critères tels que les espaces verts, la circulation, la qualité de l'air, le bruit et les stratégies de développement durable. Or, l'eau représente un tiers de la superficie de Stockholm et les parcs et espaces verts un autre tiers. En prime, l'eau est d'une telle qualité que l'on peut se baigner sans crainte en pleine ville.

Lebensart

Freundlich, modern und kulturell aufgeschlossen – Stockholm ist eine der spannendsten und charismatischsten Großstädte Europas. Sie gilt gleichzeitig auch als eine der saubersten und wurde nicht ohne Grund von der Europäischen Kommission mit dem „European Green Capital Award 2010" ausgezeichnet. Bewertet wurden Aspekte wie öffentliche Grünflächen, Verkehr, Luftqualität, Lärm und Nachhaltigkeit. Allein ein Drittel von Stockholms Flächen besteht aus Wasser und ein weiteres Drittel nehmen Grünflächen und Parks ein, zudem ist die Wasserqualität hier so gut, dass inmitten der Stadt bedenkenlos gebadet werden kann.

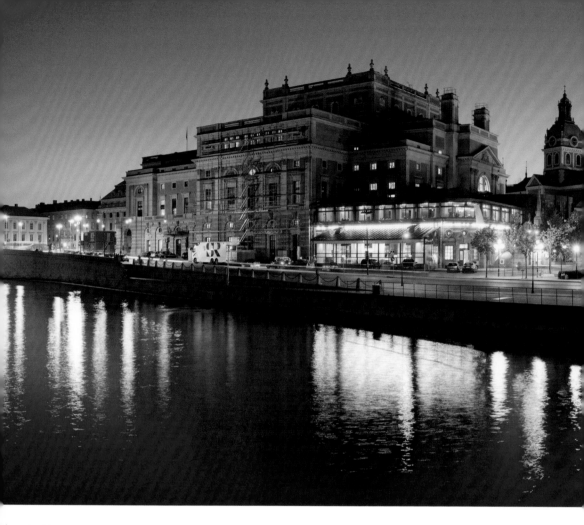

orma de vida

mistosa, moderna y culturalmente
bierta, Estocolmo es una de las ciudades
ás excitantes y carismáticas de Europa.
 mismo tiempo, es considerada una de
 ciudades más limpias de Europa y ha
do galardonada con el "European Green
apital Award 2010" por la Comisión
ropea por una buena razón. Se evaluaron
pectos como las zonas verdes públicas,
transporte, la calidad del aire, el ruido y
sostenibilidad. Una tercera parte de la
perficie de Estocolmo está formada por
ua y otra tercera parte por zonas verdes
arques; además, la calidad del agua
 tan buena que es seguro bañarse en el
ntro de la ciudad.

Modo de vida

Amigável, moderna e culturalmente
aberta – Estocolmo é uma das cidades
mais excitantes e carismáticas da Europa.
Ao mesmo tempo, é considerada uma
das cidades mais limpas da Europa e foi
galardoada com o prémio "Capital Verde
da Europa 2010" pela Comissão Europeia
por boas razões. Aspectos como espaços
verdes públicos, transportes, qualidade
do ar, ruído e sustentabilidade foram
avaliados. Um terço da superfície de
Estocolmo é constituída apenas por água
e outro terço por zonas verdes e parques.
Além disso, a qualidade da água aqui é tão
boa que é seguro tomar banho no meio
da cidade.

Levensstijl

Vriendelijk, modern en cultureel
geïnteresseerd – Stockholm is een van
de meest opwindende en charismatische
steden van Europa. Tegelijkertijd wordt
hij beschouwd als een van de schoonste
steden, en hij kreeg niet voor niets de
European Green Capital Award 2010
van de Europese Commissie. Aspecten
als openbare groenvoorziening, vervoer,
luchtkwaliteit, lawaai en duurzaamheid zijn
beoordeeld. Een derde van het oppervlak
van Stockholm bestaat uit water en een
ander derde deel bestaat uit groene zones
en parken. Bovendien is de waterkwaliteit
hier zo goed dat het veilig is om midden in
de stad te zwemmen.

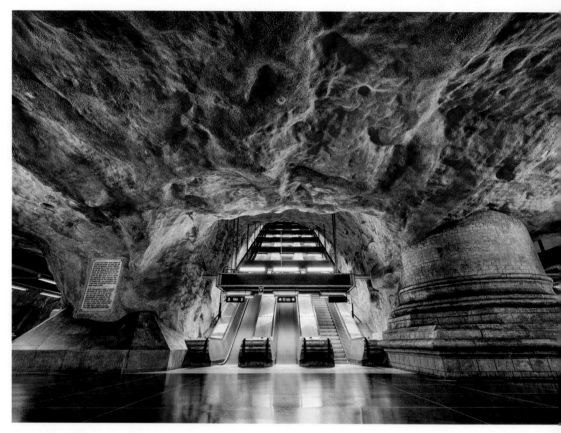

Metro Station Rådhuset, Stockholm

Subway Art

Besides many sights above the ground, Stockholm also offers real treasures underground: the "Tunnelbana" resembles a huge art gallery. Almost 90 of its approximately 100 underground stations have been individually designed and are an attraction for tourists and locals. More than 150 artists have created works of art in the cave-like stations carved into bare stone, with colorful paintings, fascinating mosaics or inspiring installations. Stockholm's underground and above-ground traffic system is considered one of the most modern in the world, and has been continuously developed into an architectural masterpiece since 1950.

L'art dans le métro

Outre ses centres d'intérêt touristiques en surface, Stockholm regorge de trésors sous terre : son métro, le Tunnelbana, peut être assimilé à une immense galerie d'art. Revisitées par des créateurs, 90 de ses 100 stations se sont muées en œuvres picturales qui enthousiasment autant les touristes que les habitants. Plus de 150 artistes se sont exprimés dans ces stations taillées à même la roche, sortes de grottes désormais ornées de peintures bariolées, de mosaïques fascinantes ou d'installations donnant à réfléchir. Les transports en commun de Stockholm, que ce soit en surface ou sous terre, se classent parmi les plus modernes du monde et, depuis 1950, sont continuellement transformés en chef-d'œuvre d'architecture.

U-Bahn-Kunst

Neben vielen Sehenswürdigkeiten oberhalb, bietet Stockholm auch unter Tage wahre Schätze – so wirkt die „Tunnelbana" wie eine große Kunstgalerie. Knapp 90 ihrer rund 100 U-Bahnhöfe wurden individuell gestaltet und sind Attraktion für Touristen und Einheimische. Über 150 Künstler haben sich an den in blanken Stein geschlagenen, höhlenartig wirkenden Stationen verwirklicht und mit bunten Malereien, faszinierenden Mosaiken oder inspirierenden Installationen Kunstwerke geschaffen. Stockholms unter- und überirdisches Verkehrssystem gilt als eines der modernsten der Welt und wurde seit 1950 kontinuierlich zum architektonischen Meisterwerk ausgebaut.

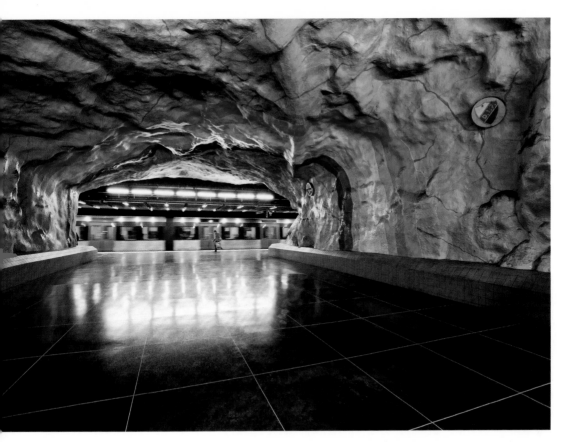

tro Station Stadium, Stockholm

te del metro

emás de muchas atracciones
ísticas, Estocolmo también ofrece
rdaderos tesoros bajo tierra, y es que el
nnelbana" parece una gran galería de
e. Casi 90 de sus aproximadamente 100
aciones de metro han sido diseñadas
lividualmente y son una atracción para
istas y locales. Más de 150 artistas han
ado obras de arte en las estaciones
vernícolas talladas en piedra desnuda,
n pinturas coloridas, mosaicos
cinantes o instalaciones inspiradoras.
sistema de tráfico subterráneo
ubterráneo de Estocolmo está
nsiderado uno de los más modernos del
ndo y se ha desarrollado continuamente
sta convertirse en una obra maestra de
rquitectura desde 1950.

Arte do metrô

Além de muitas atrações acima do
solo, Estocolmo também oferece
verdadeiros tesouros subterrâneos –
assim o "Tunnelbana" parece uma grande
galeria de arte. Quase 90 das suas
aproximadamente 100 estações de metrô
foram projetadas individualmente e são
uma atração para turistas e habitantes
locais. Mais de 150 artistas se deram conta
das estações cavernosas esculpidas em
pedra e criaram nelas obras de arte, com
pinturas coloridas, mosaicos fascinantes
ou instalações inspiradoras. O sistema
de tráfego subterrâneo e acima do solo
de Estocolmo é considerado um dos
mais modernos do mundo e tem sido
continuamente desenvolvido como uma
obra-prima da arquitetura desde 1950.

Metrokunst

Naast de vele bovengrondse
bezienswaardigheden biedt Stockholm
ook echte schatten onder de grond.
De tunnelbana ziet eruit als een grote
kunstgalerie. Bijna 90 van de ongeveer
100 metrostations zijn afzonderlijk
ontworpen en vormen een attractie voor
toeristen en de lokale bevolking. Meer
dan 150 kunstenaars hebben in de uit kale
steen gehouwen, grotachtige stations
kunstwerken gemaakt, zoals kleurrijke
schilderijen, fascinerende mozaïeken en
inspirerende installaties. Het onder- en
bovengrondse vervoerssysteem van
Stockholm wordt beschouwd als een van
de modernste ter wereld en wordt sinds
1950 voortdurend verder uitgebouwd tot
architectonisch meesterwerk.

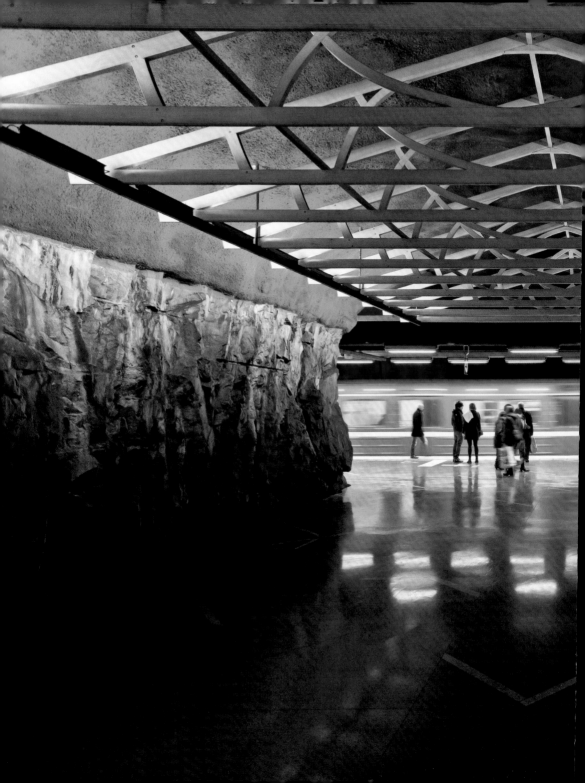

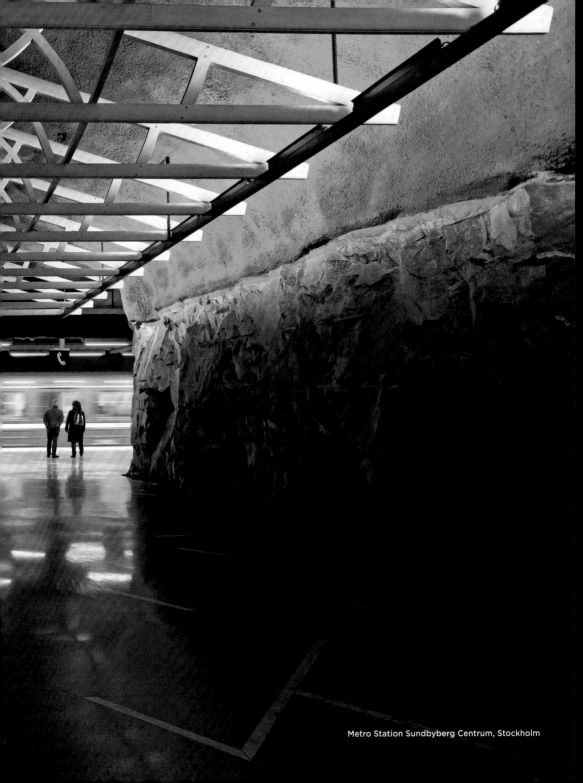

Metro Station Sundbyberg Centrum, Stockholm

eetart, Stockholm

dermalm

nted trash cans or bicycles are not an
usual sight in Södermalm (Söder). The
mer messy quarter of the metropolis
otivates with a very special charm.
ung designers, artists and students have
tled in the bare concrete and industrial
ldings and transformed Söder into one
Stockholm's hippest districts.

dermalm

el barrio Södermalm (Söder) no es raro
botes de basura pintados o bicicletas.
antiguo "barrio desaliñado" de la
trópoli cautiva con un encanto muy
ecial. Jóvenes diseñadores, artistas
studiantes se han instalado en los
ficios industriales y de hormigón y han
vertido a Söder en uno de los barrios
s modernos de Estocolmo.

Södermalm

Les poubelles et les vélos métamorphosés
en œuvres d'art sont chose courante à
Södermalm (« Söder » pour les intimes).
Un charme particulier émane de ce quartier
naguère défavorisé. Les jeunes designers,
artistes et étudiants qui ont investi les
immeubles froids en béton et les friches
industrielles en ont fait l'un des secteurs les
plus branchés de Stockholm.

Södermalm

Lixeiras ou bicicletas pintadas não
são uma visão incomum no distrito de
Södermalm (Söder). O antigo bairro sujo
da metrópole impressiona com um charme
muito especial. Jovens designers, artistas
e estudantes se instalaram nos edifícios
de concreto e industriais e transformaram
Söder em um dos bairros mais badalados
de Estocolmo.

Södermalm

Bemalte Mülleimer oder Fahrräder sind
im Stadtteil Södermalm (Söder) kein
ungewöhnlicher Anblick. Das ehemalige
Schmuddelviertel der Metropole besticht
mit ganz speziellem Charme. In den
kahlen Beton- und Industriebauten
haben sich junge Designer, Künstler
und Studenten angesiedelt und Söder
in einen der angesagtesten Bezirke
Stockholms verwandelt.

Södermalm

Beschilderde vuilnisbakken en fietsen
bieden in Södermalm (Söder) geen
ongewone aanblik. De voormalige 'vieze
wijk' van de metropool bekoort met
een heel bijzondere charme. Jonge
ontwerpers, kunstenaars en studenten
hebben zich gevestigd in de kale betonnen
en industriële gebouwen en Söder
omgevormd tot een van de hipste wijken
van Stockholm.

Gamla Stan, Stadsholmen

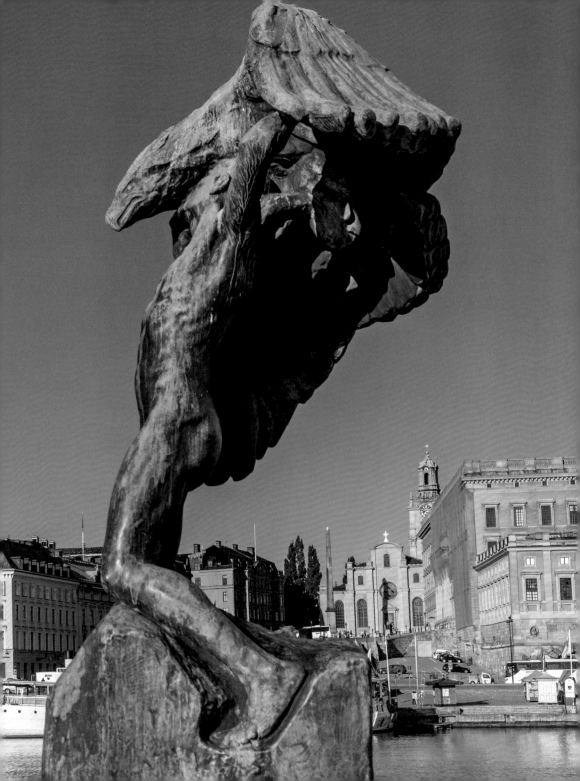

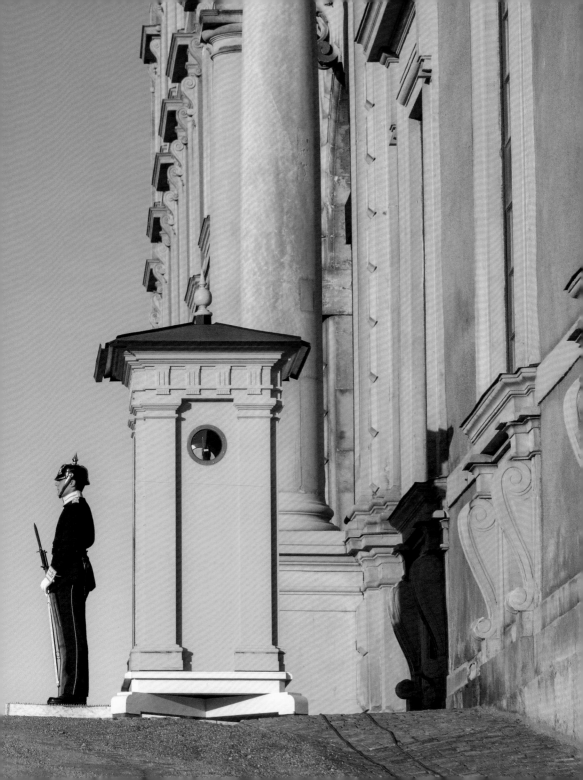

Blue Gate, Stockholm

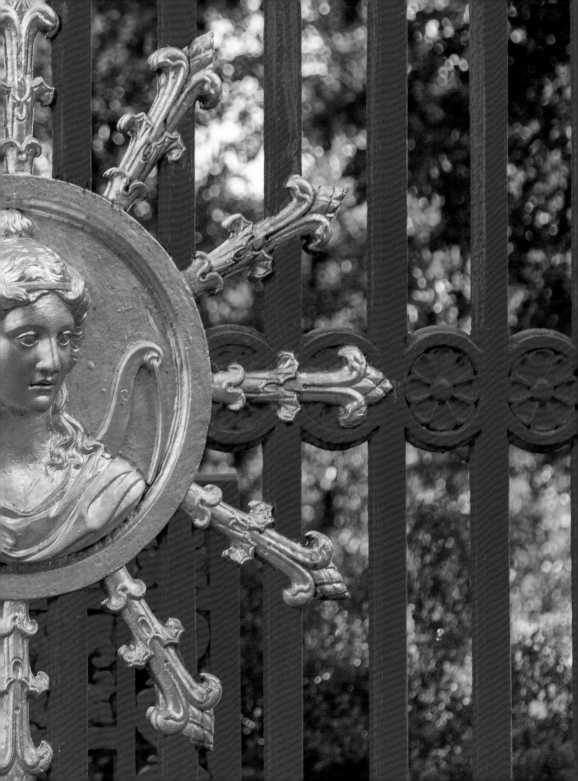

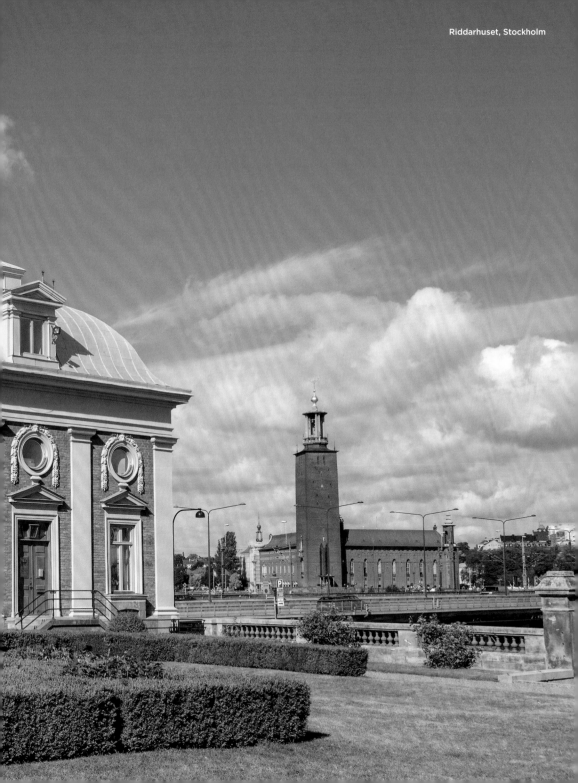

Riddarhuset, Stockholm

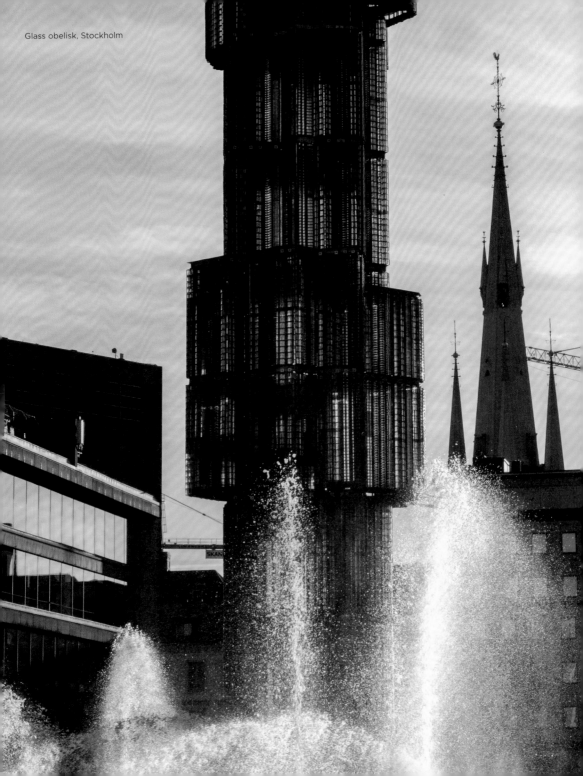

Glass obelisk, Stockholm

amla Stan, Stockholm

amla Stan

ngled alleys, paved streets, colorful 17th
d 18th century houses, magnificent
urches, palaces and Stockholm Castle
e just as much a part of the atmospheric
d town (Gamla Stan) as the many small
ops, enchanting backyards and cosy
fés. There are about 15 museums in the
ty between the bridges".

amla Stan

allejones angulosos, calles pavimentadas,
loridas casas de los siglos XVII y XVIII,
agníficas iglesias, palacios y el Castillo de
tocolmo forman parte de la atmósfera
l casco antiguo (Gamla Stan), al igual
e las numerosas tiendas pequeñas,
s encantadores patios traseros y las
ogedoras cafeterías. Hay unos 15 museos
la "ciudad entre los puentes".

Gamla Stan

Ses ruelles tortueuses, ses rues pavées, ses
maisons des XVIIᵉ et XVIIIᵉ siècles peintes de
toutes les couleurs, ses églises et palais
magnifiques ainsi que le château royal
contribuent autant au charme de Gamla
Stan (« la vieille ville ») que ses petites
boutiques, ses arrière-cours merveilleuses
et ses agréables cafés. La « cité entre
les ponts » ne compte pas moins de
15 musées.

Gamla Stan

Ruas inclinadas, ruas pavimentadas,
casas coloridas dos séculos XVII e XVIII,
igrejas magníficas, palácios e o Palácio de
Estocolmo fazem tanto parte da atmosfera
da cidade velha (Gamla Stan) como as
pequenas lojas, quintais encantadores e
cafés acolhedores. Existem cerca de 15
museus na "cidade entre as pontes".

Gamla Stan

Verwinkelte Gassen, gepflasterte
Straßen, bunte Häuser aus dem 17. und
18. Jahrhundert, prachtvolle Kirchen,
Paläste und das Stockholmer Schloss
gehören ebenso zur atmosphärischen
Altstadt (Gamla Stan) wie die vielen
kleinen Geschäfte, bezaubernden
Hinterhöfe und gemütlichen Cafés. In der
„Stadt zwischen den Brücken" befinden
sich etwa 15 Museen.

Gamla Stan

Een doolhof van steegjes, geplaveide
straten, kleurrijke huizen uit de 17e en 18e
eeuw, prachtige kerken, paleizen en het
Stockholms slot maken even goed deel uit
van het sfeervolle oude centrum (Gamla
Stan) als de vele winkeltjes, betoverende
achterplaatsen en gezellige cafés. Er zijn
ongeveer vijftien musea in de 'stad tussen
de bruggen'.

Open-Air Museum Skansen, Stockholm

Open-Air Museum Skansen

On the hilltop of Stockholm's Djurgården Peninsula you can experience a kind of time travel in a miniature Sweden covering almost 300,000 m² (3,229,173 sqft). In Skansen, in the oldest open-air museum in the world, around 150 buildings display a slice of cultural history and illustrate Swedish life and work around 200 years ago—including various social classes and animals. The museum, created in 1891, originated with the ethnographer Arthur Hazelius, who wanted to create a type of lively museum with manor houses, churches, city districts, but also workshops and farms.

Le musée de plein air de Skansen

Sur les hauteurs de la presqu'île de Djurgården, à Stockholm, le visiteur peut faire un voyage dans le temps grâce à une Suède miniature, qui se déploie sur 300 000 m². Dans le plus ancien musée de plein air du monde, à Skansen, quelque 150 constructions donnent un aperçu de la culture suédoise et du mode de vie ou des métiers d'il y a 200 ans – y compris des différentes classes sociales et des animaux. Il a été fondé en 1891 à l'initiative de l'ethnographe Artur Hazelius, qui voulait créer une sorte de musée vivant avec des maisons de maître, des églises, des quartiers entiers, mais aussi des ateliers d'artisan et des fermes.

Freilichtmuseum Skansen

Auf der Bergkuppe der Stockholmer Halbinsel Djurgården kann man auf knapp 300 000 m² Schweden im Mini-Format eine Art Zeitreise erleben. Im ältesten Freilichtmuseum der Welt, in Skansen, zeigen rund 150 Gebäude ein Stück Kulturgeschichte und veranschaulichen schwedisches Leben und Arbeiten vor rund 200 Jahren – verschiedene Gesellschaftsschichten und Tiere inklusive. Das 1891 geschaffene Museum geht auf den Ethnographen Arthur Hazelius zurück, der mit Herrenhöfen, Kirchen, Stadtvierteln, aber auch Handwerksstätten und Bauernhöfen eine Art lebendiges Museum schaffen wollte.

Open-Air Museum Skansen, Stockholm

Museo al aire libre de Skansen

En la cima de la península de Djurgården en Estocolmo se puede experimentar una especie de viaje en el tiempo en miniatura casi 300 000 m² de Suecia. En el museo aire libre más antiguo del mundo, en ansen, unos 150 edificios muestran na parte de la historia cultural e ilustran vida y el trabajo sueco de hace unos 00 años, incluidas diversas clases sociales animales. El museo, que se creó en 1891, remonta al etnógrafo Arthur Hazelius, ue quiso crear una especie de museo vivo en casas señoriales, iglesias, barrios, pero mbién talleres y granjas.

Museu ao Ar Livre de Skansen

No topo da península de Djurgården, em Estocolmo, você pode vivenciar uma espécie de viagem no tempo em quase 300 000 m² da Suécia em miniatura. No mais antigo museu ao ar livre do mundo, em Skansen, cerca de 150 edifícios mostram uma parte da história cultural e ilustram a vida e o trabalho suecos há cerca de 200 anos – incluindo várias classes sociais e animais. O museu, criado em 1891, remonta ao etnógrafo Arthur Hazelius, que queria criar uma espécie de museu animado com casas senhoriais, igrejas, bairros da cidade, mas também oficinas e fazendas.

Openluchtmuseum Skansen

Op de heuveltop van het schiereiland Djurgården in Stockholm kun je in een miniatuur-Zweden, op een kleine 300 000 m², een soort reis in de tijd maken. In het oudste openluchtmuseum ter wereld, Skansen, tonen zo'n 150 gebouwen een stukje cultuurgeschiedenis en laten ze zien hoe de Zweden ongeveer 200 jaar geleden woonden en werkten – verschillende sociale klassen en dieren incluis. Het in 1891 opgerichte museum gaat terug op de etnograaf Arthur Hazelius, die een soort levendig museum wilde creëren met herenhuizen, kerken, stadswijken, maar ook werkplaatsen en boerderijen.

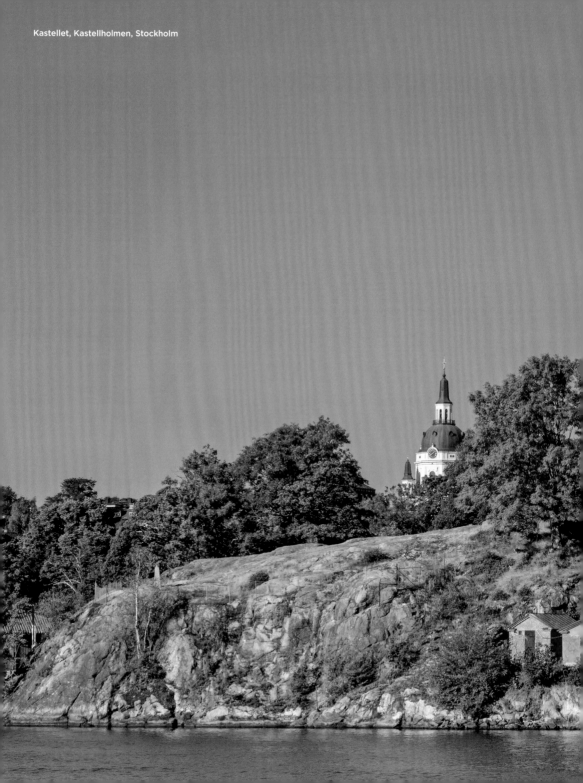

Kastellet, Kastellholmen, Stockholm

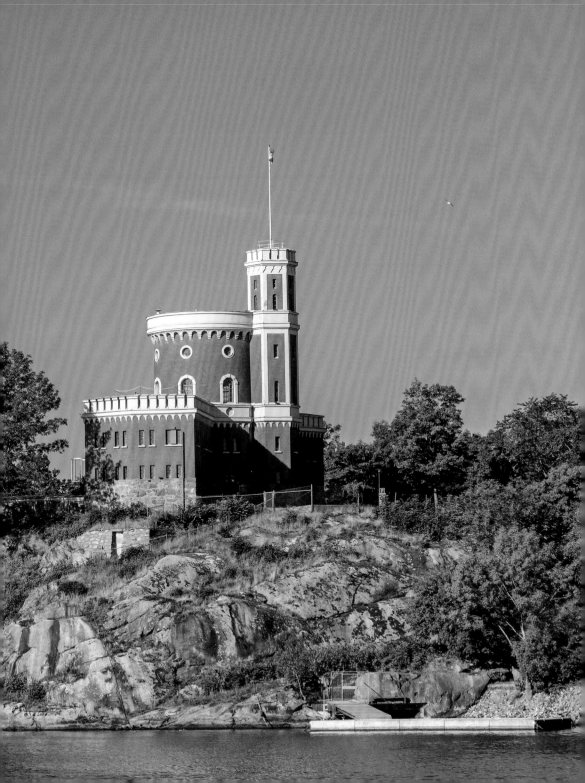

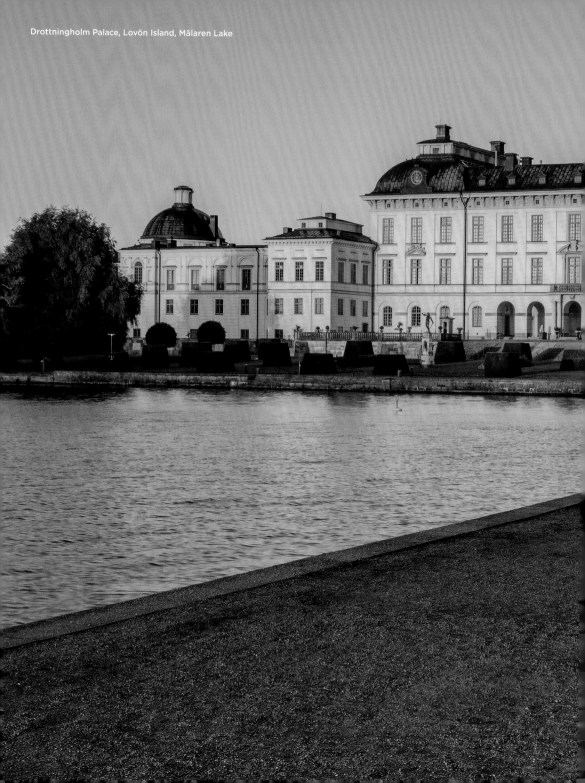
Drottningholm Palace, Lovön Island, Mälaren Lake

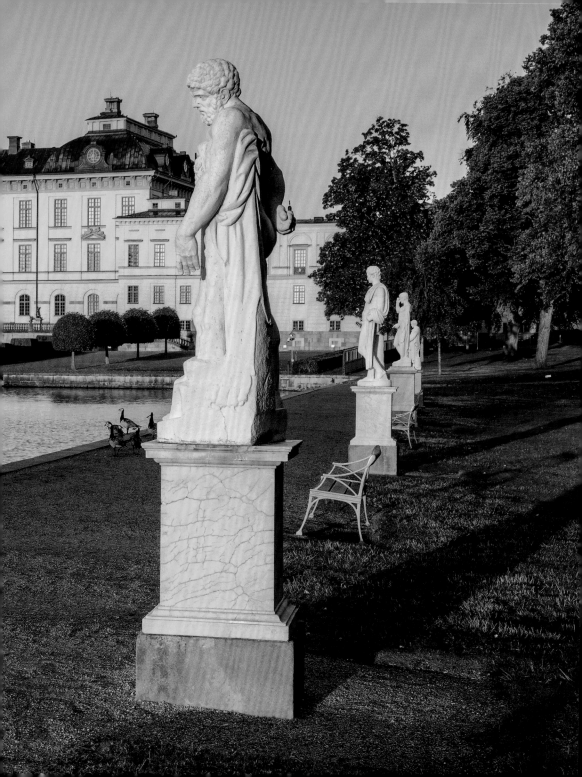

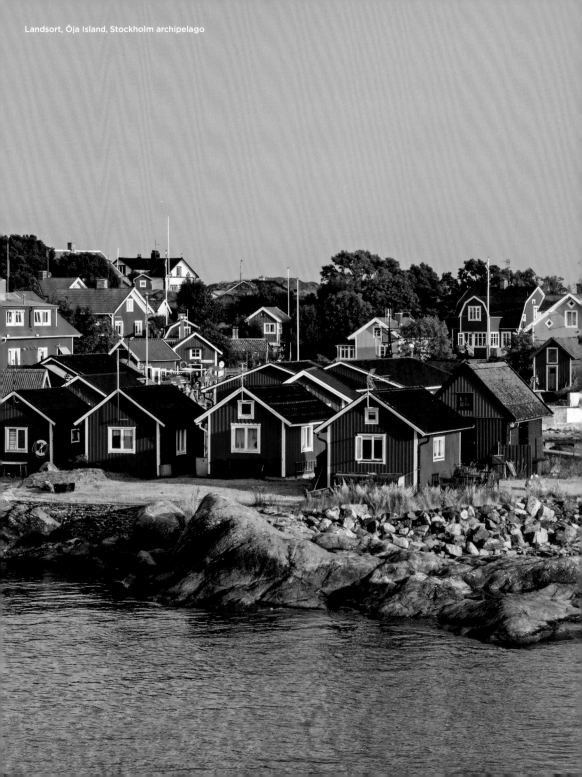

Landsort, Öja Island, Stockholm archipelago

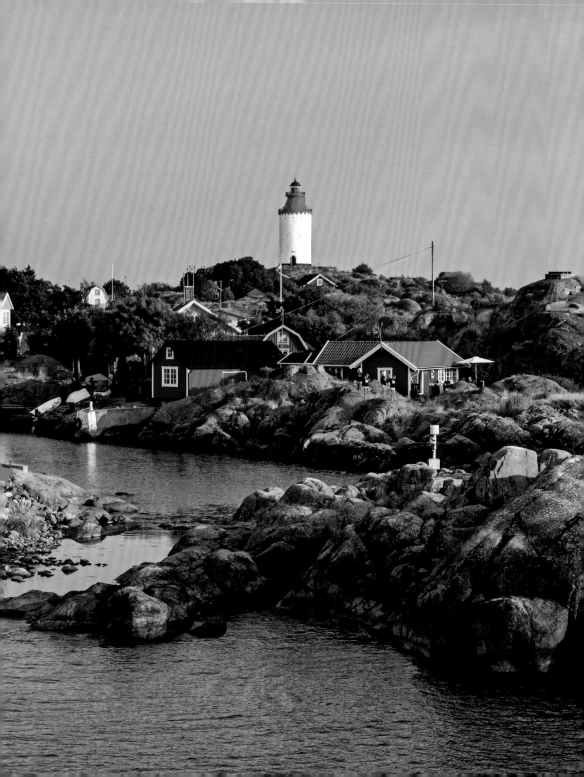

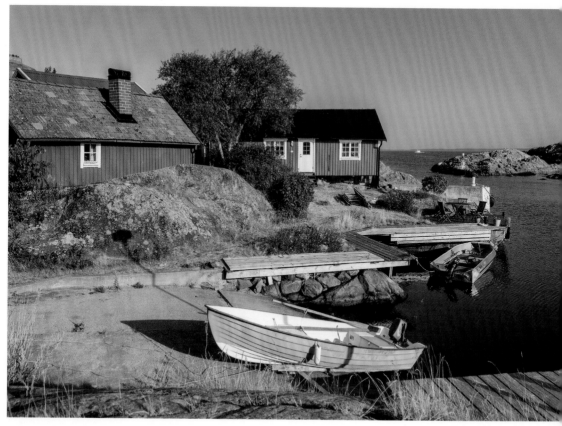

Landsort, Öja Island, Stockholm archipelago

Stockholm Archipelago

This perfect Swedish holiday idyll lies fan-shaped about 80 km (50 mi) from the city centre. In the Baltic Sea there are about 25,000 islets, skerries and rocks—large, small, inhabited and uninhabited stony outposts or grass crests. Stockholm's *skärgård* is part of the capital, easily accessible by water taxi or boat and representing a different way of life—the clock is ticks more slowly here. Many Stockholmers spend their weekends and holidays here, and may even own one of the typical red wooden houses. Around 150 of the islands are inhabited all year round and offer all kinds of sporting activities, holiday homes and restaurants.

L'archipel de Stockholm

Le site rêvé pour des vacances à la suédoise se déploie en éventail à 80 km du centre de la capitale. Environ 25 000 îlots, récifs et rochers émergent de la mer Baltique, les uns vastes et habités, les autres minuscules et déserts, simples avant-postes minéraux ou monticules herbeux. Le skärgård de Stockholm, qui fait partie de la capitale, est très bien desservi par des navettes et des bateaux et symbolise un autre mode de vie – le temps s'écoule plus lentement. Les Stockholmois sont nombreux à y passer leurs week-ends et leurs vacances, voire à y posséder l'une des typiques maisons en bois rouges. Environ 150 de ces îles sont habitées toute l'année et proposent toutes sortes d'activités sportives, l'hébergement et la restauration.

Stockholmer Schärenarchipel

Das perfekte schwedische Ferienidyll liegt fächerförmig etwa 80 km vom Stadtzentrum entfernt. In der Ostsee liegen etwa 25 000 Inselchen, Schären und Felsen – große, kleine, bewohnte und unbewohnte steinige Außenposten oder Graskuppen. Der Stockholmer *skärgård* gehört zur Hauptstadt, ist per Wassertaxi oder Boot sehr gut erreichbar und versinnbildlicht eine andere Lebensart – die Uhr tickt langsamer. Viele Stockholmer verbringen hier ihre Wochenenden, Ferien und besitzen sogar eines der typischen roten Holzhäuser. Rund 150 der Inseln sind ganzjährig bewohnt und bieten allerlei sportliche Aktivitäten, Ferienhäuser und Restaurants.

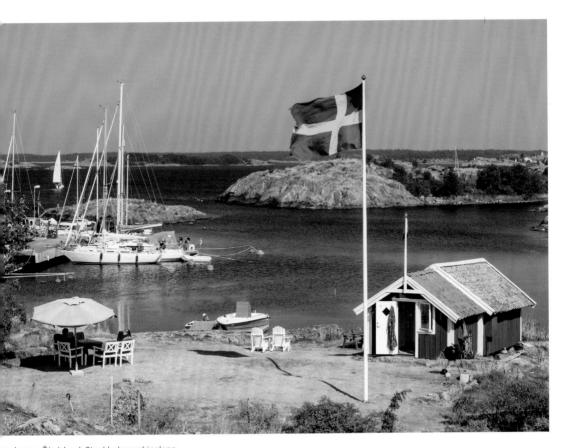

orrhamn, Öja Island, Stockholm archipelago

rchipiélago de Estocolmo

 idilio perfecto para las vacaciones en
uecia se encuentra a unos 80 km del
entro de la ciudad en forma de abanico.
n el mar Báltico hay alrededor de 25 000
letas, islotes y rocas: grandes, pequeños,
abitados y deshabitados puestos de
vanzada pedregosos o crestas de hierba.
l *skärgård* de Estocolmo pertenece a la
apital, es fácilmente accesible en taxi
cuático o en barco y representa una
orma de vida diferente: el tiempo corre
nás despacio. Muchos habitantes de
stocolmo pasan sus fines de semana
 vacaciones aquí e incluso son dueños
e una de las típicas casas de madera
oja. Alrededor de 150 de las islas están
abitadas durante todo el año y ofrecen
odo tipo de actividades deportivas, casas
e vacaciones y restaurantes.

Arquipélago de Estocolmo

O idílio perfeito para férias na Suécia fica
em forma de leque a cerca de 80 km do
centro da cidade. No Mar Báltico existem
cerca de 25 000 ilhéus, escarpas e rochas
– entrepostos pedregosos ou colinas
gramíneas grandes, pequenos, habitados
e desabitados. O *skärgård* de Estocolmo
pertence à capital, é facilmente acessível
por táxi aquático ou barco e representa
um modo de vida diferente – o relógio
está a andar mais devagar. Muitas pessoas
de Estocolmo passam os fins de semana,
férias aqui e até mesmo possuem uma das
típicas casas de madeira vermelha. Cerca
de 150 das ilhas são habitadas durante
todo o ano e oferecem todos os tipos de
atividades desportivas, casas de férias
e restaurantes.

Scherenkust van Stockholm

De perfecte Zweedse vakantie-idylle ligt
waaiervormig op zo'n 80 km van het
stadscentrum. In de Oostzee liggen circa
25 000 eilandjes, scheren en rotsen – grote,
kleine, bewoonde en onbewoonde stenen
buitenposten of grasheuvels. De *skärgård*,
scherenkust, van Stockholm hoort bij de
hoofdstad, is gemakkelijk bereikbaar per
watertaxi of boot en symboliseert een
andere manier van leven – de tijd gaat er
langzamer. Veel Stockholmers brengen
hier hun weekenden en vakanties door en
bezitten vaak zelfs een van de typische
rode houten huizen. Ongeveer 150 van de
eilanden zijn het hele jaar door bewoond
en bieden allerlei sportactiviteiten,
vakantiehuizen en restaurants.

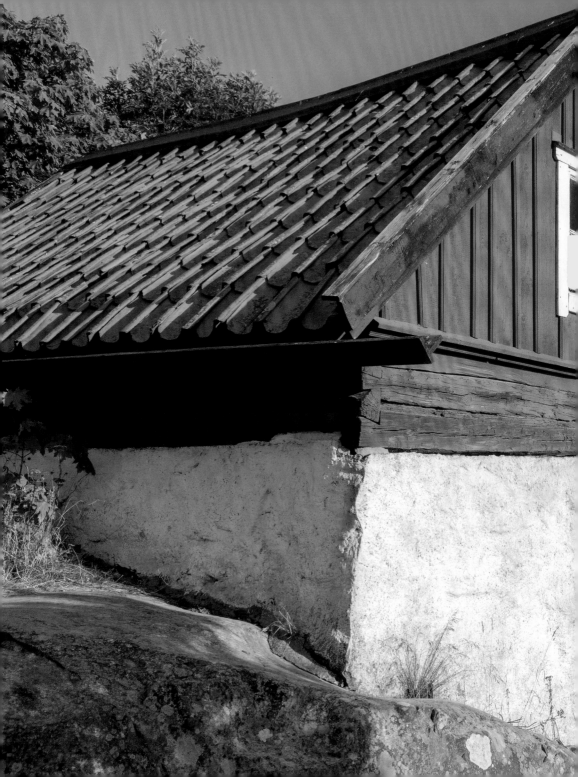

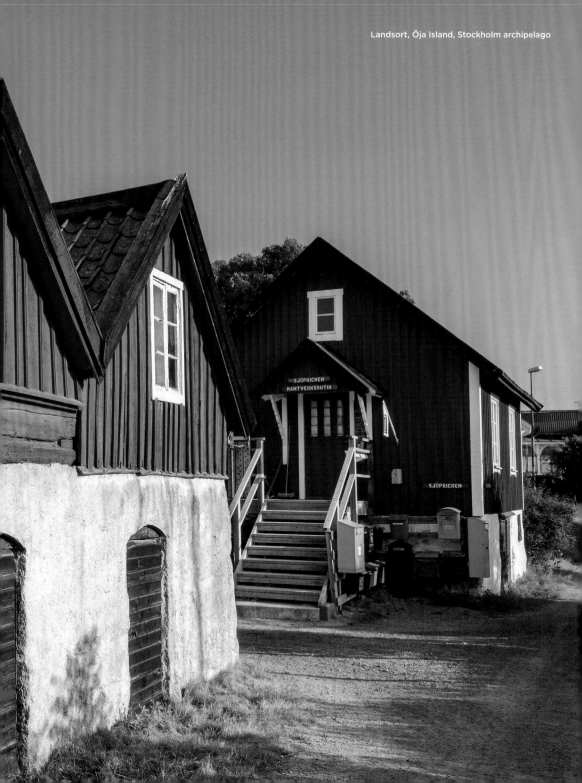

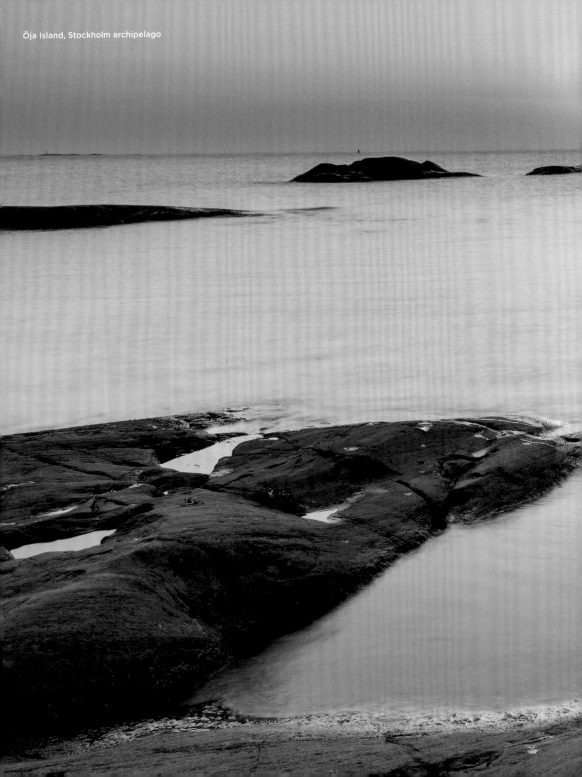

Öja Island, Stockholm archipelago

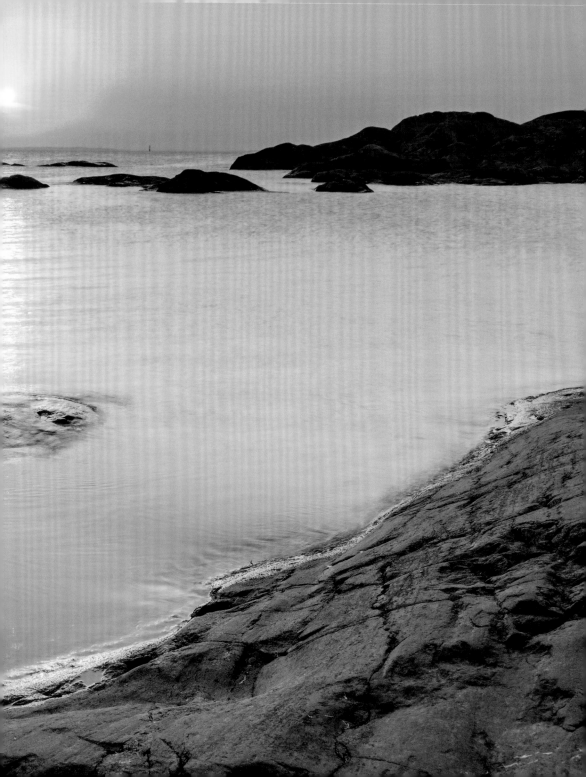

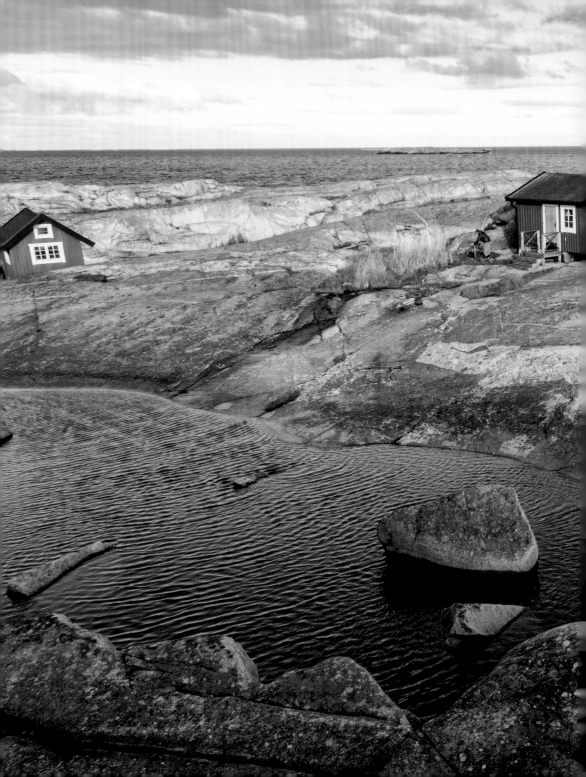

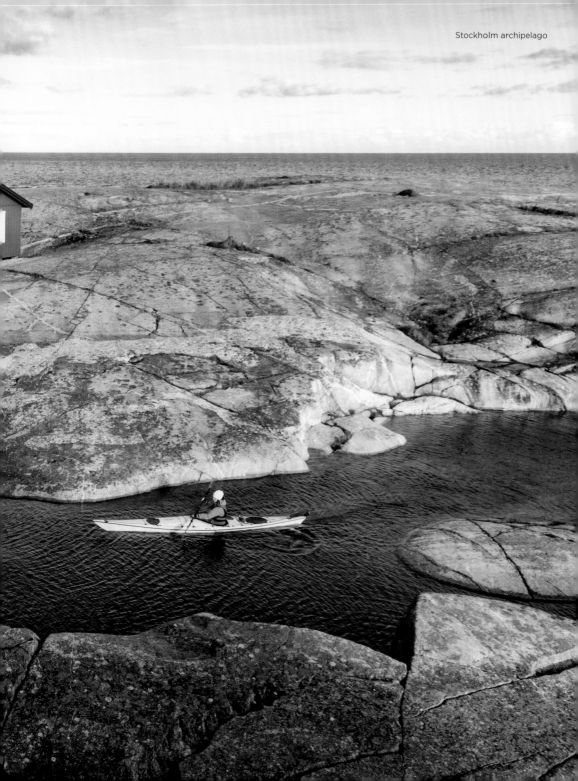

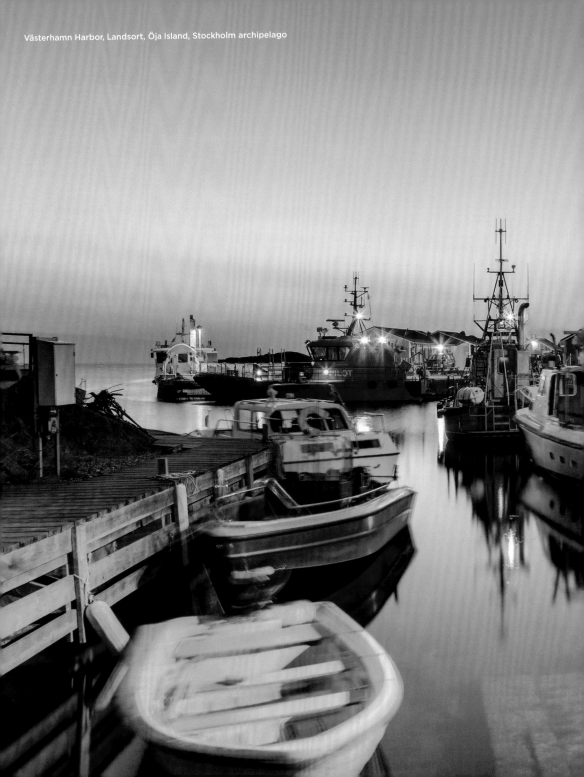

Västerhamn Harbor, Landsort, Öja Island, Stockholm archipelago

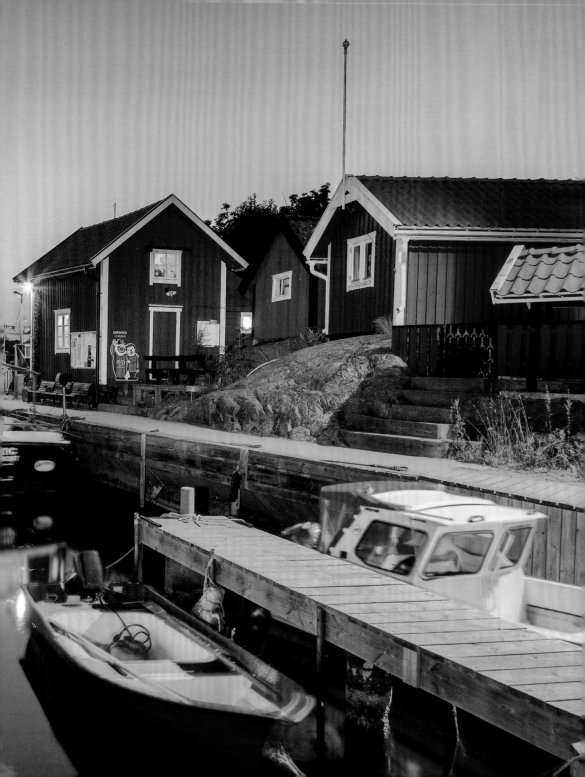

Dalarna

Vålberget

Dalarna

Pure nature—Dalarna is a region with a special atmosphere of romance, nostalgia, traditional rural villages and untouched wilderness. There are beautiful white winters and hot summers, diverse wildlife, white birches and old coniferous forests. The red Dala horses are made here—and you can watch locals fly fishing at Lake Siljan. In Dalarna, handicrafts and Swedish customs are cultivated—during the summer solstice families from cities such as Stockholm and Gothenburg come to celebrate Midsommar in this most Swedish of all Swedish provinces .

La Dalécarlie

En Dalécarlie, région dont le caractère particulier tient à un mélange de romantisme, de nostalgie, de villages traditionnels et d'écosystèmes préservés, la nature est reine. C'est le pays des chevaux rouges de Dala, des hivers merveilleusement opalins et des étés chauds, des bouleaux blancs et des antiques forêts de résineux, sans oublier la faune très riche – et, sur les rives du lac Siljan, on peut observer les pêcheurs à la mouche. Les Dalécarliens perpétuent l'artisanat de même que leurs coutumes et, lors du solstice d'été, les familles quittent les villes telles Stockholm et Göteborg pour fêter Midsommar dans la plus suédoise des provinces du pays.

Dalarna

Natur pur – Dalarna ist eine Region mit einem besonderen Flair aus Romantik, Nostalgie, bäuerlich traditionellen Dörfern und viel unberührter Wildnis. Hier gibt es wunderschöne weiße Winter und heiße Sommer, eine vielfältige Tierwelt, wachsen weiße Birken und alte Nadelwälder, werden die roten Dalapferde gemacht – und hier kann man am Siljan-See Einheimische beim Fliegenfischen beobachten. In Dalarna werden Kunsthandwerk und schwedische Bräuche gepflegt – so kommen zur Sommersonnenwende Familien aus Städten wie Stockholm und Göteborg, um in der schwedischsten aller schwedischen Provinzen Midsommar zu feiern.

ngfjället

Dalarna

turaleza pura: Dalarna es una región con
estilo especial de romance, nostalgia,
eblos rurales tradicionales y naturaleza
gen. Aquí hay hermosos inviernos
ncos y veranos calurosos, una fauna
ersa, abedules blancos y viejos bosques
coníferas, se hacen los caballos rojos de
a; y aquí se puede ver a los lugareños
scar con mosca en el Lago Siljan. En
arna se cultivan las artesanías y las
tumbres suecas: familias de ciudades
no Estocolmo y Gotemburgo vienen
elebrar Midsommar en la más sueca
todas las provincias suecas durante el
sticio de verano.

Dalarna

Natureza pura – Dalarna é uma região com
um toque especial de romance, nostalgia,
aldeias rurais tradicionais e natureza
selvagem intocada. Há invernos brancos
bonitos e verões quentes, uma vida
selvagem diversificada, bétulas brancas e
florestas de coníferas antigas, e onde os
cavalos vermelhos de Dala são feitos – e
aqui você pode ver os moradores locais
pescando com mosca no Lago Siljan.
Em Dalarna, o artesanato e os costumes
suecos são cultivados – famílias de cidades
como Estocolmo e Gotemburgo vêm para
celebrar "Midsommar" na mais sueca de
todas as províncias suecas no solstício
de verão.

Dalarna

Dalarna is een regio met een bijzondere
zweem van romantiek, nostalgie,
traditionele boerendorpjes en ongerepte
wildernis. Hier zijn prachtige witte winters
en hete zomers, is een gevarieerde
dierenwereld, groeien witte berken
en oude naaldbossen en worden de
rode dalapaardjes gemaakt. Hier kun
je bovendien de lokale bevolking zien
vliegvissen aan het Siljanmeer. In Dalarna
worden kunstnijverheid en Zweedse
gewoonten gekoesterd. Gezinnen uit
steden als Stockholm en Göteborg komen
tijdens de zomerzonnewende naar de
meest Zweedse provincie van Zweden om
Midsommar te vieren.

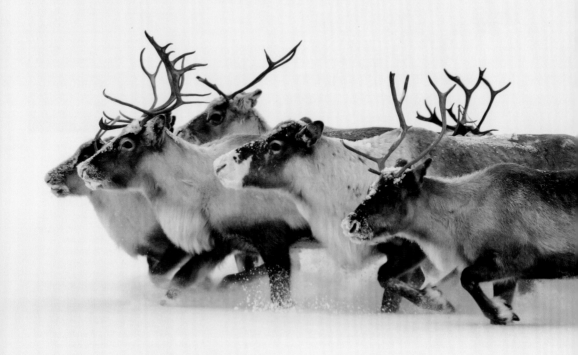

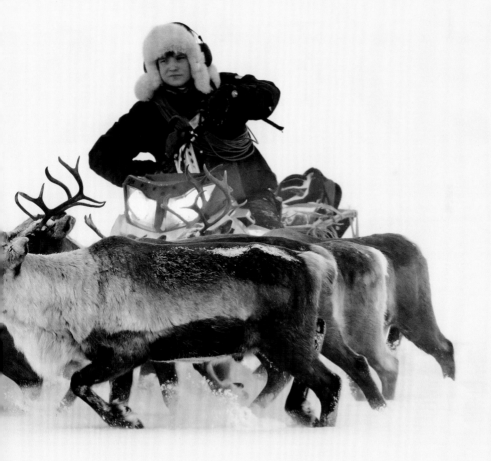

Country road, Dalarna

Winter Magic
From November onwards, when meters high snow covers the central Swedish province, lakes are frozen over, ice crystals paint flowers on trees and windows, and the beauty of the Scandinavian winter covers the region. Locals are on dog sledges and snowmobiles, lakes and streams become skating tracks, and Dalarna becomes a popular ski resort.

La magie de l'hiver
À partir de novembre, sous un manteau de neige d'un mètre, quand les lacs gèlent et que les cristaux de glace dessinent des fleurs sur les arbres et les vitres, la beauté de l'hiver scandinave transfigure cette province du centre de la Suède. Les habitants se déplacent dans des traîneaux tirés par des chiens ou en motoneige, les lacs et les rivières deviennent des patinoires et la Dalécarlie un haut lieu des sports d'hiver.

Winterzauber
Wenn ab November der Schnee die mittelschwedische Provinz meterhoch überdeckt, Seen zugefroren sind und Eiskristalle Blumen an Bäume und Fenster malen, überzieht die Schönheit des skandinavischen Winters die Region Einheimische sind mit Hundeschlitten und Schneemobilen unterwegs, Seen und Bäche werden zu Schlittschuhstrecken u Dalarna wird zum beliebten Skigebiet.

Magia invernal
A partir de noviembre, cuando la nieve cubre varios metros de altura de la provincia central sueca, los lagos se congelan y los cristales de hielo dibujan flores en árboles y ventanas, la belleza del invierno escandinavo cubre la región. Los nativos se desplazan en trineos de perros y motos de nieve, los lagos y arroyos se convierten en pistas de patinaje y Dalarna se convierte en una popular estación de esquí.

Magia de inverno
A partir de novembro, quando a neve cobre a província sueca central de até alguns metros de altura, os lagos são congelados e os cristais de gelo pintam flores em árvores e janelas, a beleza do inverno escandinavo cobre a região. Os habitantes locais estão fora de casa em trenós puxados por cães e em motos de neve, lagos e riachos tornam-se pistas de patinação e Dalarna torna-se uma estância de esqui popular.

Winterse magie
Vanaf november, wanneer de provincie i Midden-Zweden met een meter sneeuw is bedekt, de meren bevroren zijn en ijskristallen bloemen op bomen en ramen vormen, brengt de Scandinavische winte extra schoonheid aan in de regio. De lokale bevolking reist op hondensleeën e sneeuwscooters, meren en beekjes word schaatsbanen en Dalarna wordt een populair skigebied.

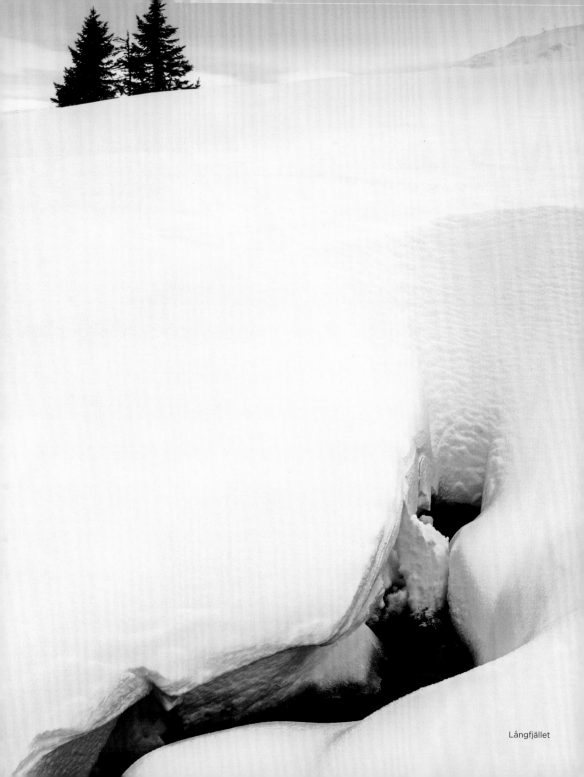

Långfjället

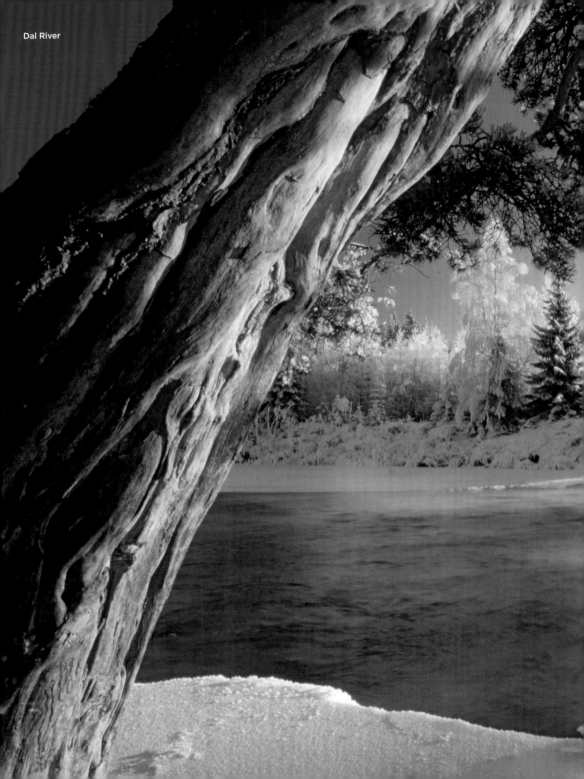

Dal River

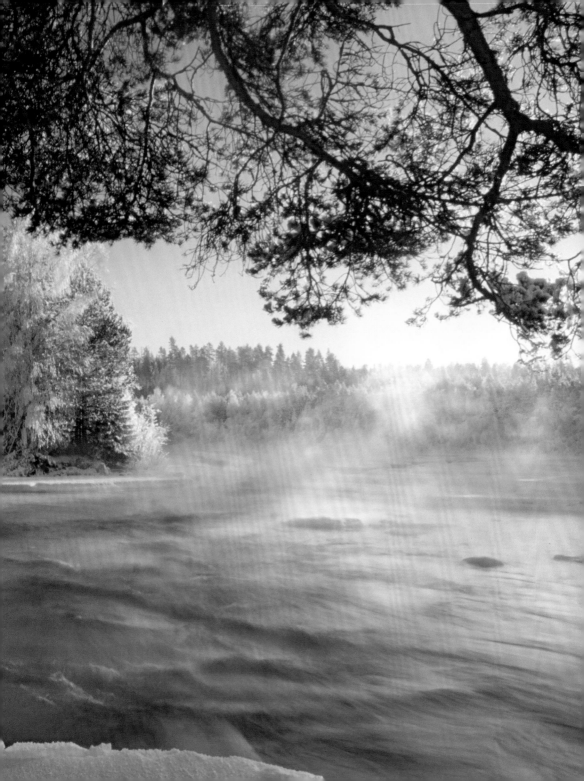

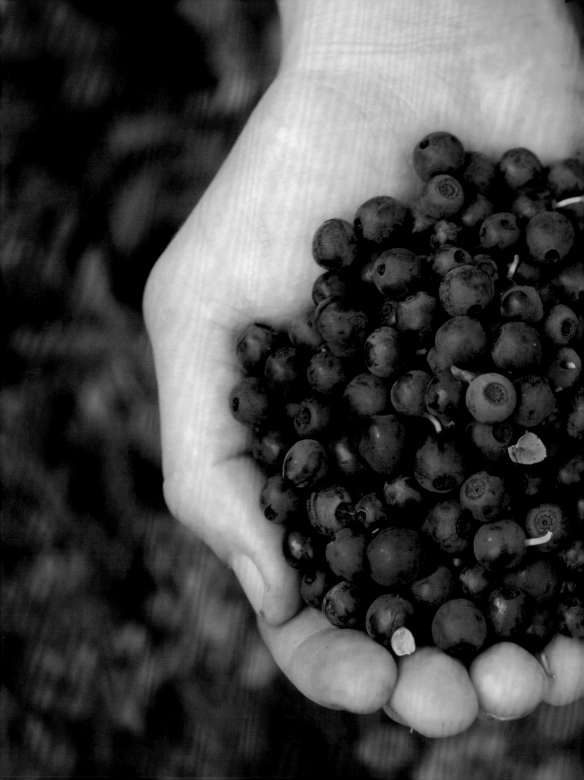

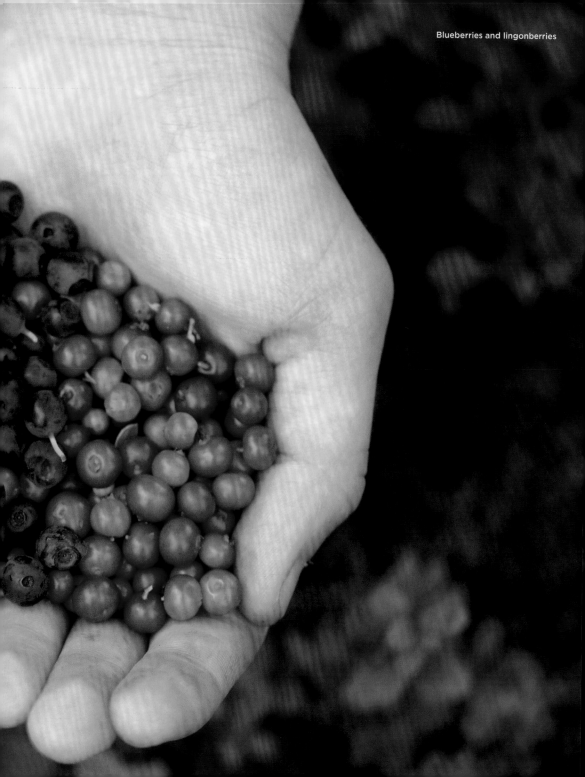

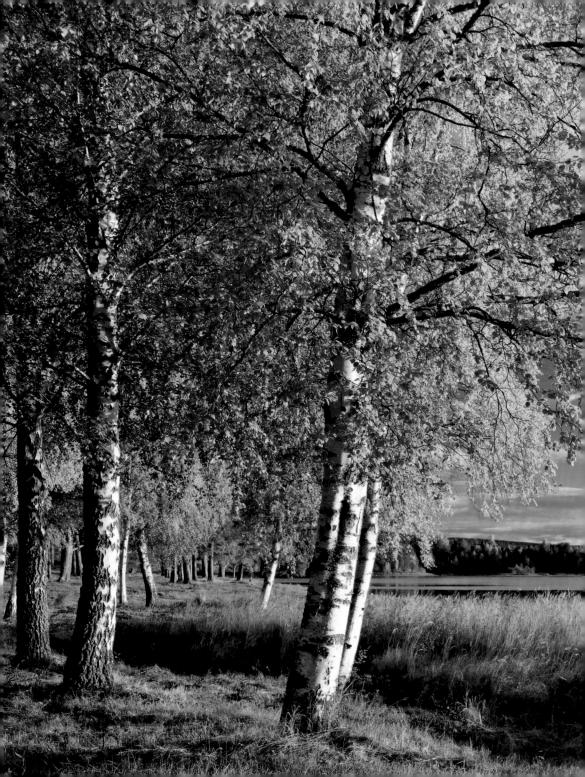

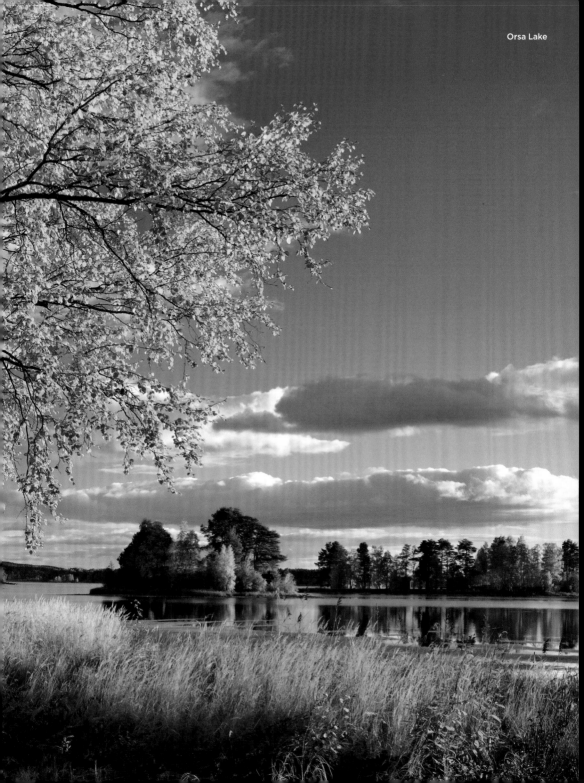

Grövelsjön Lake

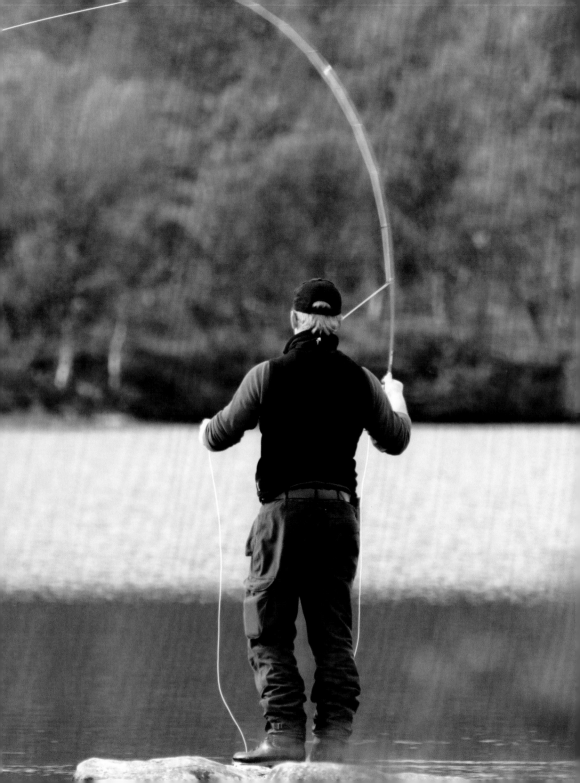

Western capercaillie

eindeer

Hamra National Park
Once Sweden's smallest national parks, Hamra lies in the middle of commercially used areas and forms an extraordinary synthesis between untouched wilderness, extensive moors, primeval forest and natural watercourses. Here all kinds of birds, quadrupeds, and also more than 450 different insect species find their habitat.

Parque Nacional de Hamra
El parque nacional más pequeño de Suecia se encuentra en medio de zonas de uso económico y forma una extraordinaria unidad entre la naturaleza virgen, los extensos páramos, los bosques primitivos como árboles y los cursos de agua naturales. Aquí encuentran su hábitat todo tipo de aves, cuadrúpedos, pero también más de 450 especies de insectos diferentes.

Le parc national de Hamra
Ce parc national, autrefois le plus petit de Suède, s'étend entre des terres agricoles et associe de façon exceptionnelle une nature sauvage, de vastes landes, des forêts qui font penser à des jungles et des cours d'eau naturels. Toutes sortes d'oiseaux y vivent, en compagnie de quadrupèdes, sans compter plus de 450 espèces d'insectes.

Parque Nacional Hamra
O menor e mais antigo parque nacional da Suécia, fica situado no meio de áreas economicamente utilizadas e forma uma extraordinária combinação de áreas selvagens intocadas, pântanos extensos, floresta primitiva como uma população de árvores e cursos de água naturais. Aqui todos os tipos de aves, quadrúpedes, mas também mais de 450 espécies diferentes de insetos encontram aqui seu habitat.

Nationalpark Hamra
Der einst kleinste Nationalpark Schwedens liegt inmitten wirtschaftlich genutzter Flächen und bildet eine außergewöhnliche Einheit zwischen unberührter Wildnis, ausgedehnten Mooren, urwaldähnlichem Baumbestand und natürlichen Wasserläufen. Hier finden allerlei Vögel, Vierbeiner, aber auch über 450 verschiedene Insektenarten ihren Lebensraum.

Nationaal park Hamra
Het ooit kleinste nationale park van Zweden ligt midden tussen voor landbouw gebruikte gebieden en vormt een buitengewone eenheid tussen ongerepte wildernis, uitgestrekte heidevelden, oerbosachtige bomen en natuurlijke waterlopen. Hier hebben allerlei soorten vogels, viervoeters, maar ook meer dan 450 verschillende insectensoorten hun habitat.

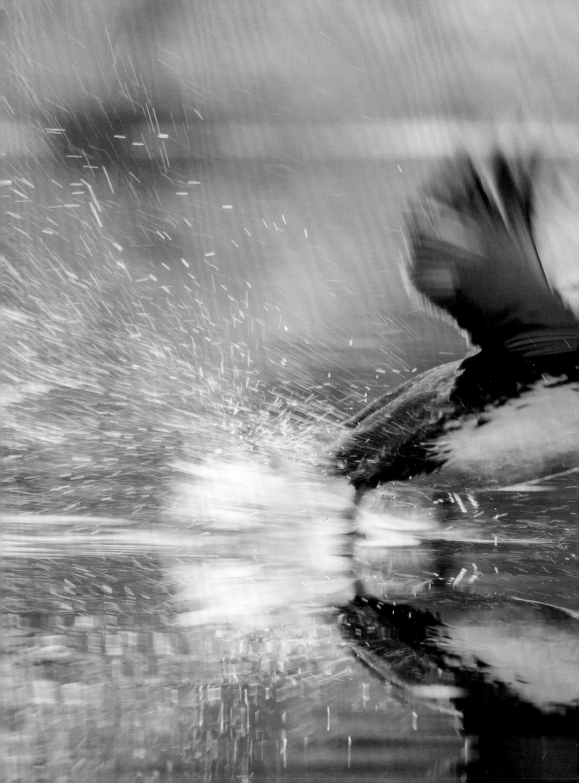

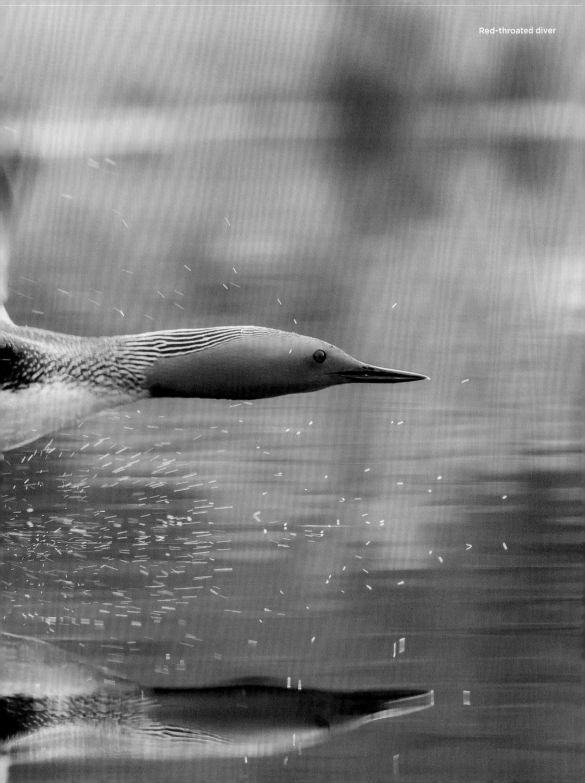

Animals

1 Wolverine, Glouton, Vielfraß, Glotón, Glutão, Veelvraat

2 Lemming, Lemino, Lêmingue,

3 Otter, Loutre, Fischotter, Nutria europea, Lontra

4 Wolf, Loup, Lobo

5 Musk ox, Bœuf musqué, Moschusochse, Buey almizclero, Os bois almiscarados, Muskusossen

6 Badger, Blaireau, Dachs, Tejón, Texugo, Das

7 Moose, Élan, Elch, Alce, Eland

8 Lynx, Luchs, Lince

9 Reindeer, Renne, Rentier, Reno, Renas, Rendier

10 Brown bear, Ours brun, Braunbär, Oso pardo, Urso pardo, Bruine beer

11 Arctic fox, Renard des neiges, Polarfuchs, Zorro ártico, Raposa-do-ártico, Poolvos

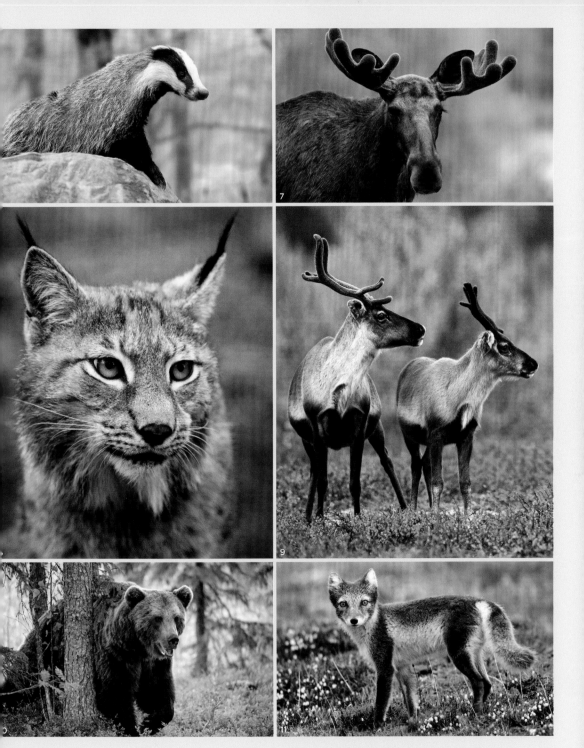

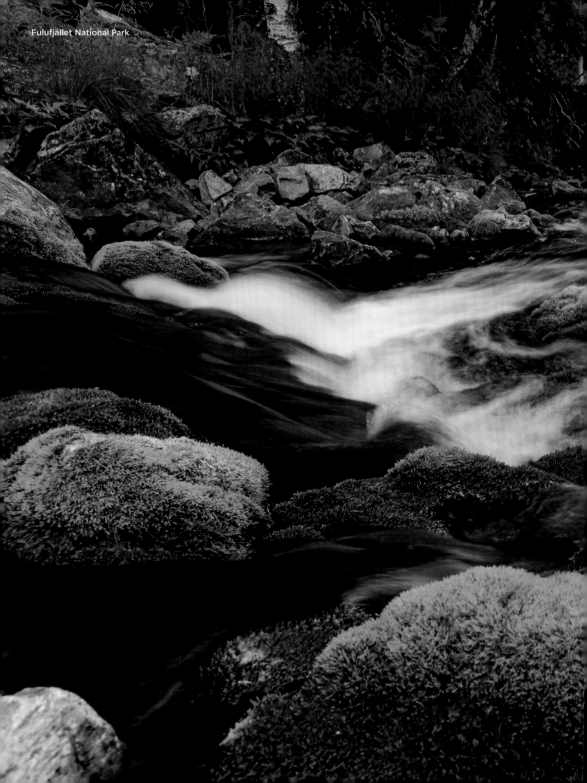

Fulufjället National Park

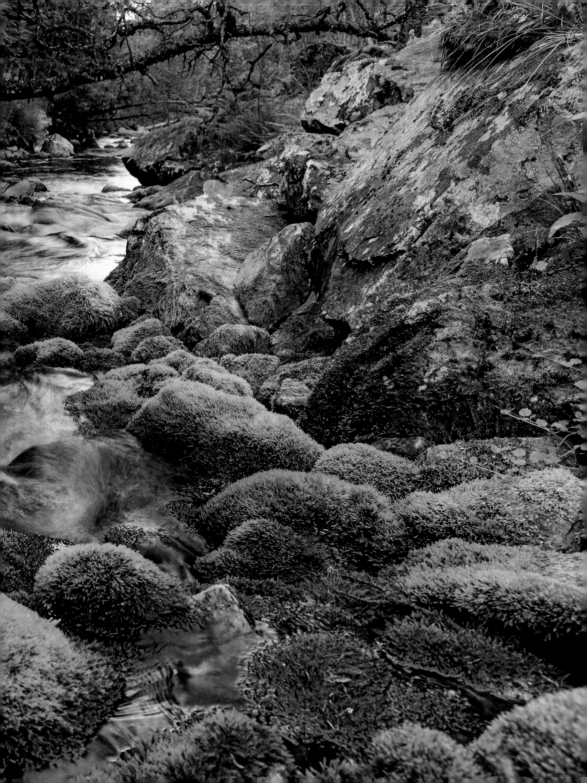

Arvselen

rvselen

ed Play of Colors

'hen the leaves turn red in autumn, they most seem to form a uniform color ith the many Swedish houses and huts ainted in *faluröd*. The typical Swedish d of today was originally mixed from on pigments, which were produced as by-product during ore extraction in the alun copper mine. It was intended to ve wooden houses a high-quality clinker one appearance.

ego de tonalidades rojas

uando las hojas se ponen rojas en otoño, si parecen formar una unidad de color on las numerosas casas y cabañas suecas ntadas en *faluröd*. El rojo sueco típico de oy se mezclaba con pigmentos de hierro, ue se producían como subproducto urante la extracción de mineral en la mina e cobre de Falun. Su objetivo era dar a las asas de madera un aspecto de piedra de inker de alta calidad.

Harmonie en rouge

En automne, les feuilles qui rougissent semblent vouloir s'harmoniser avec les maisons et cabanes suédoises peintes en *faluröd* (rouge de Falun). Cette couleur désormais si typique de la Suède provient d'un mélange de pigments à base d'oxyde de fer, un sous-produit de la mine de cuivre de Falun. Elle était censée donner aux maisons l'apparence d'élégantes constructions en brique.

Jogo vermelho de cores

Quando as folhas ficam vermelhas no outono, quase parecem formar uma unidade de cor com as muitas casas e cabanas suecas pintadas em *faluröd*. O típico vermelho sueco de hoje era misturado com pigmentos de ferro, que eram produzidos como subproduto durante a extração do minério na mina de cobre Falun. O objectivo era dar às casas de madeira um aspecto de pedra de clínquer de alta qualidade.

Rotes Farbenspiel

Wenn sich die Blätter im Herbst rot färben, scheinen sie fast eine farbliche Einheit mit den vielen in *faluröd* gestrichenen schwedischen Häusern und Hütten zu bilden. Das heute typische Schwedenrot wurde aus Eisenpigmenten gemischt, die als Nebenprodukt während der Erzgewinnung in der Kupfermine Falun entstanden. Es sollte Holzhäusern hochwertige Klinkersteinoptik verleihen.

Rood kleurenspel

Als de bladeren in de herfst rood worden, lijken ze qua kleur bijna een eenheid te vormen met de vele Zweedse huizen en hutten die in *faluröd* geschilderd zijn. Het tegenwoordig typisch Zweedse rood werd gemengd uit ijzerpigmenten die ontstonden als bijproduct van de ertswinning in de kopermijn van Falun. Het was bedoeld om houten huizen er als hoogwaardige bakstenen huizen te laten uitzien.

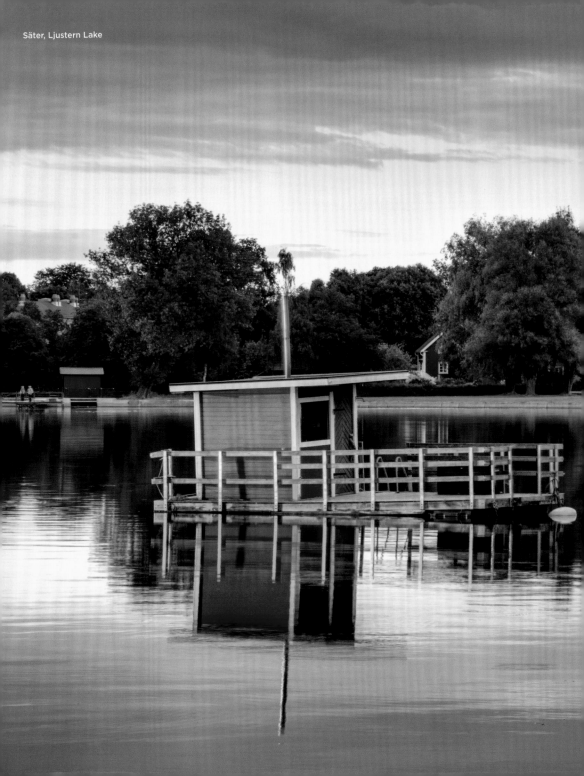
Säter, Ljustern Lake

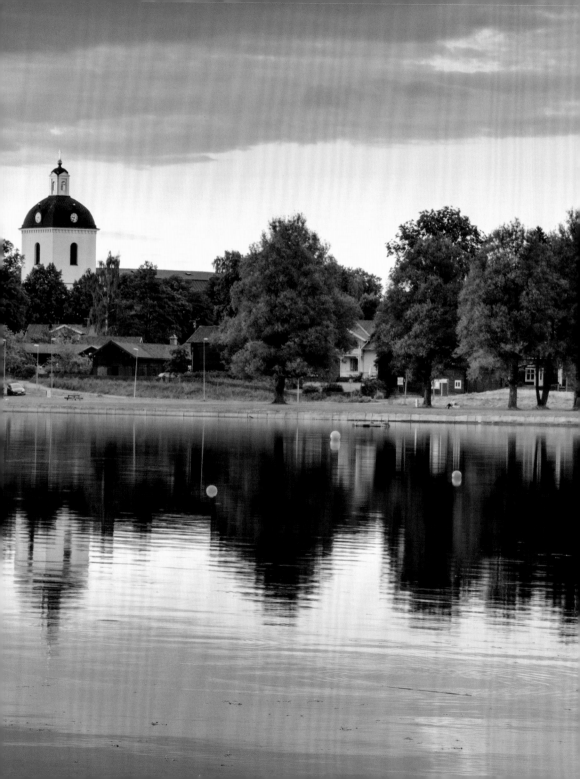

Bilberry and milk

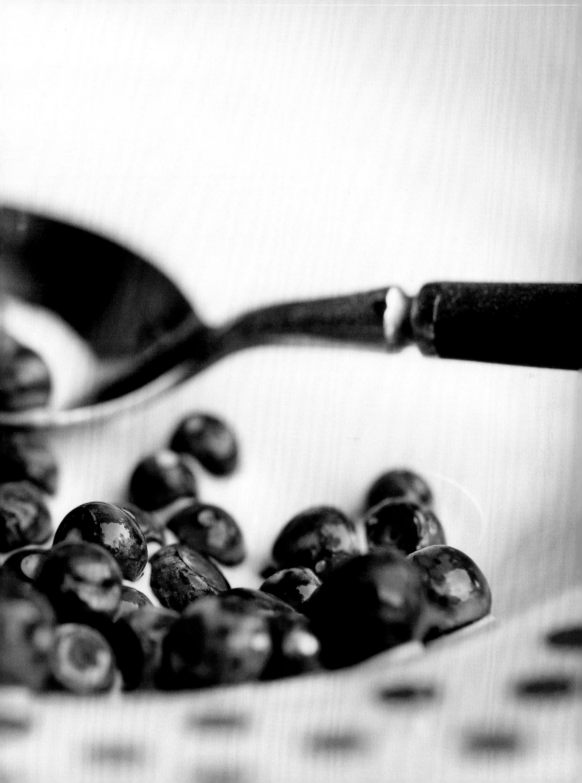

Northern Sweden

Örnsköldsvik, Skuleskogen National Park

Hällingsåfallet Waterfall, Gäddede

Northern Sweden

More than half of the country is part
of Norrland. And the further north, the
rougher the landscape and climate
become—this part of the country is also
sparsely populated. Idyllic villages such as
Gävle attract visitors to the coast, while
many places further north offer untouched
wilderness. The sub polar tundra with pine
and birch forests provides a habitat for
arctic foxes, reindeer herds, moose and
countless bird species. North Sweden is
also known for its breathtaking river and
lake landscapes with thundering waterfalls,
some of which plunge more than 40 m
(131 ft) into the depths, and the natural
phenomena of the Höga Coast, which
has been a UNESCO World Heritage Site
since 2000.

Le nord de la Suède

Le Norrland occupe plus de la moitié du
territoire suédois. Plus on se dirige vers
le nord, plus les paysages sont austères
et le climat rude, ce qui explique la
faible densité de population. Si des villes
charmantes comme Gävle attirent sur la
côte, c'est souvent une nature sauvage
qui domine plus au nord. La toundra
subpolaire, avec ses forêts de bouleaux
et de pins, offre un habitat suffisant
aux renards des neiges, aux troupeaux
de rennes, aux élans et à toutes sortes
d'oiseaux. Cependant, le nord de la Suède
plaît aussi pour ses fleuves et ses lacs
superbes, ses cascades mugissantes
qui plongent parfois sur une hauteur de
40 m, ou encore le Höga Kusten, dont
les phénomènes naturels sont inscrits
au Patrimoine immatériel de l'Unesco
depuis 2000.

Nordschweden

Über die Hälfte der Landesfläche
zählt zu Norrland. Und je nördlicher,
desto rauer werden auch Landschaft
und Klima – dementsprechend dünn
besiedelt ist dieser Landesteil. Locken
an der Küste idyllische Ortschaften wie
Gävle, herrscht weiter nördlich vielerorts
unberührte Wildnis. Die subpolare Tundra
mit Kiefern- und Birkenwäldern bietet
Polarfüchsen, Rentierherden, Elchen
und unzähligen Vogelarten genügend
Lebensraum. Bekannt ist Nordschweden
aber auch für die atemberaubenden
Fluss- und Seenlandschaften mit tosende
Wasserfällen, die zum Teil über 40 m in
die Tiefe stürzen, sowie die Höga Kusten,
deren Naturphänomene seit 2000
UNESCO-Welterbe sind.

arälven River, Värmland

orte de Suecia

ás de la mitad del país es parte de rrland. Y cuanto más al norte, más reste se vuelve el paisaje y el clima; esta rte del país está correspondientemente co poblada. Si los idílicos pueblos mo Gävle atraen a los visitantes a costa, muchos lugares más al norte nen una naturaleza virgen. La tundra bpolar con bosques de pinos y abedules oporciona hábitat suficiente para rros árticos, manadas de renos, alces e umerables especies de aves. El norte e Suecia también es conocido por sus presionantes paisajes fluviales y lacustres n impresionantes cascadas, algunas de s cuales se precipitan a más de 40 m las profundidades; y la costa de Höga, yos fenómenos naturales han sido clarados Patrimonio de la Humanidad r la UNESCO desde el año 2000.

Norte da Suécia

Mais de metade do país faz parte de Norrland. E quanto mais ao norte, mais difícil se tornam a paisagem e o clima – por conseguinte, esta parte do país é escassamente povoada. Procurando por cidades costeiras idílicas como Gävle, mais ao norte há natureza selvagem ainda intocada em muitos lugares. A tundra subpolar com florestas de pinheiros e bétulas fornece habitat suficiente para raposa-do-ártico, rebanhos de renas, alces e inúmeras espécies de aves. O norte da Suécia também é conhecido por suas paisagens deslumbrantes de rios e lagos com cachoeiras trovejantes, algumas das quais mergulham mais de 40 m nas profundezas, e a Costa Alta (Höga Kusten), cujos fenômenos naturais são Patrimônio Mundial da Humanidade pela UNESCO desde 2000.

Noord-Zweden

Meer dan de helft van het land maakt deel uit van Norrland. En hoe noordelijker, hoe ruiger het landschap en klimaat worden. Dit deel van het land is dan ook dunbevolkt. Hoewel idyllische dorpjes als Gävle bezoekers naar de kust trekken, heerst er verder noordwaarts op veel plaatsen een ongerepte wildernis. De subpolaire toendra met dennen- en berkenbossen biedt voldoende leefruimte voor poolvossen, rendierkuddes, elanden en talloze vogelsoorten. Noord-Zweden staat ook bekend om zijn adembenemende rivier- en merenlandschappen met donderende watervallen, waarvan sommige meer dan 40 meter de diepte in storten, en de Höga-kust, waarvan de natuurfenomenen sinds 2000 werelderfgoed van de Unesco zijn.

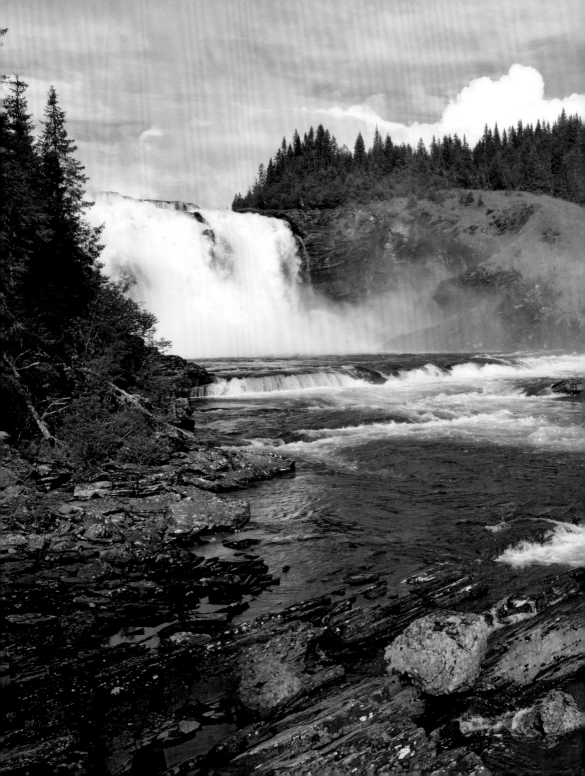

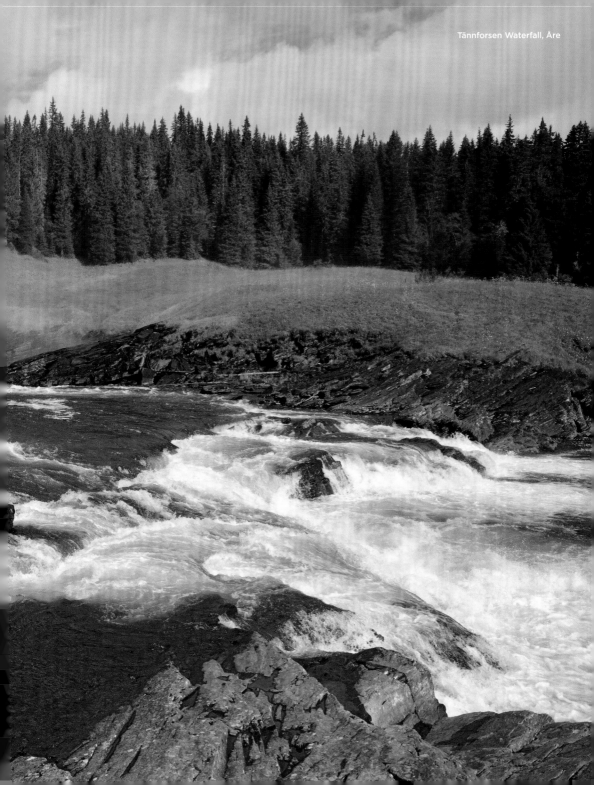
Tännforsen Waterfall, Åre

Gävle

Gävle

ävle

Gävle

…ävle is the result of the merger of several …shing villages, and has been a town since …446. The cobbled alleys of the old town …re especially charming, and the well-…ept wooden houses mostly stand on …atural stone pedestals and have facades …ecorated with colorful flowers, birdhouses …nd awnings. Today many artists live here.

Gävle

Gävle, formé par la réunion de plusieurs ports de pêche, a droit de cité depuis 1446. Les ruelles pavées de la vieille ville sont particulièrement charmantes, avec leurs maisons en bois bien soignées, le plus souvent construites directement sur le substrat rocheux, aux façades décorées de fleurs, de cages d'oiseaux et de marquises multicolores. De nombreux artistes y résident aujourd'hui.

Gävle

Gävle entstand einst aus dem Zusammenschluss einiger Fischerdörfer und hat seit 1446 Stadtrecht. Besonders reizvoll sind die kopfsteingepflasterten Gässchen in der Altstadt, in denen die gepflegten Holzhäuser meist auf Natursteinsockeln stehen und die Fassaden mit bunten Blumen, Vogelhäuschen und Markisen geschmückt sind. Heute wohnen dort viele Künstler.

Gävle

…ävle fue en su día el resultado de la fusión …e varios pueblos pesqueros y ha sido …na ciudad desde 1446. Especialmente …ncantadores son los callejones …mpedrados del casco antiguo, donde las …asas de madera bien cuidadas se levantan …obre pedestales de piedra natural y las …achadas están decoradas con coloridas …ores, casitas para pájaros y toldos. Hoy en …a muchos artistas viven allí.

Gävle

Gävle foi outrora o resultado da fusão de várias aldeias piscatórias e considerada uma cidade desde 1446. Particularmente encantadoras são as ruelas de paralelepípedos da cidade velha, onde as casas de madeira bem conservadas ficam principalmente em pedestais de pedra natural e as fachadas são decoradas com flores coloridas, casas de pássaros e toldos. Hoje em dia muitos artistas vivem lá.

Gävle

Gävle ontstond ooit uit de aaneensluiting van enkele vissersdorpen en heeft sinds 1446 stadsrechten. Bijzonder charmant zijn de met kinderhoofdjes geplaveide steegjes in het oude centrum, waar de goed onderhouden houten huizen meestal op natuurstenen sokkels staan en de gevels zijn versierd met kleurige bloemen, vogelhuisjes en luifels. Tegenwoordig wonen er veel kunstenaars.

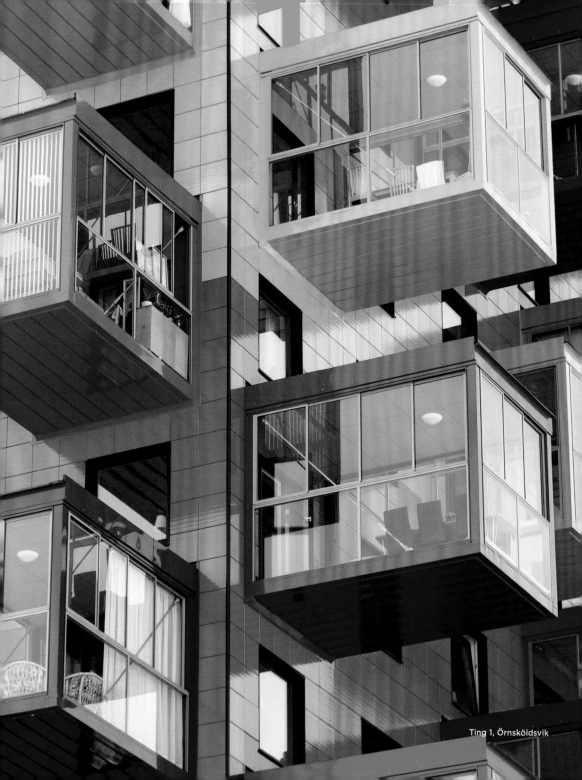

Ting 1, Örnsköldsvik

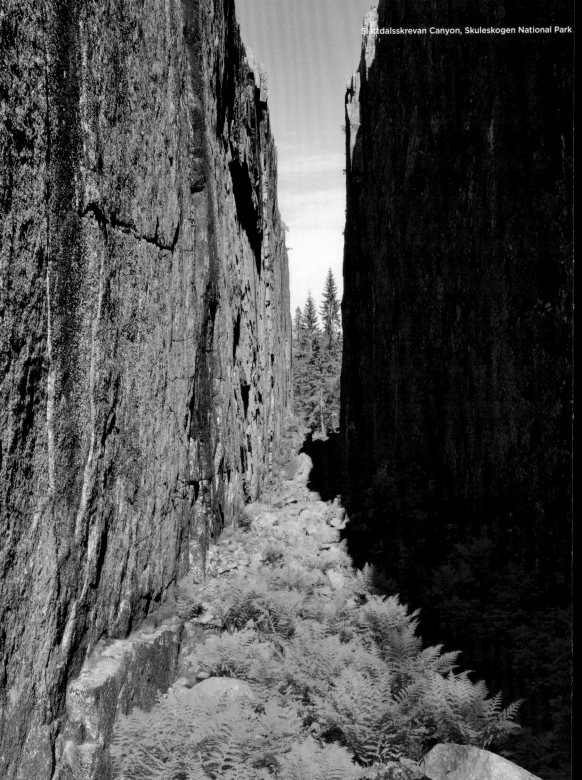

Slattdalsskrevan Canyon, Skuleskogen National Park

...ern leaves, Skuleskogen National Park

he Gorge of Slåttdalsskrevan

his impressive natural spectacle in the
...ountainous hinterland of the Höga
...usten region illustrates the formidable
...rigins of the country. In the famous
...låttdalsskrevan (Hell's Gorge) in
...kuleskogen National Park, rock faces rise
...0 m (131 ft) above the ground and create
... narrow, fern-covered path that leads
...hrough the dense forests of the National
...ark to Lake Tärnättvattnen.

...l desfiladero de Slåttdalsskrevan

...l impresionante espectáculo natural en el
...nterior montañoso de la región de Höga
...usten ilustra los enormes orígenes del
...aís. En el famoso "Barranco del Infierno"
...låttdalsskrevan, en el Parque Nacional de
...kuleskogen, las paredes rocosas se elevan
...0 metros sobre el nivel del suelo y crean
...n estrecho sendero cubierto de helechos
...ue conduce a través de los densos
...osques del parque nacional hasta el lago
...ärnättvattnen.

La gorge de Slåttdalsskrevan

L'impressionnante nature dans l'arrière-
pays montagneux de la région de Höga
Kusten donne une idée des forces
telluriques qui ont façonné ce pays.
Dans la célèbre « gorge du Diable » ou
Slåttdalsskrevan du parc national de
Skuleskogen, deux parois rocheuses
de 40 m encadrent un étroit sentier
tapissé de fougères qui conduit au lac de
Tärnättvattnen, en passant par les forêts
épaisses du parc national.

O desfiladeiro de Slåttdalsskrevan

O espetáculo natural impressionante no
interior montanhoso da região de Höga
Kusten ilustra as enormes origens do
país. Na famosa "Garganta do Inferno"
Slåttdalsskrevan, no Parque Nacional
de Skuleskogen, as paredes de pedra
se elevam 40 metros acima do solo e
criam um caminho estreito, coberto de
samambaias, que atravessa as densas
florestas do Parque Nacional até ao
Lago Tärnättvattnen.

Schlucht Slåttdalsskrevan

Das imposante Naturschauspiel im
bergigen Hinterland der Region Höga
Kusten verdeutlicht den gewaltigen
Ursprung des Landes. In der berühmten
„Höllenschlucht" Slåttdalsskrevan
im Nationalpark Skuleskogen ragen
Felswände 40 m in die Höhe und bahnen
einen schmalen, mit Farn bewachsenen
Weg, der dann durch die dichten Wälder
des Nationalparks zum See Tärnättvattnen
weiterführt.

De kloof van Slåttdalsskrevan

Het indrukwekkende natuurschouwspel in
het bergachtige achterland van de regio
Höga Kusten illustreert de gewelddadige
oorsprong van het land. In de beroemde
'helse kloof' Slåttdalsskrevan in het
nationale park Skuleskogen rijzen de
rotswanden 40 meter hoog op en vormen
ze een smalle, met varens bedekte weg die
door de dichte bossen van het nationale
park naar het Tärnättvattnen-meer voert.

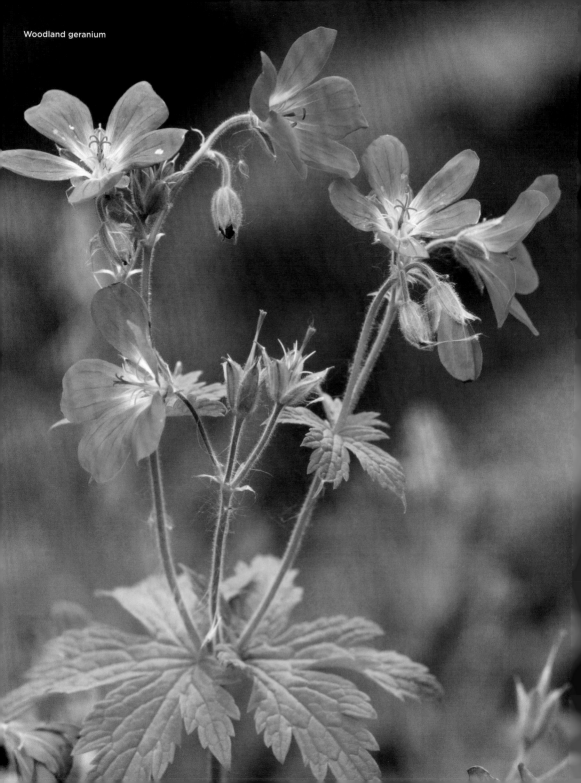

Woodland geranium

Skuleskogen National Park

Wood Cranesbill

Sweden's beautiful mountain birch forests, the wood cranesbill *(Geranium sylvaticum)* blooms from June to July and for a short time transforms the meadows, clearings and rocky shores of the almost primeval forests of the Skuleskogen National Park with a sea of pink and blue.

Geranium sylvaticum

En los hermosos bosques de abedules de montaña de Suecia, de junio a julio florece *Geranium sylvaticum,* que encanta las praderas, los claros y las orillas rocosas de los bosques casi primitivos del Parque Nacional de Skuleskogen con un mar de colores rosas y azules durante un corto periodo de tiempo.

Le géranium des bois

En Suède, dans les jolis bois de bouleaux au-dessus de la limite des forêts de résineux, le géranium des bois *(Geranium sylvaticum)* fleurit de juin à juillet. Pour une brève période, il étend une nappe mauve sur les prés, les clairières, mais aussi les berges rocheuses des forêts primitives du parc national de Skuleskogen.

Gerânio de Bosque

Nas belas florestas de bétulas de montanha da Suécia, o gerânio de bosque *(Geranium sylvaticum)* floresce de junho a julho e encanta por um curto período prados, clareiras e costas rochosas das florestas quase primitivas do Parque Nacional Skuleskogen com um mar de cores rosa e azul.

Wald-Storchschnabel

In den schönen Fjäll-Birkenwäldern Schwedens blüht von Juni bis Juli der Wald-Storchschnabel *(Geranium sylvaticum)* und verzaubert für kurze Zeit Wiesen, Lichtungen, aber auch felsige Uferlandschaften der fast urwaldartigen Wälder des Nationalparks Skuleskogen in eine rosa-blaues Farbenmeer.

Bosooievaarsbek

In de prachtige fjäll-berkenbossen van Zweden bloeit van juni tot juli de bosooievaarsbek *(Geranium sylvaticum),* die korte tijd de weiden, open plekken en rotsachtige oeverlandschappen in de bijna oerwoudachtige bossen van het nationale park Skuleskogen betovert met een zee van roze en blauw.

Plants

1 Liver floret, Anémone, Leberblümchen, Anemone hepatica, Hepáticas, Leverbloempje

2 Blueberry, Myrtille, Blaubeeren, Arándano, Mirtilos, Bosbes

3 Fly agaric, Amanite tue-mouches, Fliegenpilz, Falsa oronja, Cogumelo agário das moscas, Vliegenzwam

4 Wild pansy, Pensées sauvages, Wildes Stiefmütterchen, Pensamiento salvaje, Amor-perfeito, Driekleurig viooltje

5 Great golden maidenhair, Polytric commun, Goldenes Frauenhaarmoos, Polytrichum commune, Musgão, Gewoon haarmos

6 Lesser celandine, Ficaire, Breitblättriges Knabenkraut, Celidonia menor, Celidóniamenor, gewoon speenkruid

7 Cranberry, Airelles, Preiselbeere, Arándano rojo, Arando, Vossenbessen

8 Crocus, Krokus, Azafrán

9 Magnolia, Magnolie, Magnólia

10 Red poppy, Coquelicot, Klatschmohn, Amapola, Papoula, Grote klaproos

11 Spiked speedwell, Véronique en épi, Ähriger Ehrenpreis, Verónica, Flor Verônica, Aarereprijs

12 Pasque flower, Anémone pulsatille, Gemeine Küchenschelle, Flor del viento, Flor-do-vento, wildemanskruid

13 Lichen, Lichen, Flechte, Liquen, Líquens, Korstmos

14 Calypso orchid, Calypso bulbeux, Norne, Zapatilla de Venus, Calypso, Bosnimf

15 Holland leek, Ail Holland-Lauch, Allium hollandicum, Alho poró da Holanda, Allium

16 Cottongrass, Linaigrette, Wollgras, Eriophorum, Erva do algodão, Wollegras

17 Cloudberry, Plaquebière, Moltebeere, Mora de los pantanos, Amora-branca-silvestre, Kruipbramen

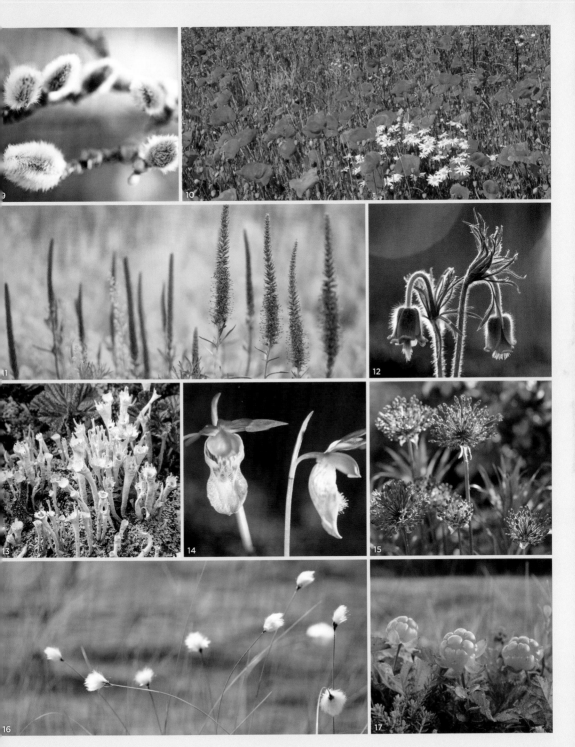

Sunne Church Ruins, Östersund

Frösö Church, Östersund

Östersund

Frösö Kyrka is one of Sweden's most popular wedding churches. This picturesque wooden building with its pointed tower stands on the small island of Frösön in Lake Storsjön, which is located close to the student town of Östersund. Once the centre of Jämtland, Frösön with its imposing town hall is now the provincial capital of Östersund. In the Jamtli open-air museum you can experience the regional history of the 18th and 19th centuries. Many of the houses on Storgatan, the main street, still have the elaborately decorated wooden facades that are typical of the original buildings of the period around 1880.

Östersund

L'une des églises où les Suédois aiment le plus se marier est la Frösö kyrka. Cet édifice pittoresque en bois, au clocher pointu, se dresse sur la petite île de Frösön, dans le lac de Storsjön en face de la ville universitaire d'Östersund. Frösön était autrefois le centre du Jämtland, mais aujourd'hui Östersund, dotée d'un imposant hôtel de ville, est le chef-lieu de la province. Au musée de plein air de Jamtli, le visiteur se plonge dans l'histoire régionale des XVIIIe et XIXe siècles. Dans la rue principale, la Storgatan, beaucoup de maisons ont gardé leurs façades de bois, typiques de la vague de construction dans les années d'expansion autour de 1880.

Östersund

Zu den beliebtesten Hochzeitskirchen Schwedens gehört die Frösö kyrka. Das malerische Holzgebäude mit dem spitzen Turm steht auf der kleinen Insel Frösön im Storsjön-See, die der Studentenstadt Östersund vorgelagert ist. Frösön war einst Zentrum von Jämtland, heute ist Östersund mit seinem imposanten Rathaus Provinzhauptstadt. Im Freilichtmuseum Jamtli wird die regionale Geschichte des 18. und 19. Jahrhunderts erfahrbar gemacht. Viele der in der Hauptstraße Storgatan stehenden Häuser besitzen noch die aufwendig verzierten Holzfassaden, die typisch sind für die ursprüngliche Bebauung zur aufstrebenden Zeit um 1880.

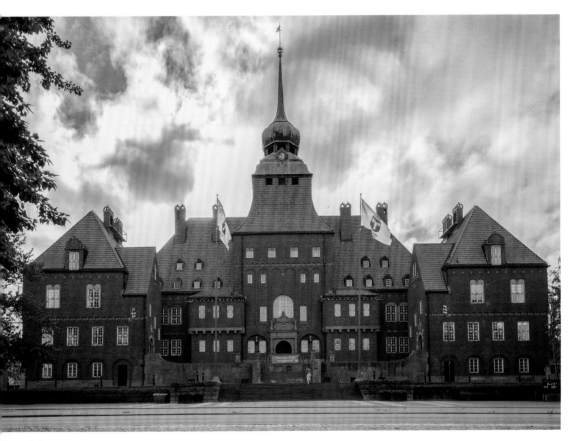
Cityhall, Östersund

Östersund

Frösö kyrka es una de las iglesias nupciales más populares de Suecia. El pintoresco edificio de madera con la torre en punta se encuentra en la pequeña isla de Frösön en el lago Storsjön, que se encuentra frente a la ciudad estudiantil de Östersund. Frösön, que antiguamente fue el centro de Jämtland, es ahora la capital de la provincia de Östersund con su imponente ayuntamiento. En el museo al aire libre de Jamtli se puede experimentar la historia regional de los siglos XVIII y XIX. Muchas de las casas de la calle principal Storgatan aún conservan las fachadas de madera, muy bien decoradas, que son típicas de los edificios originales de la época de gran auge, hacia 1880.

Östersund

A Frösö kyrka é uma das igrejas de casamento mais populares da Suécia. O pitoresco edifício de madeira com a torre pontiaguda fica na pequena ilha de Frösön, no Lago Storsjön, que fica em frente à cidade estudantil de Östersund. Outrora o centro de Jämtland, Frösön é agora a capital provincial de Östersund com a sua imponente câmara municipal. No museu ao ar livre Jamtli, a história regional dos séculos XVIII e XIX é colocada ao alcance de todos. Muitas das casas na rua principal Storgatan ainda têm as fachadas de madeira primorosamente decoradas, que são típicas para os edifícios originais do período de crescimento por volta de 1880.

Östersund

Frösö kyrka is een van de populairste trouwkerken van Zweden. Het pittoreske houten gebouw met de spitse toren staat op het eilandje Frösön in het Storsjönmeer, dat voor de studentenstad Östersund ligt. Frösön met zijn imposante stadhuis was ooit het centrum van Jämtland en is nu de hoofdstad van de provincie Östersund. In het openluchtmuseum Jamtli kunnen bezoekers de regionale geschiedenis van de 18e en 19e eeuw ervaren. Veel van de huizen in de hoofdstraat Storgatan hebben nog de uitbundig versierde houten gevels die typerend zijn voor de oorspronkelijke bebouwing uit de bloeiperiode van omstreeks 1880.

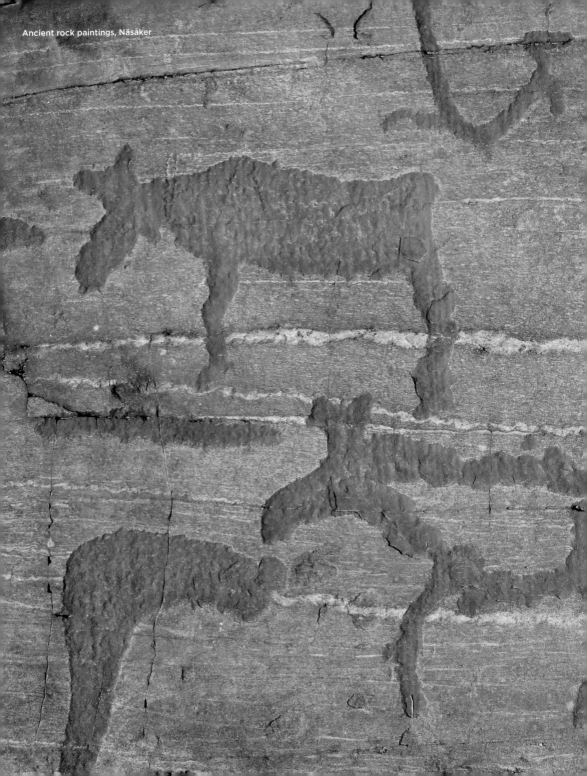
Ancient rock paintings, Näsåker

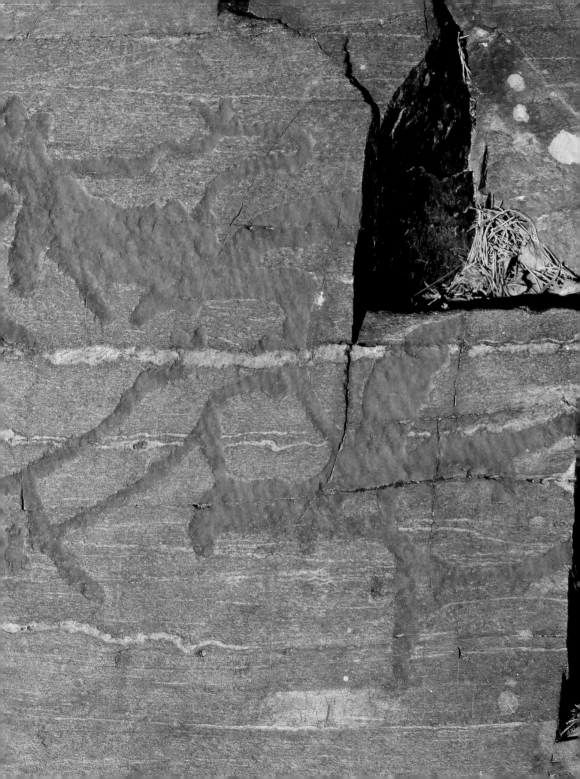

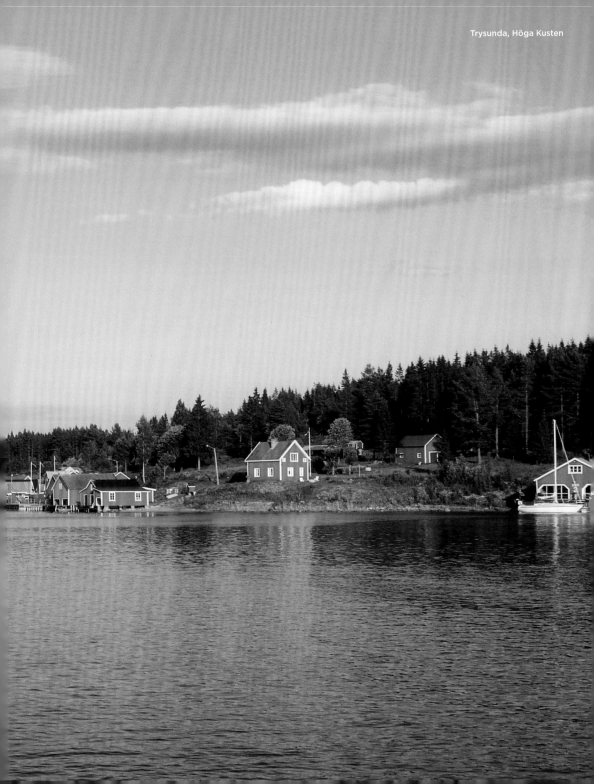

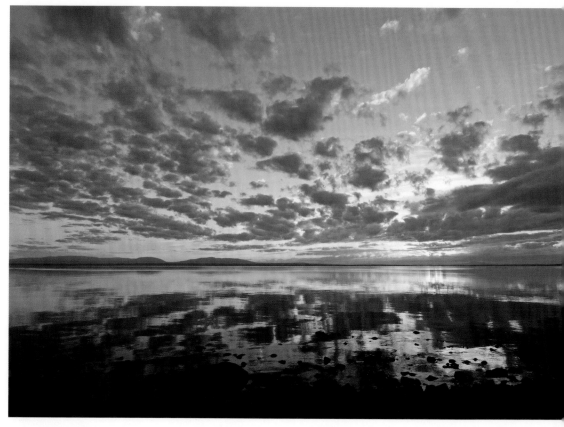

Storsjön Lake, Jämtland

Water-rich Jämtland

The historic province of Jämtland is comprised of about 8 percent waterways, the most striking being Sweden's fifth largest lake, Storsjön, with an area of 465 km² (180 sqmi). The monster Storsjöodjuret is said to live there, and is often found as a sculpture in the area and attracts many sightseers. No less than 500 km (311 mi) of hiking trails over wooded hills and through rugged mountain ranges also invite you to explore. To the west, on the border with Norway, the Scandinavian mountains rise to over 1000 m (3281 ft). Sweden's longest cave, Korallgrottan, 6 km (4,7 mi) of which is accessible, makes it worth taking a detour to Strömsund in the north-east of Jämtland.

Le Jämtland, ses rivières et ses lacs

Les eaux occupent environ 8 % de la superficie de la province historique du Jämtland, notamment le Storsjön, qui est le cinquième lac de Suède avec ses 465 km². Un monstre y vivrait, le Storsjöodjuret, que l'on trouve un peu partout sous forme de statue et qui attire des foules de curieux. Pas moins de 500 km de chemins de randonnée conduisent à travers les collines boisées et les chaînes montagneuses crevassées. À l'ouest, à la frontière avec la Norvège, la montagne scandinave culmine à plus de 1000 m. La plus longue grotte de Suède, Korallgrottan, dont 6 km sont ouverts au public, mérite le détour par Strömsund, dans le nord-est du Jämtland.

Wasserreiches Jämtland

Die historische Provinz Jämtland wird zu etwa 8 Prozent von Gewässern eingenommen, am markantesten ist mit 465 km² Fläche Schwedens fünftgößter See Storsjön. Dort soll das Ungeheuer Storsjöodjuret leben, das in der Gegend auch häufig als Skulptur zu finden ist und viele Schaulustige anzieht. Nicht weniger als 500 km Wanderwege über bewaldete Hügel und durch zerklüftete Gebirgszüge laden ebenso zur Entdeckungsreise ein. Im Westen, an der Grenze zu Norwegen, erhebt sich das skandinavische Gebirge auf über 1000 m. Schwedens längste Höhle Korallgrottan, 6 km davon sind erschlossen, ist einen Abstecher nach Strömsund im Nordosten Jämtlands wert.

ce, Jämtland

Jämtland, rica en agua

l 8 por ciento de la histórica provincia de
ämtland está ocupada por agua. El lago
nás llamativo es el Storsjön que, con una
uperficie de 465 km², es el quinto lago
nás grande de Suecia. Se dice que allí vive
l monstruo Storsjöodjuret, que a menudo
e encuentra como una escultura en la
ona y atrae a muchos espectadores. No
nenos de 500 km de rutas de senderismo
obre colinas boscosas y a través de
scarpadas cadenas montañosas también
e invitan a explorar. Al oeste, en la frontera
on Noruega, las montañas escandinavas
e elevan a más de 1000 metros de altura.
Merece la pena desviarse a Strömsund,
n el noreste de Jämtland, para visitar la
ueva más larga de Suecia, Korallgrottan,
le la que se pueden explorar 6 km.

Rica em água Jämtland

A província histórica de Jämtland é
ocupada por cerca de 8% de águas, área
mais mais impressionante é o quinto maior
lago da Suécia, Storsjön, com uma área de
465 km². O monstro Storsjöodjuret é dito
viver lá, que também é frequentemente
encontrado como uma escultura na área
e atrai muitos espectadores. Nada menos
que 500 km de trilhas para caminhadas
sobre colinas arborizadas e através de
cadeias montanhosas escarpadas também
convidam você para uma viagem de
descobertas. A oeste, na fronteira com
a Noruega, as montanhas escandinavas
sobem para mais de 1000 metros. Devido
a maior caverna da Suécia, Korallgrottan,
com 6 km de extensão, vale a pena uma
viagem a província Strömsund, situada no
nordeste de Jämtland.

Waterrijk Jämtland

De historische provincie Jämtland
bestaat voor circa 8 procent uit water,
waarvan het op vier na grootste meer van
Zweden, Storsjön, met een oppervlak van
465 km², het markantst is. Hier zou het
monster Storsjöodjuret leven, dat in de
omgeving vaak te zien is als beeld en veel
kijkers aantrekt. Maar liefst 500 km aan
wandelpaden over beboste heuvels en
door bergketens vol ravijnen nodigen uit
tot verkenning. In het westen, op de grens
met Noorwegen, rijzen de Scandinavische
bergen op tot ruim 1000 meter hoogte.
De langste grot van Zweden, Korallgrottan
waarvan 6 km toegankelijk, is een omweg
naar Strömsund in het noordoosten van
Jämtland waard.

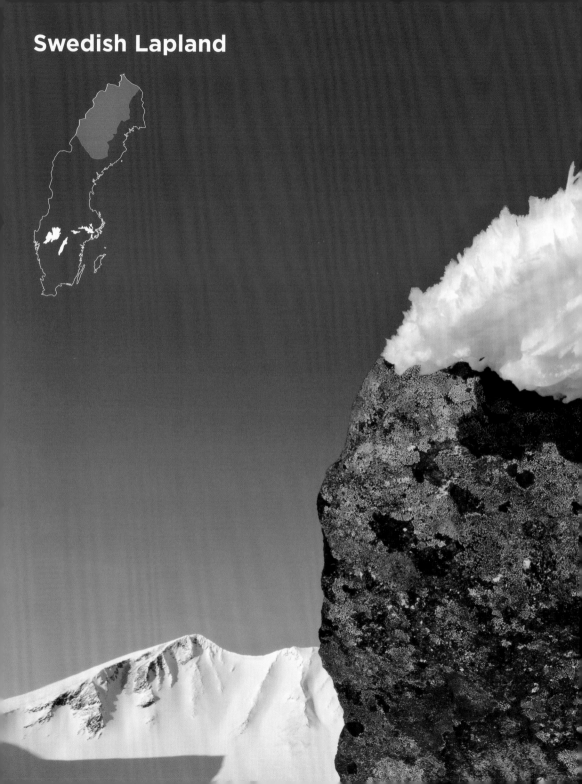

Swedish Lapland

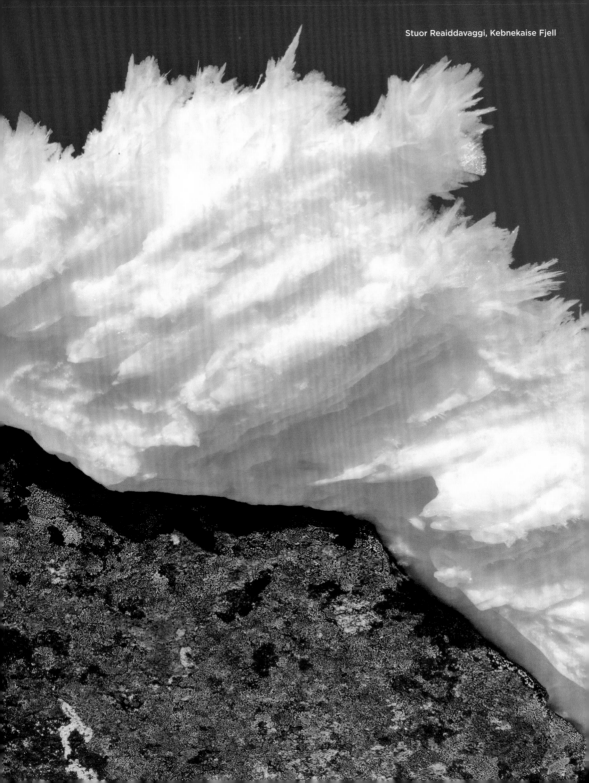

Stuor Reaiddavaggi, Kebnekaise Fjell

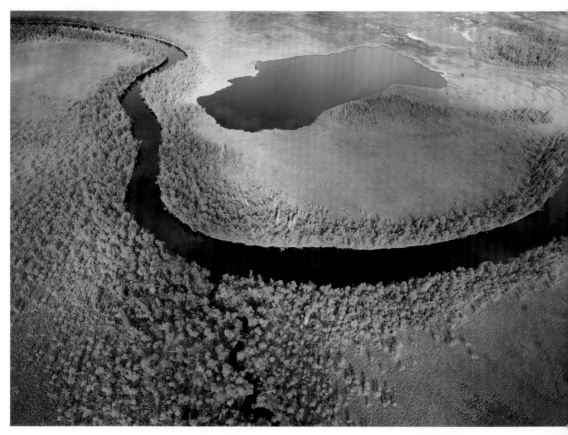

Sjaunja Nature Reserve

Swedish Lapland

Sweden's northernmost region borders Norway to the west and Finland to the north. It is home to the Samí and is Europe's last wilderness. In fact, Lapland offers the widest, most spectacular and pristine landscape in Europe. Here you will be fascinated by solitude, peace and unspoilt nature. This reindeer kingdom is a breathtaking alpine territory with deep gorges, icy glaciers, mountain meadows, streams and mountain birch forests. It barely gets dark in summer and is rarely light in winter—but you can see polar lights dancing across the night sky in one of the twelve national parks.

La Laponie suédoise

La région la plus septentrionale de Suède est bordée à l'ouest par la Norvège et au nord par la Finlande. C'est le pays des Sami et le dernier territoire sauvage d'Europe. La Laponie offre en effet les paysages les plus spectaculaires et les plus intacts du continent. Son isolement, sa solitude, sa paix et sa nature inviolée ont quelque chose de fascinant. Le royaume des rennes est d'une beauté à couper le souffle, entre ses gorges profondes, ses glaciers, ses prairies de montagne, ses torrents et ses bois de bouleaux en altitude. En été, le ciel s'assombrit à peine et en hiver la nuit n'en finit pas, mais on en profite pour aller regarder les aurores boréales dans l'un des douze parcs nationaux.

Schwedisch-Lappland

Schwedens nördlichste Region grenzt im Westen an Norwegen und im Norden an Finnland. Sie ist die Heimat der Samí und Europas letzte Wildnis. Tatsächlich bietet Lappland die weiteste, spektakulärste und ursprünglichste Landschaft Europas. Hier herrscht die Faszination von Einsamkeit, Ruhe und unberührter Natur. Das Reich der Rentiere ist ein atemberaubendes alpines Territorium mit tiefen Schluchten, eisigen Gletschern, Bergwiesen, Bächen und Fjäll-Birkenwäldern. Im Sommer wird es kaum dunkel und im Winter selten hell – dafür kann man in einem der zwölf Nationalparks Polarlichter über den Nachthimmel tanzen sehen.

Muddus National Park

aponia sueca

a región más septentrional de Suecia
mita al oeste con Noruega y al norte con
Finlandia. Es el hogar del sami y de la
última zona salvaje de Europa. De hecho,
aponia ofrece el paisaje más amplio,
spectacular y prístino de Europa. Aquí se
entirá fascinado por la soledad, la paz y
a naturaleza virgen. El reino de los renos
s un impresionante territorio alpino con
rofundas gargantas, glaciares helados,
raderas de montaña, arroyos y bosques
de abedules de montaña. Apenas oscurece
n verano y rara vez brilla el sol en invierno,
ero se pueden ver luces polares bailando
a través del cielo nocturno en uno de los
doce parques nacionales.

Lapónia sueca

A região mais setentrional da Suécia faz
fronteira com a Noruega a oeste e com
a Finlândia ao norte. É o lar do Samí e a
última região selvagem da Europa. Na
verdade, a Lapônia oferece a paisagem
mais ampla, espetacular e intocada da
Europa. Aqui você ficará fascinado pela
solidão, tranquilidade e natureza intocada.
O reino das renas é um território alpino de
tirar o fôlego, com desfiladeiros profundos,
glaciares gelados, prados de montanha,
riachos e bosques de bétulas de montanha.
Dificilmente escurece no verão e raramente
brilha no inverno – mas você pode ver
luzes polares dançando pelo céu noturno
em um dos doze parques nacionais.

Zweeds Lapland

De noordelijkste regio van Zweden
grenst in het westen aan Noorwegen en
in het noorden aan Finland. Het is het
woongebied van de Samí en de laatste
wildernis van Europa. Lapland biedt het
meest weidse, meest oorspronkelijke en
spectaculairste landschap van Europa. Hier
fascineren eenzaamheid, rust en ongerepte
natuur. Het rijk van de rendieren is een
adembenemend alpien gebied met diepe
kloven, ijzige gletsjers, bergweiden, beekjes
en fjäll-berkenbossen. Het wordt hier 's
zomers nauwelijks donker en 's winters
zelden licht – maar in een van de twaalf
nationale parken kun je aan de nachtelijke
hemel het noorderlicht zien dansen.

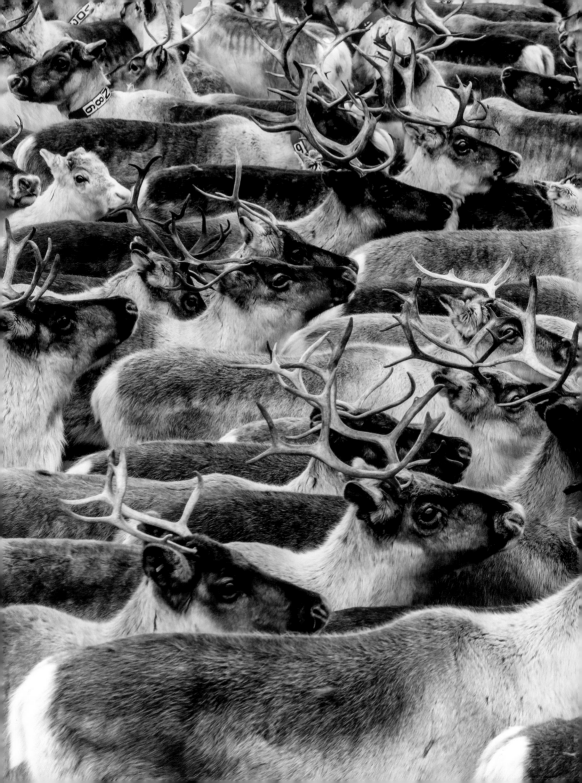

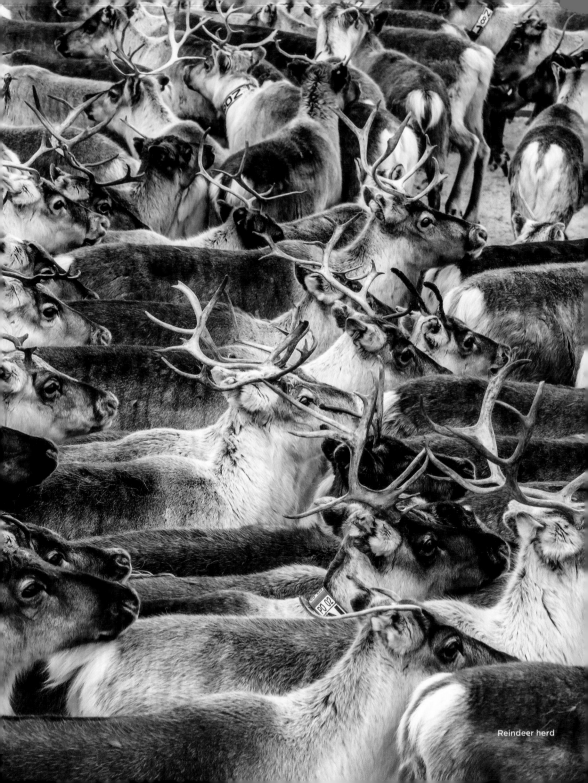

Reindeer herd

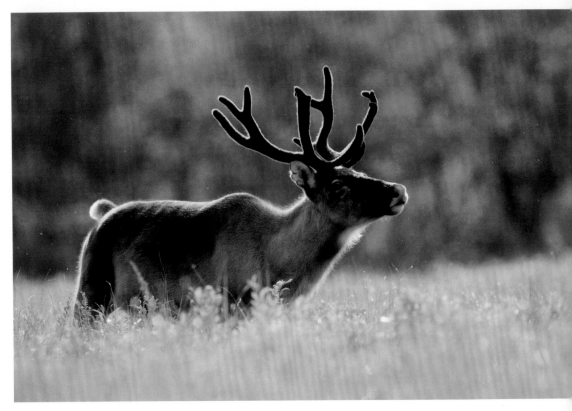

Reindeer

Moose and Reindeer

These magnificent ruminants with velvet fur live in Swedish Lapland. Moose only exist in the wild, but unlike these shy loners, reindeer are herd animals and almost all are privately owned by the indigenous people. Slender legs and royal antlers are typical for both species—but the female moose do not wear a noble headdress.

Alce y reno

Los magníficos rumiantes de pelo aterciopelado viven en Laponia sueca, pero solo hay alces en estado salvaje. A diferencia de estos animales tímidos y solitarios, los renos son animales gregarios y casi todos son propiedad privada de los aborígenes. Sus patas delgadas y su cornamenta real son típicos de ambas especies de ciervos, pero las vacas de alce no llevan un tocado noble.

L'élan et le renne

Ces magnifiques ruminants au pelage de velours vivent en Laponie suédoise, mais seuls les élans sont encore sauvages. Contrairement à ces solitaires farouches, les rennes vivent en troupeaux et appartiennent presque tous à des Lapons. Ces deux espèces de cervidés se distinguent par leurs pattes fines et leur ramure impressionnante, mais les femelles de l'élan ne portent pas de bois.

Alces e Renas

Os magníficos ruminantes com a pele de veludo vivem na Lapónia sueca, selvagens entretanto são só os alces. Ao contrário dos solitários tímidos, as renas são animais de rebanho e quase todos são propriedade privada dos nativos. As pernas finas e o chifre real são típicos de ambas as espécies de veados – mas as alces fêmeas não possuem chifres.

Elch und Rentier

Die prächtigen Wiederkäuer mit dem Samtfell leben in Schwedisch-Lappland, wild gibt es an sich jedoch nur Elche. Anders als die scheuen Einzelgänger sind Rene Herdentiere und fast alle in Privatbesitz der Ureinwohner. Schlanke Beine und ein königliches Geweih sind für beide Hirscharten typisch – allerdings tragen die Elch-Kühe keinen edlen Kopfschmuck.

Eland en rendier

Deze prachtige herkauwers met hun fluwelen vacht leven in Zweeds Lapland, maar in het wild leven alleen de elanden. In tegenstelling tot die schuwe eenlingen zijn rendieren kuddedieren en zijn ze bijna allemaal particulier bezit van de inheems bewoners. Slanke poten en een koninklijk gewei zijn kenmerkend voor beide hertensoorten – maar de elandkoeien bezitten geen edele hoofdtooi.

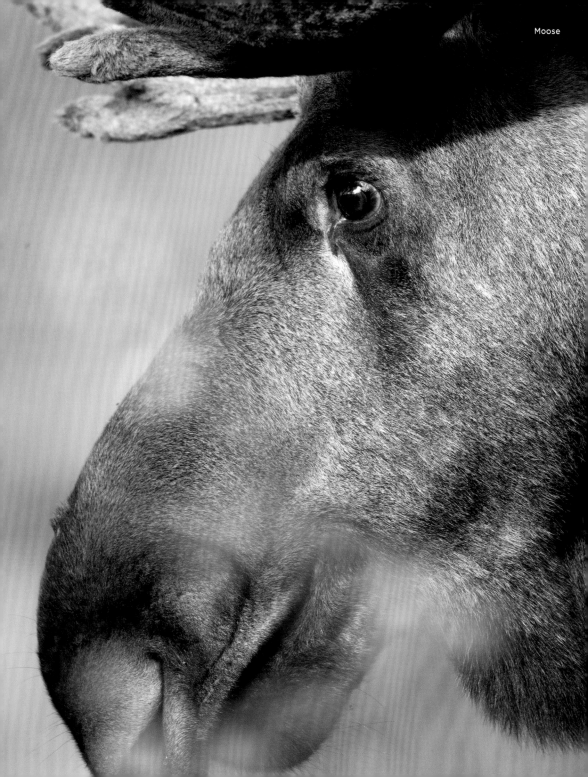

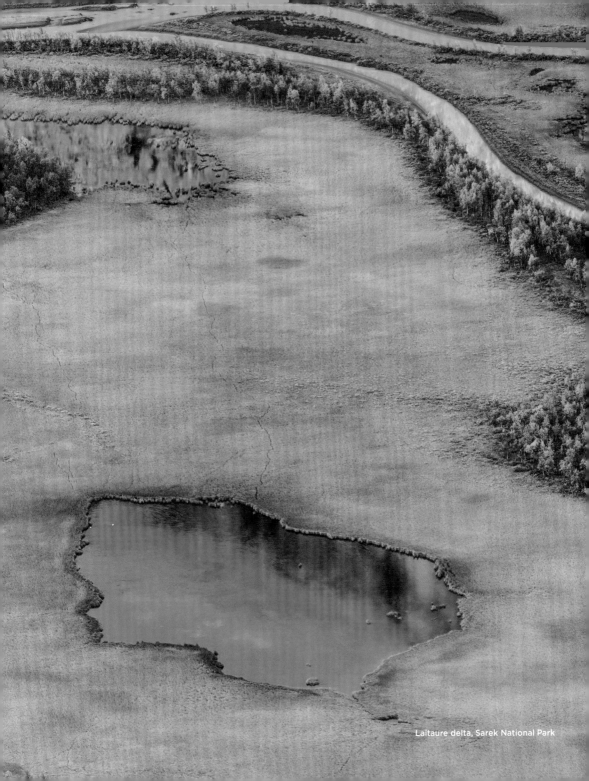

Laitaure delta, Sarek National Park

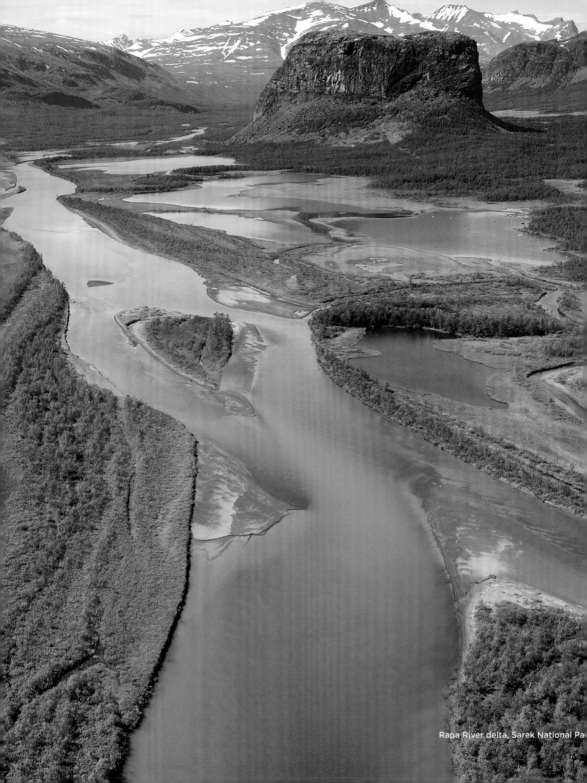

Rapa River delta, Sarek National Pa

Rapa River delta, Sarek National Park

Sarek National Park
Here Sweden shows its roughest side—
Sarek National Park is uninhabited,
spacious and secluded. There are no
hiking trails, and the rivers are pristine and
free. Sarek also enchants with an alpine
world consisting of almost 100 glaciers,
the endless Scandinavian taiga and many
turquoise lakes.

Le parc national de Sarek
Ici, dans ce parc inhabité, immense et loin
de tout, la Suède se montre sous son jour
le plus austère. Il n'y a pas de chemins de
randonnées et les cours d'eau sillonnent où
bon leur semble. Les paysages alpins et les
cent glaciers de Sarek, sa taïga scandinave
infinie et ses lacs turquoise n'en sont pas
moins fascinants.

Sarek National Park
Hier zeigt sich Schweden von seiner
rauesten Seite – der Sarek Nationalpark ist
unbewohnt, weitläufig und abgeschieden.
Es gibt keine Wanderwege, die Flussläufe
sind ursprünglich und frei. Außerdem
verzaubert Sarek mit einer alpinen Welt,
bestehend aus knapp 100 Gletschern, einer
endlos wirkenden skandinavischen Taiga
und vielen türkisfarbenen Seen.

Parque Nacional de Sarek
Aquí Suecia muestra su lado más
áspero: el Parque Nacional de Sarek está
deshabitado, es espacioso y se encuentra
aislado. No hay senderos para caminar, los
ríos son prístinos y libres. Sarek también
es fascinante, con un mundo alpino
formado por casi 100 glaciares, una taiga
escandinava interminable y muchos lagos
de color turquesa.

Parque Nacional Sarek
Aqui a Suécia mostra seu lado mais
áspero – o Parque Nacional Sarek é
desabitado, espaçoso e isolado. Não
há trilhas para caminhadas, os rios são
imaculados e livres. Sarek também
encanta com um mundo alpino que
consiste em quase 100 glaciares, uma taiga
escandinava infinita e muitos lagos com
águas turquesas.

Nationaal park Sarek
Hier toont Zweden zich van zijn
ruigste kant: het nationale park Sarek
is onbewoond, weids en afgelegen. Er
zijn geen wandelpaden, de rivieren zijn
ongerept en vrij in hun loop. Sarek betovert
bovendien met een alpiene wereld die
bestaat uit bijna honderd gletsjers, een
eindeloos aandoende Scandinavische taiga
en veel turquoise meren.

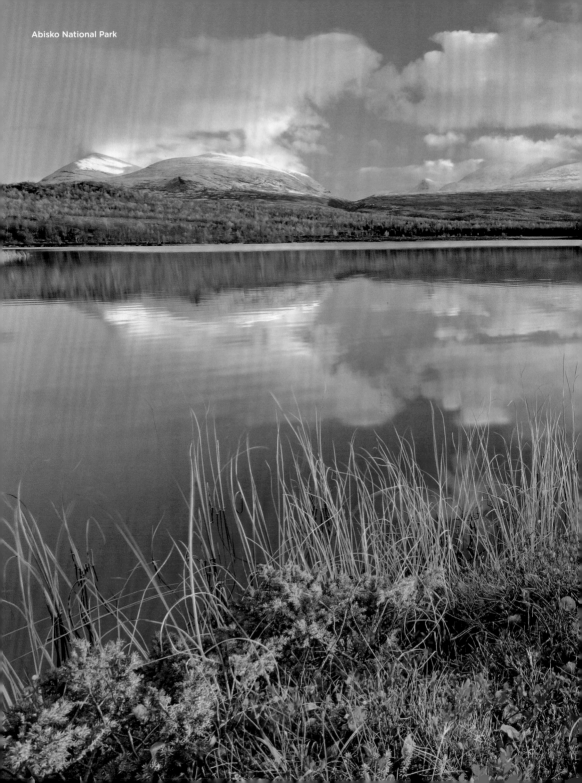

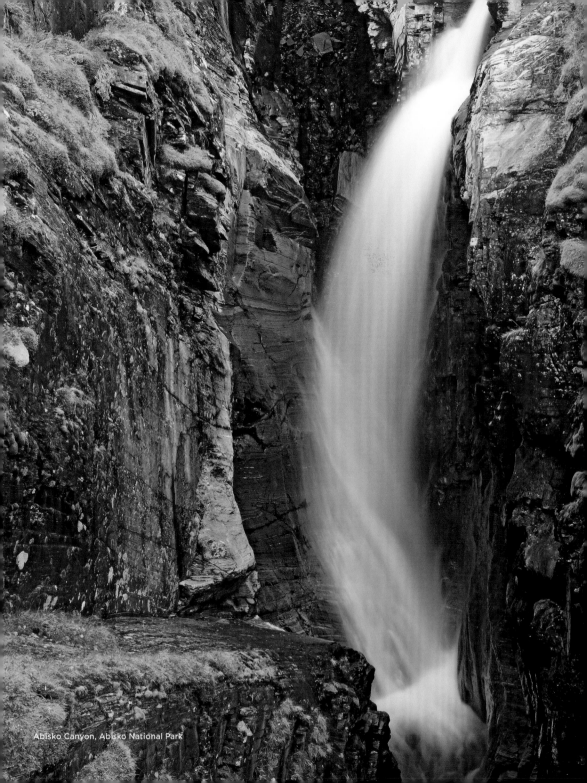

Abisko Canyon, Abisko National Park

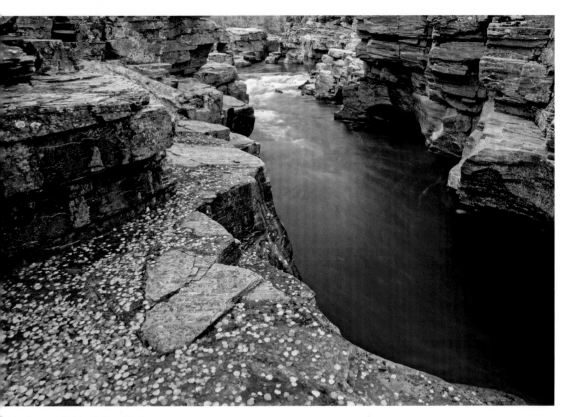

Abisko Canyon, Abisko National Park

Abisko National Park

The best place to see the northern lights – 200 km (124 mi) north of the Arctic Circle—in the Abisko National Park, founded in 1909, nature follows its own laws. Featuring arctic forests, mountain ranges and raging waterfalls, there are more animals than people in this region. The Abiskojåkka river winds its way through this lonely wilderness.

Parque Nacional de Abisko

El mejor lugar para ver la aurora boreal es 200 km al norte del círculo polar ártico: en el Parque Nacional de Abisko, fundado en 1909, donde la naturaleza sigue sus propias leyes. Este lugar está caracterizado por bosques árticos, cordilleras y cascadas enfurecidas, y en esta región hay más animales que personas. Abiskojåkka se abre camino a través de esta solitaria zona salvaje.

Le parc national d'Abisko

À 200 km au nord du cercle polaire, le parc d'Abisko est le lieu idéal pour observer les aurores boréales. Dans ce site ouvert en 1909, la nature agit à sa guise. C'est une région dominée par les forêts arctiques, les chaînes montagneuses et les cascades déchaînées, où les animaux sont plus nombreux que les hommes. Une rivière, l'Abiskojåkka, coule au milieu de cette solitude.

Parque Nacional Abisko

200 km ao norte do Círculo Ártico é o melhor lugar para ver a aurora boreal – no Parque Nacional Abisko, fundado em 1909, a natureza segue suas próprias leis. Caracterizada por florestas árticas, serras e cachoeiras, há mais animais do que pessoas nesta região. O rio Abiskojåkka serpenteia por este deserto solitário.

Abisko Nationalpark

200 km nördlich des Polarkreises befindet sich der beste Ort, um Nordlichter zu erblicken – im 1909 gegründeten Abisko Nationalpark folgt die Natur ihren eigenen Gesetzen. Geprägt von arktischen Wäldern, Bergketten und tobenden Wasserfällen gibt es in dieser Region mehr Tiere als Menschen. Mitten durch diese einsame Wildnis schlängelt sich der Abiskojåkka.

Nationaal park Abisko

200 km ten noorden van de poolcirkel is de beste plek om het noorderlicht te zien: in het in 1909 opgerichte nationale park Abisko volgt de natuur zijn eigen wetten. In deze door arctische bossen, bergketens en woeste watervallen getekende regio leven meer dieren dan mensen. De Abiskojåkka slingert zich een weg door deze eenzame wildernis.

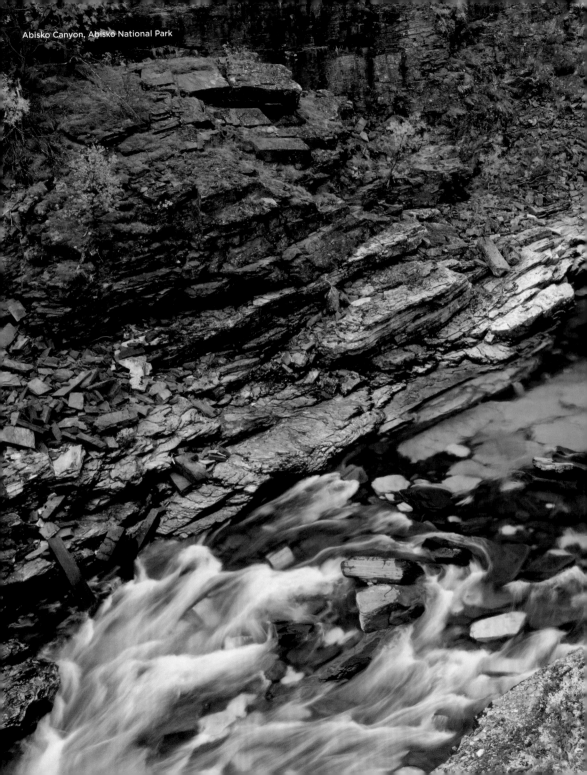

Abisko Canyon, Abisko National Park

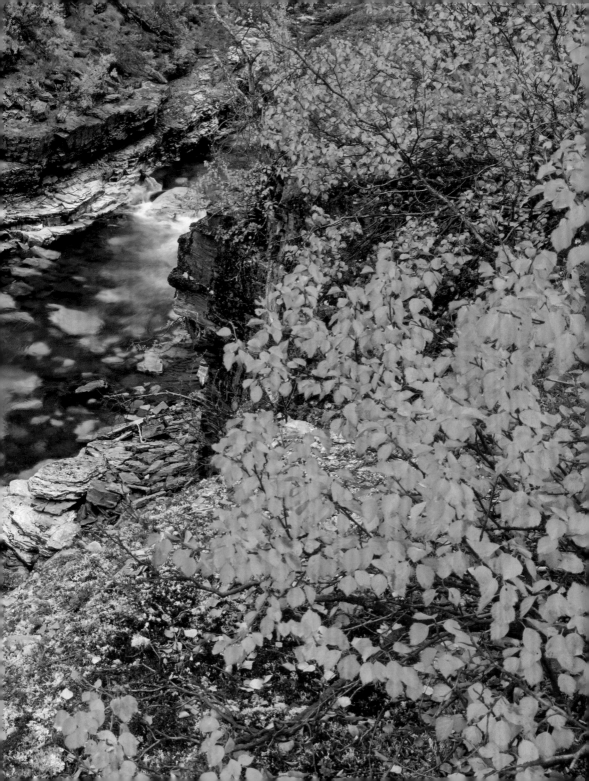

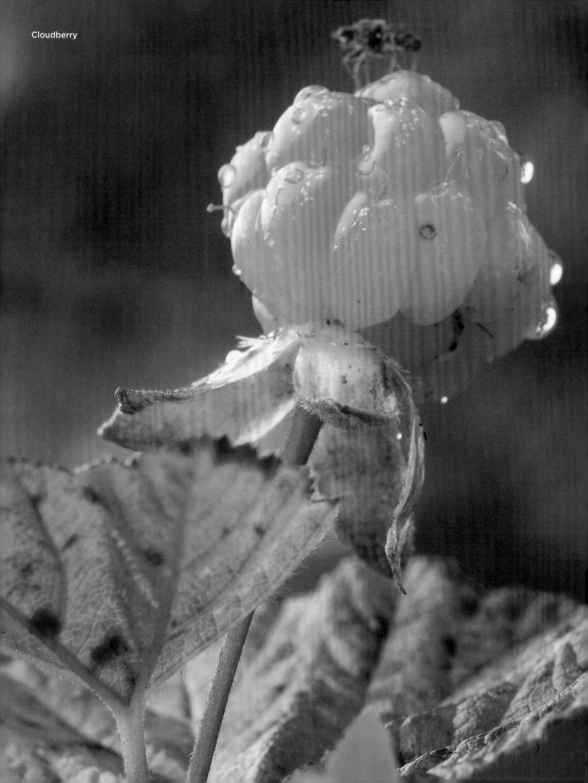
Cloudberry

Barberry

Berry World

Sweden's world of berries is diverse—besides blueberries, currants and cranberries, cloudberries are considered a delicacy. The so-called "Gold of Lapland" is also a hallmark of this region. The sweetish herb tasting fruit resembles precious drops of amber. The jam made from them, Hjortronsylt, is eaten with waffles and ice cream.

Mundo de bayas

El mundo de las bayas en Suecia es diverso: además de los arándanos azules, las grosellas y los arándanos rojos, la mora de los pantanos se considera un manjar. El llamado "oro de Laponia" es también un hito de esta región. Las frutas con sabor a hierba dulce parecen preciosas gotas de ámbar. La mermelada hecha de ellos, Hjortronsylt, se come con gofres y helado.

Les baies suédoises

En Suède pousse tout un éventail de baies, myrtilles, groseilles et airelles, mais aussi la plaquebière, qui est un délice. Surnommée « l'or de la Laponie », elle est l'emblème de la région. Sous son apparence de goutte d'ambre pur, elle possède un goût âpre et sucré. On en fait une marmelade, l'hjortronsylt, que l'on savoure avec de la glace et des gaufres.

Mundo dos frutos silvestres

O mundo dos frutos silvestres da Suécia é diversificado – além de mirtilos, groselhas e arandos, as amoras-brancas-silvestres são consideradas uma iguaria. O chamado "Ouro da Lapónia" é também um marco desta região. Os frutos de sabor adocicado e amargo parecem preciosas gotas de âmbar. A geléiafeita destes frutos, Hjortronsylt, é comida com waffles e gelado.

Beerenwelt

Schwedens Beerenwelt ist vielfältig – neben Blau-, Johannis- und Preiselbeeren gilt die Moltebeere als Delikatesse. Das so genannte „Gold Lapplands" ist auch ein Wahrzeichen dieser Region. Die süßlich-herb schmeckenden Früchte wirken wie edle Bernsteintropfen. Die aus ihnen gemachte Marmelade, Hjortronsylt, isst man zu Waffeln und Eis.

Bessen

Het Zweedse bessenaanbod is heel divers. Naast bosbessen, aalbessen en vossenbessen worden kruipbramen beschouwd als een delicatesse. Het zogenaamde Laplandse goud is ook een kenmerk van deze regio. De zoete, iets kruidig smakende vruchten zien eruit als kostbare barnsteendruppels. De jam die ervan gemaakt wordt, hjortronsylt, wordt gegeten met wafels en ijs.

Sami

Life in the Arctic Circle with reindeer, colorful knitted hats and traditional costumes is associated with one of the oldest indigenous peoples on earth—the Samí. These original nomads are known for their closeness to nature, and today live mainly from reindeer husbandry, agriculture, handicrafts and tourism. The approximately 20,000 indigenous people living in Sweden have their own flag and national anthem.

Les Sami

Les Sami, l'un des plus anciens peuples autochtones du monde, vivent aux abords du cercle polaire avec leurs rennes ; ils sont vêtus de casquettes et de costumes brodés. Ces peuples nomades, très proches de la nature, tirent aujourd'hui leur subsistance de l'élevage des rennes, de l'agriculture, de l'artisanat et du tourisme. Ils environ 20 000 à habiter en Suède et possèdent leur propre drapeau ainsi que leur hymne national.

Samí

Ein Leben am Polarkreis mit Rentieren, bunten Strickmützen und Trachten assoziiert man mit einem der ältesten Urvölker der Erde – den Samí. Die ursprünglichen Nomaden sind bekannt für ihre Naturverbundenheit und leben heute hauptsächlich von Rentierzucht, Landwirtschaft, Kunsthandwerk und Fremdenverkehr. Die rund 20 000 in Schweden lebenden Ureinwohner besitzen eine eigene Flagge und Nationalhymne.

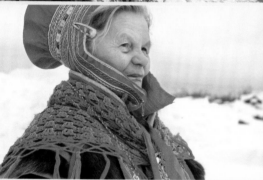

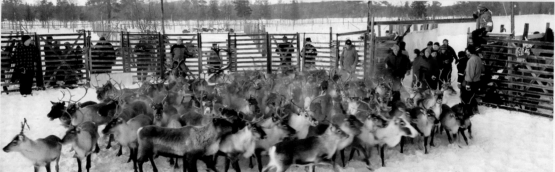

Sami

La vida en el círculo polar ártico, con renos, coloridos sombreros de punto y trajes tradicionales, se asocia con uno de los pueblos indígenas más antiguos del mundo: los samis. Los nómadas originales son conocidos por su cercanía a la naturaleza y hoy en día viven principalmente de la cría de renos, la agricultura, la artesanía y el turismo. Los aproximadamente 20 000 indígenas que viven en Suecia tienen su propia bandera y su propio himno nacional.

Sami

A vida no Círculo Ártico com renas, gorros coloridos e trajes tradicionais está associada a um dos mais antigos povos indígenas do planeta – os Samí. Os nômades originais são conhecidos por sua proximidade à natureza e hoje vivem principalmente da criação de renas, agricultura, artesanato e turismo. Os cerca de 20 000 nativos que vivem na Suécia têm a sua própria bandeira e hino nacional.

Samí

Een leven in de poolcirkel met rendieren, kleurige gebreide mutsen en klederdracht wordt geassocieerd met een van de oudste oervolken op aarde: de Samí. De oorspronkelijke nomaden staan bekend om hun verbondenheid met de natuur en leven tegenwoordig vooral van de rendierhouderij, landbouw, kunstnijverheid en het toerisme. De ongeveer 20 000 Samí die in Zweden wonen, hebben hun eigen vlag en volkslied.

Virihaure Lake, Padjelanta National Park

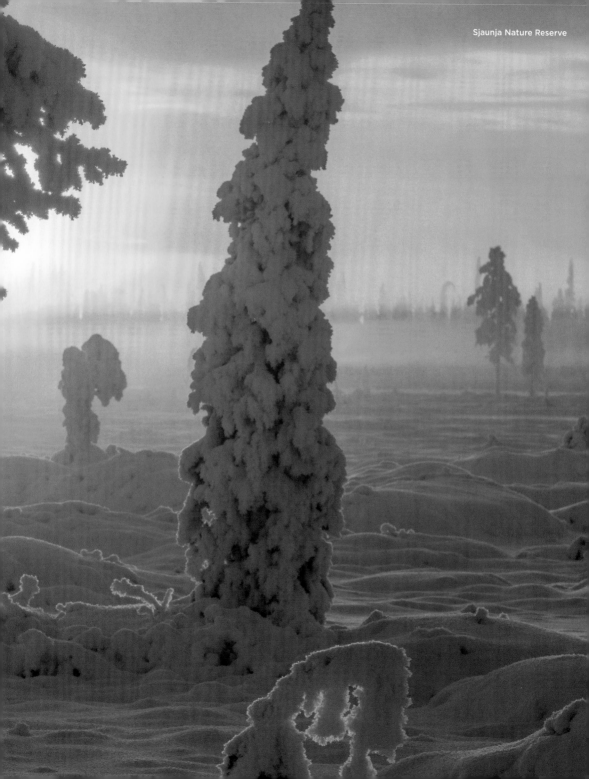

Torneträsk Lake, Abisko National Park

Arctic Adventures

Snow is guaranteed from November to April, with temperatures as low as minus 35 degrees. Nature then conducts life under deep snow, and almost no noise penetrates the cold winter landscape— only the joyful barking of dogs and the crunching and gliding of paws and sled runners on the snow resound in the silence. When Swedish Lapland displays its winter beauty, dog sledges are almost the only means of transport besides snowmobiles. Husky safaris are very popular with adventurers, and are one of the region's attractions.

L'aventure dans l'Arctique

Ici, la neige est garantie de novembre à avril, assortie de températures descendant jusqu'à – 35 °C. Sous des couches records de neige, c'est la nature qui décide de tout. On n'entend presque aucun son dans ce paysage hivernal glacial, à part les aboiements joyeux des chiens, le crissement et le glissement des pattes et des traîneaux sur la neige au milieu du silence. Lorsque la Laponie suédoise se montre dans toute sa beauté hivernale, les traîneaux de chiens et les motoneiges sont à peu près les seuls moyens de locomotion. Les safaris de chiens husky, dont raffolent les touristes aventureux, sont l'une des grandes distractions.

Arktische Abenteuer

Hier gibt es Schneegarantie von November bis April mit Temperaturen von bis zu minus 35 Grad. Tief verschneit dirigiert dann die Natur das Leben, fast kein Geräusch dringt durch die klirrend kalte Winterlandschaft – nur freudiges Hundebellen und das Knirschen und Gleiten von Pfoten und Schlittenkufen auf dem Schnee klingt in die Stille hinein. Wenn sich Schwedisch-Lappland von seiner ganzen winterlichen Schönheit zeigt, sind Hundeschlitten neben Schneemobilen fast das einzige Fortbewegungsmittel. Die so genannten Husky-Safaris sind bei Abenteurern sehr beliebt und zählen zu den Attraktionen der Region.

Dog sledding, Sarek National Park

Aventuras en el Ártico

Aquí la nieve está asegurada de noviembre a abril, con temperaturas que llegan a alcanzar los menos 35 grados. La naturaleza entonces dirige la vida en la nieve profunda, casi ningún ruido penetra a través del paisaje frío de invierno; lo único que rompe el silencio es el ladrido alegre de los perros y el crujido y el deslizamiento de las patas y los corredores de trineo en la nieve. Cuando la Laponia sueca muestra toda su belleza invernal, los trineos de perros son casi el único medio de transporte, junto con las motos de nieve. Los safaris de huskys son muy populares entre los aventureros y son una de las atracciones de la región.

Aventuras no Ártico

A neve é garantida de novembro a abril com temperaturas tão baixas quanto 35 graus negativos. A natureza então dirige a vida na neve profunda, quase nenhum som penetra através da paisagem congelante e fria de inverno – apenas o som do ladrar alegre do cão e do ranger e deslizar das patas e dos corredores de trenó na neve soam no silêncio. Quando a Lapónia sueca mostra toda a sua beleza invernal, os trenós para cães são quase o único meio de transporte para além das motas de neve. Os chamados safáris de Husky são muito populares entre os aventureiros e são uma das atrações da região.

Arctische avonturen

Hier ligt van november tot april, bij temperaturen tot min 35 graden, gegarandeerd sneeuw. Onder een dikke laag sneeuw dicteert de natuur dan het leven. Bijna geen geluid dringt door in het ijskoude winterlandschap – alleen het vrolijke geblaf van de honden en het kraken en glijden van dierenpoten en sleeijzers op de sneeuw klinken op in de stilte. Als Zweeds Lapland zich in al zijn winterse schoonheid toont, zijn hondensleeën naast sneeuwscooters bijna het enige vervoermiddel. Huskysafari's zijn erg populair bij avonturiers en behoren tot de attracties van het gebied.

Fascinating Northern Lights

This luminous natural phenomenon is breathtakingly beautiful and can be admired especially well in Abisko, a village in Swedish Lapland: Northern lights, also known as Aurora Borealis or polar lights, occur when charged particles of the solar wind enter the earth's atmosphere. Due to electromagnetic processes, they appear as colorful veils in the clear night sky.

Les aurores boréales

Aurora borealis est un spectacle de lumière absolument fabuleux que l'on peut observer particulièrement bien à Abisko, un village de Laponie suédoise. L'aurore boréale se produit quand des particules chargées du vent solaire pénètrent dans l'atmosphère terrestre. Par la magie de l'électromagnétisme, elles se transforment en voiles aux couleurs délirantes.

Faszination Nordlichter

Atemberaubend schön ist dieses leuchtende Naturphänomen, das man besonders gut in Abisko, einem Dorf in Schwedisch-Lappland, bestaunen kann: Nordlicht, auch Aurora Borealis oder Polarlicht genannt, entsteht, wenn geladene Partikel des Sonnenwinds in die Erdatmosphäre eintreten. Aufgrund elektromagnetischer Prozesse scheinen sie als farbenfrohe Schleier am klaren Nachthimmel.

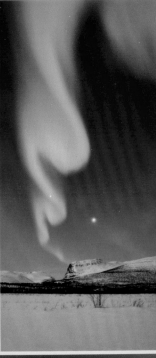

Fascinación de la aurora boreal

Este fenómeno natural luminoso es de una belleza impresionante y se puede admirar especialmente bien en Abisko, un pueblo de la Laponia sueca: la aurora boreal se produce cuando las partículas cargadas del viento solar entran en la atmósfera terrestre. Debido a los procesos electromagnéticos, aparecen como velos de colores en el cielo nocturno despejado.

Fascinação Luzes do Norte

Este fenómeno natural luminoso é de uma beleza deslumbrante e pode ser bem admirado especialmente em Abisko, uma aldeia na Lapónia Sueca: As luzes do norte, também chamadas de aurora boreal ou luz polar, ocorrem quando partículas carregadas do vento solar entram na atmosfera terrestre. Devido a processos eletromagnéticos, eles aparecem como véus coloridos no céu claro da noite.

Fascinerend noorderlicht

Dit lichtgevende natuurverschijnsel is adembenemend mooi en is vooral goed te bewonderen in Abisko, een dorp in Zweeds Lapland. Het noorderlicht, ook wel aurora borealis of noordpoollicht genoemd, ontstaat wanneer geladen deeltjes van de zonnewind de atmosfeer van de Aarde binnenkomen. Door elektromagnetische processen verschijnen ze als kleurrijke sluiers aan de heldere nachthemel.

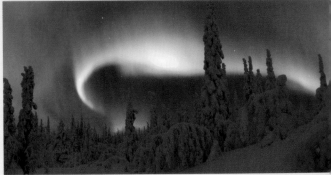

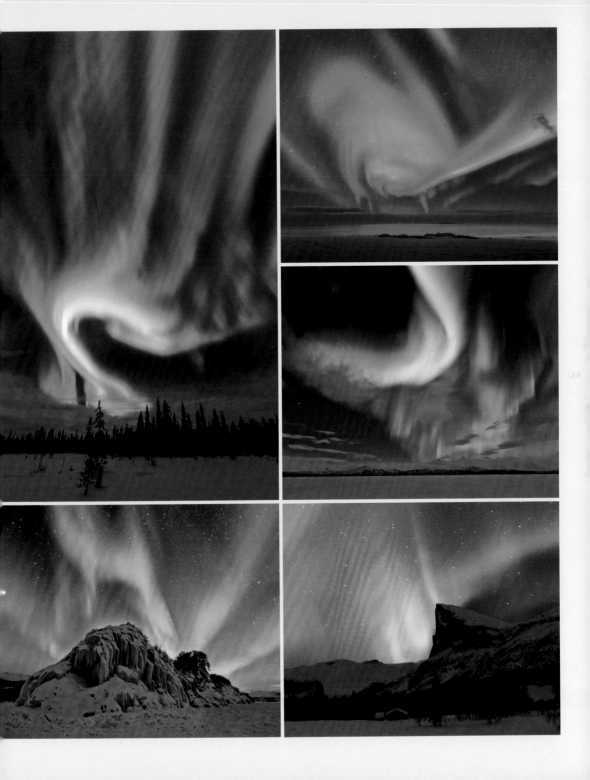

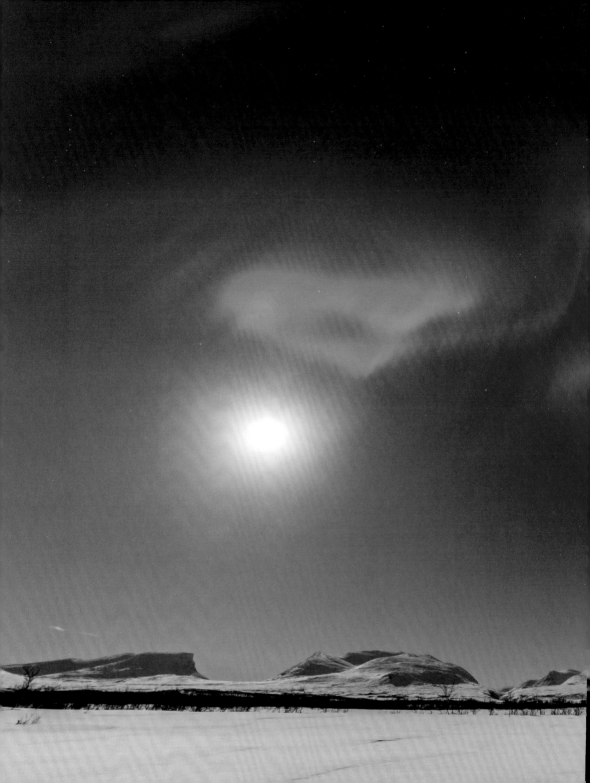

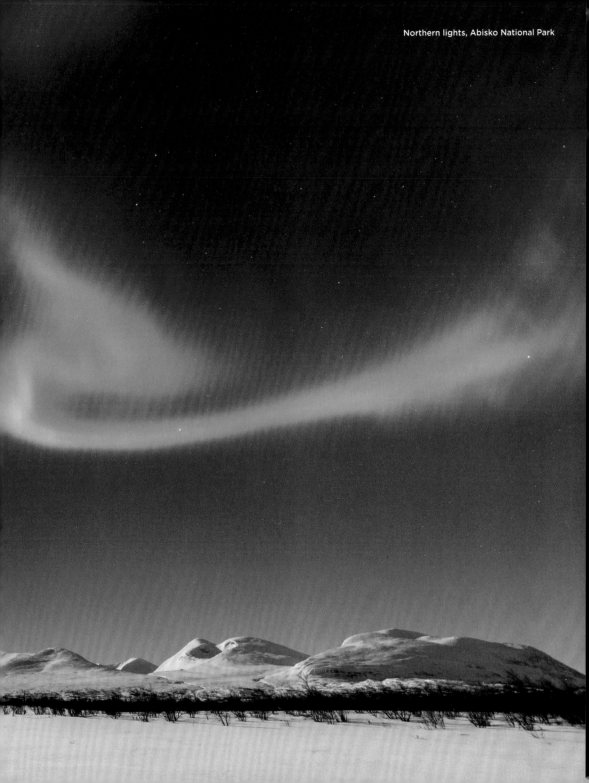

Northern lights, Abisko National Park

Laktatjakko Mountain Lodge, Bjorkliden

Kiruna

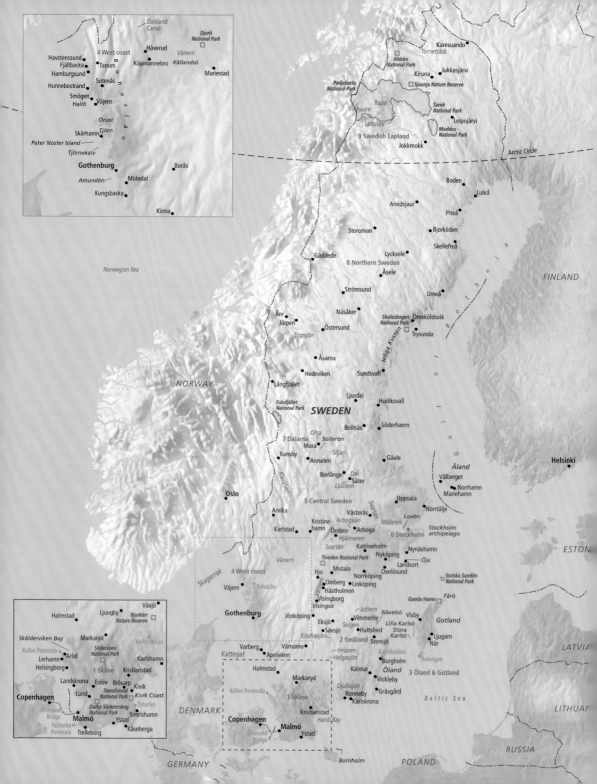

Index

Photo credits

Getty Images
4/5 Johner Images

Mauritius Images
2 Alamy/Peter Adams; 6/7 Alamy/Zoonar/Gunar Streu; 8/9 K. Schlierbach; 10/11 K. Schlierbach; 12/13 Bäck Christian; 14/15 Bäck Christian; 16/17 K. Schlierbach; 18 Alamy/Mikael Utterström; 21 Alamy/Anders Tukler; 22 Johnér; 24/25 K. Schlierbach; 26 age fotostock/Peter Erik Forsberg; 27 Walter Bibikow; 28/29 K. Schlierbach; 30 K. Schlierbach; 31 K. Schlierbach; 32/33 K. Schlierbach; 34 K. Schlierbach; 35 K. Schlierbach; 36/37 Bäck Christian; 38/39 K. Schlierbach; 40/41 K. Schlierbach; 42/43 K. Schlierbach; 44/45 Alamy/Utterström Photography; 46/47 Maskot/Håkan Jansson; 48/49 Bäck Christian; 50/51 K.

Schlierbach; 52 Alamy/karin010759, Alamy/Mieneke Andeweg-van Rijn, Alamy/Zoonar/MYCHKO, Alamy/Zoonar/Rudolf Bindig, Johnér, Masterfile/Siephoto, The Picture Pantry/Roberta Dall'Alba; 53 Alamy/Dagmar Richardt, Alamy/Johner Images, Alamy/Marian Lesko, Alamy/Oksana Bratanova, Alamy/Siim V, Alamy/Vladimir Isaakjan, Arctic-Images, foodcollection/The White Ramekins, Johnér, Oliver Borchert; 54/55 K. Schlierbach; 56 K. Schlierbach; 57 K. Schlierbach; 58/59 K. Schlierbach; 60/61 K. Schlierbach; 62 Alamy/Antony McAulay; 63 Alamy/Antony McAulay; 64/65 Anders Ekholm; 66 blickwinkel/Foto Begsteiger; 67 Thomas Ebelt; 68 Thomas Ebelt; 69 Alamy/Stefan Sollfors; 70/71 K. Schlierbach; 72/73 K. Schlierbach; 74 Westend61/Harald

Hempel; 75 Westend61/Harald Hempel; 76/77 Alamy/Rolf_52; 78/79 K. Schlierbach; 80 Travel Collection/Gerald Hänel; 81 Anders Ekholm; 82/83 Anders Ekholm; 84/85 Prisma/Weber Raphael; 86 age fotostock/Michael Breuer; 87 Johnér; 88/89 Alamy/pictureproject; 90/91 K. Schlierbach; 92/93 Alamy/Per Karlsson - BKWine.com; 94 Alamy/Bjorn Svensson, Alamy/Utterström Photography, Johnér, K. Schlierbach, Westend61/Torsten Becker; 95 Alamy/3QuarksMedia, Alamy/superclic, Alamy/Utterström Photography, Alamy/Zoonar/Knut Niehus, Bäck Christian, Johnér, Westend61/Torsten Becker; 96/97 K. Schlierbach; 98 Alamy/Per Karlsson - BKWine.com; 99 Alamy/Blue Room; 100/101 Bäck Christian; 102/103 Bäck Christian; 104/105 Bäck Christian; 106

KÖNEMANN

© 2020 koenemann.com GmbH

www.koenemann.com

© Éditions Place des Victoires

6, rue du Mail – 75002 Paris

www.victoires.com

Dépôt légal : 1er trimestre 2020

ISBN 978-2-8099-1786-4

Series Concept: koenemann.com GmbH

Responsible Editor: Jennifer Wintgens

Picture Editing: Udo Bernhart

Layout: Regine Ermert

Colour Separation: Prepress GmbH, Cologne

Text: Sabine von Kienlin

Translation into French: Virginie de Bermond-Gettle

Translation into English, Spanish, Portuguese and Dutch: koenemann.com GmbH

Maps: Angelika Solibieda

Front Cover: mauritius images/Johnér

Printed in China by Shyft Publishing / Hunan Tianwen Xinhua Printing Co., Ltd.

ISBN 978-3-7419-2524-5